The Big Book of Decorative Painting

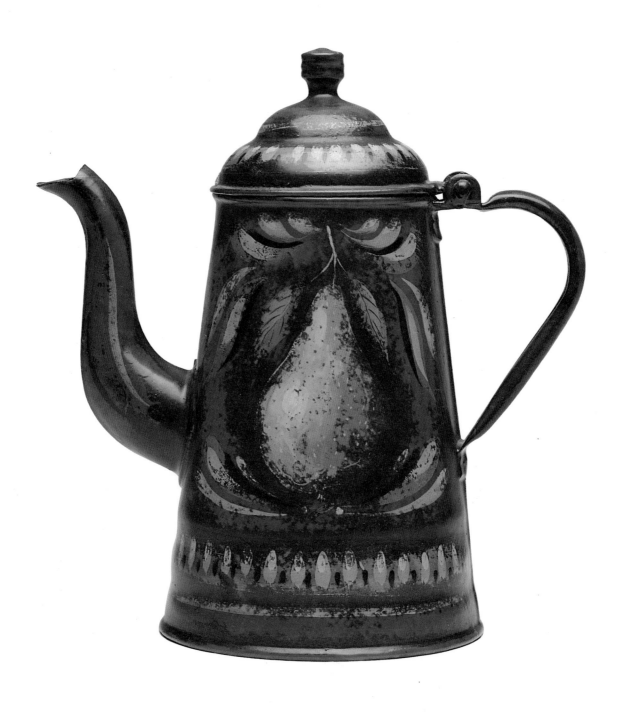

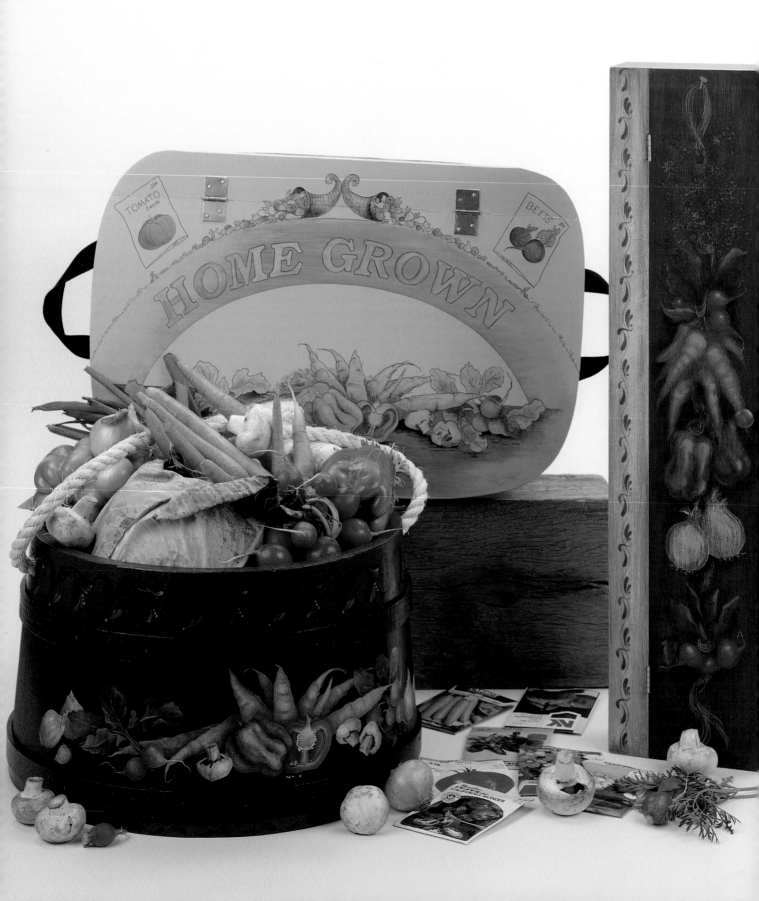

The Big Book of Decorative Painting

How to paint if you don't know how—and how to improve if you do

Jackie Shaw

Watson-Guptill Publications/New York

In honor of my mother, Grace Johnson Waters;
in memory of my father, Walter Rex Johnson;
and dedicated with devotion to Lynn—
my loving husband of thirty years, my severest critic,
and my greatest supporter and helper.
With love.

Notes on the Art
Page 1: A coffeepot painted by American depression-era decorative artist Peter Ompir. *Courtesy Decorative Arts Collection, Inc., Newton, Kansas.*
Page 2: The completed projects for the Quick and Easy, Intermediate, and Advanced Vegetables lessons. (See Chapter 10, "Vegetable Designs.")
Page 6: A Norwegian rosemaling plate by Ragnvald Frøysadal. *Courtesy Vesterheim Norwegian-American Museum, Decorah, Iowa.*

Except where noted, all photography is by Lynn Shaw.
The original illustrations on pages 18–32 are by
Mary Bosman, Smithsburg, Maryland.

Senior Editor: Candace Raney
Edited by Joy Aquilino
Designed by Areta Buk
Graphic production by Ellen Greene

Copyright © 1994 by Jackie Shaw

Published in 1994 in the United States
by Watson-Guptill Publications,
a division of BPI Communications, Inc.,
1515 Broadway, New York, N.Y. 10036

Library of Congress Cataloging-in-Publication Data

Shaw, Jackie.
 The big book of decorative painting: how to paint if you don't
know how—and how to improve if you do / Jackie Shaw.
 p. cm.
 Includes index.
 ISBN 0-8230-0265-9
 1. Painting—Technique. 2. Decoration and ornament. I. Title.
TT385.S452 1994
745.7—dc20 93-38486
 CIP

Distributed in Europe (except the United Kingdom), South and Central America, the Caribbean, the Far East, the Southeast, and Central Asia by Rotovision S.A., Route Suisse 9, CH-1295 Mies, Switzerland.

Distributed in the United Kingdom by Phaidon Press, Ltd.,
140 Kensington Church Street, London W8 4BN, England.

Manufactured in Hong Kong

First printing, 1994

8 9 / 02 01 00 99 98

For information on membership, educational programs, and other decorative painting activities, contact:

The Society of Decorative Painters
P.O. Box 808
Newton, Kansas 67114
(316) 283-9665

If you'd like to share your ideas, thoughts, or memories, write to me at the following address:

Jackie Shaw
Jackie Shaw Studio
13306 Edgemont Road
Smithsburg, Maryland 21783

Acknowledgments

The loyalty of special people, whose contributions and hard work were a major factor in creating this book, makes me aware that as I blaze my way through this life I am but one small spark. If my fire burns brightly on occasion, it is because its flame is fanned and fed by others working quietly in the shadows. My efforts are illuminated by their diligent work, and any credit that is bestowed on my accomplishments must unreservedly be shared with each of them.

For all they have done, and most especially for keeping my resolve kindled with their interest and support, I am truly thankful. Special thanks to Penny Bohn and Barb Winters, for endless hours of surface preparation and finishing, proofreading, organizing, and typing; to Neva Martin, for working around the clutter and confusion of creativity; to daughters Kathy, Laurie, and Jenny, for their understanding and encouragement; and to my husband, Lynn, for his constant help and patience through all my revisions.

Thanks also to my students, both in the United States and abroad, who have enabled me to test and improve my own skills, and gain greater insight into ways of making learning easier and more rewarding. For their patience and endurance, as well as their sharing and enthusiasm, I am most grateful.

At Watson-Guptill Publications, my gratitude goes to Candace Raney, senior editor, for inviting me to write this book; to Joy Aquilino, associate editor, for her sensitivity and for being a constant joy to work with; to Areta Buk and Ellen Greene, for their skill and imagination in putting this book together; and to Mary Suffudy, publisher.

Special appreciation for photographs—and willingness to share them—goes to: the boards of directors and staffs of The Society of Decorative Painters, Inc., and The Decorative Arts Collection, Inc., both in Newton, Kansas; Maud Oving, Meine Visser, and Mrs. C. Hack, curator of the Hidde Nijland Museum in Hindeloopen, Netherlands; Charles Langton, publicity director of the Vesterheim Norwegian-American Museum in Decorah, Iowa; Bill Cochran of Maryland; Melinda Neist of Australia; and the many others who were willing to share their photographs. Thanks also to Priscilla Harsh of Clopper's Orchards in Smithsburg, Maryland, for enduring this artist's often crazy requests; and to Bee and Paul Darrow, for helping to keep holiday traditions alive while I worked on this book.

To all my friends, who have lessened my burdens and increased my joys, I thank you most sincerely.

Contents

Introduction

What Is Decorative Painting?

Decorative painting is one of the many branches of artistic expression accomplished with paint. In its initial stages, it is a craft, easily taught by a systematic, step-by-step approach, and readily learned. It requires no previous academic training or drawing skill. Through the conscientious exercise of discipline in practice and craftsmanship in execution, even those who claim a total lack of creativity can learn to paint.

Decorative painting is an expression of joy—the joyful use of color, of subject matter, and of surface area; the joyful acts of personalizing and of decorating. It is an interaction between the painter and the project, and it is what happens when the painter's creativity flows from the heart through the hairs of the brush. At this level, the craft of decorative painting becomes an art.

It is the craft of decorative painting that I will share with you—the skills and techniques, the mastery of brushes, and basic designing and color theory. These are the things you can read and practice; things that you can learn from a teacher in class or from working with an instructional video. These are the tools of decorative painting.

What you do with the tools, how you incorporate your own spirit and emotions into your decorative painting and how you express yourself in your work, is where your art comes in. That part cannot be taught. It must be felt. My aim is to share with you as many tools of the craft as possible, so that you can approach decorative painting with skill and confidence. That skill and confidence will free you to experiment and grow, and ultimately to express your own personality and emotions in your decorative painting; to develop your decorative painting style.

An English Chippendale-style papier-mâché tray, circa 1815. *Courtesy Decorative Arts Collection, Inc., Newton, Kansas.*

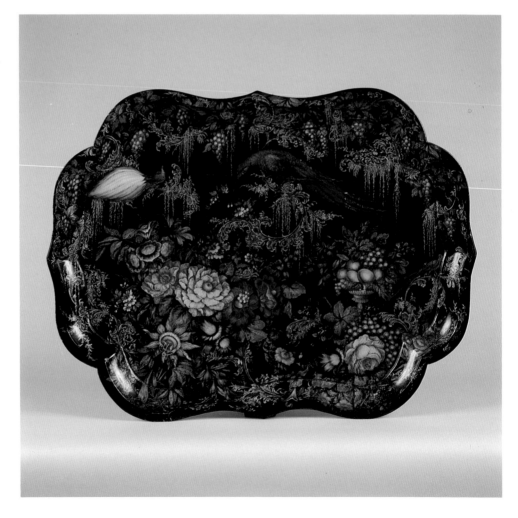

8

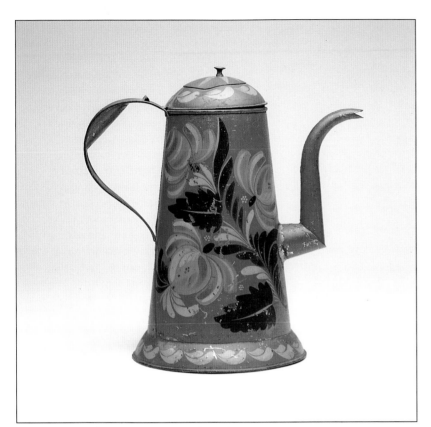

A gooseneck coffeepot.
Courtesy Decorative Arts Collection, Inc., Newton, Kansas.

Regardless of your present painting ability, you can find painting lessons and projects in this book that you can easily accomplish, and that will help you develop your skills. You will master some skills more quickly and easily than others; however, with practice and perseverance, you will soon master them all.

Think of the instructions in this book solely as a point of departure, designed to set you on a course; once you're under way, let your own feelings, creativity, curiosity, and eagerness to explore possibilities guide you. If you follow the illustrated steps, you will arrive at a destination. Just remember that there can be many destinations and many ways to get there. The route that I show you is not the only way; it merely provides a safe path while you're learning the mechanics of the craft. So be adventurous in your explorations, and daring in your experiments. You'll soon become your own best teacher.

Lessons for All Levels

The chapters on color mixing and theory, brushstrokes and brush control techniques, blending and paint application, and other basic techniques are intended to be learned at whatever pace is set by the individual reader. Regardless of your level of skill in any of these subjects, you will find plenty of lessons and projects that you can accomplish with ease.

Each of the various fruit, vegetable, and floral motifs are presented on three levels to accommodate the skills of beginning, intermediate, and advanced painters. The list of skills needed to accomplish each Quick and Easy and Intermediate lesson is included at its beginning, while the Advanced lessons presume mastery of *all* skills.

There is no need to follow the lessons in any particular sequence; just look at the list of skills required to determine whether the project is within your range of capabilities. Don't be afraid to tackle a project that requires one or two skills in which you are not completely proficient; just expect to work a little harder. The effort will help you to grow. Avoid, however, taking on too many new skills at once; that will frustrate you. Build slowly.

Quick and Easy. For most of the lessons in this category, beginners need only be able to fully load a brush with paint; some require a familiarity with comma strokes; and a few include other simple techniques that can be easily omitted. The subject matter of these lessons is stylized and sometimes primitive or folk art in nature. All are forgiving in matters of technique, and their projects are designed to be completed quickly and easily, hence their designation: Quick and Easy.

Intermediate. The Intermediate lessons require some brushstroke mastery, some paint application/blending skills, and a little understanding of color mixing and theory. The subject matter of the Intermediate projects is treated most often in a stylized manner, but the increased mastery of skills through these lessons will lead one readily into the Advanced lessons and a more realistic treatment of subject matter. Strokework embellishments are more complex than those in the Quick and Easy lessons, but not as intricate or as difficult as those in the Advanced lessons.

Advanced. The Advanced lessons presume complete mastery of all color mixing skills, paint application/blending techniques, and brushstrokes illustrated in the book. They approach the painting of the subject matter in a more realistic manner in order

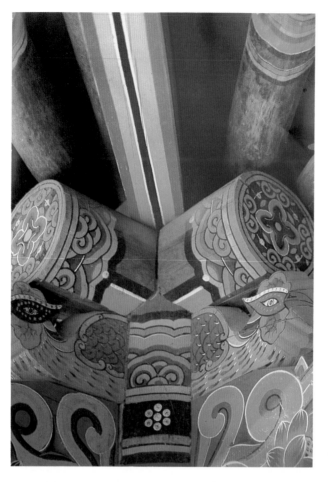

Detail of a Korean temple.

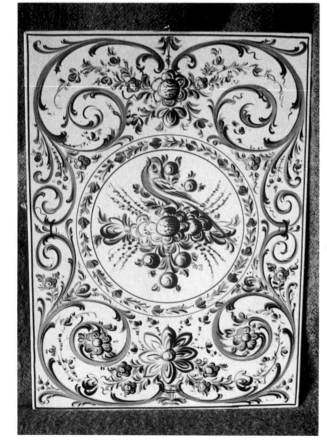

A Hindeloopen-style panel by Meine Visser done in a monochrome color scheme. *Maud Oving Collection.*

to fully exercise the variety of paint application/blending skills, and involve more skillful brush control and more complex stroke work. These lessons are considerably more time-consuming than those in the Quick and Easy and Intermediate categories, and they present greater opportunities for exploration and experimentation.

Getting More for Your Money

Regardless of your skill level, you can have fun working with three times as many designs by interchanging the patterns and lessons. For example, if you're a beginning painter and you'd love to paint, say, blackberries on the back of a decoy as shown in the Advanced project on page 158, use the Advanced-level pattern and project, but substitute the Quick and Easy technique.

Have fun mixing the patterns and techniques. By experimenting you will force yourself to grow. Condensing the process of painting into a series of steps can result— for both teacher and student—in a loss of spontaneity, freshness, and happenstance that is so much a part of art. Therefore, once you have learned the techniques, ease away from the step-by-step approach, and let spontaneity rule.

About the Lessons and Worksheets

While developing and writing the lessons, I tried to anticipate the questions you might have and the situations you might encounter. That makes for lengthy instructions. Don't be intimidated by them. Just read through them entirely at first to gain an understanding of the process. Then as you paint, refer to the color worksheet with its abbreviated directions. Return to the written step-by-step instructions only if you need clarification.

How To Use This Book

Before beginning to paint, spend some time leafing through the book to familiarize yourself with its contents. By gaining an understanding of the complete process of decorative painting—which includes surface preparation, a variety of decorating techniques, and finishing, as well as the use of special effects—you will be better able to make creative decisions.

Once you are acquainted with the various processes, gather your paints, brushes, and a stack of practice paper and work conscientiously through the chapters on color mixing, brush control and loading, basic brushstrokes, and paint application and blending. You need

not master everything in all four of these areas immediately in order to begin the painting lessons in the mid-section of the book, but you do need to begin to develop some ability in each area. Return to those four chapters often to refine your skills and to continue to develop your technique, even as you paint the lessons on projects. And by all means, don't wait until you are "accomplished" to start a project. Those who stay "paper trained" for too long often find it more intimidating to tackle a project than those who jump right in.

When you are ready to paint your first project, follow this sequence of steps:

1. Prepare and basecoat the surface of the project.
2. Transfer the pattern onto the project.
3. Paint the design.
4. Remove the pattern lines.
5. Varnish.
6. Antique (optional).

Some Food for Thought

Join a painting class. While this book is designed to be used for self-teaching, nothing can replace a warm, caring, supportive, and excellent teacher. Try to find a class to join. Ask at your favorite arts and crafts shop about decorative painting classes, or contact the Society of Decorative Painters (see page 4) about teachers in your area. If there are none nearby, form a painting group with a few friends. You'll learn a lot from one another as you work your way through this book, and the bond of friendships formed will lead to many happy memories.

Learn from as many different teachers and authors as you can. Assimilate their techniques, but let your own painting personality evolve. A good teacher should encourage you to develop your own style, not follow blindly in his or her path. If your teacher insists, "This is the only way to do it," or is uncomfortable with letting you add

A Norwegian rosemaling cabinet. *Courtesy Vesterheim Norwegian-American Museum, Decorah, Iowa.*

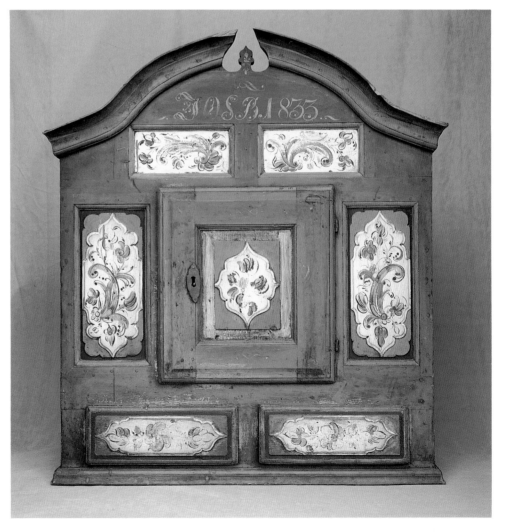

A Russian tray from Zhostovo. *Grace Waters Collection.*

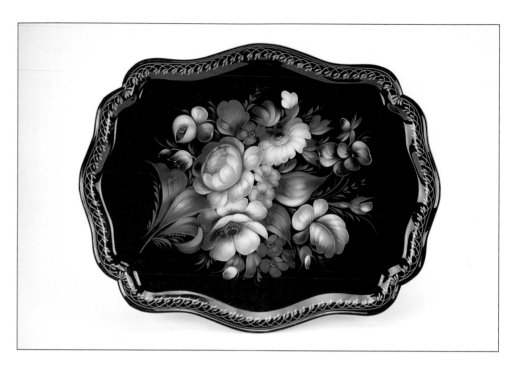

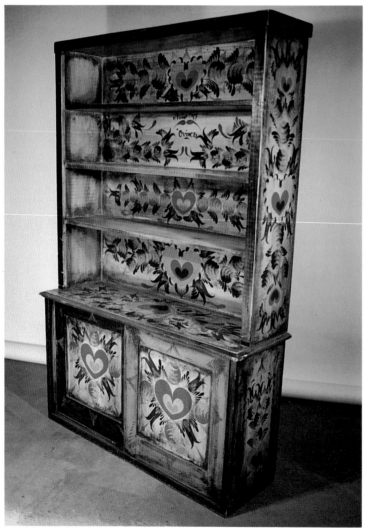

A cupboard painted by Peter Hunt, an American depression-era decorative artist. *Courtesy Decorative Arts Collection, Inc., Newton, Kansas.*

your personal touches, find another teacher. You should be allowed and encouraged to freely exert your creative self-expressions. Imitating a teacher's style is one way to begin, but I think the saddest thing is to see so many carbon copies where the students' development was arrested through a teacher-imposed or self-imposed lack of exploration and experimentation. On the other hand, be a *receptive* student, open to what your teacher is trying to present. If you are unwilling to at least try things a new way, you'll never know what you're missing. You can learn something from everyone, even if it means learning that there are ways that you *don't* want to do things.

There are no rules! Keep in mind that there is no single right way of doing anything. There should be no rules in art, period—only guidelines that suggest effective methods. Had Gainsborough followed the "rule" of his day—never use blue as a predominant foreground color—he would never have painted *Blue Boy.* Unless we dare to do something different, there would never be change. It's been said that "If you always do what you've always done, you'll always get what you've always got." If this were the case, decorative painting would not have evolved into the multifaceted art form it is today.

Paint from your heart, not your head. As you accumulate knowledge and techniques, your style will develop, emerge, and change,

just as a caterpillar becomes a butterfly. Don't try to create a style; just let it happen. When you are the designer, you are the authority; paint it the way it pleases you. Paint who you are, not who somebody else is; for you need please no one but yourself. You should paint with the innocence of childhood, taking naive delight in decorating and personalizing your surroundings. Most important, you should paint from the heart, not the head. In the beginning, while you're learning the techniques, the head will do most of the work. The head, however, may lead you to overwork your painting, laboring it to death in the name of perfection. If a painting is technically perfect but lacks spirit from the heart, it might as well have been painted by a machine. Remember, the early decorative painters were unschooled in the fine arts, but their paintings reflect the pleasure and joy they found in expressing their innate creativity. Their work is in great demand by museums and collectors—not because of the skill, but because of the spirit. Don't let laborious effort hamper your joy of creating, and mar the finished product by being obvious.

Platonic relationships don't work. Reading this book won't make you a decorative painter, but experimenting, failing, and trying again will. Don't just read about the various exercises; learn by doing. The more senses you involve, the greater your comprehension and retention. So don't let your affair with decorative painting be simply platonic. Get involved.

Flirt with failure. Experiment boldly. Don't expect everything you paint to be a success. Be willing to paint a lot of failures along the way. You will learn more from the disastrous failures than from the easy successes. It's been said that if you're not failing a lot of the time, you're not creating.

A contemporary adaptation of baurenmalerei, rococo style, by Melinda Neist.

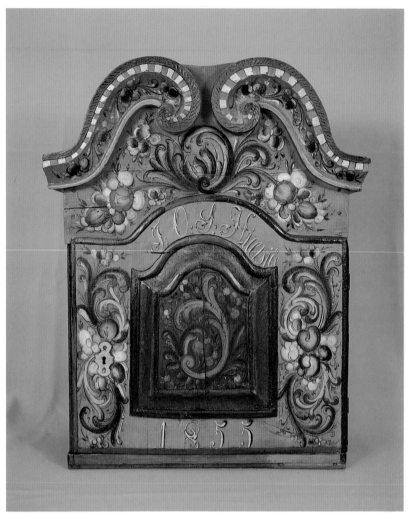

Another Norwegian rosemaling cabinet. *Courtesy Vesterheim Norwegian-American Museum, Decorah, Iowa.*

In an effort to imitate the exquisite paintings, carvings, and wall hangings of the rich and famous, the less wealthy hired itinerant painters who, generally untrained in the fine arts, often worked in exchange for their room and board. It was not uncommon for the entire interior of a dwelling to be decorated, ceilings included, particularly in Scandinavia. In Bavaria, the exteriors of buildings were often subjected to a painter's brush as well.

The most direct influence on early decorative painting in America was European, having been brought to the colonies by settlers in the form of painted chests and other functional items. In the early days of our country (before movies and television), our ancestors often sought entertainment through their own self-expression. So for many, once their chores were done, painting was a ready outlet. Although they were generally without any formal training in the fine arts, their work reflects both their satisfaction in doing it and their own lives and times. Much of the inspiration of early American decorative painting is drawn from the settlers' religious beliefs, natural surroundings, and transplanted culture. Their paintings show Old World influences in motifs, strokework, and use of color. The work, now widely sought by museums and collectors, is frequently stylized and simplified, but never without charm.

Decorative painting was spread throughout the colonies, as it was in Europe, by itinerant painters who often bartered for bread and board. The Yankee peddler, forerunner of the traveling salesman, also helped boost the popularity of decorative painting in America. He traveled from place to place with his wagonload of goods, a large part of which were tinware, or tole, as it was then called. (*Tole* is French for sheet metal). At first, tinware was unpainted. Then, enterprising tinsmiths discovered that decorated tinware had greater sales appeal than raw tin. Furthermore, the paint helped prevent rust. Ultimately, the application of paint through cutout stencils made possible the mass production of painted wares (as well as walls and chairs and other furniture). Recreation, decoration, preservation, and—even then—sales promotion were all satisfied by this form of folk art.

With the advent of industrialization, people no longer had the time, the need, or the inclination to carry on the pleasures of

Court success. It's too easy to say, "I can't," and then never try. Instead, say "I'll try," and discover that you can! A positive attitude is your greatest ally. Furthermore, that attitude will be reflected in your work. Paint happily and freely, and your joy will be reflected in what you paint.

Our Heritage

The history of decorative art dates back some 20,000 years to paintings on cave walls, and spans the globe as a visual art that has enabled people to express their natural creativity and satisfy their desire to make things pleasing to the eye. Indeed, the need to decorate our surroundings has been described as one of our basic instincts, along with the need for shelter, food, and procreation. Decorative painting, as a means of embellishing furnishings and interiors, was at its height in Europe during the eighteenth and nineteenth centuries. Some of the most beautiful decoration was commissioned by royalty or by the church.

decorative painting, so its practice temporarily became a part of our cultural past. Now, in our increasingly electronic, impersonal, and mass-produced world, we feel the need to reassert human qualities as well as our own unique personalities. Thus, the desire to furnish our surroundings with warmth and artistry has led to a renewed interest in decorative painting.

Access to books and visual records of art from all cultures and ages has given us a great advantage over our painting predecessors by enabling us to draw inspiration from widely divergent forms of ethnic art. The scope broadens as we continue to rediscover old techniques, experiment with new ones, develop new painting media and materials, and pass our discoveries on to others through classes, videos, and books. The nature of decorative painting—to evolve with the times—keeps it constantly changing and challenging. However, as we adapt the old styles and techniques to fit our personalities and lifestyles, I hope we never cease to appreciate the unique characteristics and traditions that make each ethnic folk art distinctive.

To that end, I would urge you to delve further into our wonderful decorative painting heritage. A small sampling is included throughout this Introduction. You'll see designs ranging from very simple to exquisitely complex, color schemes from subdued to bold, styles consisting of a profusion of brushstrokes as well as styles with none. These few pages do not do justice to decorative painting's vast history and visual delights. Rather, the presentation is intended to whet your appetite and send you running to libraries and museums.

If you really enjoy decorative painting, you should join the 35,000 other painters who are members of the Society of Decorative Painters. There's a chapter near you, hosting paint-ins, educational programs, public service painting activities, lending libraries of painting books and videos, wonderful camaraderie, classes, and much, much more (refer to page 4 for information). The Society of Decorative Painters also founded The Decorative Arts Collection, Inc., for the purpose of collecting, displaying, and preserving both historical and contemporary examples of decorative painting. This growing collection is on display at the Society's headquarters in Newton, Kansas.

Decorative painting has been the starting point for numerous former nonpainters into the fine arts arena as well as into graphic design, interior design, illustration, and other forms of art. I hope this book will launch *you* in the direction you'd like your painting to take you.

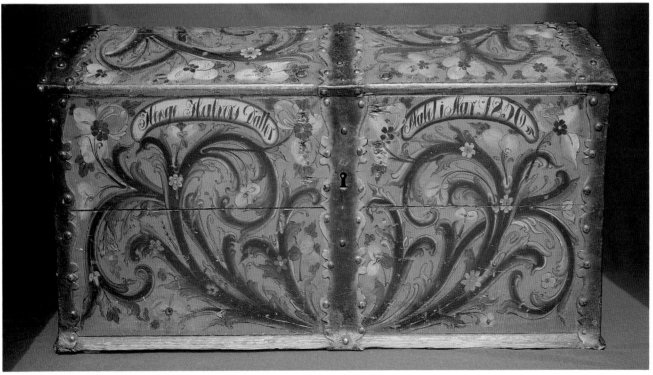

A Norwegian rosemaling trunk. *Courtesy Vesterheim Norwegian-American Museum, Decorah, Iowa.*

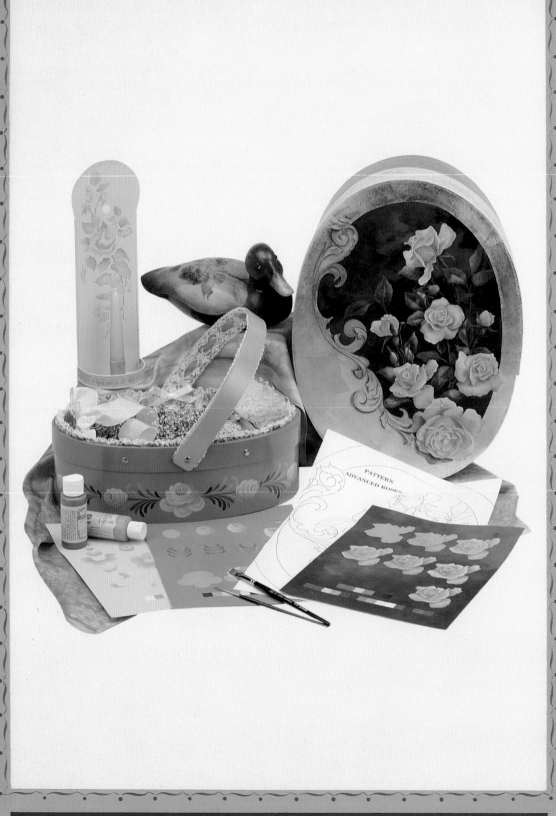

Chapter 1

Getting Started: Organizing Your Supplies and Workspace

You can get started in decorative painting with little initial expense: Three brushes, four or five colors of paint, and a few common household items are all you need. The market abounds with materials in all price ranges. Buying the cheapest is usually false economy, however. Inferior products do not yield superior results, and they interfere with learning while squelching your confidence. Since it is possible to begin with so few supplies, pamper yourself with the highest-quality paints and brushes. It is an investment that will bring you a lifetime of pleasure.

You will also benefit from suggestions for claiming a workspace and arranging your time so that you can begin your decorative painting experience with confidence and knowledge. In addition, there are recommendations for developing your skills by utilizing a variety of learning aids, including keeping a notebook to chart your progress, compiling a picture morgue, and cultivating a positive attitude toward experimentation.

With a little paint and practice, you can use your brushes, paints, and patterns to decorate "ordinary" household items and beautify your surroundings.

Basic Supplies

A Note on the Paints

The paints used throughout this book are acrylics (in squeezable bottles). If you already have other paints (tube acrylics, oils, watercolors), use them. You'll need to make adjustments to accommodate their different attributes, but you can still have a lot of fun with decorative painting.

The brushes, paints, and household items listed and shown below are all you need to start painting. These supplies are the ones that I use, so I have listed brush numbers and paint colors according to specific manufacturers. If you are unable to find the brands and series suggested, ask your shop owner to help you find something comparable. It should be noted that the range of quality within each category of item is extremely broad.

Brushes (Loew-Cornell)
- Flat: No. 6 (Series 7300)
- Round: No. 3 (Series 7000)
- Liner: No. 1 (Series JS)

Acrylic Paints
(DecoArt Americana Acrylics)
- True Red
- True Blue
- Lemon Yellow
- Snow White
- Black (optional)

Miscellaneous
- A jar of water for rinsing brushes (replace later with a brush tub or basin)
- A bottle cap or 35mm film canister lid, to hold water or extender for thinning paints on the palette
- Paper towels (cut in quarters for economy's sake) or old rags for blotting brushes
- Styrofoam meat trays, egg carton lids, old magazines, or freezer paper, on which to squeeze paints (replace later with waxed palette pad)
- Butter knife, plastic knife, or popsicle stick for mixing paints (replace later with a trowel palette knife)
- Tracing paper for copying patterns
- Pencil or chalk for making transfer paper for patterns
- Scrap paper to practice on
- Soap (such as Ivory) for cleaning brushes
- A notebook in which to record everything you do and learn
- Something to decorate (see "Something to Paint On," page 20)

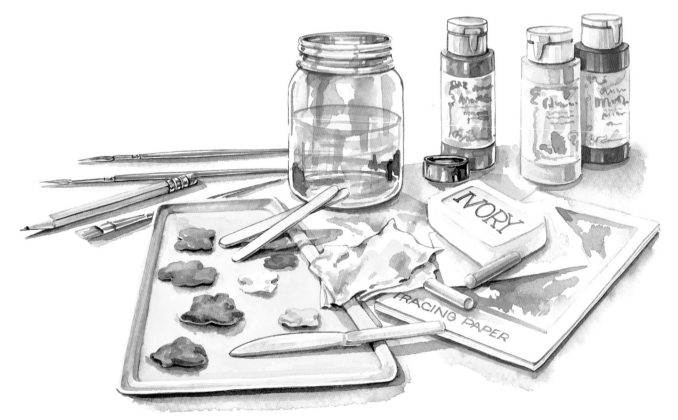

Basic decorative painting supplies: a selection of brushes, a jar for rinsing, a pencil, paints in primary colors, bottle caps for keeping paints moist, a bar of soap, tracing paper, chalk, a palette, paper towels, and mixing implements.

Wish List

As your expertise and your desire to have more of the colors and tools associated with decorative painting increase, there are other items you may wish to acquire. Be sure to give a copy of this "nice-to-have-someday" list to all the people who love you.

More Brushes

- Flats: Nos. 2, 4, 8, 10, and 12 (Series 7300); the 1/2-inch (Series 7550) for painting large strokes, applying washes, and blending; and two large flats, 1- and 1 1/2-inch, for basecoating and varnishing
- Liner: Nos. 2 and 10/0 (Series JS)
- Round: No. 4 (Series 7000)
- Filbert or cat's tongue: No. 8 (Series 7500) for soft blending
- Spotter or detail brush: No. 2/0 (Series 7650) for tiny strokes
- Dagger or sword striper: 3/8-inch (Series 7800)
- Mop brush: 3/4-inch (Series 275)

More Paints

There are hundreds of premixed colors from which to choose. You can also purchase other primary colors (different reds, blues, yellows) and do your own mixing.

Miscellaneous

- Brush 'n Blend Extender, a medium that prolongs the working time of acrylics to facilitate color blending; it is also useful in making transparent washes.
- A trowel-style palette knife, for mixing paints
- Waxed palette paper (pad of 50 disposable sheets), for use with multimedia. Waxed sheets are a must with acrylics.
- A brush tub or basin for cleaning brushes. This item has dividers that separate clean and dirty water, ribs for vibrating the paint out of brushes, and a rack for soaking dirty brushes.
- Artists' transfer paper (such as Chacopaper), which works like carbon paper. (Never use carbon paper; it will eventually bleed through and spoil your artwork.)
- Specially treated brushstroke practice paper, designed for repeated practice of brushstrokes using just water
- A spray mister, to keep the acrylic paints on your palette from drying too quickly
- A hair dryer, to reduce the drying time of your painting
- Alcohol or fingernail polish remover, for cleaning neglected brushes
- Crow quill pen and India ink

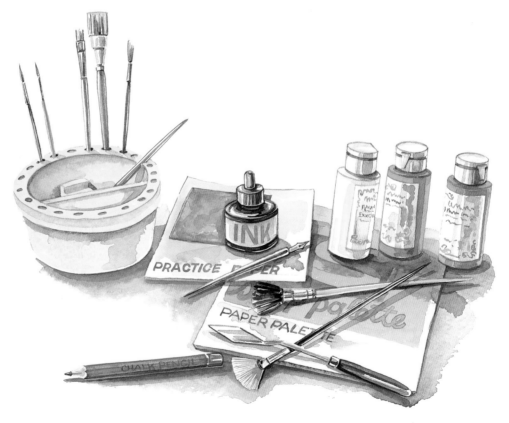

A few items for your "wish list": more brushes in a variety of shapes and sizes, a brush tub with a rack and ribs, India ink and a crow quill pen, specially treated practice paper, more paints in other colors, a trowel-type palette knife, waxed palette paper, and a chalk pencil.

Something to Paint On

There are thousands of wonderful items on the market designed specifically for the decorative painter. The manufacturers of the items featured in the lessons are listed in the Source Directory at the back of the book. You may already have many paintable items in your attic, basement, garage, or perhaps even in your living room or bedroom. Look around. By making some minor adjustments in the patterns (also at the back of the book), you can start decorating your surroundings without incurring any additional expense.

Things to Look For:
- Tin cans (these make handy pen and pencil holders)
- Wooden coat hangers
- Blank note cards and envelopes
- Cigar boxes, mushroom baskets
- Paper bags (for lunch or gift bags)
- Attic or basement stow-aways
- Flea market finds
- Lamps and lamp shades
- Foot stools, chairs, benches
- Dressers, chests, trunks
- Tables, trays, shelves
- Candleholders, picture frames
- Trash cans, crates, baskets
- Decoys, wooden cutouts
- Book covers
- Window shutters
- Walls, floors, doors
- Kitchen cabinets
- Dishwasher, refrigerator

In addition to castoffs you might find around the house, these unfinished wooden items can be transformed into beautiful projects. (To see a selection of these, turn to page 286.)

Choosing Your Brushes

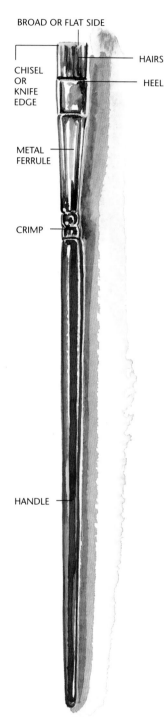

BROAD OR FLAT SIDE

HAIRS

CHISEL OR KNIFE EDGE

HEEL

METAL FERRULE

CRIMP

HANDLE

The basic components of a brush. Note that the ferrule, which can be either flattened or cylindrical, is attached to the brush handle by the crimp. The cut ends of the hairs, which are also referred to as bristles or filaments, are securely glued inside the ferrule.

The brushes suggested for use in the lessons are moderately priced taklon synthetic brushes by Loew-Cornell, and are designed specifically for use with acrylic paints. When purchasing brushes, look for the following qualities:

- A brush should be resilient, snapping quickly back to its original shape when used, with no stray hairs to spoil your work.
- Flat brushes should form sharp chisel edges; round and liner brushes should form fine points.
- The handle should fit snugly into the *ferrule* (the piece of metal that holds the bristles or hairs on the handle) with no wobbling.

Since your brushes will greatly affect the outcome of your decorative painting, it will be well worth your time to spend a few minutes becoming acquainted with the parts of a brush, the different types of brushes, and their care and handling.

Basic Components

Facing a manufacturer's stupendous assortment of painting brushes can be almost as bewildering as trying to select a single flavor of ice cream from fifty delicious choices. Knowing how some of the flavors taste helps make the selection of ice cream a little easier. Perhaps knowing how some of the brushes paint will help you select those that are best suited to your painting needs.

First, let's simplify the confusing array of brushes by thinking of them in general categories, according to handle length, type of bristle or hair, size of the body of hairs, and the shape of the body of hairs (round, flat, liner, and assorted specialty brushes).

The Handle

Some brushes have long handles; others of the same size, shape, and style have short handles. The long-handled brushes, which are designed to be held near the end of the handle, permit freedom and looseness in painting. This enables easel painters to stand back from their work as they paint, allowing them to evaluate its progress.

Decorative painters, on the other hand, tend to work very close to their projects, holding the brush near the metal ferrule. Short-handled brushes, which are popular

with most decorative painters, allow tighter control and facilitate the painting of fine details. When you're working extremely close to a project and holding the brush near the business end of the handle, it's nice not to have a long-handled brush feeling out of balance or threatening to poke an eye. However, decorative painters should be sure to cultivate the habit of holding the project at arm's length periodically to view it more objectively.

The Hairs

Wherever you can find a hair—whether on a camel, sable, squirrel, goat, or other creature—someone has probably painted with it. In fact, it is claimed that the early American fraktur paintings were often executed with brushes made from hairs taken from the family cat! The stiffer natural hairs, such as hog's hair and boar's hair, are called *bristles*. The finer, softer hairs, such as sable, badger, and camel, are referred to as *hairs*. Brush hairs are also made from synthetic filaments such as nylon or taklon.

The bristle brushes are generally used for canvas painting, where their stiffness permits the decisive and expansive movement of oil or acrylic paint on the canvas. Bristles leave their imprint in the paint, creating a brushed and painterly look. Their use in decorative painting is primarily limited to special effects.

The softer, more flexible natural hair and synthetic brushes are ideal for the controlled painting of details, for rendering smoothly blended, slick passages, and for decorative brushstroke work. Soft-haired brushes are used with oils, acrylics, and watercolors. Fine red sable and Kolinsky sable are long-standing favorites in this category, especially for use with oils and watercolors. Because of the exceptional quality of the hair involved, these brushes are costly. The soft natural-hair brushes are popular with decorative painters, particularly those who work with oil paints. Because of their durability, synthetic brushes are particularly well suited for use with acrylics. Since they are attractively priced, they are also often used with other media. Some brush manufacturers combine synthetic and natural hairs in their products to give painters the best qualities of both types of hair in a single brush. These mixed-hair brushes are used with all media.

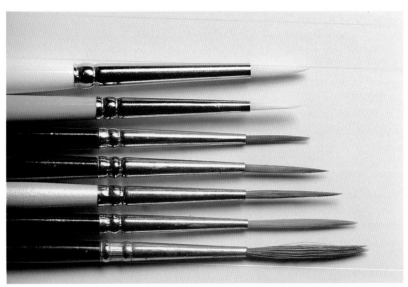

Although these brushes are all No. 1s, the varying lengths of their hairs make each suitable for a different task.

As you will see, there is a bewildering variety of brushes available. Rather than attempt to list them all, I've included a selection of the brushes you're most likely to encounter in future classes and in other books, in the hope that your knowledge of them will both lessen your confusion and whet your appetite for experimentation. For now, however, you can get by quite nicely with a flat brush, a round brush, and a liner brush.

Flat Brushes

Flat brushes, which have flattened ferrules, include *flats* (sometimes called *shaders*), *brights* (also called *chisels*), *angulars* (also referred to as *rose brushes*), and *filberts* (sometimes called *cat's tongues*).

Flats or Shaders. These brushes are available in soft natural hairs, synthetic hairs, and stiff natural bristles. The *soft* natural- and synthetic-hair flat or shader is a staple for decorative painters. Its body of hair tapers to a fine knife or chisel edge. The length of its hairs is greater than its width. This long length makes it possible to fill the brush with ample paint for doing stroke work; that is, for forming distinct brushstrokes with a single, positive stroke of the brush. These brushes are also used for special effects such as doubleloading, sideloading, washing, and glazing of transparent paint over an opaque basecoat.

When used with oils or acrylics, the *stiff* natural bristles result in painterly, textured strokes well suited to filling large areas with color, such as in landscape and still life painting.

Brights or Chisels. Because they are indeed flat, these brushes are often mistakenly referred to—and purchased by beginners— as flat brushes; however, they do not have the long hairs that are characteristic of flat brushes. Close inspection will reveal that the width and length of the hairs of the bright brush are approximately the same, thereby creating a brush with a square body of hair. These shorter hairs are designed to have good resilient snap and to be less elastic than those of the flat, thus enabling the painter to blend areas skillfully and to create crisp edges—short hairs for short blending strokes. This brush is not intended for the long, flowing stroke work that is the domain of the flat or shader. It is available in synthetic, soft natural hairs, and stiff natural bristles.

Sizes

As can be seen in the accompanying photograph, brush sizes can be very confusing. The two round brushes at the top and the five liner brushes, all made by the same manufacturer, are all No. 1s. Yet the hairs of each are a different length. Are they misnumbered? No. They are each from different series, which are designed for different purposes. Within each series, brushes are usually numbered according to the width or diameter of the body of hairs at the base of the ferrule; the greater the width or diameter, the higher the number on the brush. Depending upon the series and manufacturer, other No. 1 brushes could be broader or narrower at the ferrule, and have longer or shorter hairs.

Notice the variation in the lengths of the hairs of each of the seven brushes. The different lengths suggest that each brush will behave slightly differently. Shorter hair lengths are excellent for detail strokes, while longer lengths are better suited to painting long, flowing lines. Generally, the longer the hairs are, the more flexible they are, and hence, the more difficult they are to control. (Mastery of even the longest-haired brush *is* possible with practice.) Select your brush hair length to suit the painting task.

Brush Styles

There are flat brushes, round brushes, and a great variety of specialty brushes with hairs trimmed to form curved corners, slanted angles, wedge or fan shapes, and other configurations. The two primary brush styles, flat and round, refer to the flattened or cylindrical shape of the ferrule. The specialty brushes can have either flat or round ferrules.

Angulars or Roses. Angular or rose brushes look like flat brushes with the hairs cut at an angle. Blending in tight areas can be easily accomplished with this brush. This brush is also used for painting controlled, blended, tapering strokes, such as for rose petals, hence its name.

Filberts or Cat's Tongues. A filbert looks like a flat brush with both its corners trimmed, with the hairs in a nearly oval shape. Filberts are available in stiff and soft natural hairs and in synthetic filaments. These brushes are popularly used for creating lost (faded) or soft edges, and for blending colors. The filbert can also be used for some brushstroke designs, specifically with S, comma, crescent, and scroll strokes.

Round Brushes

Round brushes, which have cylindrical ferrules, include *rounds, liners, lettering brushes,* and *spotters* (which are sometimes called *detail brushes*).

Rounds. These brushes have a full body of hairs that are shaped to a point. Fine-pointed natural- or synthetic-hair round brushes are used to make beautiful decorative strokes

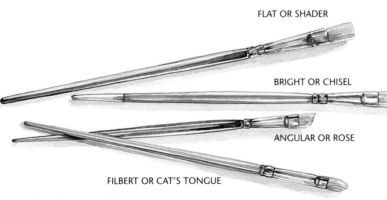

FLAT OR SHADER

BRIGHT OR CHISEL

ANGULAR OR ROSE

FILBERT OR CAT'S TONGUE

A selection of brushes with flat ferrules.

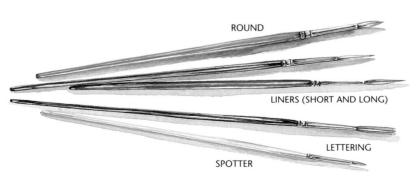

ROUND

LINERS (SHORT AND LONG)

LETTERING

SPOTTER

A selection of brushes with round ferrules.

such as the comma stroke, crescent stroke, the S stroke, and others. This brush is also sometimes used for blending colors together to create soft edges. It is excellent for detail work because its fine point enables the painter to work in tight areas of the design where a flat brush would be too broad.

The round brush is also available in stiff bristles for canvas painting. It is especially well suited to *scumbling* (blending one color against another to create a softly mottled effect).

Liners. Also known as *scrollers, monogrammers, riggers,* and *script liners,* these brushes have a small-diameter ferrule and hence fewer hairs than the round brush. Liners are used for painting flowing scrolls and calligraphic strokes. They are available in different hair lengths (short, medium, and long). A liner with short hairs can be used for some fine detail work and for small or short stroke work. These liners are easily controlled but limited in versatility because the short hairs cannot hold a lot of paint. Liners with very long hairs, such as script liners and riggers, hold an ample charge of paint and can carry a stroke for long distances before needing to be reloaded. Long liners, however, are tricky for most beginners to master because of their long, flexible hair; in addition, they are not well suited to tiny detail work. Liners with hairs about 5/8 inch long are an ideal size: They are versatile, easily manipulated for fine details, long enough to paint flowing stroke work, and not too intimidating for beginners.

Lettering Brushes. Lettering brushes have round ferrules, but the hairs of some are shaped to a flat chisel edge. The long length of the hairs permits the painting of long, flowing strokes without the necessity for frequent reloading. While these brushes are fun to work with, especially for someone interested in brushstroke lettering, you can get by using your liner brush for lettering. I've pointed this brush out so that you won't mistakenly buy one thinking it is a liner. The lettering brushes whose hairs are shaped to a chisel edge rather than to a point are handled more like flat brushes when doing stroke work.

Spotters or Detail Brushes. These are short, stubby, little round brushes. Use them for painting eyelashes on a ladybug, spots and dots on a butterfly, and teeny, tiny detail strokes, such as commas, teardrops, and S strokes, and highlights on blackberry drupelets.

Specialty Brushes

This is a Pandora's box of interesting and sometimes unusual brushes. Some have flattened ferrules; others have round ones. Some work best with a single medium; others are suited to both the watermedia (watercolors and acrylics) and oils.

Fans. The hairs of fan brushes are spread open like a handful of playing cards. Fan brushes are used more often in canvas painting than in decorative painting. Nevertheless, it's fun to have one handy for creating some special effects, such as for painting foliage and for wood graining. The spread hairs also permit delicate handling of paint, particularly oil paint, for merging colors and softening edges.

Mops. These brushes, which are packed with natural hairs (usually camel), are soft and fluffy like makeup brushes. A mop is used to skim the surface of a wet application of oil paint, delicately merging or softening the colors. It is a valuable tool in oil antiquing where making a barely discernable transition in the application of glaze is desirable. Wielding this brush with a wispy, featherlike touch will obliterate distinct and abrupt changes in color or value. Before using a new mop, slap it sharply in the palm of your hand to dislodge and remove loose hairs.

Daggers or Sword Stripers. These brushes look like very long-haired flat brushes with one side trimmed at an angle to form a point on the other side. Daggers or sword stripers were traditionally used in early decorative painting for striping the edges of such objects as trays and chairs. Because of the length and width of its hairs, this brush holds quite a bit of paint and will cover a lot of ground. With practice, you can overcome the fear of painting straight, even lines. A bit of talcum powder on your little and ring fingertips will help them glide smoothly over the surface of your project as you pull the brush steadily toward you. You can also have fun painting stroke ribbons with this brush, as well as special effects such as the carrot leaves on page 195.

Deerfeet or Stipplers. Set in a round ferrule, the short stubby hairs of these brushes are cut on an angle. By rotating a deerfoot in your fingers while applying paint with a pouncing action, you can create some lovely textural effects suggestive of foliage. You can also use a deerfoot to apply drybrushed highlights or shading.

Stencil Brushes. Available in stiff and soft hairs for working on coarse or smooth surfaces or on fabrics, these brushes are set in broad, round ferrules and are used in a rubbing, circular motion. Only a scant amount of paint is loaded on the brush, most of which is removed on paper toweling before rubbing the brush across a cutout stencil or using it to add drybrushed accents.

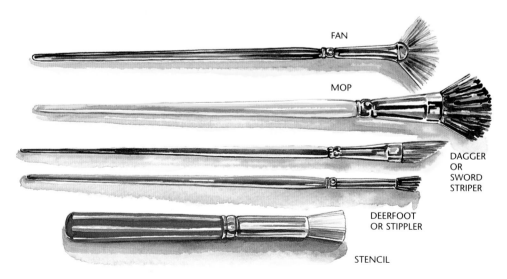

FAN

MOP

DAGGER OR SWORD STRIPER

DEERFOOT OR STIPPLER

STENCIL

A selection of specialty brushes.

Caring for Your Brushes

Get in the habit of taking meticulous care of your brushes. It is easy to do and a worthwhile effort for protecting an investment that will bring you endless hours of enjoyment.

Before you introduce your new brushes to your paints, take a moment to familiarize yourself with what a new brush in excellent condition looks and feels like. Slide your thumb and forefinger along the metal ferrule and onto the hairs of the brush. Do this several times, imprinting in your mind how smooth the transition is from the ferrule to the hairs. Notice that there are no lumps or bumps in the hairs at the base of the ferrule. Small amounts of paint left in the brush as a result of inadequate cleaning will cause a knot to form there.

Wet the new brush with water and notice how crisply it forms a point or a chisel edge, with the hairs all drawn closely together. The hairs of a neglected brush will form a sort of tunnel instead, or will separate like teeth on a comb. Both of these conditions are caused by paint that has been left to harden in the brush.

Look closely at the tips of the hairs. They should lie flat, not curl outward or away from the main body of hair. Improper scrubbing of the brush on soap, fabric, paper toweling, sponges, or your hands, or using it on rough surfaces will cause the hairs to wear and curl in this fashion. There is no cure for such curly hair. You'll simply have to replace the brush. Save it, however, to use for drybrushing and other special effects (see "Scruffy or Ratty Brushes," page 27).

However, there are brush problems that can be corrected: Hairs that are curved (on brushes that were left standing on their hairs in water) or bent (brushes that are not carefully stored) can be straightened by using the method suggested below (see "Repairing Damaged Brushes").

The handles of your new brushes fit firmly in their ferrules and the protective coat of lacquer is smooth and pleasant to grasp. The handles of brushes left standing in water above the ferrule will swell when wet and shrink upon drying. Such swelling and shrinking of the wood will cause the handle to become loose and wobbly in the ferrule, and the lacquer to crack and peel.

There is no need for brush hairs to curl, bend, form tunnels and hard knots, and there is no need for handles to crack, peel, and become loose in their ferrules. Careful cleaning, use, and storage will eliminate most of the problems.

Cleaning Your Brushes

1. Clean your brushes thoroughly and frequently, particularly if you are working with acrylics. Leaving a dirty brush dangling in water will not prevent the paint from hardening in the brush. Likewise, a quick swish through water for acrylics or through turpentine for oils is not sufficient for cleaning the brush.

 After removing most of the paint by rinsing in water (for acrylics) or thinner (for oils), finish the job with a thorough soap and water cleaning. Fill the brush with soap by gently stroking the hairs of the brush on a wet bar of soap. Do *not* scrub the hairs into the bar.

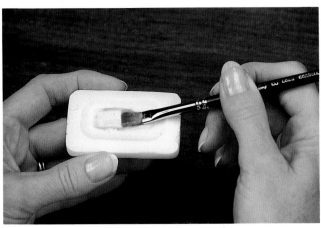

Stroke your brush carefully on a bar of soap.

Do *not* scrub the hairs into the soap.

2. Holding the tip of the hairs between your thumb and forefinger, squeeze the soap up toward the ferrule, wiggling the brush gently to work the soap in amongst all the hairs. Do *not* bend the hairs sharply against the ferrule; this could cause hairs to break.

3. Rinse the hairs well, then repeat steps 1 and 2. Continue soaping, squeezing, and rinsing until every trace of color is gone. Don't leave even a hint of color in the brush. A lot of little "hints" will some day form one big knot and create a dreaded tunnel in the hairs, putting that brush completely out of commission.

4. When you're convinced that the brush is totally clean, stroke it gently on the bar of

soap once more. Draw the hairs through your thumb and forefinger, shaping flat brushes to a smooth chisel edge, and round and liner brushes to a fine point.

Rather than standing the brush on its handle and in a jar to dry, lay it flat. This prevents any moisture remaining in the ferrule from draining down into the wooden handle and causing it to swell. When the brush is thoroughly dry, store it to protect the hairs. The hairs will have dried quite stiff from the soap. This will help them retain their fine shape, and minimizes the risk of damage in storage. When you're ready to paint again, rinse the brushes to remove the soap. Use water for acrylics brushes, turpentine for oil brushes.

Note: Brushes used with oil paints may be cleaned with lard oil instead of soap. Follow the procedures above, omitting the water rinse. Wipe excess oil and color from the brush onto a cloth or paper towel.

Caution: NEVER shape brushes to a point or chisel edge by putting them in your mouth. Some paints contain toxic substances.

Repairing Damaged Brushes

Now that you know what your brushes are like when new, what you need to do to keep them that way, and what can happen to them through neglect, here are some last-resort restorative measures you can use to try to undo careless handling.

Squeeze the soap gently toward the ferrule.

Shape the brushes to their natural configuration.

- To remove a hardened knot of paint near the ferrule, which causes hairs to separate and tunnel, soak the brush in alcohol, acetone, or nail polish remover. This is a harsh measure, so don't use it in your regular cleaning routine. Keep the solvent off the handle; otherwise it will dissolve the lacquer and create a gooey, sticky mess. An ashtray makes a good soaking dish. Follow the solvent soak with a thorough cleaning with soap (see above).

- To straighten hairs that were bent in storage or through prolonged soaking, dip just the tip of the hairs quickly in and out of a cup of boiling water. Repeat as necessary. Do *not* dip the ferrule into the hot water; it could loosen the glue used to set the hairs, so you won't have to worry about cleaning that brush again. When the hairs are straight, fill them with bar soap and shape them to their natural configuration. Set the brush aside to dry.

Scruffy or Ratty Brushes

A scruffy or ratty brush is an invaluable item that you cannot buy, but sometimes unintentionally create. This includes the brush whose hairs curl sideways, for which there is no cure, or the brush that can't be salvaged through solvent soaks or hot dips. Save them. You'll never use them for stroke work again, or for careful blending techniques, but you can do wonderful things with them. Use them for drybrushing, scumbling, streaking, dabbing, and creating special effects.

Storing Your Brushes

Store your brushes carefully so the hairs will not be bent or crushed. You can buy cases designed specifically for storing brushes, or you can create your own. *Hint:* Round brushes and liners are often sold with a clear plastic tube over the hairs to protect them. Once you remove the protective tube, throw it away. Do *not* try to replace it. Too often hairs are caught and bent while sliding the cap back on.

- Stand cleaned, dry brushes on the handle end in a jar, can, or cup.
- Weave the handles of the brushes into a woven placemat, then roll it up and tie it with ribbon for storage or travel.
- Store the brushes in their original cases if purchased as a kit, or in purchased cases fitted with springs to hold them securely.
- Fasten the brushes to a piece of cardboard with elastic or rubber bands.
- Stitch a folding case with individual pockets for each brush.
- Use tube-type travel cases that are specially designed to separate the brushes and keep them from shifting.
- When you don't plan to use them for some time, store sable brushes in a tin or plastic box in which you have placed a few mothballs. Otherwise the moths will show you that your favorite sable brush was also theirs.

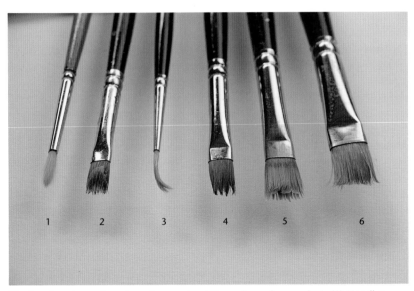

The brushes shown here have been ruined through careless neglect: (1) Handles split, peel, and wobble when they're allowed to soak in water. (2) Acrylic paint will harden in a brush if it is not properly cleaned. (3) Hairs are bent in storage or when carelessly left standing in water. (4) Hairs separate this way when paint is allowed to dry in a brush. (5) Tunnels result from paint hardening near the ferrule. (6) Curly hairs result from painting on rough surfaces, from rubbing the brush rather than stroking it, and from rough cleaning practices.

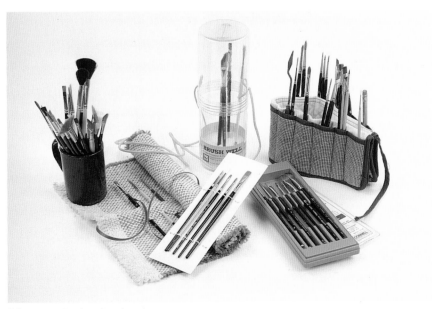

A few ways to store brushes.

Choosing Your Paints

As mentioned earlier, I will be focusing in this book on the use of acrylic paints. Acrylics have become the most popular medium among decorative painters in recent years, and are well suited to the busy lifestyle in which most of us find ourselves. A very versatile paint, acrylics dry within minutes, allowing the rapid buildup of multiple thin layers. When you understand their attributes and master certain techniques, you can use them to imitate the appearance of oil paints, or thin them to mimic watercolors.

If you are a painter already and prefer working in either oils or watercolors, by all means do so. By using the techniques you already employ for handling your preferred medium, you can adapt the lessons and designs to try your hand at decorative painting. The directions, particularly for the blended lessons, will lend themselves readily to watercolor technique. When working with oils, you will probably want to eliminate the wash/floated color/glaze techniques (which require complete drying between layers) and substitute instead the faster approach of blending wet colors into one another. The brushstroke designs can be easily rendered in either oil paints or watercolors.

Basic Characteristics

Paints contain a variety of pigment types—natural, chemical, and man-made. The pigments are suspended in a binder; the type of binder determines whether the paint is acrylic (acrylic polymer resin), oil (linseed oil), or watercolor (gum arabic). The binder also affects the dried paint film; linseed oil dries to a brittle film within a few years, while acrylic resins retain their elasticity.

The formulations of both oil paints and watercolors are fairly simple; because of this, different brands of each paint type can be safely mixed together. However, the formulations of acrylic paints—developed in the 1940s, they are relative newcomers to the painter's palette—vary among manufacturers. Besides using different acrylic resins, companies may also include an assortment of the following additives: preservatives, fungicides, defoamers, solvents, inert materials that impart a matte or gloss finish and aid drying, glycols that stabilize the paints during freezing and thawing, and thickeners or fillers that make the paint workable and prevent the other ingredients

from separating. While some manufacturers interviewed maintained that intermixing different brands of acrylics should pose no problems, others were adamant that brands should not be intermixed. I like to give my work every advantage for outlasting me, so I choose to work with a single brand of acrylic paint. While laboratory tests have proven acrylics to be extremely durable and nonyellowing, we must let them (and our practices with them) stand the test of time.

Good-quality paints are heavily pigmented to provide good coverage, and are creamy, nontoxic, and consistent in quality and color. Paint swatches are provided on the worksheets to help you match the colors used in this book to those you may already have in your paint box. Be aware, however, that while different brands of colors may appear identical in color swatches, they often react quite differently when combined with other colors, or when used as thinned washes. The paints used throughout the lessons and shown on the color worksheets are DecoArt Americana Acrylics. If you are using a different brand of paint, anticipate that results may vary from those pictured. Regardless, you should learn to work with your paints to make them work for you.

Identifying and Matching Colors

In the rapidly expanding acrylic paint market, there is a lack of standardization in the naming of the paint colors. With some companies offering hundreds of premixed colors, it becomes a challenge to give every color a unique name. Some companies draw inspiration from nature, others from foods and spices, and some use names that are traditionally associated with oil and watercolor pigments. Several manufacturers may have a color called, for example, Adobe Clay, but each manufacturer's paint may be a totally different hue. On the other hand, several manufacturers might offer an almost identical hue, say a medium-value, intense blue-green, but each has given it a different name.

To eliminate the confusion of so many names for so many acrylic colors by so many different companies, I have assigned letters to each paint color used in the lessons. The lesson will advise you to use color **A** or **D**, for example, or to mix colors **D+F** to create a

different color. Swatches of the colors used are shown on the lesson worksheet with their assigned letter. This eliminates the need for having to refer constantly to elaborate color conversion charts.

Mark a set of stickers or masking tape labels with the letters **A** through **T**. When you're ready to paint a lesson, find near matches to the palette colors on the color worksheet with the colors in your paint box. Tape the corresponding letter to each paint cap. The letters will vary with each lesson, so be sure to remove the labels and start again when you begin a new lesson. The names of the colors I used are listed with each lesson for your convenience in comparing them to color conversion charts, should you so desire. Charts comparing the colors of the eight leading acrylic paint manufacturers can be found in *The Acrylic and Fabric Painter's Reference Book* by Susan Adams Bentley (Smithsburg, Maryland: Jackie Shaw Studio, 1989), available through your arts and crafts store.

Note: In acrylic paints, the pigment is suspended in a soupy white resin which dries through polymerization to a clear state, so your acrylics will appear slightly lighter when they're wet and look darker once they've dried. The pigment is not actually changing color; the binder is simply turning clear as it dries, allowing the true pigment color to show.

As you try to match the colors on the worksheets, keep the following in mind:

- Similar colors of different brands of paint may vary slightly in the way they mix with other colors.
- It may be difficult for you to match the worksheet colors exactly, even if you use the same colors and brand that I used. This is because of the many factors involved in color printing: photography, lighting, films, processing, color separating, printing inks, and others, all of which can cause a shift in color from the original artwork to the printed copy. With this in

mind, don't work for an exact duplication of the worksheets and projects. Instead, strive for a pleasing appearance overall.

- If your paint box does not contain a near match for a color on the worksheet, you should be able to mix a good substitute (see Chapter 2, "Learning to Mix Color").
- With an understanding of color mixing and theory, you can follow the techniques in each lesson while changing the color scheme entirely. Try it, it's fun!

Mixing Colors for the Worksheets

When the painting directions require colors to be mixed together, begin the mixture with the first color cited and slowly add the second color. Therefore, a mixture of **A+B** would contain more **A** than **B.** The same colors listed in reverse order would indicate that **B** is the predominant color. Where mixtures include three or more colors, the third and succeeding colors are used to make slight shifts in the mixture.

Keep track of the colors in your paint box by making paint swatches. You'll find them invaluable when you're trying to decide on color schemes, or looking for "just the right color." The following are two of my favorite ways to keep track of my collection of colors.

Color Swatch Rings

1. Cut a 4 × 6 inch index card into three strips, each measuring 4 × 2 inches.
2. Using one strip for each color of paint you own, apply two coats of paint to the strip. If you would like to see how the color would appear as a thin wash, apply a single coat thinly at one end of the strip. This is especially helpful with dark colors. To see how the paint would look varnished, brush on varnish along one side.
3. Write the color name on the front of each strip at the bottom edge.
4. Punch a hole in the top of each strip, then thread them onto a clasp ring.
5. If you'd like to protect your color strips, cover them with clear plastic.

Color Swatch Disks

1. Slice a $^3/_4$-inch or 1-inch dowel into circular disks about $^3/_8$ inch thick.
2. Paint each disk with a color from your selection.
3. Write the color name on the front.
4. Store the disks in a jar, or attach a piece of strip magnet to the back of each one and stick them on a metal surface.

Color swatches of your paints are an invaluable aid.

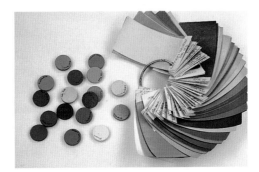

Keeping Your Paints Fresh

Once your paints are exposed to air, they begin to dry. The rapid-drying feature that makes acrylics so popular among decorative painters also makes them frustrating when it starts to work while the colors are still on the palette. Oils will stay fresh on the palette a little longer, but they, too, will skin over if held for several days. Watercolors dry uniformly throughout without forming a skin, so they can be reconstituted with water. To prolong the palette life of your acrylics and oils, try the tips below.

Acrylics

You can conserve your acrylics and prevent waste by providing needed moisture during and between painting sessions.

- While you are painting, use an atomizer or spray bottle to frequently spray a fine mist of water over the paints on your palette. You can also splatter water droplets onto the paint by dragging a finger across the wet bristles of a toothbrush.
- Squeeze your paints onto a small tray with raised sides, such as a Styrofoam meat tray. Cover the tray with a damp paper towel. For additional moisture, you can squeeze your acrylics directly onto a damp paper towel. Tube acrylics work nicely this way, and it's helpful when doing blended work with jar acrylics.

- To leave your acrylics for several hours, scrape each color into a condensed pile. Sprinkle a drop or two of water or water plus extender onto each, then cover snugly with a 35mm film canister lid or bottle cap.
- Use a Masterson Sta-Wet Palette with special palette paper on a wet sponge sheet.

Oils

Oil paints do not dry out as quickly on your palette as acrylics. If you must hold them over for a few days, however, try one of the following tips to increase their longevity.

- Cover the leftover piles of paint with a piece of plastic wrap or with individual 35mm film canister lids.
- Transfer the leftover paints to a piece of glass. Submerge the glass and paints in a tray of water. The water will not mix with the oil paints, but will prevent air from reaching them and drying them out. A few minutes before you're ready to resume painting, remove the paints from the water and transfer them onto your palette to allow the moisture to evaporate.
- Blend a drop or two of oil of cloves (available at most pharmacies) into each pile of paint to slow the drying.
- Store your entire palette in an airtight plastic box or use a Masterson Palette Seal, which is designed for the storage of oil paints.

A few aids for prolonging the life of your acrylic paints.

A few aids for prolonging the life of your oil paints.

How to Tell When Paint Is Dry

Regardless of whether you're working with oils or acrylics, some techniques, such as washes, glazes, and floated color, require that the previous layer of paint be dry before proceeding. It is also imperative that you know your paints are dry before you apply finishing coats of varnish. Below are some hints to help you determine when it's alright to proceed.

Acrylics

The first test to check whether paint has dried is to look: If the paint looks shiny, it's still wet. Acrylics dry duller and slightly darker than when wet.

The next test is to touch: If the painted area feels cool (compare by touching a similar surface), the water in the paint is still evaporating and the paints are not yet dry.

Never apply a coat of acrylic paint on top of a layer that is partially dry. The moisture in the new coat will cause portions of the damp underlying coat to lift, and you'll end up with an unsightly and difficult-to-repair gap in your paint coat. Either blend a new layer of wet paint immediately into a still completely wet layer, or wait for the first layer to dry thoroughly, then add the second layer.

You can gently speed the drying of the acrylic paint by using a hair dryer set on low and held a few inches away from the project. Although acrylic paints dry quickly, I prefer to let them dry overnight before applying varnish coats. This helps to ensure that thick applications of paint, such as builtup dots and strokes, have dried throughout.

Varnishing will rejuvenate the depth and sparkle of dried, dull acrylics. If you'd like to see how varnish will affect your project, brush some clean water across a dry painted area. Another way to determine how your acrylics will look under a coat of varnish is to paint some color swatches on a sheet of glass, then turn the glass over and view the colors through the glass.

Oils

Even if you're painting primarily with acrylics, you may sometimes use oils for antiquing and other special effects. It's helpful, therefore, to know a little bit about them.

Oil colors do not dry at a uniform rate. Drying times will vary, depending upon a variety of factors: the thickness of the paint application, the choice of painting medium and the choice of colors (for instance, cadmium colors and alizarin crimson are relatively slow drying, while the umbers and Prussian blue dry more quickly).

Driers such as cobalt siccative can be added to the paints to hasten the drying time, but these should be used sparingly. There are also rapid-drying mediums available that can be mixed with oil paints.

The popular practice of lightly misting oil-painted projects, while still wet, with varnish or acrylic spray to speed drying is risky and best avoided. Unevaporated vapors from the thinner and oils can become trapped under the spray film, especially if applied too heavily, only to expand later and cause delamination or cracking.

Although oil paint may be dry to the touch, it is not necessarily cured and ready for varnishing. Depending upon the thickness of the paint application, oil paints may take several months to a year to dry completely. Most decorative painting in oils, however, is done with very little buildup of paint, and can therefore be varnished much sooner than a canvas painting. Thin washes, glazes, or antiquing films, especially when mixed with varnish or rapid-drying mediums, will dry within 12 to 24 hours. For other decorative painting projects painted in oils, I like to wait three or four weeks before varnishing.

Arranging Your Workspace

When you sit down to paint, try to arrange your supplies for the greatest efficiency. If you are right-handed, for example, you will be picking up your brush, loading it with paint, rinsing paint out of it, blotting it on paper towels, mixing paints with the palette knife, and so on, all with your right hand. Therefore, you should place your brushes, jar of rinse water or brush tub, paper towels, palette, and palette knife to your right in an arrangement that is convenient and requires the least expenditure of effort—paper towels right beside the rinse water, for instance. Place the item you're decorating in front of you. Place other less frequently used items to your left. (Lefties should reverse the procedure.) Then, while painting, you will reach *away* from your project to rinse, wipe, and load your brush, rather than *across* it if your supplies are scattered at random. For example, if your rinsing jar is to your left and the paper towels to your right, you risk the possibility of dripping dirty water on your painting or dragging a sleeve through the wet paint. If you always set up your work area in a deliberate arrangement, however, your movements will become automatic and not a second will be wasted fishing about for what you need, or causing little accidents to impede your progress.

Creating a Studio

It is also important for you to claim a space for your studio—a space that will be yours alone, a space you don't have to clean up, share, or apologize for. It might be just a corner in the kitchen, or a cubby in the attic, or only a TV tray pulled up to the throne in a seldom used half-bath. Whatever and wherever it is, make it yours, and make it off-limits to anyone else.

My first painting studio was in a former clothes closet, which also doubled as my sewing room. My worktable was the closet door laid across a stack of cinder blocks. The sewing machine sat on one end of the table, the paints on the other, while I sat at the middle on a small stool. A bare bulb dangling above my head was the only source of light. But it was mine, all mine. And it was too small for our three daughters—ages six, three, and newborn—to get into.

A place where you can leave your painting clutter *out* and *as is* is a must. There's nothing more detrimental to creativity than tidiness. My studio gets a good cleaning only between major projects. Otherwise, the clutter is part of the creative process. If you must drag your supplies out from under the bed every time you want to paint, the effort will soon discourage you. Besides, you'll be constantly reminded of the dust bunnies proliferating there, and the guilt—thinking that you should be cleaning, not painting—will totally destroy your creativity. Having to clear your paints away from the dining room or kitchen table for every meal is not an ideal situation, either. Your ultimate goal should be to paint *through* mealtimes. All that stuff you've heard about "starving artists" is not exactly accurate: We get so full of creativity that we easily forget to eat or cook—it's our *families* that go hungry.

Arrange your workspace for efficiency and convenience.

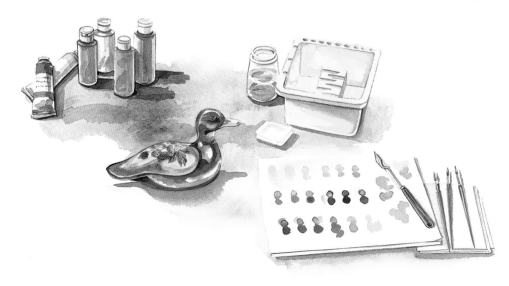

Painting Day by Day

Once the paint starts "flowing through your veins," your priorities and your life will change. Remember my "sewing room"? When I compared the fun of painting with the futility of the constant mending and hemming and unhemming of little dresses, I learned to leave the mending in the basket until the clothes were outgrown. Then I could give them away without guilt. Not mending meant I had more time for painting.

Teaching children to help with chores at a tender age pays off eventually in time saved, too. Helping sort laundry and match socks is fun when you're two years old; not so when you're thirty-two. With a little cunning, you can have the children doing the entire laundry by the time they're seven, giving you more time to paint. When our three went off to college, they were each amazed to learn that no one else in the dorm knew how to wash and dry the laundry. My painting time had helped make them confident, independent citizens. Children can also be trained to sand, seal, and basecoat your projects—other wonderful skills they can take with them into adulthood. You'll soon catch on to other creative ways of extending the usual 24-hour day.

If you're also struggling to accommodate your painting time within the hectic schedule of work outside of the home, you can train your painting hand to work more diligently when you do have time to paint by surreptitiously practicing some brushstroke and brush control techniques during board or staff meetings. Others there will be so busy taking notes (or doodling) that they won't notice that your doodling is with an empty brush. If you have a long commute, pay for the gas and let someone else do the driving. Then you can trace and transfer patterns on the way to work, and maybe even do a little designing.

Recording Your Progress

The importance of keeping a notebook to chart your progress cannot be overstated. Save everything—your very first practice brushstrokes, color mixtures and color schemes, sketches, patterns, and experiments that failed as well as those that worked. Even sheets of used palette paper are sometimes helpful reminders of how you mixed colors for a certain project. Take careful notes in painting classes, painting quick reminder sketches as you go. Keep a photographic record of all your painted projects. This material will be a valuable resource in your day-to-day painting, and it will be fun to look at fifteen or twenty years from now. You'll be pleased to see how much your skill has grown.

I still have the first comma strokes I painted over twenty years ago. They're positively dreadful, but at the time I painted them I thought they were wonderful. As my skill developed and I looked back on those early efforts, it was gratifying and encouraging to see that I had, indeed, improved. We learn best, and are encouraged to go on, when we can see progress being made.

Keeping samples as we learn also helps keep us in touch with what it was like to be a beginner—an important characteristic for anyone who may someday become a teacher and pass on knowledge and experience to others. Don't discount too quickly the idea that you may ultimately teach a subject that is so new to you now. Teaching and sharing with others is the best way to reinforce your learning and to continue to grow. The notes you make and the experiments you try today could well become an instructional book for the decorative painters of tomorrow.

Students are often so in awe of a teacher's expertise that they assume the skill was always there. They fail to realize that the difference between their skill and their teacher's is usually just a matter of will—the will to persevere and practice.

My first strokes have been a most valuable teaching aid (and a most humbling one, I might add). Whenever a student's spirits begin to sag, a quick peek at where I started gives hope that anyone who perseveres will succeed.

If you are fortunate enough to join a painting class, a well-kept notebook will help you through the times when your teacher is not by your side. There are so many things to learn and, hence, so many things to forget. Keep them in your notebook so you can find them when you need them.

Compiling a Picture Morgue

The picture morgue is one of the most helpful tips I share with beginning decorative painters. A *picture morgue* is a reference collection of photographs and pictures

clipped from magazines, newspapers, advertising brochures, wrapping paper and gift cards, catalogs, food box and can labels, seed packages, calendars, and other printed material. As your collection of images grows, it will become a valuable source of inspiration and knowledge, providing you with physical details for in-depth study (such as botanical and zoological features), color schemes, historical and geographical descriptions, tips on perspective drawing and composition, figure poses, body parts, hair styles, ethnic designs, and so on.

It's easy to start a picture morgue: All you need is a shoe box or file folder and a pair of scissors. Clip out everything you see that you'd like to be able to paint right now, as well as some images that might provide insight or inspiration in the future. Even if you don't care for horses or cats, cut them out—you'll be glad you have them in your morgue. Someday you may receive a sizeable commission to paint a sign for a horse farm or a plaque for a cat lover. Keep an open mind and an alert eye. The gingerbread trim on an old Victorian house, for example, may provide the inspiration for a border design on a tray. Lines drawn to vanishing points on the photograph of a room interior can help you learn to draw furniture in perspective. Advertisements, even of things in which you have no interest, can provide exciting ideas for color schemes. Your family and friends will also enjoy looking for things to add to your collection.

Don't worry about sorting and filing at first; just accumulate. As your collection grows, it will dictate the categories you'll need to designate and the number of individual files you'll need to make. When your shoebox or folder starts to bulge, spread your treasures in front of you and group similar things together. For example,

put all the animals in one pile, the flowers in another, the seascapes in another, and so on. Grab a youngster to help you. You'll both have fun. When you finish sorting, you'll probably have enough in some piles to fill many folders, while others are still skimpy. You may have—as I had at first—a meager selection of animals but several dozen flowers. I lumped my few animals into a single folder titled "Animals," and divided my flowers into two folders, "Spring Bulbs" and "All Other Flowers."

As my early folders began to overflow, I divided the material again, and yet again whenever there was enough to demand its own category. Each individual flower now has a separate folder. In addition, there are folders for such things as "Mixed Florals," "Florals for Borders," "Floral Compositions," and so on.

My file drawer for animals now consists of main categories such as "Forest Animals," "Zoo Animals," "Farm Animals," and "Domestic Animals/Pets." Within those categories, there are separate files for each animal, except those for which I have little material. These are lumped together in a common file—"Assorted Zoo Animals"—until there is enough to warrant separate files.

Over the twenty years since I first established my picture morgue, I have weeded out and replaced inferior material several times, adding clearer, more detailed, and more accurately colored pictures. It has been fun watching the improvement both in the printing and photography techniques and in the helpfulness of the clippings in my morgue. In spite of periodic purging, what began in a homemade file folder now exceeds a large, four-drawer, legal-sized filing cabinet. I treasure its contents. The abundance of inspiration it contains overloads my senses and excites me to exhaustion.

Stretching to Grow

My priority these past twenty years has been to paint everything within arm's reach. If you have access to ladders, scaffolding, and hydraulic lifts, your arms can reach a lot of everything, even when the reaching is a bit scary. Throughout this book, I'll be encouraging you to stretch, to go beyond your comfortable skills, to reach and grow. It sounds good as I write it, but maybe what I really mean is to stretch to reach what you want to paint *on*. Painting on the wall near the ceiling in my three-story-high classroom required lots of stretching from a 30-foot ladder. Nothing topped the "scary" of stretching, however, to operate a hydraulic lift up the front of our home/studio. Maneuvering that suspended body bucket along an 8 × 8 foot expanse of window to decorate under the eaves and under the peak of the roof was almost terrifying enough to stop my heart from pumping. As I warned you earlier, when paint flows through your veins, you'll do things you never dreamed.

Decorative painters go to great lengths (and sometimes heights!) to find something to paint on.

You'll do things like using up several boxes of plastic food wrap by sticking it in wet paint on your walls, and by rolling old T-shirts and paper bags in the paint. I know they sound a bit absurd, but try them once and you'll never have to wash the walls again. (Just think how much extra time that will give you for painting.) When I ran out of walls at our Old Stone Mill home, I started on the ones in our church Sunday school. So if you're afraid to tackle your own house, look around—somewhere there are walls begging to be decorated. Sometimes people will even pay you for having all that fun.

When you move on to greater things, you can move your studio out of the closet or corner and into a spacious addition with lots of good lighting, several tables to clutter with creativity, running water, endless cupboards, and a couch to stretch out on for creative thinking. You may have to fend off other family members who'll want to use it, but stick by your brushes; that's your space, and yours alone. I share my studio with no one but my grandchildren.

As soon as you claim your studio space, get out your paints, turn the page, and jump into color mixing. It is for me (after twenty-plus years) still one of the most exciting aspects of decorative painting.

Chapter 2

Learning to Mix Color

The most intriguing aspect of painting is the exciting opportunity it affords to mix an endless array of colors. Unfortunately, however, color mixing is frequently the most intimidating part of painting for beginners; yet it need not be. With that in mind, let's take a few moments to dispel the mystery and the fear of color mixing and theory to prove how fun they truly are.

It should be pointed out that you can only learn color mixing by actually mixing colors. Reading and thinking about it just aren't enough. You must learn through personal involvement how colors interact. That interaction may result from physically mixing two or more colors together to create a new color. It may be an effect created by presenting colors so that they are visually mixed, which can be accomplished by laying a transparent color wash over an opaque color, or by placing various spots of color next to one another. The interaction may also result from placing one color against a background of another. Yes, colors do wonderful and exciting things, and they will work *with* you if you let them—and *against* you if you don't understand them.

You can skip this chapter entirely if you prefer to use ready-mixed acrylic colors. Before you make that decision, however, you should know that you'll miss an important opportunity to understand the tools you'll be working with and to grow as an artist—and I strongly suspect that your painting will suffer as a result. Work your way through the chapter once, then refer to it whenever you need to as you continue through the other chapters.

A color wheel. The small strokes painted on each flower are low-intensity colors, which were obtained by mixing the color of the flower with its complement (the color directly opposite from it). The light-colored comma strokes are tints, which are a mixture of the color of the flower and white.

Painting a Color Wheel

A Note on the Terminology: Intermediary and Tertiary

Just to clear up some confusion, the colors we mix by combining a primary color with a related secondary color have been called different names by different artists and authors. These colors are located between a primary and a secondary color on a color wheel (for instance, between yellow and green), and involve the mixture of the two. I prefer to use the designation *intermediary* for these "in-between" colors, and save the term *tertiary* for those colors that, as defined by Webster's New Universal Unabridged Dictionary (1990), are "produced by mixing two secondary colors"—in effect, *all three* primary colors.

Before you actually start painting a project, sit down and play with your paints. That's right—play with them! Look at them. Touch them. Smell them. Do everything but taste them. The more senses you involve, the more complete your learning and the greater your retention will be. So right now, today, let household, lawn, and office chores wait. Allow the dust bunnies to multiply under the beds and the laundry to pile up in the corners. Put that telephone caller on indefinite "hold" and send the family out for pizza. Let today be the day you discover the endless variety of gorgeous colors you can get out of only three bottles (or jars, or tubes) of paint: red, yellow, and blue. (Later, we'll also use black and white to darken, lighten, and gray the mixed colors.)

Red, yellow, and blue are known as the *primary colors.* They are the basis of all other colors. We *cannot* create a red, yellow, or blue by combining any of our other pigments, but we *can* mix combinations of those three colors to create other colors.

Of course, there are several varieties of reds, yellows, and blues available. Some reds, for instance, have a slightly yellowish cast, while others have a tinge of blue. The blue-reds, when mixed with certain blues, result in rich, clear purples or violets. When mixed with blue, the yellowish reds create muddy purples. You'll soon learn why.

For your initial color mixing exercise (the color wheel described on page 37), select, if you have a choice, the purest red, yellow, and blue you own. Later, you can work with other reds, yellows, and/or blues. It's fascinating to see the diverse mixtures that result from combinations of different primaries. For example, a dull or deep yellow, when mixed with red, will create an entirely different orange than a pure yellow.

Note: While mixtures from less-than-pure primary colors can be beautiful, you should first see the colors that result from mixtures of pure primaries. Sometimes it's possible to adjust a color to make it even purer. For example, an orangish red mixed with a deep, purplish red may result in a rich, brilliant red. Likewise, sometimes mixing two blues (or two yellows) together will result in a purer color than either of the two alone.

A *color wheel* is a fun and convenient way to study colors and their relationships to one another. (Remember, don't just read it, do it!) I've made the color wheel on page 36 a little more elaborate than usual to help you visualize which colors have been mixed together to create new colors. Refer to this color wheel as you work through the color mixing exercises on pages 40–48.

Primary Colors

First, imagine that the color wheel will be arranged like the numbers on a clock. We'll place the three *primary colors* (yellow, blue, and red) at 12, 4, and 8 o'clock, respectively.

From the three primaries, we will mix colors to place at all nine remaining numerals on the clock, plus some additional colors.

Secondary Colors

By mixing two primary colors together, we create a *secondary color.* The secondary colors are orange (red + yellow), green (blue + yellow), and violet (red + blue). Now we have created three additional colors, for a total of six. Note that directly opposite every primary color (across the wheel, through the center dot) is a secondary color.

The six unfilled spaces on our color wheel clock are the odd-numbered spaces between the primary and secondary colors. The colors that will be placed in those spaces are called *intermediary colors* (see box, left).

Intermediary Colors

The *intermediary colors* are obtained by mixing a primary color with an adjacent secondary color: yellow + green = yellow-green; blue + green = blue-green; blue + violet = blue-violet; red + violet = red-violet; red + orange = red-orange; and yellow + orange = yellow-orange. You'll note that the primary color name is *generally* listed first in the combination.

We now have twelve colors on our color wheel. Notice that each primary color appears in seven positions on the wheel—once in its pure state, and then in three mixtures on either side of it.

Look again at the intermediary colors. You'll see that in each oval shape I have actually illustrated *two* colors. Take, for example, the intermediary color at 1 o'clock

between yellow and green. If we add more yellow to half of it, we have yellow-green; if we add more green to the other half, we create green-yellow. In this case the compound color name indicates the predominant color in the mixture by listing it first.

Tertiary Colors

The *tertiary colors* are obtained by mixing together any two secondary colors. "Tertiary" means "third"; therefore, tertiary colors each consist of all three primary colors in varying proportions. (Remember, two primaries make a secondary, so if we mix together two secondary colors, we will actually be mixing *all three primaries*). Orange (red + yellow) mixed with green (blue + yellow) results in citrine, a color with approximately two parts yellow, one part blue, and one part red. Russet, which is obtained by mixing orange (red + yellow) with violet (red + blue), has approximately two parts red, one part yellow, and one part blue. Olive is obtained by mixing green (blue + yellow) with orange (red + yellow). Olive contains approximately two parts yellow, one part red, and one part blue. Since all three primary colors are used in the mixtures, thus automatically mixing each color with its *complement,* tertiary colors are somewhat dulled, or lowered in *intensity* or brightness. (See "Complementary Colors" and "Intensity," both later in this chapter.)

The primary colors on the color wheel.

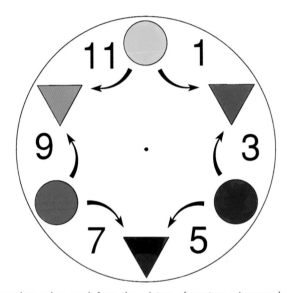

Secondary colors result from the mixture of any two primary colors.

Intermediary colors result from the mixture of a primary color with an adjacent secondary color.

Tertiary colors (in the center of the wheel) are obtained by mixing any two secondary colors (in the middle ring), thus using all three primary colors (the outer ring).

From Muddy Mixtures to Glowing Grays

By varying the proportions of the three primary colors in the tertiary mixtures, you can create a complete color wheel of muted colors. Be careful, though: Whenever you mix approximately equal amounts of all three colors, you will get what is commonly referred to as "mud." The thoughtful and knowledgeable mixture of all three primaries, however, can lead to some absolutely wonderful grays and neutrals. And therein lies a fantastic color mixing exercise (see "A Color Mixing Exercise," below).

A Color Mixing Exercise

Before you begin this exercise, reread the section on complementary colors on the opposite page so that you will have a clear understanding of how it works.

1. Mix all three primary colors together to create a completely neutral gray—one that is neither too reddish, too purplish, too greenish, or too brownish. Make the mixture as dark as possible. This mixture is an ideal substitute for black, and is a much livelier color.
2. Once you have created a puddle of the dark neutral gray described above, mix a small amount of white along its edge. If the lightened mixture tends toward a reddish gray, try to neutralize the red by adding a *minute* bit of green, red's complementary color. If the lightened mixture seems a bit purple, mix in a *small amount* of yellow, the complementary color of violet.

By carefully mixing complementary colors to make minor adjustments to the gray mixture, all the while working to achieve a perfect neutral, you will learn a surprising amount about color mixing. Just make sure you're *thinking* while you're doing this exercise. Randomly throwing more colors on the heap, hoping for a lucky hit, will teach you nothing. If you achieve a perfectly neutral gray on your first attempt, too bad. You will miss out on a tremendous learning exercise, as well as an opportunity to see a colorful selection of warm and cool grays (see "Temperature," page 45).

TOO RED;
ADD GREEN

TOO VIOLET;
ADD YELLOW

TOO BLUE;
ADD ORANGE

JUST RIGHT

Mix all three primary colors together to create a perfect neutral gray, but remember how to mix all the other colorful grays you encounter. You'll be sure to need them someday.

Complementary Colors

A pair of complementary colors consists of all three primary colors.

(Top) When placed side by side, complementary colors intensify each other. *(Bottom)* When mixed together, complementary colors neutralize each other.

Complementary colors are located diametrically opposite one another on the color wheel. Look at the color wheel on page 36. Find the color directly opposite green, which is red. Mixing a color with its complement will produce a dull, grayed, or neutralized version of that color; that is, a color whose intensity is lower or reduced. If, for instance, you've mixed a bright green and would like to make it a little less bright, mix a small amount of its complement, red, into it. Look at the color wheel again to locate the complement of violet, of blue, of yellow, of orange, of blue-violet, and of yellow-green.

It's easy enough to determine a color's complement when you have a color wheel handy. But how can you remember which colors are complements when you're mixing colors and don't have a color wheel to refer to? Try using one or a combination of the following memory aids:

- The complement of a primary color is a secondary color, and vice versa.
- The complement of a cool color is a warm color, and vice versa.
- A *pair* of complementary colors consists of *all three primaries.* For example, if you are working with red and need to know its complement, think of the two remaining primaries: blue and yellow. Mix them together and you get green. The complement of red, then, is green. If you need to know the complement of orange, first think of the primaries it's composed of (red and yellow). Which primary is missing? Blue. Hence, the complement of orange is blue.
- As an alternative, try the following when you're stuck in traffic, waiting in a carpool, trapped on the phone, or enduring a boring meeting: Stare at an object as if you were looking straight through it for 15 seconds or so, or until your eyes feel fatigued, then close your eyes or shift your gaze to a sheet of white paper or other white surface. Within about 5 seconds you should see the color's *afterimage,* or the complementary "ghost" of the color, slowly take shape. For example, if you

stare at a red apple, you'll first notice a white glow forming around it. When you close your eyes or look at a white surface, you'll see a green apple. After focusing your gaze on an American flag, you'll see an afterimage of a field of orange with black stars and green-and-black stripes. Don't worry if this doesn't work for you right away. Persevere. You'll "get it"!

- One final crutch to help you remember pairs of complementary colors: Think of the colors commonly associated with Christmas, Easter, and the Howard Johnson's restaurant chain:

> Christmas—red and green
>
> Easter—violet and yellow
>
> Howard Johnson's—orange and blue

How Complementary Colors Work

When placed next to each other, complementary colors intensify each other. Note how vibrant green looks when placed next to its complement, red. When mixed with one another, these same complementary colors neutralize each other.

Color Mixing Tips

When you begin mixing colors, keep the following suggestions in mind:

- Always add the darker color, slowly, to the lighter color. To do the reverse by attempting to lighten an entire pile of dark value paint could result in nearly enough of a mixture to paint your walls, particularly if the darker color is an intense one.
- Not all colors have the same power or strength. Some blues, for example, may be very weak; some reds may be overpowering. Therefore, a violet color that is midway between a weak blue and an intense red *cannot* be mixed from *equal* parts of these two colors even though both are the same value. Instead, begin with the weaker color (the blue, in this case) and slowly add the stronger color (red) until the desired violet color is achieved.

Basic Color Terminology

Study the color mixtures. How would you describe their hues?

What is the value of each of the hues shown above?

Every color has four properties or characteristics: hue, value, intensity, and temperature. Familiarity with these four properties will help you understand colors and how they interact with one another, both in mixtures and when placed side by side in a painting.

If I told you that I drive an automobile whose color is Seafoam Haze, would you have a fairly accurate understanding of the color of my car? Probably not, especially if the sea you're thinking of is the Atlantic Ocean and I'm referring to the color of the water in the Caribbean. So while Seafoam Haze, Twilight Blue, and Mountain Mist are colorful-sounding names, they really do not adequately describe a color. If I said to you that my car is a light, bright, cool blue-green, you would know that it is a mixture of blue and green with a predominance of blue—the first color of the compound color name (hue) and the coolest color (temperature) on the color wheel; that it is light rather than dark (value); and that it is not dull or grayed, but bright and clear (intensity).

Hue

Hue is just a fancy word for "color." What color is it? What hue is it? *Hue* is the characteristic of color that designates it as red, yellow, blue, green, and so on. For example, burnt sienna is a color that is red-orange in hue. Aquamarine is a color that is green-blue in hue.

Hue is an important consideration in painting because color helps set the mood for the work. A painting in hues of blue and green suggests serenity, coolness, restfulness, and spaciousness. On the other hand, hues of red imply strength, action, and excitement. Yellow hues suggest warmth, happiness, and light.

Value

The term *value* indicates a color's relationship to white, black, or the grays in between: Is it light, medium, or dark in value? Yellow, for example, is a light-value color; violet is dark in value. A color's value can be changed by adding white or black, or by adding a lighter or darker color. We can lighten red, for example, by adding white, orange, or yellow.

The Munsell value scale (shown on the opposite page) specifies nine distinct, equidistant steps of gray between pure white and pure black. (The scale is named for the American portrait painter and teacher who originated it, Albert Henry Munsell, 1858–1918.) Notice the dots of gray on each of the value steps. The dots appear darker on the light values and lighter on the dark values. Are you surprised to learn that all the dots are the same value, taken from the paint mixture in value step 5? Remember, then, that a color is always affected by the color that surrounds it. If you mix what appears to be a medium-value pink on your white palette, and then brush it onto a dark background, it will not look the same as it did on your white palette. Depending on the background's hue, it will appear much paler, and possibly even affect its hue.

Each color on your color wheel can have nine distinct and equidistant values. By mixing black or white with each of the twelve colors on your wheel, you can create 108 variations. You could also make value scales for each of the tertiary colors and all their possible variations. You could even add a mixture of black and white to every color you had mixed.

Changing a Color's Value: Creating Tints and Shades

Colors may be changed in value by the addition of white or black. To raise the value of any color, add white. The addition of white creates a *tint*. To lower the value of any color, add black. The addition of black creates a *shade*. We can also alter the value of a color by adding the color above it on the color wheel to raise the value, or by adding the color below it to lower the value.

To prevent a tinted color from appearing chalky (from the addition of white) or a shaded color from appearing muddy (from the addition of black), keep the following in mind:

- **When *raising the value* of a color by adding white, also add a small amount of yellow. The yellow will mellow the chalky appearance. For example, raising the value of red with the addition of white results in pink, but perhaps not the desired hue.

Value and Color Relationships

By becoming aware of the color values around you, you will become a more sensitive painter.

1. Take a black-and-white photograph or make a photocopy of your color wheel. You'll notice that the colors at 11, 12, and 1 o'clock are light in value; those at 9, 10, 2, and 3 are medium in value; and those at the bottom of the color wheel, at 4, 5, 6, 7, and 8, are dark in value, with 6 o'clock being the darkest.

2. Take some time now to paint your own value scale. Make each step distinctly different in value from its neighbor. (It's not as easy as it looks.)

3. Paint a design three times: once in low-value (dark) colors, once in high-value (light) colors, and once with a full range of color values.

4. Can you determine the value of each hue in the lower figure on the opposite page? Squint your eyes (to help you block out extraneous detail and concentrate on lights and darks) to see the lightness and darkness of the colors in relation to the value scale.

5. Study the value scale, then determine the value (that's relative lightness or darkness, now; we're not talking dollars and cents) of each of the following: the carpeting, the wall, the sky at this moment, the wastebasket, the sofa, the chair, and your shirt or blouse.

6. Look for value changes. Study the draperies, perhaps in the area of the tie-backs, if there are any; otherwise, look at the folds and wrinkles in the fabric. Squint. Take another look at the carpet, this time under a table; look again at the walls, perhaps in a corner or near the ceiling. You know the walls are all the same color, but does one wall appear darker or lighter than the other? Are some shadows on the carpet much darker in value than others?

HIGH VALUE		
LIGHT VALUES	WHITE	●
	9	●
	8	●
	7	●
MEDIUM VALUES	6	●
	5	●
	4	●
DARK VALUES	3	●
	2	●
	1	●
	BLACK	●
LOW VALUE		

The Munsell value scale, which specifies nine steps of gray between pure white and pure black.

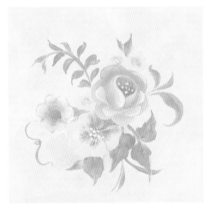

A high-key or high-value painting is one that has been executed in values exclusively on the upper half of the value scale. High-key colors suggest hope and happiness.

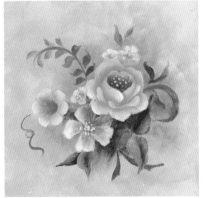

A painting that includes values from throughout the value scale is a full-value painting.

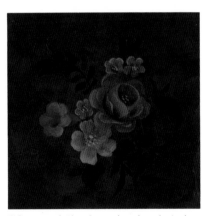

When a painting is rendered exclusively in the values on the lower half of the value scale, it is referred to as a low-key or low-value painting. Low-key colors suggest mystery and somberness.

TINT SHADE

Raising the value of a color creates a tint, while lowering its value creates a shade.

Avoid mixing chalky-looking tints by adding a little yellow with the white.

Avoid mixing dull, drab shades by adding a little of the lower neighboring color on the color wheel with the black.

When black is added to yellow, the result is usually green. To create a darker yellow, then, it is best to add brown or a brownish mixture of the three primaries.

Create tones by adding a mixture of black plus white to your color. In the example above, black was added in progressive steps, working from left to right.

To help the red retain its redness, add a bit of yellow (or orange, since it contains yellow). When lightened with white, green becomes pasty-looking. A touch of yellow will warm it back to a greener light green. Adding a little yellow to white to lighten blue will prevent it from looking flat and give it some sparkle. (Too much yellow will give you green, so be careful.) When lightening violet with white, prevent a chalky look by adding a minute amount of yellow. Take care, though: Because yellow is violet's complementary color, adding too much will dull the mixture.

- **When *lowering the value*** of a color by adding black, also add a small amount of the lower adjacent color on the color wheel to prevent your shades from looking dull or drab. For example, to lower or darken the value of blue, add black plus a little of blue's neighbor, violet. When lowering the value of orange, add black plus a little red. To lower the value of red, add violet with the black. To lower the value of green, add blue with the black. As a general rule, however, add black sparingly to avoid deadening your colors.

Changing a Color's Hue: Creating a Tone

By mixing gray (black + white) with any hue, you create a *tone*. Depending on the proportions of black and white used in the mixture, a tone can be made light, medium, or dark in value. Tones can also be created by the addition of earth colors—yellow ochre, raw sienna, burnt umber, raw umber, and burnt sienna.

Intensity

Intensity (also referred to as *chroma* or *saturation)* is the relative brightness or dullness of a color. Is the color or hue bright or dull? Intense color—for example, any one of the three pure primaries—is brilliant, pure, strong, and does not contain a trace of any other color.

We may lower the intensity of any color, thereby muting or dulling it, by adding a small amount of its complementary color. Let's experiment with blue and orange. Note that you can dull or gray a color either slightly or considerably, depending on how much of its complement you add to it.

When complementary colors are mixed together in approximately equal proportions (remember that because some colors are

You can make a color less intense by mixing it with its complement.

stronger than others, less of the stronger color is required in the mixture), the result is a neutral color, such as the one shown in the center of the blue and orange mixture in the figure at left. To make sure you actually see the neutral color and are not distracted by the brighter colors at the ends of the strip, cover the ends with your hands.

Use your knowledge of intensity and value to direct attention to the focal point in your paintings. Paint the important areas with the more intense color and value contrasts. Render the less important areas and minor details in lower-intensity colors and more subtle value changes so as not to detract from the focal point. When you know how to take advantage of color, you can lead the viewer's eye exactly where you want it to go.

Temperature

In painting, *temperature* is a subjective, rather than a physical, property of color. Warm colors (reds, oranges, and yellows) appear to advance or move toward the viewer, while cool colors (greens, blues, and violets) appear to recede or move away. (Look back at the color wheel on page 36. Notice that opposite every warm color is a cool one, which means that each pair of complementary colors is composed of a cool color and a warm color.) Expanding your awareness of colors to include their advancing and receding effects allows you to further manipulate what happens in your painting.

Consider, for example, that you'd like to paint an orange vase with yellow flowers. If you paint the orange and yellow against a grayed blue-violet background, the subject matter will appear to almost levitate off the painting toward you. That is because the cool background colors (blue and violet) are receding, while the warm colors (orange and yellow) are advancing. (Note that blue-violet/yellow-orange is a *complementary color scheme;* see page 49.)

Imagine then that you've painted a green background behind your orange and yellow subject. Green, being a cool color, will tend to recede, but it will not have as dramatic an effect as the blue-violet. The more yellow you add to the green, the warmer it will become, thereby reducing its receding effect. All the elements in the painting contain yellow, which serves to unify the background with the subject matter. (Note that green-yellow/yellow-orange is an *analogous color scheme;* see page 49.)

Now imagine the same orange vase and yellow flowers painted on a background of red, which is a warm and advancing color. Although the vase and flowers are painted in warm colors, we must prevent the red from becoming too aggressive and overpowering the subject of the painting. A bit of blue mixed with the red will cool the color somewhat and help control it. The red can also be controlled by adding a little black (to lower its value), or its complement, green (to lower its intensity).

Learning to See

1. Go to a museum and study a painting from a distance. Be aware of where your eye moves first, then where it goes next. How does it travel around the image? Where does your glance finally end up before leaving the painting? Then think about why your eye traveled through the painting the way it did, and about what the artist did to make you look *where* you did. By learning about and understanding how accomplished artists use hues, values, and intensities (and temperatures, which we'll study next) to create effective paintings, we can ourselves become better decorative artists.

2. Consider the colors you mix together. To mix violet, for example, if you use an orangish red and a blue, do you think you will get a brilliant, clear violet? Because the orangish red contains yellow—the complementary color of violet—the violet you obtain will be dull or low in intensity. Note that you would be using all three primary colors in such a mixture.

WARM COOL

Note that warm colors advance, while cool colors recede.

How Color Temperature Affects Composition

1. Look at the orange-yellow spot in the figure at right. Note how much more vibrant it appears on a blue-violet background (far right). Note also that the same orange-yellow spot on a red background is not nearly as commanding (center). Just as we need to keep in mind the effects that intensity and value contrasts have on our paintings, we need also to remember how a color's temperature affects the final results. For example, when painting a spray of flowers and leaves, you might position the warmer-colored flowers near the focal point and use the cooler colors to make the leaves and less important flowers recede. Otherwise, the bit players in your production may try to take over the entire scene.

2. Observe how different backgrounds (cool and warm) affect the colors of the subject. In the example at right, the cool background recedes and provides a striking contrast for the pears. Also, note how the light value of the cool background strengthens the impression of depth. In the example below right, the warm background advances and closes in around the pears.

 It is important to note that this does *not* imply that yellow pears must *always* be painted on blue-violet backgrounds in order to achieve an effective painting. On the contrary: Pears can be effectively painted on *any* background color—you just need to be aware of the effect you're striving for, and how to use the properties of color (hue, value, intensity, and temperature) to achieve it.

The orange-yellow spot *(left)* appears more vibrant on a blue-violet background *(right)* and is somewhat subdued on a red background *(center)*.

Notice how vibrant the warm yellow pears appear on a cool blue-violet background.

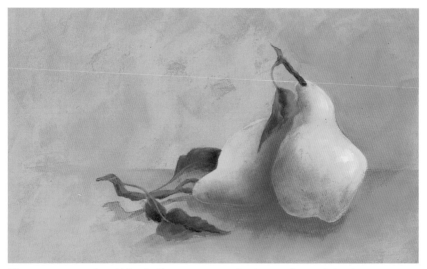

The same pears painted identically on an orange background are subdued.

Getting Acquainted with Your Paints

The following activities will help acquaint you with all the colors in your paintbox, and how they interact with one another.

Color Mixtures Chart

1. Using a T-square or other straight edge, divide a large piece of poster board (available at most drugstores, variety stores, and art shops) into columns both horizontally and vertically. Use the chart below as your guide, but make sure yours has enough rows and columns to accommodate your paints. (Refer to "Dividing Spaces Evenly—Without Math!" page 303.)

2. Leaving the box in the upper left corner empty, list all your colors in the far left vertical column. Place a sample of each color in the corresponding box. Repeat this procedure across the top of the chart, from left to right, listing the paints in the same order they appear from top to bottom in the vertical column. To make comparisons easy, group the colors in families (all the reds together, all the blues together).

3. Select a color name from the vertical column and another from the horizontal one. Locate the area on the chart where the two meet by running your fingers down and across the columns.

4. At the point where the columns intersect, place a sample of the mixture of those two colors. As each color is mixed with *itself,* a diagonal line extending from the upper left corner to the lower right corner is formed, effectively dividing your chart

in half. Place your color mixtures below the diagonal line; in the spaces above it, you can make shades and tints with the mixtures. Three examples are illustrated.

Transparent Color Wash Chart

Make another chart similar to the one below, but instead of mixing colors together, see what happens when you brush a transparent wash of each color over dry stripes of the other colors. See page 48.

Special Mixtures

Whenever you mix an interesting or special color, be sure to take notes and keep a sample of the mixture. Keep these kinds of records in your notebook or in a file box where you will remember to look for them. If nothing more, a torn-off section of your paper palette can be a wonderful reference when it contains the mixed color along with samples of the colors that you used to make it.

Color Mixture File Cards

Use the example at the bottom of page 48 to create a series of 4 × 6 inch color mixture file cards. The following steps are keyed to the lettered boxes in the diagram.

1. Place a color in box A at the top left section of the card. Write in the color name. We'll refer to this as color **A.**

2. Place a second color in box B in the top right section of the card. Record its name also. We'll refer to this as color **B.**

A sample color mixture chart.

	LEMON YELLOW	TRUE OCHRE	TRUE RED	BURGUNDY WINE	TRUE BLUE	DIOXAZINE PURPLE
LEMON YELLOW						
TRUE OCHRE						
TRUE RED						
BURGUNDY WINE						
TRUE BLUE						
DIOXAZINE PURPLE						

3. In a long horizontal strip running directly below the two sections (**C**), mix the two colors together. The mixture in the center of the strip should be midway between **A** and **B**. The mixture toward the left of the strip should contain more of **A**; the mixture toward the right of the strip should contain more of **B**.

4. Divide the remainder of the card into four wide vertical columns (**D** through **G**). Place white at the bottom of column **D**. Place some of the midway mixture of **A+B** at the top of the column. Mix a *tint*, increasing the amount of white as you work toward the bottom of the column.

5. Place a middle-value gray mixture (**black + white**) at the bottom of column **E**. Working from top to bottom as for column **D**, mix a progressively grayer *tone*.

6. Place black at the bottom of column **F**. Again, beginning with the midway mixture of **A+B** at the top of the column, mix a progressively darker *shade*.

7. Place the complementary color of the mixture at the bottom of column **G** and, starting at the top of the column, mix the **A+B** mixture to a progressively lower intensity as you work toward the bottom.

While these cards are an excellent reference, they do not tell the entire story. For example, this card doesn't show all the variations possible if we chose, instead of the midway mixture of **A+B**, the mixture more to the left or right for making the tints, tones, shades, and less intense colors. As you become more familiar with the color mixing process, you will be able to imagine the other possibilities.

A sample color wash chart.

	LEMON YELLOW	TRUE OCHRE	TRUE RED	BURGUNDY WINE	TRUE BLUE	DIOXAZINE PURPLE
LEMON YELLOW						
TRUE OCHRE						
TRUE RED						
BURGUNDY WINE						
TRUE BLUE						
DIOXAZINE PURPLE						

A sample color mixture file card.

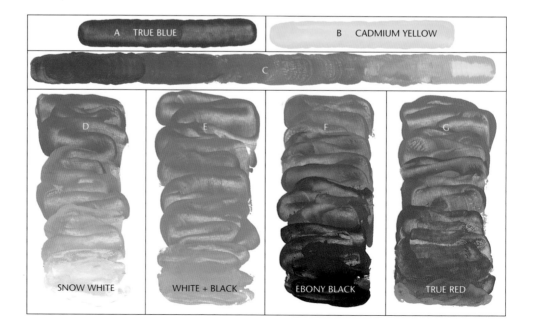

A TRUE BLUE	B CADMIUM YELLOW

C

D	E	F	G
SNOW WHITE	WHITE + BLACK	EBONY BLACK	TRUE RED

Choosing a Color Scheme

The task of selecting a color scheme for a project can be one of the most troublesome aspects of painting for a beginner. However, it can be the most exciting—and the easiest—part of decorative painting.

To acquaint you with some color scheme terminology, and to give you the added confidence that a little knowledge brings, I'd like to introduce to you five of the most common color schemes. It's a good idea to familiarize yourself with them, but don't be intimidated or inhibited by them. They are merely suggestions to help you begin thinking about ways to combine colors. There are several other types of color schemes, and you may even invent a combination of colors for an as yet unnamed scheme. The color schemes shown below, however, are those most often referred to in books on art and color theory.

Monochromatic

Monochromatic color schemes include tints, shades, and tones of a single hue (for example, blues, light and dark, muted and intense).

Analogous

Analogous color schemes include two to five colors that lie side by side within one-third of the color wheel (for example, yellow, orange, red; or green, green-yellow, yellow, yellow-orange, and orange).

Complementary

Complementary color schemes include two colors that are diametrically opposite one another on the color wheel (for example, red and green, or burgundy and moss). Avoid giving both colors equal dominance in the color scheme.

Split Complementary

Split complementary color schemes use three colors on the color wheel: a key color, and two colors on either side of its complement (for example, orange, blue-green, and blue-violet).

Triadic

Triadic color schemes include any three colors that are equidistant from one another on the color wheel (such as red, yellow, and blue).

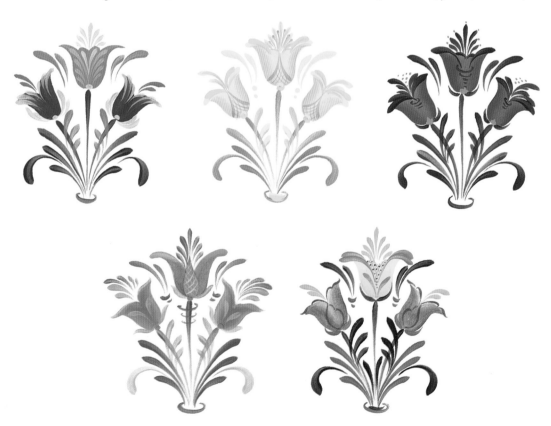

Five basic color schemes: monochromatic, analogous, complementary, split complementary, and triadic.

Tips on Using and Choosing Colors

The most important thing to remember about selecting a color scheme is that you should use colors that please you, or that help to develop the concept of your painting. Your color scheme need not fit neatly into a precise category. Color preferences are very personal. Color schemes that dismay some viewers as being too gaudy or overdone appeal to others as cheerful, happy, naive (incidentally, a characteristic of many ethnic folk arts). Muted color schemes, while restful to some, may seem too somber or foreboding to others. Decorative painting should reflect the joy *you* have in painting, so use combinations of colors that *you* enjoy, whether muted, intense, light, dark, somber, or cheerful. Avoid getting carried away with complicated color schemes, however, as they are difficult to work with. Harmony is more easily achieved with simple schemes and few colors.

Color schemes and combinations are everywhere you look. Learn to take advantage of these endless opportunities for studying color.

The following are nine foolproof tips that I use with my seminar students for selecting pleasing color combinations. I hope that these tips will make it easy for you to develop color schemes and help alleviate the anxiety associated with making color selections.

1. Borrow wallpaper and/or upholstery books from your local paint store or decorating shop. Spend an entire day mixing colors to match those used in each wallpaper or fabric sample. Record the mixtures on index cards and keep them on file for future reference. You'll be amazed at what an inspiration having color scheme samples on hand can be. If you can obtain a discarded wallpaper sample book, that's even better. Cut out three-inch squares of every wallpaper sample in the book, including those you're not especially fond of at the moment. (Tastes do change!) Glue the squares onto index cards, then mix colors to match those used on the sample and

The wallpaper swatch on the right suggested the color scheme on the index card above it, which in turn inspired the decoration of the rocking horse shown in the photograph.

paint swatches of the mixtures on the cards, noting which colors you used.

2. Study catalogs to see how colors are used together. Save clippings of magazine ads and illustrations whose colors please or excite you. Observe how your eye travels throughout an ad as a result of color placement. Remember to make color placement work for you when you are planning color locations in your own artwork.

3. Visit fabric stores and linen departments. Note the current popular color combinations. Beg or buy narrow swatches of fabrics to add to your index card color scheme file. If you coordinate several painting friends to make files also, you can share the minimal costs involved in purchasing special fabric swatches, and you can prepare duplicate color swatch/mixture cards to exchange with one another.

4. Scrutinize your own wardrobe. What colors do you select to coordinate an outfit? You may know more about color schemes than you give yourself credit for.

5. Use a piece of clear acetate or plastic to help you test color schemes on a basecoated project (an item on which you have painted a background color). Paint swatches of your selected colors on the acetate, then lay the painted acetate over the project to see how well the colors relate to the background color. If the colors are pleasing to you, use them. If not, wipe them off the acetate and try again. This gives you a little preview of what the finished item will look like without the risk of ruining it because of a poor choice of colors.

6. When you basecoat your project, also apply the same color to a couple of pieces of lightweight cardboard (such as that found in shirts, stockings, and on the backs of writing tablets). Test your color scheme directly on the painted cardboard. This is particularly helpful if you are planning to work with thin washes of color and sideloaded brushstrokes, both of which allow the background color to show through. It is a little difficult to get a true picture of the final effect of wash techniques when using acetate.

7. Once you are satisfied with your chosen color scheme, be sure to repeat each color used at least three times in a somewhat triangular fashion, rather than in a straight line. This method of application will ensure that the viewer's eye will travel around the painting. For instance, on seeing a blue passage in one area of a painting, the eye will be drawn to blue passages elsewhere. If for some reason you wish to emphasize a particular part of the subject and would prefer to keep the viewer's eye from traveling, do not repeat the color elsewhere. A single color, unrepeated, will immediately draw and hold the viewer's attention as would a single red gumball among a bunch of green, yellow, and blue ones.

8. Take photographs of all the projects you paint. File them in a notebook or card box along with painted swatches of the colors you used and notations about the colors and mixtures. You'll soon become familiar with the color combinations you use effectively. You'll also be able to evaluate whether you've fallen into a comfortable rut and are, perhaps, growing stale in your choice of color schemes.

9. Invest time in studying color values and intensities. Study also the use of complementary colors. Learn to recognize how the various properties of color are used to suggest depth, dimension, transparency, reflections, and shadows. Once you understand how other artists achieve certain effects, you'll be much more adept at creating your own colorful interpretations. For example, if you like the way an artist has painted a realistic yellow rose but you would actually prefer to paint pink roses, you can apply all the artist's techniques by studying the placement of values, determining where subdued colors were used to turn edges, where reflected lights were placed to help suggest form, where complementary colors were used to suggest transparency, shadows, and depth, and by being able to see all the subtleties of color in the rose.

A yellow rose is not just light and dark yellow: Its color is affected by all the colors that surround it, the light in which it is seen, its degree of development, and the transparency and velvety texture of its petals. *The whole secret of learning to paint with color is in learning how to see color.*

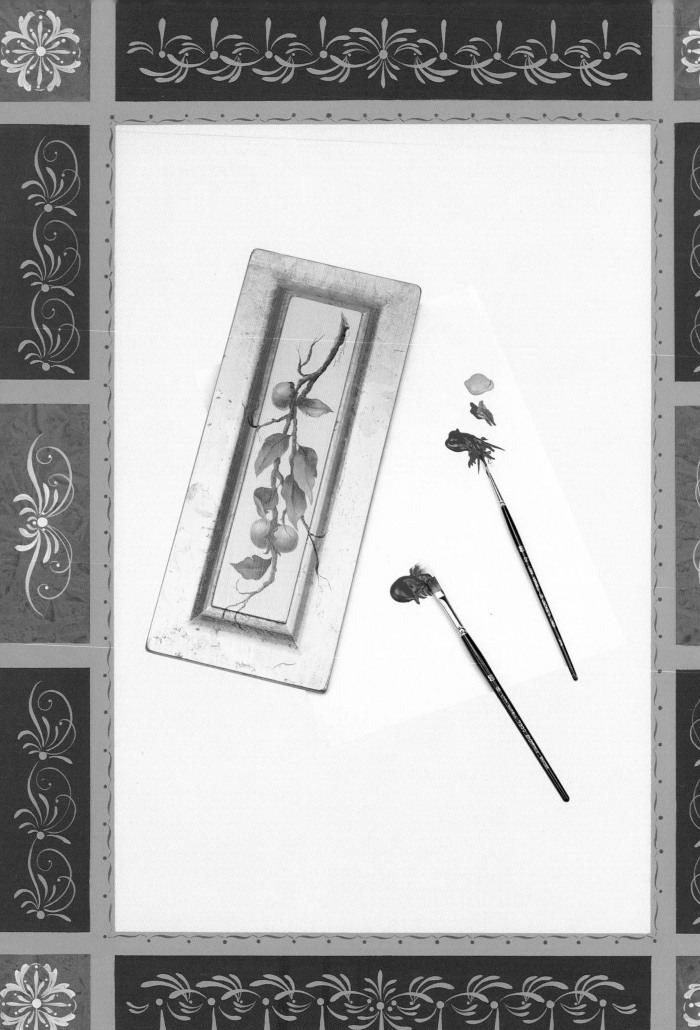

Chapter 3

Brush Control and Brush-Loading Techniques

Now that you are proficient in color mixing and theory, let's tackle brush control and loading. In decorative painting, and particularly in brushstroke designing, adept handling and control of the brush can mean the difference between easy success and conspicuous failure. Furthermore, skillful brush-loading techniques and brush control will favorably affect not only your brushstroke designs but your blended paintings as well.

The sixteen brush control techniques outlined in this chapter will help you master your brushes and enable you to execute flowing, confident stroke work. You should continue to refer to this chapter until the techniques become a natural part of your good habits in brushstroke painting.

Mastery of this chapter's seven brush-loading techniques will give you a variety of ways to easily accomplish special effects with paint. You'll find some of the techniques easier to master than others, but with practice, patience, and perseverance, your skills will be perfected. While you're learning, remember to relax and enjoy the thrill of discovery, accomplishment, and growth.

Your mastery of brush control and brush-loading techniques will be clearly evident in all your projects, both stylized and realistic.

Brush Control Techniques

1. **Use only good-quality brushes** in excellent condition. You will defeat yourself by using poor-quality or damaged brushes. Inferior brushes result in inferior brushstrokes—period!

2. **Consider the consistency of the paint** that's required for the stroke you plan to make. Some strokes and techniques require very thin paint, while others need paint with a little more texture. Remember that the hairs of your brush work like an ink reservoir in a fountain pen, holding the paint in reserve until it is needed at the tip. The paint must be thin enough to flow through the hairs to the tip of the brush as it skims across the surface being painted. For very long strokes, such as scroll strokes, the paint should have an almost ink-like consistency. For short strokes that suggest texture or dimension, paint can be almost as thick as sour cream. For most of your brushstroke painting, at least in the beginning, plan to work with paint that has the consistency of light to heavy cream. To achieve that consistency, thin acrylics with water, and thin oils with painting medium.

3. **Load paint into your brush patiently and thoroughly.** Work slowly and deliberately. You paid for $^1/_2$ inch of brush hairs, so do not dab paint quickly and carelessly on only the first $^1/_8$ inch at the tip. Load paint well up into the hairs. For effective brushstroke work, it is important that you use a thoroughly loaded brush. That means paint is *inside* the brush, not just clinging to it in globs. Stroke the brush back and forth through the edge of the puddle of paint, applying gentle pressure to force the paint up into the hairs. (An exception to this would be the scant loading of paint into the brush required for some blending and wash applications.)

4. **Sit comfortably.** Push away from the table and work in your lap so that your arms hang freely. If you work at a table, you may be forced to hold your arm up to paint your project. This could result in not only a kink in the shoulder but a real pain in the neck.

5. **For most brushstroke work, hold the brush perpendicular to the painting surface.** (All exceptions are noted in Chapter 4, "Basic Brushstrokes.") This position will give you the greatest control, and will enable you to easily vary the pressure on the brush from heavy to light. For blending work, lay the brush back in your hand and hold it more horizontally in relation to the painting surface.

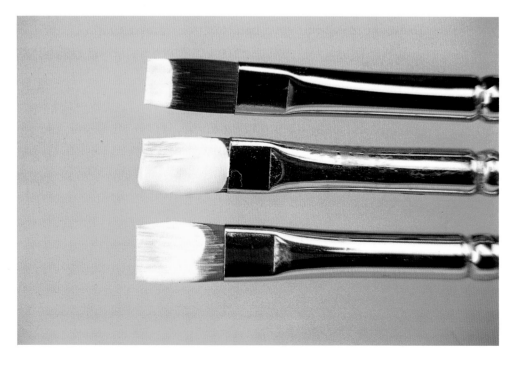

A comparison of loaded brushes: *(top)* insufficient paint; *(center)* too much paint, not thoroughly loaded; and *(bottom)* a well-loaded brush.

When holding your brush, balance your hand on your little finger, either extending it so that it touches the worksurface *(top),* or curving it inward or under so that your knuckle rests on the worksurface *(bottom).*

stroke work. It may take a little getting used to, but it will give you greater freedom and more flexibility. Try this: Hold a pencil in your hand and rest your arm and hand on the table as you normally do for writing. Now draw the smallest and the largest letter "C" you can while keeping your hand stationary. In this instance, your work is very tightly controlled. Next, hold the pencil while balancing on your little finger. Again, draw the smallest and largest letter "C" you can, using your entire arm and moving freely and expansively. This time, your work should be fluid. If you put your other hand on your shoulder, you should be able to feel its "gears" moving as you write. Remember, the little finger must move as a unit with the shoulder, but still provide support for the hand.

6. **Balance your hand on your little finger for stroke work,** keeping your wrist, arm, and elbow off the table and your painting project. So that you better understand how this position works, hold a brush or pencil so that it is perpendicular to a flat, horizontal surface. Extend your little finger so that it touches the surface, or curve your little finger inward so that the knuckle rests on it. Keeping your arm and wrist off the table, use your little finger as a lever to raise and lower the brush or pencil, as a pivot to help make curved strokes, and as a support for your entire arm. As you paint, your little finger should glide along the surface, providing support, but always moving freely.

7. **Paint from your shoulder.** This means that you will use your entire arm, shoulder, and little finger as a unit in all your

8. **Always** *pull* **the brush hairs by the handle; never** *push* **them with the handle.** When you pull the hairs of the brush, you are able to control them. When you push the brush, you lose control of the hairs as they splay out and move haphazardly. Don't be tempted, near the end of a brushstroke (especially if your little finger is not moving), to finish it by pushing the brush the last little bit. Instead, keep your whole arm (including your little finger) moving, and *pull*—don't push— that stroke.

ALWAYS pull the brush . . .

. . . NEVER push it.

9. **Lean the brush handle into the curves when painting curved strokes** (just as you would lean a bicycle when peddling around a curve). Leaning the handle in the direction of the curve enables the hairs to follow along, thus keeping you in control.

10. **Do not twist or rotate the brush** unless specifically called for in the brushstroke directions. Most variations in strokes are made by applying and releasing pressure. Our eagerness to paint strokes often leads us to do things with the brush that actually interfere with the proper formation of the stroke. Many brushstrokes will almost paint themselves if we do not interfere.

11. **Stay in control of the brush.** Most people who lose control of their strokes do so at the end of the stroke. We are so pleased to get that stroke on the project and resume breathing that we do not hang around for the "follow-through." Instead, we finish the stroke with the brush in midair. Remember: Hurrying a stroke to complete it will cause you to lose control. Practice the steps below until they become a comfortable habit.
 - As you near the end of the stroke, slow down.
 - Gradually release pressure on the brush, allowing the hairs to return to a point or a chisel edge.
 - Come to a precise and deliberate stop.
 - Then—and only then—*lift the brush off the surface.*

12. **Think *contrast*.** Contrast adds interest and excitement. Incorporate the following contrasts in your stroke work:
 - *thick*/thin
 - *long*/short
 - *very curvy*/nearly straight
 - *light*/dark
 - *warm*/cool
 - *ornate*/plain

Be expressive with your brushwork, creating visual and artistic impact. Let it exclaim, "I did it; I'm glad I did it; and I loved doing it."

13. **Care for your brushes.** If you're working with acrylics, clean your brushes thoroughly and often during a painting session. Even while wet, acrylics can set up, or begin to harden—especially near the ferrule—and ruin your brushes.

14. **Paint with authority.** Paint your strokes, then leave them alone—even when they're less than perfect. Wiping out and repainting strokes hinders your spontaneity and is a detriment to developing creativity. Be comfortable with the fact that you are a human being, not a machine. Let your painting reflect your individuality and your imperfections. Never attempt to repaint a stroke; to do so merely calls attention to the fact that you goofed on your first attempt. Efforts to repair imperfect strokes generally create a worse mess. Instead, leave the stroke alone and create a painterly diversion somewhere else. If anyone should notice the peculiar stroke, they would surely assume that since you left it there, "as is," it must be what you intended. And they could hardly argue with that. You're the artist. Paint confidently!

15. **Practice every day,** even if it's just with water on the kitchen counter. As great musicians and singers practice every day, great painters should paint every day. Practice painting both gigantic and tiny strokes with the same brush. Practice making strokes in all directions. Practice all the brush control habits above. Unfortunately, we cannot accomplish our goals overnight. Success requires practice and patience.

16. **Relax and have fun.** That's what this art form is all about.

Brush-Loading Techniques

Part of the fun of decorative painting is the variety of effects we can achieve through different brush-loading techniques: We can paint single strokes with two or more colors, shaded strokes and streaky strokes, and long, flowing strokes or short, thickly textured ones. We can float transparent washes, lay paint down heavily, or leave just a hint of color. Each effect is most easily accomplished through proper loading of the brush. These brush-loading techniques are useful for both brushstroke designs and for blended painting. (Learn how to work with these techniques in Chapter 5, "Blending with Acrylics.")

The easiest technique is full loading. Master it first while you're practicing on some of the other aspects of brushstroke work that may be unfamiliar to you. Sideloading, and its companion, doubleloading, are the two most difficult techniques to master. For that reason, I will elaborate at length on sideloading. Do not let the amount of text discourage you. Sideloading is my favorite, and most used, brush-loading technique, and I've provided additional descriptive material to ensure that it becomes a comfortable favorite of yours, too. You'll be able to create a variety of effects with these and the other loading techniques described below.

Fully loading the brush.

Full Loading

Slightly dampen the hairs of the brush, using water for acrylics and painting medium for oils. On a paper towel, blot off any excess. Stroke the hairs repeatedly through the edge of the puddle of paint, applying slight pressure as you stroke. The pressure will cause the hairs to spread out, like fingers, and pull the paint up into the brush. Continue stroking the paint into the hairs until the paint begins to approach the metal ferrule. (Ideally, you should avoid getting paint *into* the ferrule; if it dries there it can damage the brush. On the other hand, do not be timid about loading paint into the brush. Insufficient paint will result in incomplete strokes or ineffective brushwork.) Work the paint smoothly and evenly into the brush, leaving no blobs clinging to the sides or edges of the brush. As you leave the paint, pull flat brushes to a chisel edge, and pull and twist liner and round brushes to a point unless you are painting comma strokes.

To ensure a nicely rounded "head" on comma strokes, after fully loading the liner, round, or detail brush, flatten the tip by tapping it on the palette. Then scoop up a small amount of paint as if you were scooping snow with a snow shovel. This extra dollop of paint, when pressed onto the painting surface, will spread to form a rounded head on the comma stroke.

Sideloading

A sideloaded stroke has solid color on one side and fades gradually to weak or no color on the other. There should be no sudden change from solid color to weak color. Paint for sideloading can be taken directly from the container or thinned to create a wash. This brush-loading technique is invaluable in the advanced blending lessons (see Chapters 9, 10, and 11) and is very effective in stroke designs. Eliminating the line of demarcation between paint and no paint requires practice and skill. The following tips should be helpful.

1. Be sure that the brush you use is a *flat* (the kind with long hairs), not a *bright* (which is also flat, but has shorter hairs). This is important: The longer hairs will

hold more paint, and are more suitable for stroke work. (Note: You can also sideload round brushes and liner brushes by flattening them before loading.)

2. Dip the brush in water for acrylics, and in painting medium for oils. Shake off the excess; then blot the entire length of hairs (on one side only) on a paper towel. Watch the hairs as the wet shine disappears. As soon as the hairs on the upper side of the brush are no longer shiny, lift the brush up. Do not blot the upper side. The water or medium remaining in the brush should provide just the right amount of moisture. Too much moisture will make the paint too juicy to control, and too little will allow the acrylics to dry too rapidly or cause the oils to drag.

3. With the slightly damp brush, do one of the following: (a) Dip a corner of the hairs into the paint to pick up a little paint and move it to another location. (b) If the area around the paint puddle is clean, slide the corner of the brush alongside the puddle, picking up a small amount of paint.

4. This is a critical step. Stroke the brush back and forth (either on a clean section of the palette or beside the paint puddle). Make the strokes no longer than an inch (work in even smaller units with smaller brushes). Stroke over and over in the same spot, working paint upward into one half of the brush toward the ferrule, and gradually across the bottom of the brush. Remember that this technique calls for color on one side of the brush, but not

on the other, so be sure that when you're stroking the brush you keep the nonpaint side out of the paint. If you load small amounts of paint at a time into the brush, the spot where you are working will not become messy and thus cause you to load paint across the full width of the brush. Do not make the common mistake, however, of moving around the palette to a different clean spot with every stroke; doing so will cause you to run out of paint before you accomplish the gradual shading for which this technique is used.

5. Stroke the brush on both the top and the undersides of the hairs to ensure that paint is worked evenly through the brush. If you stroke the brush only on its underside, paint will be pushed to the top and will not be smoothly distributed.

6. If there seems to be a lot of color on half of the brush and a sudden change to no color on the other half, try "walking" the brush away gradually from the edge of paint. If the paint is on the left edge of the brush, "walk" toward the right by making short, narrow strokes parallel to—and close beside—the original stroke. Then walk back toward the left, gobbling up the little trail of paint by applying pressure on the brush while stroking. At first "walk" only half the width of the hairs of the brush until you learn how to "eat" up the paint trail on the way back. This technique will help distribute the paint across the hairs to create a gradual shading from solid color to a transparent wash. Be careful not to get paint on the nonpaint edge of the brush.

7. Another trick to help soften a hard edge of color in the middle of the brush is to wiggle the brush slightly as you pull a blending stroke on the palette, creating a sort of zigzag stroke. Repeat this several times, then brush over the stroke again with a straight back-and-forth motion.

8. If the paint begins to drag a bit, dip the nonpaint corner of the brush into a drop of water (for acrylics) or medium (for oils). I like to keep a drop of water on my palette for this purpose, rather than dipping the brush into the water basin. It is surprising to what extent—and how quickly—the hairs will absorb water. Be sure to blot the newly moistened corner of the brush to remove excess water or medium, then begin again.

Sideloading the brush and "walking" away from the paint puddle.

Doubleloading the brush.

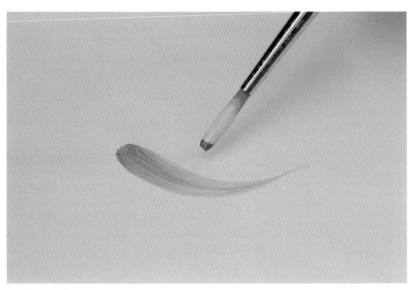

Stroking with a tipped brush.

drying too rapidly, try mixing extender and water or using extender only.

All of these steps may seem like a lot of effort just to load a brush, but once you master the technique it will become second nature. You'll be able to do it quickly, and the results in both your stroke work and blended work will be thrilling.

Doubleloading

A doubleloaded brushstroke has a different value or color on each side of the brush, with a gradual blending of the two in the center. For example, imagine a brush doubleloaded with red on one side, yellow on the other. Their gradual merging in the center of the brush creates orange.

Follow the tips for sideloading, but this time pick up a different color on each side of the brush. Blend the colors on the palette until you achieve a gradual merging of colors in the center. Reload the brush as needed to work color up toward the ferrule and across the bottom of the hairs. If you "walk" the brush sideways and then back (see "Sideloading," Step 7, above), be sure that you do not walk one color into another. For example, do not walk the yellow side of the brush into the red on the palette.

Tipping

Create streaky or variegated strokes by tipping a fully loaded brush into one or more colors or values of paint. After fully loading the brush, tap the tip of the hairs on the palette to remove some excess paint. Then dip just the tip of the hairs into another color or value. Tap once or twice gently to remove excess paint and to blend the added color slightly into the previously loaded color. Streaky strokes are wonderful for painting flower petals and hair.

Drybrushing

Drybrushing is a foolproof way to add subtle highlights and interesting texture and sheen. Drybrushing is very similar to delicate stenciling in that very little paint is used. The technique can be hard on brushes, so it is best to use old, splayed ones. (I have a favorite ratty, grungy brush I save for drybrushing.)

Pick up a little paint and work it well into the hairs of the brush by stroking it on the palette. Then immediately try to wipe all of the paint out of the brush by rubbing the hairs on a paper towel. Repeat the rubbing

9. If you accidently get solid color all the way across the brush, don't give up and rinse the brush completely to start all over again. You've already invested time getting paint up into the brush. Just dip the edge of the brush that was supposed to be clear or pale into a drop of water or medium. Pull that edge through a paper towel held between your thumb and forefinger. Remoisten the corner, blot it, and continue sideloading.

10. Practice sideloading a No. 10 or No. 12 flat brush until you've mastered the technique. Then try it with smaller brushes. It's a little more difficult to sideload the No. 2 or No. 4 flat brushes than the larger ones.

11. If you are working with acrylics and find that you have difficulty with the paint

Preparing a dry brush.

Using the tip of the brush to create a stipple effect.

Two examples of glazing: A gradated wash *(left)* and a flat wash *(right)*.

once or twice. Any paint remaining in the brush should be nearly dry. Hold the brush horizontal to the surface or project and skim it lightly across the area to be highlighted. You should have to skim many times, each time depositing a barely perceptible layer of paint. With repeated applications from the same loading, you will need to rub harder and harder in order to pull paint from the brush. Slowly, the color should begin to be noticeable. Think of the application of paint as buffing. If the color is immediately obvious on your first pass, your paint is still too wet. Wipe more of it from the brush, then try again.

Stippling

Skimpily load the brush by tapping the hairs onto a thin smear of paint on the palette. Apply the paint with a patting motion using the side of the brush, or with a pouncing motion using the tip of the brush. Use very little paint and pressure. This will create a stippled, broken color effect, and can be striking when one color is stippled on top of a previously applied, already dry color. Use the technique to suggest texture or nap in fabric, mottling of color on fruit and vegetables, or highlights where more dramatic paint application is desired than is possible with drybrushing. Stippling is also an effective way to paint pollen in flower centers, speckles on fruit, and freckles on noses. As with drybrushing, use old, splayed brush or children's cheap watercolor brushes to prevent damaging good ones.

Washing or Glazing

Washing (or glazing) a translucent or semitranslucent layer of paint over a dry, opaque, light-value layer of color creates a luminous, light-from-within, effect. Thin color washes or glazes are great for adjusting colors, for creating shading, and for suggesting depth. Generally, a large flat brush is most appropriate for applying a wash. Load the brush with thinned paint. (Thin acrylics with water or extender; thin oils with painting medium.) There are two kinds of washes or glazes: gradated and flat. A *gradated wash* is one in which the color fades from strong to slight, while a *flat wash* is evenly colored. To apply a gradated wash, use a sideloaded brush. To apply a flat, evenly colored wash, use a brush fully loaded with thinned paint. I make abundant use of color washes in my blended style of painting.

Flagging Your Brushes

Brushstroke Symbols

Watch for these symbols, particularly in flat brushstrokes.

denotes the starting position of the brush

shows the direction in which to travel

▲

indicates the direction in which the flag is pointing

Now that you know how to control and load your brushes, it's time to start to work. In the following chapter, I will introduce you to all the brushstrokes you will probably ever need. Variations on these strokes can lead to many additional strokes.

To make it easy for you to understand the motions and positions of the brushes in creating strokes, I will describe some of them in relation to the numerals on a clock face, indicating to you whether the flag on your brush (which you will soon attach) should move. Many of the illustrated brushstrokes will be accompanied by arrows and numerals. The numerals represent positions on the clock, and indicate in which directions your flag should be pointing, both at the beginning and at the end of the stroke.

In order to follow the directions in the next chapter, tape a small, stiff paper flag to the end of the handle of each brush. On the liner and round brushes, the relation of the flag to the hairs is irrelevant. On the flat brushes, however, be sure that the flag is exactly parallel to the flattened width of the ferrule. After attaching a flag to the flat brush, stand the brush perpendicular to the clock face below. Align the chisel edge of the brush with the vertical line in the center of the clock. If your flag points *directly* to 12 o'clock (or 6 o'clock), it is aligned properly. If it is not precisely on 12 or 6, remove it and reattach it.

Now that you're ready to begin painting, turn the page and let's start making brushstrokes.

Place flags on your brushes to help you follow the directions in the next chapter.

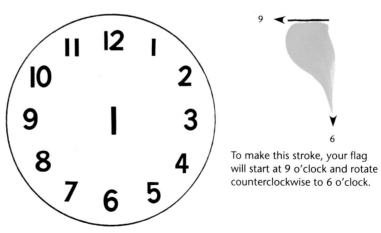

Stand your flagged brush on the line in the center of the clock's face. The flag on your brush should be pointing to 12 or 6 o'clock.

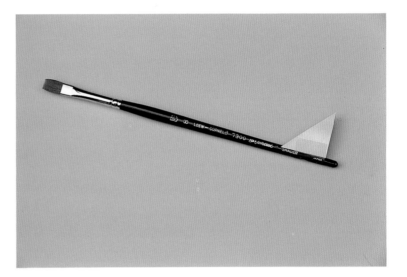

To make this stroke, your flag will start at 9 o'clock and rotate counterclockwise to 6 o'clock.

Chapter 4

Basic Brushstrokes

Grab a stack of used computer paper or typing or copier paper, your favorite color paint, and your liner brush. Doing a few warm-up exercises will get you off to a good start by helping to loosen you up and by developing the fine motor control skills you need for doing sure, flowing stroke work. Try to practice the warm-up exercises for a few minutes every day. It isn't necessary that you always use paint—you can simply load your brush with water and practice on the kitchen counter. Just imagine all the brushstrokes you could practice while waiting for the coffeepot to perk or the microwave to ding. And since you won't have paint-laden brushes to clean up afterward, you have no excuses for not practicing. When you have carpool duty for the kids, or whenever you are going to be stuck sitting and waiting somewhere, take out your brushes, a jar of water, and a sheet of reusable Practice Paper and begin practicing. Don't worry about those folks with the curious, admiring stares. They may soon be eager students, gathered around your kitchen table. The best way to reinforce your own learning is to share what you've learned.

Lefties, please note: You'll find it helpful to start painting on the right-hand side of the page and progress toward the left. Likewise, on strokes such as the crescent and the S, begin on the right leg of the strokes. Where the instructions suggest that you point the flag on your brush to, say, 10 o'clock and end up at 2 o'clock, you will reverse the directions, beginning at 2 and ending at 10. This will ensure that your hand does not obscure your vision.

The brushstrokes reviewed in this chapter can be combined to produce a virtually unlimited number of configurations, enabling you to make each of your projects unique.

Warm-up Exercises

Load the liner brush with water or very thin paint. Remember to (1) balance your hand on your little finger, (2) hold the brush perpendicular to the painting surface, (3) keep your wrist and arm off the table, and (4) maintain all the other good habits covered in the previous chapter, including working with brushes and paints, your posture and body movements, and practicing to develop your skill and confidence. Work slowly, carefully, and deliberately. In the beginning, strive for precise, uniform strokes.

Lettering

When you tire of these exercises, use the liner brush to write the alphabet, the Declaration of Independence, your name, or your favorite movie star's name over and over. It doesn't matter if you don't know how to execute elegant lettering; right now the main thing you must do is doodle with the liner brush until you fall in love with it and it loves you enough to do everything you want it to do. (See page 266 for hints on lettering with the liner brush.)

Spiral

Begin painting the spiral on the outside edge, applying pressure to the brush. Gradually release the pressure as you spiral inward. Lean the handle of the brush into the curve so that you are always *pulling* the hairs.

Coil

Work with your whole arm, pulling the stroke from your shoulder. Develop and maintain a rhythm. Try to keep the loops of the coil even and consistent in their overlapping.

Double Loops or Figure 8s

It's sometimes hard to get this exercise started. Don't worry if your beginning looks confused. Just keep going. The loops will soon fall into place. Humming the "Skater's Waltz" will help you maintain a steady rhythm. Be deliberate; do not race.

Ss and Straight Lines

Strive for precision and uniformity. Proceed slowly and keep a steady rhythm.

Liner, Round, and Detail Brushstrokes

In this category, there are ten basic brushstrokes: the comma, the teardrop (with two variations, the wiggly-tail and the sliding teardrops), the fern, the S, the crescent (with one variation, the dipped crescent), the scroll, and the chocolate chip. Used alone and in a series of combinations, they serve as the basis of a variety of more complex stroke designs. Experiment with the streaky and two-toned effects suggested below in all your brushstrokes.

Comma

Remember while loading the brush to flatten the tip of the hairs and scoop up a little extra paint. (For a streaky comma stroke, load the brush with one color, then tap the excess off the tip. [Do not wipe it off.] Dip the brush in a second color, then tap it slightly to merge the colors.)

Step 1. Lean the brush handle slightly back in your hand. Press the brush down, letting the hairs flair out to form the rounded head.

Step 2. Pull the stroke, gradually releasing pressure on the brush and letting the hairs return to a point.

Step 3. Pull the stroke to a fine point, standing the brush perpendicular to the painting surface. Stop, then lift off.

Teardrop

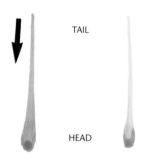

This stroke, which is also referred to as the Norwegian teardrop, is the reverse of the comma stroke: It begins skinny and ends fat. (For a two-toned teardrop, load the brush with one color, then wipe the tip. Load the tip with a second color. Paint the teardrop. The last color loaded on the brush will form the teardrop's tail, the first will be found in its head.)

Step 1. Begin on the tip of the brush, skimming lightly on the surface to form the tail. For best results in starting a skinny tail, begin the stroke in the air and glide gently onto the surface.

Step 2. Gradually apply pressure while pulling the brush until you've obtained the length or fullness desired.

Step 3. Come to a complete stop, then stand the brush back up on its tip perpendicular to the surface. Notice that, upon stopping, the tip of the brush is in the middle of the head. Lift off.

Wiggly-Tail Teardrop

Step 1. Like the teardrop stroke, skim lightly on the tip of the brush.

Step 2. Gradually press to form the head.

Step 3. Stop, then stand the brush perpendicular to the painting surface, but don't lift off. Drag the tip through the head with a slight wiggling motion. Make the wiggly tail shorter than the main tail of the stroke.

Sliding Teardrop

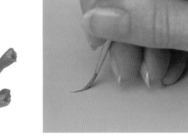

Step 1. Let the brush lay back in your hand (as if you were writing) rather than holding it perpendicular to the painting surface. Pull the stroke to form a thin tail.

Step 2. Simultaneously begin applying pressure (laying down the full length of the hairs) and sliding toward either the left or the right.

Step 3. Stop, lifting up the heel of the brush first, then the tip.

Fern

This stroke is a combination of the teardrop, the sliding teardrop, and the wiggly-tail teardrop. (You may find it tricky at first. It was originally a "goof," the result of trying to paint teardrops when my wrist and fingers were in a cast. I use it everywhere now.

Step 1. Begin painting a teardrop.

Step 2. Slide, as for the sliding teardrop.

Step 3. Flick the tip of the brush in the opposite direction of the slide to form a slight hook. If you slid to the right, hook to the left.

The S

This is not a curvy S as in lettering, but a graceful Hogarthian curve. (Note that with the S stroke you begin and end heading in the same direction. The beginning and ending legs of the stroke should be parallel to one another. Your flag should never change direction.)

Step 1. Begin on the tip of the brush at 8 o'clock. Pull toward 2 o'clock.

Step 2. Apply gradual pressure and change direction, heading toward 4 o'clock.

Step 3. Release pressure gradually and resume heading toward 2 o'clock.

Crescent

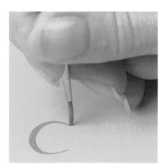

Step 1. Begin on the tip of the brush with little pressure.

Step 2. Gradually apply pressure, putting the greatest pressure on the top of the curve. Then gradually release pressure as you head toward the end of the stroke.

Step 3. Slowly return to the tip of the brush. Stop, then lift off.

Dipped Crescent

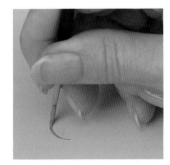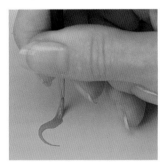

Step 1. Begin on the tip of the brush with little pressure, gradually adding more pressure.

Step 2. Near the middle of the stroke, increase the pressure on the brush while simultaneously dipping the center of the stroke to form an indentation.

Step 3. Gradually release pressure, returning the brush to a point.

Scroll

Step 1. Skim across the surface on the tip of the brush, pulling a long, flowing curve.

Step 2. Apply gentle pressure while rounding the curve. Lean the handle of the brush into the curve.

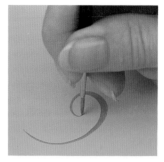

Step 3. Release the pressure gradually and return to the tip of the brush.

Chocolate Chip

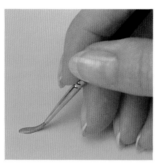

Step 1. Scoop a blob of paint onto the tip of the liner brush. Lay the handle of your brush against your index finger. Press the blob of paint onto the painting surface.

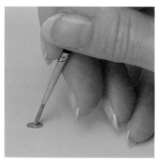

Step 2. Stand the brush up, leaving the tip in contact with the blob of paint.

Step 3. Flick or drag the tip of the brush a short distance out of the blob, forming what looks like a painted chocolate chip.

Flat Brushstrokes

If you can make these two strokes with your flat brush, you can make all thirteen of the strokes demonstrated in this section: the knife or chisel, the broad, the zigzag, the flat S, the flat scroll, the flat crescent (with two variations, the flat dipped and bumpy crescents), the leaf, the flat comma, the half-a-heart, the pivot-pull, and the circle. Practice with a No. 8, 10, or 12 flat brush. Try making strokes in different directions.

Knife or Chisel

Skim the knife or chisel edge of the brush along the surface to form a thin line. Be sure to keep the brush perpendicular for the best control and the narrowest line.

Broad

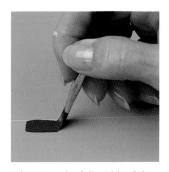

Maintaining even pressure, pull a stroke using the full width of the flat brush. Pull the brush back to a chisel edge, standing it up perpendicular to the painting surface, leaving a clean, even edge.

Zigzag

Watch your flag on this stroke. It should *not* change direction.

Step 1. Beginning with the flag pointing to 8 o'clock and pulling toward 2 o'clock, slide on the knife edge of the brush. Stop abruptly.

Step 2. Change direction and pull a broad stroke toward 5 o'clock. Stop abruptly. The flag should still be pointing to 8 o'clock.

Step 3. Stand the brush back up on the knife edge and pull a chisel stroke parallel to the one made in the first step. The beginning and ending strokes should be perpendicular to the center stroke.

The Flat S

This stroke is formed by applying and releasing pressure. Watch your flag—it should never change direction! Do *not* rotate the brush in your fingers, or attempt to "draw" the letter "S."

Step 1. Start at 8 o'clock and slide toward 2 o'clock, gradually increasing pressure.

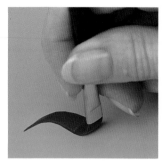

Step 2. Continue to increase pressure as you change direction and head for 5 o'clock. In the middle of the stroke, begin gradually releasing pressure.

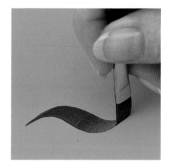

Step 3. Continue releasing pressure as you change direction again and head for 2 o'clock, ending on the knife edge of the brush. The "legs" of the stroke should be parallel and the same length.

Flat Scroll

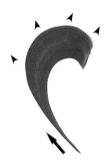

Practice this stroke on a large scale at first. It should be flowing and expansive. Your flag will rotate only about a quarter of a circle. If you use a doubleloaded brush, the color you lead with, on the chisel edge, will appear on the outside of the curve.

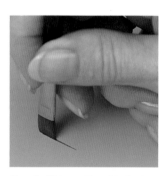

Step 1. Slide on the chisel edge of the brush toward 10 o'clock and gradually begin applying pressure.

Step 2. Increase the pressure as you round the curve, rotating the brush until the flag points to approximately 2 o'clock.

Step 3. Return to the chisel edge, pulling the brush just enough to make a clean ending.

Leaf

This stroke starts with a broad stroke, rotates 90 degrees, and ends with a chisel stroke. If you start with the flag pointing to 9 o'clock, you should end with the flag pointing to 6 o'clock or 12 o'clock, depending on which way you rotate the brush.

Step 1. Press the brush down to pull a broad stroke toward 6 o'clock. Immediately start to rotate the brush either clockwise or counterclockwise, simultaneously releasing pressure.

Step 2. Continue pulling, rotating, and releasing—all simultaneously. (As pictured above, I'm pulling the stroke down toward the bottom of the paper, toward the 6 o'clock position, which is on the right side of the photograph.)

Step 3. End the stroke with a chisel or knife edge.

Flat Crescent

This stroke is similar to the scroll stroke in the beginning, but ends a little differently. If you start the stroke with your flag pointing toward 10 o'clock, you should end the stroke with the flag pointing toward 2 o'clock. Watch your flag—be sure it doesn't backtrack.

Step 1. Slide on the chisel edge with the flag pointing toward 10 o'clock, and gradually begin applying pressure.

Step 2. Increase pressure as you round the curve, rotating the brush until the flag points toward 2 o'clock. Then gradually begin releasing pressure.

Step 3. Continue releasing pressure and pull the brush to the chisel edge. The beginning and ending legs of the stroke should be identical—the same length and width.

Flat Dipped Crescent

This stroke looks like the crescent stroke but instead has a depression in the middle.

Step 1. Slide on the chisel edge of the brush with the flag pointing toward 10 o'clock. Begin applying pressure just before you round the curve.

Step 2. As you reach the center of the stroke, release the pressure and pull the brush to form the dip; then reapply pressure to form the second hump, rotating the brush slightly toward 2 o'clock.

Step 3. Gradually release pressure, returning to the chisel edge, and sliding to complete the leg.

Bumpy Crescent

This stroke may take a little practice to get the bumps, scoots, presses, and releases worked out. If you start the stroke with the flag pointing to 10 o'clock, you should complete the stroke pointing to 2 o'clock.

Step 1. Slide a short distance on the chisel edge of the brush with the flag pointing toward 10 o'clock, then quickly add pressure.

Step 2. Bounce the brush as you press and release.

Step 3. Also, drag the brush—for variety, sometimes when it's pressed down, sometimes when it's on the chisel edge—while gradually rotating the flag toward 2 o'clock.

Step 4. When the stroke is as wide as needed, release pressure and slide on the chisel edge.

Flat Comma

This stroke looks similar to the scroll stroke but is painted in the reverse direction—from head to tail. If you start the stroke with the flag at 12 o'clock, it should rotate gradually to about 2 o'clock; then stop rotating as you slide to complete the stroke, pulling the tail toward 7 or 8 o'clock.

Step 1. Press the brush down and begin pulling a flat stroke.

Step 2. Continue pulling while releasing pressure and curving the stroke slightly. Let the handle lean into the curve.

Step 3. Continue releasing pressure and pulling until the brush comes to the chisel edge. Stop and lift off.

Half-a-Heart

Put two of these side by side to create a heart. They also make good leaves. Watch your flag on this stroke—it should rotate a full half circle. Note the similarity of this stroke to the pivot-pull (see opposite). This stroke, however, has a rounded top, while the pivot-pull has a flat top.

Step 1. Begin the stroke with the flag pointing toward 12 o'clock. Slide slightly toward 12 o'clock, then press the brush down (toward 2 o'clock).

Step 2. Rotate the brush until the flag points to 4 or 5 o'clock. Notice how much pressure is on the hairs.

Step 3. Slowly begin releasing the pressure; continue rotating, and slide on the chisel edge of the brush to 6 o'clock.

Pivot-Pull

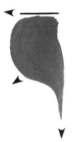

Two of these strokes side by side make nice stroke leaves. Their flattened tops allow them to be placed against fruit or flowers, and thus appear to be behind or under the subject.

Step 1. Start with your flag pointing to 9 o'clock.

Step 2. Simultaneously press the brush down and rotate it until the flag points to about 7 o'clock. Apply enough pressure to fill out the stroke on both sides.

Step 3. Release pressure slowly while continuing to rotate the brush until the flag points to 6 o'clock. Slide the brush up onto the chisel edge. Repeat the stroke, beginning with the flag at 3 o'clock, rotating to 5 o'clock, and sliding on the chisel edge to 6.

Combine the bouncing effect (from the bumpy crescent) with this stroke to create a ruffled edge that's nice for leaves.

Circle

To make this stroke, you'll begin by winding up, just as a pitcher winds up before throwing the ball. (See "The Circle Stroke 'Windup,'" below.)

Step 1. Wind up (point the flag to approximately 9 o'clock), then press the brush down.

Step 2. Maintain even pressure on the hairs so that none are pressed so hard to the surface that they cannot move with the rest of the brush. Begin rotating the brush clockwise, lowering the elbow and turning the wrist back out.

Step 3. Continue unwinding, rolling the brush between your thumb and forefinger. As you complete the circle, bring the brush up on the chisel edge.

The Circle Stroke "Windup"

Do not balance on your little finger. Hold the brush at the ferrule with the flag pointing to 9 o'clock. Pull the ferrule with your thumb, rotating the brush counterclockwise until the flag points to 5 or even 3 o'clock. (Lefties, your brush will move clockwise from 9 o'clock until the flag points to 2 or 3 o'clock.) Do not "walk" your thumb around the ferrule as you pull it. It should end up resting along your thumbnail, and your index finger should be wrapped around the brush. (Sound awkward? It is!) Now rotate your wrist in toward your body, and raise your elbow. Check your flag—it should be pointing to 12 o'clock (for lefties, 6 o'clock). If you can get it to 10 or 9 o'clock (lefties, 8 or 9 o'clock), that's even better. (To paint the circle stroke, see steps 1, 2, and 3, above.)

You'll feel awkward the first twenty times you paint this stroke, but with practice it will become very easy to do. If you paint the stroke without first winding up, you will quickly "run out of thumb" to roll the brush along, and feel in danger of dropping the brush.

Try this stroke again, this time winding up clockwise and painting counterclockwise. (Lefties, wind counterclockwise and paint clockwise.) To wind up, push the brush with your thumb until it lies along your index finger. Turn your wrist out instead of inward. Note the starting position of the flag when you begin the windup. When you complete the windup and are ready to paint the circle, the flag should have rotated around almost completely, to its original starting position.

Painting with the Handle End of the Brush

You might as well get your money's worth out of your brushes and use *both* ends for painting. When you get tired of practicing strokes, turn your brush upside down and have some fun with the handle end.

You can use the dots between elaborate strokes as a sort of "resting place" for the eye, or as the tiny anthers on the delicate stamen of small blossoms. Use the comma strokes to make small leaves and petals.

Dots

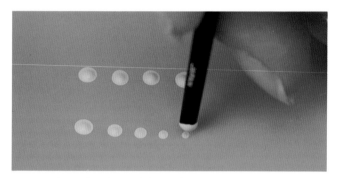

- To make uniformly sized dots, reload the handle with paint for each dot.
- To make a series of dots that decrease in size, load the handle once, then press a line of dots. Each dot will be progressively smaller than the previous one.
- For very small dots, use a stylus.

Comma Strokes

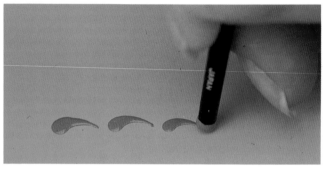

Press a dot, then pull and gradually raise the handle. To make very tiny comma strokes, use a stylus.

Dot Hearts

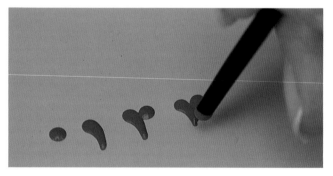

Press a dot, then pull a comma stroke. Press a second dot beside the first, then pull a comma stroke, joining the first one at the tip of the tail.

Dot Roses

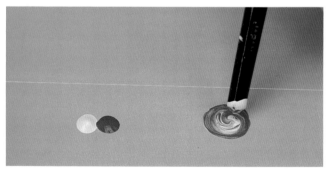

Place dots of two different colors—or different values—side by side. Use the handle to stir the colors together in a circular motion.

Make these dot roses by stirring together two colors of paint with the handle end of your brush. Add lots of little leaf-stroke leaves to complete the design. (You might even try using the handle end for the leaves' flipped-edge comma strokes.)

Learning from Your Mistakes

Many things can go awry with your first attempts at making decorative brushstrokes. And as true as it may be, it's sometimes little comfort to know that "you learn from your mistakes." Nevertheless, striving in the beginning to practice your strokes to perfection will give you confidence and freedom later. Once your skill is developed, focus on painting brushstrokes for the sheer joy of it, letting your style emerge. Your painting will look fresh and lively. While perfection may be admirable technically, it may be detrimental from an emotional and aesthetic standpoint. Meticulously precise objects and renderings can be manufactured by machines; those made by humans are spontaneous and unpredictable—the qualities for which we cherish handmade things.

While you're struggling for perfection, the charts below and on pages 76–79 may help you by illustrating some of the more common problems and offering solutions for them. Carefully critique your work, mark the weak areas on your strokes, and note the changes you need to make in your technique.

Warm-up Exercises

What You're Trying For	What You Might Get		Why You Got It
COIL	1	2	1. Painting too quickly or too carelessly means your work will be out of control. Slow down. Paint precisely. 2. When you use your fingers rather than your whole arm, you may develop little glitches. These glitches are also caused by hesitating slightly, and by making abrupt changes in direction (such as when you turn from moving upward toward heading back down).
SPIRAL	1	2	1. Your work is careless and uncontrolled. Slow down. Aim for uniformity. 2. Read about glitches in the second example of the coil stroke, above.
DOUBLE LOOPS OR FIGURE 8s	1	2	1. Strive for consistency in the size and uniformity of your loops. Slow down. 2. The pressure on the brush is inconsistent. Developing a rhythm will help you apply pressure consistently.
Ss AND STRAIGHT LINES	1	2	1. On the down stroke, swing gradually into a curve leading into the next S. This will prevent an abrupt change of direction at the bottom of the stroke. 2. Try to be more precise and consistent. Work slowly. Exert pressure on this stroke to produce a variety of thick/thin lines.

Round, Liner, and Detail Strokes

What You're Trying For	What You Might Get	Why You Got It

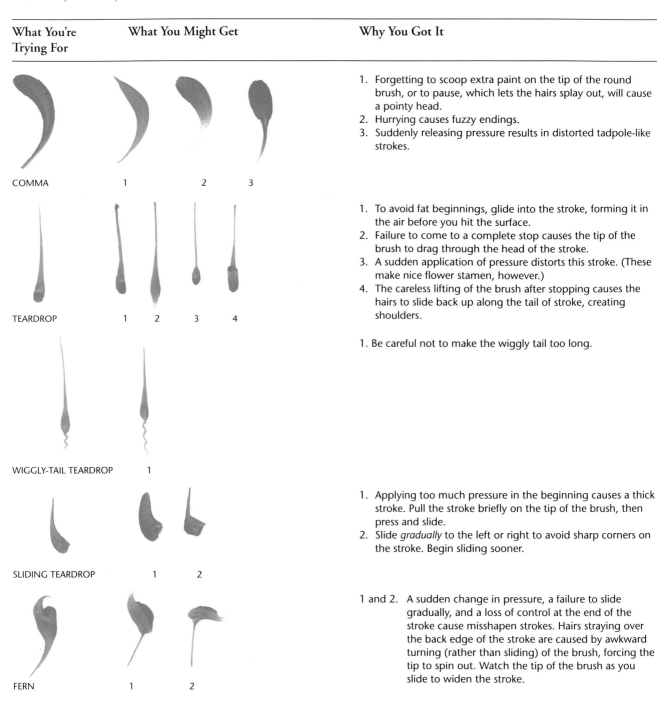

COMMA 1 2 3

1. Forgetting to scoop extra paint on the tip of the round brush, or to pause, which lets the hairs splay out, will cause a pointy head.
2. Hurrying causes fuzzy endings.
3. Suddenly releasing pressure results in distorted tadpole-like strokes.

TEARDROP 1 2 3 4

1. To avoid fat beginnings, glide into the stroke, forming it in the air before you hit the surface.
2. Failure to come to a complete stop causes the tip of the brush to drag through the head of the stroke.
3. A sudden application of pressure distorts this stroke. (These make nice flower stamen, however.)
4. The careless lifting of the brush after stopping causes the hairs to slide back up along the tail of stroke, creating shoulders.

WIGGLY-TAIL TEARDROP 1

1. Be careful not to make the wiggly tail too long.

SLIDING TEARDROP 1 2

1. Applying too much pressure in the beginning causes a thick stroke. Pull the stroke briefly on the tip of the brush, then press and slide.
2. Slide *gradually* to the left or right to avoid sharp corners on the stroke. Begin sliding sooner.

FERN 1 2

1 and 2. A sudden change in pressure, a failure to slide gradually, and a loss of control at the end of the stroke cause misshapen strokes. Hairs straying over the back edge of the stroke are caused by awkward turning (rather than sliding) of the brush, forcing the tip to spin out. Watch the tip of the brush as you slide to widen the stroke.

Round, Liner, and Detail Strokes

What You're Trying For	What You Might Get	Why You Got It

THE S 1 2 3 4 5

1. Apply and release pressure earlier in the stroke to prevent all the weight from falling to the bottom.
2. Remember: The S stroke has only three directional changes. This example shows four.
3. The top and bottom legs of the stroke should be parallel. Avoid painting hooks.
4. Sharp angles are caused by suddenly changing direction and pressure. Slide around the corner, adding pressure just before the bend.
5. This stroke is too curvy. Straighten the ends a bit.

CRESCENT 1 2 3

1. Stay in control at the end of the stroke to avoid overlapping ends.
2. Try to begin (and end) the stroke with a fine line.
3. Avoid painting squared corners. Think "round" as you paint.

DIPPED CRESCENT 1 2

1. Keep the brush sliding through the center of the stroke. Don't stop, and don't apply sudden pressure.
2. Slow down to complete the stroke so that the ends don't get out of balance and overlap.

SCROLL 1 2 3

1. Painting too slowly or deliberately can cause shaky strokes. Try to be freer and more fluid.
2. Using your fingers (rather than your entire arm and shoulder) can result in a loss of control.
3. Uniform widths in the stroke make it boring. Remember to include some *contrast*.

CHOCOLATE CHIP 1

1. Unless you're intentionally painting a tack, do not pull the tail of the stroke too far.

Flat Brushstrokes

What You're Trying For	What You Might Get	Why You Got It

KNIFE OR CHISEL 1 2

1. Uneven pressure, or not holding the brush perpendicular to the painting surface, can cause thick, irregular strokes.
2. A mistreated flat brush that no longer holds a sharp, chisel edge will make a blurred stroke. You can use it for something else, but not for stroke painting.

BROAD 1 2 3

1. A change in pressure will cause the stroke to vary in width.
2. Hurrying through the ending of the stroke makes fuzzy edges. Remember to slow down, let the hairs return to the chisel edge of the brush, stop, then lift off.
3. Pressing too far down onto the heel of the brush, then lifting straight up, deposits a blob of paint.

ZIGZAG 1 2

1. To get crisp lines and angles, you must be precise and abrupt when applying and releasing pressure. Slide; change direction and press; release pressure and change direction.
2. Beginning and ending legs should be parallel to one another and perpendicular to the center portion.

THE FLAT S 1 2 3 4

1. The beginning and ending legs of the stroke should be the same length. Slide the brush on the knife edge a little longer before beginning to add pressure.
2. Stay in control at the end. Don't rush.
3. Remember, there are only three directional changes to this stroke.
4. Avoid leaning the handle, which makes the hairs flip.

FLAT SCROLL 1 2 3

1. Thick beginnings are caused by too much pressure on the brush. Slide onto the chisel edge of the brush before applying pressure.
2. Fuzzy endings at the end of the stroke show a lack of control. Slow down. Come to a complete stop.
3. Don't work too hard trying to paint a rounded head. Liner detail strokes later will suggest roundness.

LEAF 1 2 3

1. Pull, rotate, and release pressure in one continuous motion. This stroke shows a sudden release of pressure and rotation of the brush.
2. Avoid swinging out while rotating the brush. Achieve the desired width by applying greater pressure.
3. Be sure you have completed the rotation before lifting the brush.

Flat Brushstrokes

What You're Trying For	What You Might Get	Why You Got It

FLAT CRESCENT 1 2 3

1. Keep the beginning and ending legs the same length, and allow more space between them.
2. Avoid making sharp edges or corners, or having the legs parallel to one another and straight. Begin with the brush pointing to 10 o'clock and end with it pointing to 2 o'clock to create a curved top.
3. Avoid flip-overs by rotating the brush from 10 to 2, and by keeping the flag pointing at 2 o'clock while completing the stroke.

FLAT DIPPED CRESCENT 1 2

1. Avoid making a distinct dividing line in the middle of the stroke by keeping the brush moving as you release and add pressure.
2. To avoid making flipped strokes, refer to the third example of the flat crescent stroke, above.

BUMPY CRESCENT 1 2

1. This stroke is too squarish. Remember to start and stop on an angle (10 o'clock to 2 o'clock).
2. The ruffles in this stroke are too rigid and predictable, almost like pleats. Slide, bounce, and increase and release pressure with great irregularity to create a softer, more interesting stroke.

FLAT COMMA 1 2 3

1. Fuzzy endings indicate a lack of control at the end of the stroke. Come to a complete stop before lifting off.
2. Try to round the curve gradually to eliminate hard corners.
3. Once you've rounded the curve, make sure that the brush hairs on the top side of the curve stay toward the top, outside edge to prevent flip-overs. Watch the flag.

HALF-A-HEART 1 2

1. Avoid holes in the hearts by applying enough pressure to fill the gap.
2. To avoid a sharp angle near the base of the heart, begin sliding downward to form the point before you paint the entire half-circle.

PIVOT-PULL 1 2 3

1. Release pressure slowly when pulling to a point to avoid this abrupt change.
2. Avoid swinging the brush out as in a crescent stroke. Apply pressure, and pivot on the hairs.
3. The rounded top makes it difficult to butt this stroke (as a leaf) against a flower. Begin with the flat edge of the brush perpendicular to—not aligned with—the direction in which the tip of the leaf will flow.

CIRCLE 1 2

1. Eliminate holes by applying adequate and even pressure. Try to overlap the beginning and ending to create a smooth outside edge.
2. When uneven pressure is applied to the brush, some hairs get stuck temporarily, only to spring loose when you don't expect it and slip over the edge of the circle.

Chapter 5

Blending with Acrylics

We can paint boldly, in flat, unmodulated colors, to create a naive or primitive expression, or we can use a variety of brush-loading techniques and paint application methods to create a gradated, blended look. Both styles of painting have their place in decorative painting, each one providing a special "look."

Working in flat, unblended colors with no shading or highlighting is often referred to as *color-book painting,* which is a matter of simply applying flat color within the lines of a pattern. To achieve a blended look, we must consider several factors (including color values and temperature, highlights, shadows, reflected lights, mood, and complementaries) and use a variety of techniques (such as floating color, glazing, or washing; drybrushing; side- and doubleloading; using extender; and brush mixing.)

This chapter helps you combine what you've learned about color mixing and brush-loading techniques, and shows you how to achieve the smoothly blended look of oil paints while using faster-drying acrylics. Mastery of the blending and paint application methods in this chapter is an essential ingredient in all of the Advanced lessons. In the Intermediate lessons, dexterity with the techniques will be helpful, but mastery is not critical. Beginners will have a little opportunity to try drybrushing and floated color washes on a few of the Quick and Easy projects.

This angel features a variety of blending techniques (see pages 84–87 for details): The green stripe was shaded using Method 8; the white stripe was shaded using Method 9; the blue stripe was shaded and highlighted using Method 3; the belt and halo were shaded using Method 4; her cheeks were shaded using Methods 4 and 10; her red coat was drybrushed using Method 10; and her sleeves were scumbled using a doubleloaded brush.

Work with Your Paints—Not Against Them

There are two basic styles of rendering color: in bold, flat, unmodulated colors *(top)*, and in a gradated blending of colors *(bottom)*.

To achieve a smoothly blended, gradated look with acrylics, you will have the greatest success and the least frustration if you learn to take advantage of their quick-drying characteristic rather than fight it. Most decorative painters who have experience using oil paints become frustrated if they use the same techniques to achieve with acrylics the results they are accustomed to getting with oils. Oils dry slowly and can be leisurely blended *wet-in-wet* or *side-by-side.* You will find, however, that the use of these techniques is limited in the projects at all levels. Blended effects with acrylics are more easily accomplished with the other methods that are covered in this chapter: Because they dry quickly, acrylics perform best (and respond most quickly) in blending applications when doubleloaded or sideloaded strokes or thin washes are used. The fast-drying trait of acrylics also makes

them ideal for building up layers of translucent and transparent washes or glazes to develop shading, highlighting, and gradated blending. While glazes or washes are also possible with oils, the process is slower because oils dry slowly; in addition, previous applications of paint must be dry before the next layer can be applied. It's interesting to note that the Flemish masters of the early fifteenth century used transparent glazes to make their paintings appear to radiate light from within. The glazing or floating color technique was also popular among decorative painters in the late 1700s to early 1800s (see the Chippendale tray on page 8).

It is clear that while each medium has its strong points, we should work with its defining features rather than struggle against them, so that our painting experience will be more gratifying and more effective.

A Note on the Terminology: Washes, Glazes, and Floated Color

In this book, and in general usage, the terms *wash, glaze,* and *floated color* are used interchangeably to refer to the application of a thin, transparent layer of paint over a dry, opaque basecoat. More refined definitions suggest that a "wash" is paint thinned with water; a "glaze" is paint thinned with painting medium or extender; and "floated color" is thinned paint laid on top of a thin film of water, extender, or medium. In all three cases, the result is the same: a subtle change in color effected through the application of a thin layer of paint that permits light to reflect through it.

Experiment with the use of both water and extender or other acrylic painting mediums to determine whether you have a preference. Extender slows the drying time of acrylics, making them workable

for a little longer. Applying successive layers of paint thinned with extender can be tricky if you're not careful. Previously applied layers must be absolutely dry before you proceed; otherwise, the paint will drag, grab, and lift up the previous coat. The reduced drying time of water permits the more rapid application of multiple layers without mishap. For this reason, I prefer to use water, except in large areas where more work time is needed, for final layers, or where multiple coats are unnecessary. If you like to work at a more leisurely pace, you may prefer the extender. I have provided a few lessons using extender so you can become familiar with it. You can, of course, substitute water for the extender, and vice versa, in any of the lessons.

Basic Blending Techniques

STEP 1. UNDERCOAT

STEP 2. SHADE

STEP 3. HIGHLIGHT

STEP 4. ACCENT

STEP 5. WASH AND
ADD FINAL DETAILS

These five steps outline the
basic blending process.

Following are the basic steps required in working with layers of opaque and transparent color to build form and create luminosity in your acrylic work. Note that steps 2 to 5 can be done in random order and are frequently repeated several times to adjust color, deepen shading, or brighten highlights.

1. **Undercoat the subject matter.** Keeping in mind how complementary and adjacent colors affect one another will help when you are creating on your own and must decide what color to use for undercoating. For example, if you wish to suggest a translucent glow in a ripe, juicy berry or grape, undercoat with a light-value color and follow up with progressively darker-value washes through which that inner light will reflect. (See Intermediate and Advanced Cherries, pages 161–167). In some cases, you may undercoat the subject with an opaque, dark-value color in order to emphasize the highlights that will be applied later. (See the trompe l'oeil brass vase in Advanced Dogwood, pages 226–230). Sometimes, you may work from a medium-value undercoat (such as on the oranges at left), building up light-value washes for the highlights and dark-value washes for the shades.

2. **Shade the subject by applying very thin dark-value wash layers over the dry undercoat.** Apply several layers, building up the depth of color gradually. (Note that three shading layers were applied to the orange at left.) You can always add more color in successive coats to make the shading deeper or darker, but you cannot take excess color away except by recoating with the lighter-value undercoat and

beginning again. If you try to build the color too rapidly by applying denser wash layers, you'll lose the luminous glow. (Other methods of applying washes are discussed on page 84.)

3. **Highlight the subject by building up lighter values in the general area where the light strikes it.** In some cases, you may choose to use thin washes of light value; in others, you may apply a heavy, opaque highlight layer (by brushing, stippling, sponging, or drybrushing), then submerge it into the subject with a colored wash. Repeat the application of opaque and wash layers until you're satisfied with the strength of the highlight. The process of alternating between wash and opaque layers is fun and the results are interesting to observe. (See "Other Blending Techniques," Method 7, page 85.)

4. **Accent with patches of thin, colorful washes** to provide individual character to each subject in your painting. These accents include reflected lights, strong shadows, bruises, and tinges of different colors, such as the red blush on a pear, the turning color on a leaf, the complementary color applied to a grape to make it look translucent, the colored reflections in a shiny object like brass, and the scattered patches of wash applied to a flower petal to make it look undulating and fragile rather than as stiff as cardboard.

5. **Use a unifying wash of the general local color to soften any obtrusive areas,** subtly submerging accents and highlights if needed. If you submerge too much, simply reapply the lost accent or highlight and wash again, using a thinner layer of paint. Then add the final details.

Other Blending Techniques

Using any of the methods suggested below, apply color to a dry undercoat working with the largest flat brush you can handle in the area to be blended. Dip the brush in water, water plus extender, or full-strength extender according to your preference, or as suggested in each method below. Blot excess moisture, then load the brush skimpily with color. Note that it is not necessary to fill the brush to the ferrule as in brushstroke painting.

Method 1. *Thin the paint with water* to a watercolor consistency, with just a hint of color. Load the thinned paint onto the full width of the brush and apply to the dry undercoat using a light touch. Work quickly. You can apply succeeding wash layers almost immediately—as soon as the water evaporates, the color loses its shine, and the surface of the paint no longer feels cool.

Method 2. *Thin the paint with extender or extender plus water* to a wash consistency and apply as above. You'll have a few more moments to play with the color than in the first method. Be cautious in applying succeeding coats so that you won't disturb the tender previous layer. Use a hair dryer to help set the extender wash.

Method 3. *Doubleload a brush with the undercoat color and the shading (or highlight) color* to be added. Stroke it on the palette until the color blends in the middle. With the dark- (or light-) value side of the brush facing the area to be shaded (or highlighted), begin stroking on the color at a spot *away from that area and moving into it.* For example, with the dark value on the left side of the brush, you will stroke toward the left. As you reach the far left edge, you will still be applying dark color with the left side of the brush, but the undercoat color on the right side will be softening and blending the paint being laid down just ahead of it. This method can also be used with a sideloaded brush.

Method 4. *Sideload the brush with color, stroking it on the palette* until the color is worked gradually across, fading to clear water on the other side. Begin stroking the color on at the point where you want the strongest application to be. For example, if the color is on the left side of your brush, and you want to shade the left side of a cherry, begin applying the color along the left edge of the cherry with the left side of the brush. Work gradually to the right. (This is the reverse of Method 3.) This time, after your first stroke, you will be laying color down on a film of moisture deposited by the right side of the brush.

If the paint in the left side of the brush is too heavy, you may get some streaking as you work toward the right because the paint is not blending readily into the moisture film. Sometimes, restroking with a very light touch while the paint is wet, and before moving on, will correct the problem; at other times,

Methods 1 and 2. Blending layers of flat wash. Note that a different color may be used for each wash.

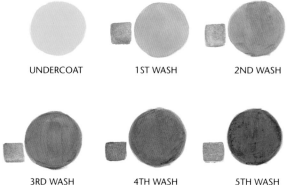

UNDERCOAT 1ST WASH 2ND WASH

3RD WASH 4TH WASH 5TH WASH

Method 3. Adding value with a doubleloaded brush.

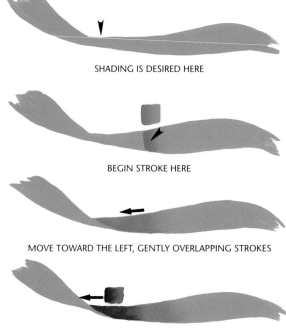

SHADING IS DESIRED HERE

BEGIN STROKE HERE

MOVE TOWARD THE LEFT, GENTLY OVERLAPPING STROKES

ADD DEEPER SHADING BY DOUBLELOADING THE BRUSH
WITH THE NEW UNDERLYING COLOR AND A DARKER SHADE

Method 4. Adding value with a sideloaded brush.

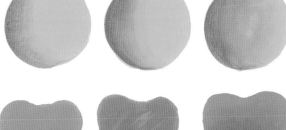

Method 5. Adding value with floated color.

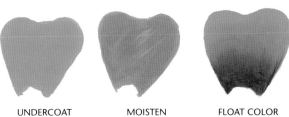

UNDERCOAT　　　　MOISTEN　　　　FLOAT COLOR

Method 6. Merging colors by blending against a stroke of water.

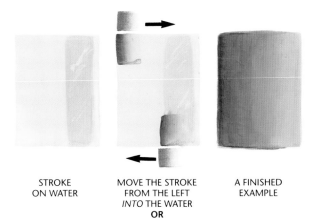

STROKE ON WATER

MOVE THE STROKE FROM THE LEFT *INTO* THE WATER
OR
MOVE THE STROKE FROM THE WATER HEADING *TOWARD* THE LEFT

A FINISHED EXAMPLE

Method 7. Building highlights through successive layers of washes.

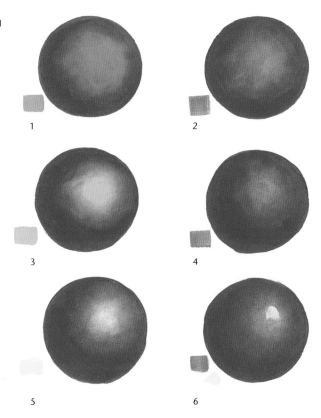

1　　2

3　　4

5　　6

restroking will lift the color off. In either case, do your best to achieve a gradual change from the added layer of color to the dry undercoat color. Let dry, then repeat the application to even it out. Note that this blending method can also be used with a doubleloaded brush, as described in Method 3.

Method 5. *Use water or extender to moisten the entire area to be colored.* Then float thinned paint over the area using a fully loaded brush if a flat wash is desired, or a sideloaded brush for a gradated wash.

Method 6. *If you have difficulty making your washes fade out to nothing, try this:* At the point where you wish the color to disappear, apply a brushstroke of clear water or water plus extender. (It's handy having an extra brush for this process because it will allow you to move along without stopping to rinse.) With a moist brush already sideloaded with color, work *toward* the edge of the stroke of water, or start along the edge of the water and work *away* from it. The extra moisture provided by the clear brushstroke on the surface will supplement the moisture on the clear side of the brush and help disperse the pigment on the other side.

Method 7. *To build up highlights on an object that has a medium to dark local color (such as a deep red apple), try this:* Sideload a light-value wash (a lighter red, pink, orange, or even yellow) onto the brush. Keep the loaded side of the brush toward the center of the highlight area, with the clear side toward the outside edge to help disperse the edge of the color. Brush the lighter value on, rotating the brush as needed to cover the area. Let dry, then apply a wash over the highlight area and onto the rest of the subject, using a color that will help merge the highlight and the preceding coat together.

Repeat the highlight process, this time working within the area applied above and covering less space. (Imagine you're building a pyramid with light-colored blocks: Each time you lay on a new course of blocks, you make them a little less wide than the preceding course, and a little more opaque; in the same way, you apply succeeding thin coats of paint to help them blend into—but still remain a little lighter than—the light, opaque coats beneath them.) Continue building until you have created the dimension you want. Then add the final, strong, accent highlight.

Method 8. *To make highlights such as those seen on a crisp satin ribbon, sideload the brush with a light-value color.* Make a stroke where you want the lightest area to be. Immediately turn the brush over, put the color on the other side, and make another stroke adjacent to the first, laying color beside color. If you work quickly, you can lay down several strokes on one side, moving away from the center of the highlight and fading out; then begin at the center again, working away toward the other side. Stretch the highlight area so that it's a little broader than desired. Let dry. Then sideload the brush with the underlying color. Working from the underlying color, stroke up onto the highlight area a little to blend colors together. Note that this method can also be used for shading. (For softer highlights, such as those on velvet ribbons, see Method 10.)

Method 9. *For another crisp highlight technique, follow the same process described in Method 8 but use a doubleloaded brush.* On half of the brush, place the color that is presently on the object and will be under the color to be added. On the other half of the brush, place the color that you'll be applying. Stroke, moving in one direction; then turn the brush over, return to your starting point, and stroke in the other direction. People who have trouble working with sideloaded brushes find this method easier. By loading the "underneath" color on one side of the brush, and the lighter or darker value you wish to blend in on the other side, you can work along the length of a ribbon, adding both shading and highlighting colors and blending them gradually into the underlying color that is being freshly laid down by the other half of the brush. Repeat as often as needed, and work with additional values if desired. In this method you begin applying color where you want it, then *move away* from the area, the reverse of Method 3. You can also add a soft, drybrushed highlight (see Method 10).

Method 10. *Drybrush on soft, subtle highlights.* With most of the paint wiped out of a skimpily loaded dry brush, rub the color sparingly onto the surface to be highlighted or accented. (You might also consider applying a thin wash over the drybrushing, using a color close to the underlying color. Repeat the drybrush-wash process a couple of times if needed to achieve the look you want.) To suggest the nap of a fabric such as velvet, drybrush on light values, subtly, even on unhighlighted areas.

Method 11. *Wet-in-wet blending (blending one wet color into another)* is easily accomplished with oils, but must be hastily done with acrylics. Apply an undercoat of color, such as blue. While it is still wet, quickly blend another color, such as yellow, into it. A little

Method 8. Highlighting (or shading) with a sideloaded brush.

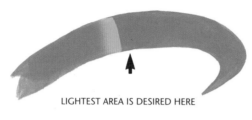

LIGHTEST AREA IS DESIRED HERE

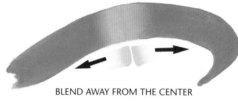

BLEND AWAY FROM THE CENTER

STROKE ON UNDERLYING COLOR

Method 9. Highlighting (or shading) with a doubleloaded brush.

Method 10. Drybrushing highlights.

A SINGLE
APPLICATION OF
DRYBRUSHING

DRYBRUSHING
AND WASH
REPEATED TO
BUILD UP VALUE

Method 11. Wet-in-wet blending blends one wet color into another.

Method 12. Side-by-side blending uses crisscrossing strokes to blend one wet color into another.

BLUE WASH

YELLOW WASH

Experiment with your colors to learn how they affect one another as washes.

extender added to your paints will give you a few additional moments of working time, but you must stop blending immediately when the paint starts to dry or it will drag and lift off. With acrylics, you can more easily accomplish a similar effect using Method 7.

Method 12. *To blend two colors side by side* (such as blue and yellow), apply your acrylic paints quickly so you can begin blending them while they're wet. Using crisscrossing strokes, work one color into the other along their adjoining edge, until the colors merge, forming a third color or value. Mixing extender into the paint will give you a little more blending time. With acrylic paints, we accomplish side-by-side blending more efficiently by doubleloading a brush, as described in Methods 3 and 9.

Helpful Hints

- Always be sure that the preceding coat of acrylic is dry before laying more paint on top of it. If necessary, use a hair dryer on low heat to speed things up.
- If the layer of paint you're applying starts to drag or grab on the previous layer, don't fight it and try to fix it. Stop! Let it dry thoroughly, then apply another coat. In the case of fruits, flowers, and vegetables, the flaw will simply add character and make the finished product more realistic looking: These things have lumps, bumps, and imperfections, after all. An additional wash layer will usually help to soften the irregularity, melding it somewhat into the rest of the painting. Such flaws, however, are not welcome when they occur where a slick, smooth appearance is critical, such as on a ribbon or a solid form that you don't want to appear dented. If the damage is severe, you may need to undercoat and start again.
- If you get a piled-up ridge of paint along an area you've sideloaded, wipe the ridge with your finger, pushing the paint from the edge into the painted area.

- I do most of my blending with a sideloaded brush because I like to use the damp, clear side of the brush to tickle the color on and to blend with a whisper.
- Each layer of glaze or wash alters the previous one so there is a gradual buildup of tone. The sequence of the application of colors will influence the outcome. For example, a blue wash over a yellow basecoat will not look the same as a yellow wash over a blue basecoat.
- Try to break up passages of color every $1/2$ inch or so. Color changes, whether subtle or striking, will help to make your painting vibrant and interesting. To avoid an overblended, predictable, and stiff look, I like to wipe from the brush onto other areas at random a little of the color I've been using elsewhere in the painting.
- Work damp with washes for the best results. Squeeze your paints on a *barely* damp paper towel. Each time you rinse your brush, blot it on the towel to replenish the moisture available to the paints. They'll stay workable longer, and blotting on the damp towel, rather than on a dry one, will help leave more moisture in your brush.
- Sometimes, when you're laying on the undercoat or the succeeding washes, following the contours of the subject will help suggest form. Study the worksheets for Advanced Apples (page 148) and Advanced Dogwood (page 227) to see how following contour lines affected the painting. Contour lines may be precisely indicated (such as veins in a flower petal), or they may be loosely suggested by positioning of brushstrokes.

 Be aware of contour lines so you can use them to your advantage when needed, but don't be a slave to them. Sometimes a loose, spontaneous brushstroke makes a greater statement than one that follows the contours.

The leaf at left shows an exciting use of color, while the one on the right is unimaginative, flat, and stiff.

(Left) Make the veins in your flower petals look natural by following contour lines. *(Right)* The outlines of the two branches are drawn identically, but notice how the contour lines make one appear to bend *in* where the other bends *out*.

Making Your Blended Paintings Work

Once you've mastered the skills involved in applying colors to build form and depth, you'll want to incorporate other factors that will make your art even more effective. Consider the following points about shadows, highlights, creating a focal point, working with values, and a few color "tricks."

About Shadows

- Shadows occur when something blocks the path of a light source. The shape and position of the shadow depends on where the light strikes the obstruction in its path.

 If the light source is low, the shadow will be long and narrow.

 If the light source is high, the shadow will be short and broad.

 If the light source is directly overhead, the little shadow that is cast will fall directly beneath the object. Notice your own shadow when the sun is straight above you; it will be short and squat even if you're long and lanky.

- When you're outside on a sunny day, notice the shapes and positions of cast shadows in relation to the position of the sun. Watch what happens to the shadow of a telephone pole as the shadow falls across the road, into a ditch, and up over a rock. Understanding how shadows move will help you know what to do with the shadows you may paint. The more you observe and see, the more confident and effective you'll be in your decorative painting.

- Shadows are not merely black; they are composed of many colors. The next time you're at a dance or in a club, or at the theater for a play or concert, look at the shadows cast by the colored lights. If the light is cool (blue or green) it will cast a warm-colored shadow (red or orange); if the light is warm, it will cast a cool shadow.

- The color of the cast shadow will be further affected by the color of the surface on which it falls. If we place a red apple on a white board, for example, and shine a red light on the apple, the cast shadow will appear greenish. The cool green shadow beside the apple will make the apple appear even redder because of the visual effect of complementary colors side by side. If we substituted a colored board for the white one, the green shadow color would be affected by the color of the board.

- Shadows are not merely dark; they are many values. If the light source is close to the object, the shadow will be dark; the farther away the light source, the more diffused the shadow. Where the shadow is close to the object casting it, the shadow will be darkest, unless there are other objects nearby casting reflected light into the area.

- An object will have multiple shadows when there are multiple lights, with the closest light casting the strongest shadow.

- When you must turn your project upside down and sideways to work on it, how can you remember where you had decided your light source would be? To help you remember at a glance, stick a small piece of masking tape at the appropriate spot on your project.

About Highlights

- In most of my decorative painting, I find pure white to be too harsh a highlight color, and prefer instead to use a warmer white with a slight touch of yellow, or sometimes a cooler white with a touch of blue.

- For an interesting effect, try adding cool (bluish white) highlights to warm-colored subjects to make them appear even warmer; and warm (yellowish white) highlights to cool-colored subjects to make them appear even cooler.

Creating a Focal Point

- Contrast creates drama, whether in thick and thin brushstroke embellishments, bold and subdued colors, light and dark values, large and small shapes, or detailed and softened or "lost" edges.

- Contrast helps pull attention to the focal point. Use contrast in intensity, value, texture, and detail. A few strategically placed detailed waterdrops, for example, will draw the eye to a focal point. Too many waterdrops scattered all around will cause the eye to jump from detail to detail in a confusing search for the focal point. So unless you are painting a rainstorm, limit the waterdrops you add to your project to a few carefully placed ones.

- Avoid giving equal weight to complementary colors; allow one to dominate. Otherwise

your viewer may have difficulty determining the focal point. You can make one color dominate by subduing the intensity of the other color or by decreasing the amount of space given to it.

Working with Values

- Creating the appearance of dimension with paint is a matter of using at least three values:

Medium value—for local color

Dark value—for shading

Light value—for highlighting

Additional values plus reflected light and blushes of other colors further add to the depth and form of your painting.

- Put light values against dark ones, and dark values against light ones.
- Our perception of a color's value is affected by the other values that surround it. A hue that appears to have a medium value as it sits on a stark white palette will look very light when placed on the dark background of a project. That same medium-value color will appear dark if surrounded by light pastels. Test your colors on a painted cardboard sample of the project's background color to avoid unhappy surprises.
- If you have trouble making something in your painting appear light enough, stop working on the highlight and instead make the surrounding values darker.

Some Color "Tricks"

- Avoid working with pure black, especially for large areas. It is flat and uninteresting. Add a little color to it. To make it appear darker and richer, add a clear, deep red; to make it softer and lighter, add a cool blue.
- Use your palette knife only when mixing large quantities of paint for basecoating and surface prepping. For most of your other paint mixing, you will find that mixing on the brush as you work will result in more vibrant, less overmixed colors, and greater variety in your painting.
- To create balance among your colors, try to repeat them in at least three positions on your work. This helps move the viewer's eye throughout your painting.
- If you wish to focus the viewer's attention on just one spot, try a single, unrepeated color (a blue bird among orange and yellow autumn leaves, or a red apple in a barrel of green ones).
- Use a color's complement to enhance its hue. To make red look redder, paint a dull, grayed green beside it. The duller the green, the brighter the red will appear. Blue will look bluer next to a dull orange. Orange will look brighter next to a dull blue. If this is a revelation to you, you've skipped over some exciting information in Chapter 2, "Learning to Mix Color." In that case, you should read that chapter again.

Developing Your Blending Skills

The following exercises will help you learn more about working with color while giving you an opportunity to practice your blending skills.

1. Using the pattern below, paint the grapes purple and the pear yellow. (Remember, these are complementary colors.) Select the background and foreground colors to help you accomplish the goal of each of the following exercises.
 - Give the complementary colors equal play. Notice the conflict of the focal point.
 - Emphasize the pear with intense color or value while merging the grapes into the background or foreground color.
 - Emphasize the grapes with intense color or value while merging the pear into the background or foreground color.
 - Paint the pear with warm tones but with little detail. Paint the grapes with a lot of detail. Although the warm colors will advance and will fight for dominance, try to make the detailing in the grapes help them claim the focal point. Consider your choice of background/foreground colors. (They can either help or hinder your effort.)
2. Once you have mastered the blending methods in this chapter and have learned how to apply the various hints to your blended paintings, you might enjoy trying a trompe l'oeil painting (see Advanced Dogwood, pages 226–230). Enlarge the pattern below to lifesize. Set up a still life of a pear and grapes to study highlights, shadows, and other details. Then paint the pattern with as much realism as you can muster.

Use this pattern to combine your newly acquired blending skills with what you learned about color mixing and theory in Chapter 2.

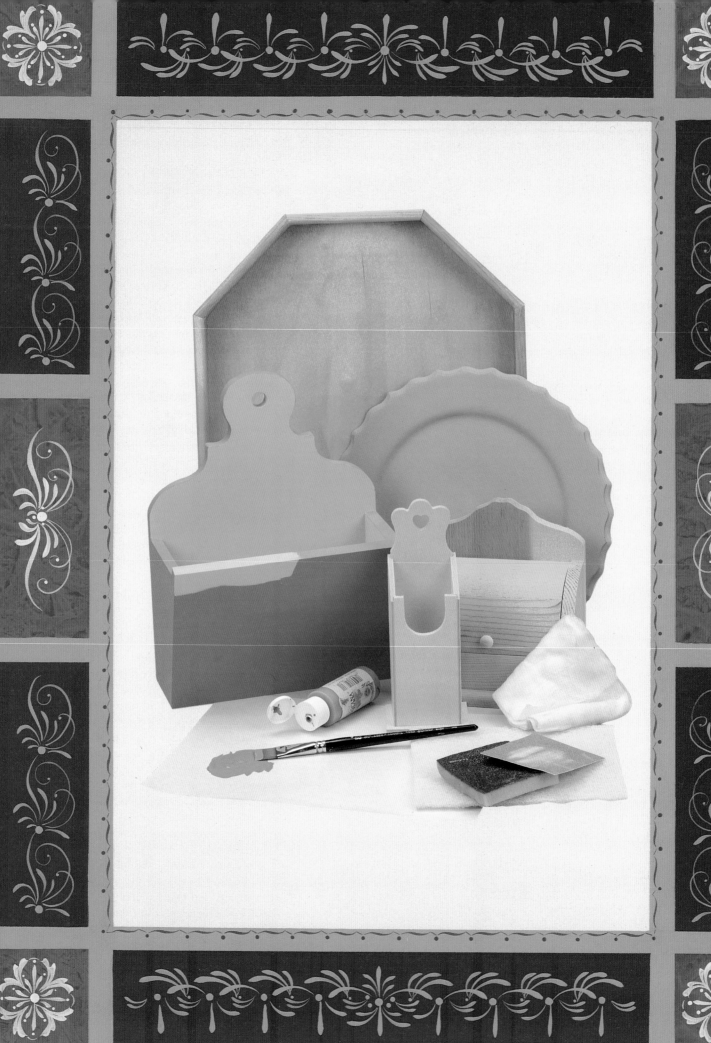

Chapter 6

Surface Preparation: Before You Start a Project

Decorative painters are notorious for painting on anything and everything, especially if it stands still for more than a minute. While some things can be painted on "as is," others may need some preparation to salvage them from previous years of use, misuse, or disuse. Some may need a change of background color to coordinate with a particular color scheme. Even the surfaces of new and unfinished items need to be made receptive to decorative painting.

Many painters, in a hurry to get on with the decorating, skip surface preparation chores, or at least take shortcuts. Granted, surface "prepping" is not the most fun part of decorative painting, but it is a vital ingredient in the finished product. If you plan to apply your best painting skills and techniques to a project, then you should spend the time and effort preparing it to be worthy of your artwork.

To ensure that you start your decorative painting on a good foundation, read this chapter carefully. To make surface preparation seem like less of a hindrance to your creativity, plan to prepare many pieces at once, in assembly-line fashion. That way, you'll always have several items on hand, and when the urge to paint strikes, you won't have to wade through the sanding and sealing chores.

This chapter covers the details you might need to attend to before decorating, such as gluing wood; using masks; stripping old paint and varnishes; staining wood; and preparing tinware, punched tin, glass, and note cards.

Wood

Gluing Wood

Some items include two or more pieces of wood that must be glued together when decorating is complete. To create a tight glue bond, glue raw wood to raw wood. Before sealing and basecoating any projects that will require gluing, be sure to follow the simple steps below.

1. Decide where the pieces will be glued. Roughly mark the outline of the piece to be glued on the item to which it will adhere (such as the chunky cutout mushroom glued to the plaque; see Quick and Easy Mushrooms, page 205).
2. Apply a couple of masking tape patches within the outline area drawn in step 1. The masking tape will prevent sealer and basecoat paint from filling the pores of the wood.
3. Seal, paint, decorate, and varnish the project pieces, working directly on top of the tape patches. Do not, however, seal, paint, decorate, or varnish the *back* of the item to be glued to the other surface.
4. Peel up the masking tape patches. If any residue from the tape remains, carefully remove it with acetone. (Acetone will also remove paint.) Spread glue on both pieces.
5. Press the pieces together and, with a damp cloth, wipe away any glue that oozes out from between them. Apply weight or pressure until the glue dries. Read the label on the bottle to determine drying time.

Contact paper and drafting tape masks have been applied to this project, which is now ready for basecoating.

Making Masks

Masks made of contact paper or drafting tape can simplify tricky tasks (such as painting circular and oval-shaped insets, and straight, even borders).

Contact Paper Masks

1. Basecoat or stain the project and let it dry thoroughly. Do not rush the drying or you will risk damaging the paint later when applying and removing the mask.
2. Draw or trace the shape to be masked onto the contact paper. Let's assume you need a mask for a circle such as the seat on the step stool shown below. Carefully cut out the circle. Save the cutout piece for possible use another time.
3. Remove the backing from the contact paper mask and apply the mask to the project. (In this example, the top of the stool is covered except for the circular shape.)
4. Firmly press down the edges surrounding the part to be painted (the circular shape). Use the back of your fingernail, the bowl of a spoon, or the edge of an old credit card as a burnisher. A tight bond will keep paint from seeping under the mask.
5. Apply paint within the masked area. Brush the paint from the edge of the mask toward the center of the shape, instead of from the center toward the edge of the mask. This way, you won't be pushing paint under the edge of the mask.
6. Gently peel up the mask. Save it for possible reuse. (I stick such masks inside the cabinet doors in my studio.) Also, see steps 3 and 4 under "Drafting Tape Masks."

Drafting Tape Masks

Use drafting tape or Scotch removable transparent tape to aid you in painting straight shapes such as borders and rectangles. (See Advanced Pears, page 176, for that project's marbled rectangular insets; and the borders on the Quick and Easy, Intermediate, and Advanced Mushroom projects, pages 204–211.)

1. Align the tape along the edges to be masked. (For an example, look at the steps on the stool shown at left.) Press the tape edges down snugly by burnishing with the edge of an old credit card, the

bowl of a spoon, or the back of your fingernail.

2. Apply paint, moving the brush away from the taped edge to avoid pushing paint under the tape. Also, try to prevent a builtup ridge of paint from forming along the edge of the tape. Use your finger to push the paint gently away from the edge if necessary.

3. When you finish painting, carefully peel up the tape and check for run-unders. If there is a ragged edge caused by paint creeping under the tape, quickly slide the chisel edge of a damp flat brush along the painted edge. If the paint is still wet, you may be able to remove it. If not, a quick retouch with the background color will redefine the edge.

4. If you need to camouflage imperfect edges, paint a simple stroke border along the edge. The strokes will conceal the irregularities and add a pleasing finishing touch to the project.

Painting Already Finished Wood

Raid your basement, attic, or garage: You'll probably find several wooden items you could paint on, things you just can't bring yourself to throw away but that are too tired-and drab-looking to fit into your present decor. Garage sales, flea markets, and antique shops are also good sources. To prepare a previously finished wood item for decorative painting, work in a well-ventilated area away from fire and flame, preferably outdoors, and follow the easy steps outlined below.

Cleaning

1. To remove all grease, oil, wax, and dirt, dip a #0000 steel wool pad in paint thinner or mineral spirits and buff lightly and quickly, moving the pad in a circular motion in one small area at a time.

2. Use a soft, clean cloth to wipe loosened residue from each area before moving on to the next.

3. Dip the steel wool pad in clean thinner to remove all residue and go over the piece one more time, moving in the direction of the wood grain and wiping up the residue with a clean cloth. If you plan to paint with acrylics, wipe the piece with a 50:50 mixture of vinegar and water.

4. Polish dry with a clean, dry cloth.

5. If the item has a high-gloss finish, rub lightly with fine sandpaper. This will create "tooth" to which your painting can adhere. Wipe gently with a tack cloth. Your item's

surface may now have a dusty look, which is caused by the fine scratches rubbed into the finish. Don't worry: A finishing varnish coat, when your decorating is complete, will bring the surface color back to life.

Your "found object" is ready for your magic touch. Change the background color if you like, add a faux finish, or get right to decorative painting.

Testing the Finish on Old Items

Upon completion of your decorative painting, you will want to apply a protective finish. Before doing so, you should try to determine whether your "found object's" finish—if there is one—is varnish, shellac, or lacquer. You should try to use the same type of finish that is already on the item. Some finishes are incompatible with one another and, when combined, result in blistering, crazing, cracking, or smearing. For example, lacquers contain such powerful solvents that their use over enamels, varnishes, oil stains, and products containing linseed oil or tung oil can easily soften or otherwise damage these undercoats. In addition, when used as a topcoat over any of these products, lacquer may craze or crack.

To avoid undesirable results in your finishing, first conduct a test. In an inconspicuous spot, brush on a layer of the finish you plan to use. Let dry according to the manufacturer's directions. If the finish blisters, crazes, or causes the finish underneath to soften or smear, do *not* use it to finish that piece. Test a different finish. If it appears compatible, apply a second test layer of the same product over the first. If it looks satisfactory, you should be able to use it without hesitation. To play it safe, isolate the unknown undercoat from the intended finish coat by applying a coat of shellac, which is usually invulnerable to the effects of the lacquer solvents. Read the label to be sure. Then finish your "found object" with confidence.

It's interesting to note that most antiques were initially finished with shellac. Spray lacquer was developed in the early 1900s, but was not widely used until after World War I. Today, most factory finishes are lacquer. To increase your understanding of the materials that are mixed together to create the products we buy and use, read *Coloring, Finishing, and Painting Wood* by Adnah Newell (Peoria, Illinois: C. A. Bennett Co., 1961). Also, read product labels. You'll find plenty of helpful information. Heed it!

Stripping Old Paint and Varnish

If the item is in poor condition, it is best to strip it to the raw wood and begin anew. You can do this with commercially available products, or you can make your own concoctions.

Using Commercial Strippers or Removers

You can find paint and varnish remover at your hardware store. It is available in both watery-thin and heavy, pastelike formulations. To remove multiple layers of paint and varnish, I prefer the remover with the heavier consistency; its wax base prevents the solvent from evaporating too quickly. For simple jobs, the thin remover is best.

Working with paint and varnish removers or strippers is messy business, so wear old clothes. Work in a well-ventilated area, preferably outdoors. Wear goggles and cotton-lined rubber gloves. A protective breathing mask is a good idea too, especially if you plan to strip a large item or several at one time.

Follow the manufacturer's directions for applying and timing the stripper, and for removing the "glop" it creates (either with water or by using a scraper). Then wipe the item with a neutralizer (turpentine, denatured alcohol, naphtha, or lacquer thinner) recommended by the manufacturer. This is particularly important when using a wax-based stripper, as a waxy residue will interfere with the adhesion of the new finish.

As an added precaution: Before painting with acrylics, wipe the article with a 50:50 mixture of vinegar and water to remove any oil residue and buff dry. If the item is large or intricate and required copious amounts of water to remove the stripper, let it dry thoroughly for several days before basecoating.

Making Your Own Strippers or Removers

There are effective and less expensive alternatives to commercial paint and varnish removers. Nearly every book on refinishing furniture lists one or more of that author's favorite concoctions, which usually include such ingredients as ammonia, baking soda, acetone, benzol, denatured alcohol, lye, lacquer thinner, and TSP (trisodium phosphate). The three home-brewed removers that seem to have widest appeal, and that I have found to be quite effective, are composed of ingredients that can be easily obtained from any well-supplied hardware store—ammonia, lye, and TSP. Ammonia and lye (sold as drain cleaner) can also be found in the cleaning supplies section of the grocery store.

Paint Removers. Try one of the three popular "home remedies" listed below. *(Caution:* Like commercial strippers or removers, these agents are caustic and should be used with the same precautions. Use an old brush for the TSP or ammonia solutions, and use a cotton dishmop for the lye, as lye will dissolve the bristles of a brush.)

1. One 20-ounce can of lye or Drāno poured slowly into 1 quart of very hot water.
2. Three cups of TSP (trisodium phosphate) added to 1 gallon of hot water.
3. Ammonia, used full strength.

Slather the solution on freely and generously, working it around to loosen the layers of paint. Let the solution act on the finish, causing it to blister and lift. Then use a metal scraper, such as a putty knife, to remove the resulting glop. A wire brush is helpful for removing stubborn paint or paint in intricate areas.

All solutions should be thoroughly rinsed from the item with water. Note that only the lye must then be neutralized with vinegar, and the item rinsed again.

Some darkening of the wood may occur with these solutions, as well as with the commercial strippers. If this is objectionable, lighten the wood by wiping it with any chlorine bleach, then wipe again with a damp cloth.

Lacquer/Varnish Remover. A popular, all-purpose concoction for removing old finishes *(not* paint) is a 50:50 mixture of lacquer thinner and denatured alcohol. Both the thinner and alcohol are solvents and work by softening the old finish. Apply the mixture liberally, in a small area at a time, with a #0 steel wool pad. Rub in a circular motion to loosen the old finish. Pick up as much of the glop in the pad as possible, squeeze it into an old coffee tin, rinse it in the concoction, and begin again. Give the item a final rubdown with #0000 steel wool, working in the direction of the grain. Wipe and buff with a clean, soft cloth. No neutralizing or rinsing is needed. The item will dry almost immediately. Traces of the finish remaining in the pores of the wood will act as a sealer.

With the old finish or paint removed, you are ready to proceed with surface preparation.

For a delightful discourse on stripping, read *Instant Furniture Refinishing and Other Crafty Practices* by George Grotz (New York: Doubleday and Co., 1966).

Preparing Unfinished and Stripped Wood

1. Repair any holes, dents, and flaws with the wood putty, wood filler, or spackle. Use the palette knife to mound the putty onto the flawed area. The putty will shrink slightly as it dries, so use a little more than you think you need. Let dry according to the manufacturer's directions.

2. Sand the puttied areas, moving in the direction of the grain of the wood. If the wood is in very rough condition, you may have to use a coarse-grit sandpaper to begin. Follow this with a gentle sanding using medium-grit sandpaper, then finish with fine-grit sandpaper. For wood items that are already very smooth, you may omit this step, sanding only the repairs made in step 1. (Many items sold specifically as painting projects are presanded.)

3. Wipe the project *very* lightly with the tack cloth to remove sanding dust. Do *not* rub the cloth on the surface; doing so may deposit a film to which the acrylic paint cannot firmly adhere. (If you want to stain rather than basecoat your surface, proceed to "Staining Raw Wood," page 96.)

4. Seal the wood with sanding wood sealer or fresh shellac. Try to brush smoothly, avoiding lap marks, ridges, runs, and sags. Let dry.

5. Sand very lightly, removing only the stiffened peach fuzz feel on the wood. Use #600 wet-and-dry sandpaper or #0000 steel wool.

6. Remove dust with the tack cloth.

7. Basecoat by applying several thin coats instead of one thick, ridgy one. Let dry thoroughly, sand lightly, and wipe gently with the tack cloth between each coat. If the color you want for a basecoat is too transparent to cover well, first basecoat the project with a color close to but more opaque than the one you'll be working with. Then use the desired color for the final coats. Your project is now ready for faux finish treatment or decorating.

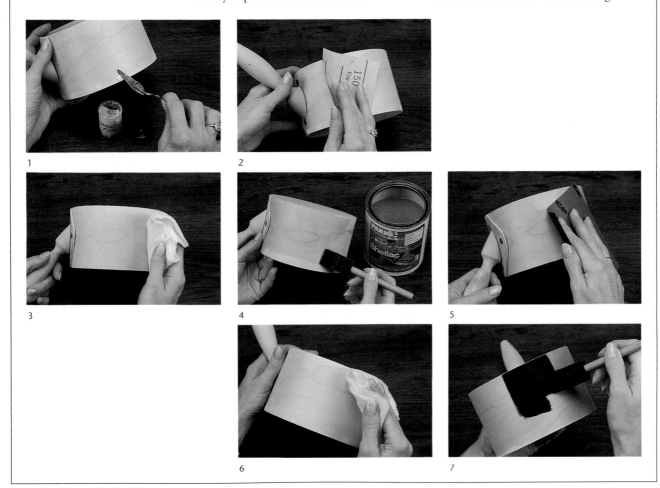

1

2

3

4

5

6

7

Staining Raw Wood

If the pattern of the wood grain (the light
and dark markings in the wood) is subtle and
won't overwhelm the decorative painting
design, you may prefer to stain the wood rather
than basecoat it with paint. (For examples of
staining, see Intermediate Pears, page 172,
and Advanced Blackberries, page 158.) Stains
are either oil-based or water-based.

Follow steps 1 through 3 for "Preparing
Unfinished and Stripped Wood," page 95. If
you want a deep stain, apply the stain before
applying the sealer (step 4). If the wood has a
prominent grain, you may prefer to seal it first
to help equalize the absorption of the stain.
Otherwise, the light areas and the crosscut ends
of the wood will absorb stain faster, and thus
turn darker, than the rest. Sometimes a second
coat of sealer may be required, especially on
the crosscut edges. Sand lightly after each coat
has dried. If you plan to do much staining,
look in your local hardware store for stain
controller, which can be used as a substitute
for shellac or sealer. Ready-made stains, both
oil- and water-based, are available at both
hardware stores and some craft shops. You may
work with these or make your own stains.

Making and Using Oil-based Stains

To make an oil-based stain, select a color of
artist's oil paint. (For a warm brown tone,
try burnt umber; for a cool brown tone, try
raw umber. You can also experiment—stains
are not necessarily limited to brown.) Squeeze
about a tablespoon of the paint into a small
jar or can; for a small item, mix the stain on
your palette. Slowly mix in mineral spirits or
paint thinner, blending until the mixture is
the consistency of half-and-half. Test your
stain in an inconspicuous place on your
project. If it seems too heavy or too dark,
thin it with more spirits or thinner.

Brush or wipe the stain generously on the
project. Let it rest for a few minutes, then
remove the excess with cheesecloth. Give the
project an antiqued appearance by wiping off
more stain in those areas that would receive
heavy use and leaving other areas, such as
crevices and corners, darker. While the stain
is still wet, or after it has completely dried,
you can emphasize dark areas by rubbing on
additional tube oil paint. Also, rub more paint
into the corners and grooves or carved areas.

Have some fun with oil-based stains.
Since stains dry slowly, you can use any of
the faux finish techniques (see Chapter 13),
to create various patterns on the wood.

Let the stain dry overnight, then apply a
coat of sealer, shellac, or varnish. This will
isolate the oils contained in the stain from
your decorating paints (important if you're
using acrylics) and protect your staining job
while you're working on your design. Sand
the sealer lightly to provide tooth to which
your decorative painting can adhere.

Making and Using Water-based Stains

You can purchase ready-made water-based
stains or you can make your own using acrylic
paints. As I see it, there are two benefits and
two disadvantages to using water-based stains.

Benefits
1. They dry quickly.
2. You don't have to worry about whether
 your acrylics will adhere to an oil-based
 undercoat.

Disadvantages
1. They dry quickly! You don't have the
 luxury of time, allowing you to work and
 rework (as with oil-based stains) until
 you're satisfied.
2. The wood tones, while quite adequate,
 are not as rich, clear, and deep as those
 achieved with oil-based stains. (I have
 been pleased, however, with all the
 acrylic-colored stains I've made.)

To stain with acrylics, follow steps 1
through 3 for "Preparing Unfinished and
Stripped Wood," page 95. Then choose one
of the two methods described below.

Method 1. To prevent the raw wood from
soaking up color uncontrollably, brush water
liberally over the project. Let it soak in briefly,
then blot any puddles. While the wood surface
remains damp, brush on acrylic paint thinned
with water. With a clean cloth, immediately
wipe the acrylic stain to get the effect you
want. If the color appears too pale after it has
dried, brush on a second coat. It's better to
apply two or three thin coats, building up the
color gradually, than to try to get a deep color
in a single application. The water will raise the
grain of the wood, so a light sanding will be
in order once your staining is complete. Apply
a light protective coat of varnish or sealer.

Method 2. Mix water-based varnish (thinned
slightly with water) with a scant amount of
any acrylic color of choice. Brush the mixture
onto the project in a thin wash. Let dry. Sand
the raised grain lightly. Apply additional
coats for deeper, richer color.

Tinware

It is believed that tinware first became widely available in America following the arrival in 1738 of two skilled tinsmiths from Ireland, William and Edgar Pattison. The brothers opened a shop in Connecticut and began producing much-needed household items. As an affordable substitute for more expensive silver and pewter and an ideal replacement for fragile china and bulky wooden implements, tinware's popularity quickly spread from one community to another through the efforts of itinerant Yankee peddlers. It wasn't long before the urge to decorate (by painting and punching) left its mark on a variety of utilitarian tinware items. Shopkeepers and peddlers discovered that decorated tinware had greater sales appeal; the ornamented pieces brought color or design to otherwise often drab surroundings.

Today, there seems to be no end to the variety and availability of shapes and sizes of tinware, both old and new, for decorating. Just look at some of the things in the far reaches of your cupboards (old pizza pans, muffin tins, loaf pans, and cookie cutters) and attic or basement (metal boxes, trays, cups, and Band-Aid boxes). Browse through antique shops and flea markets (dough risers, deed boxes, and coffeepots). If you round up a bunch of items and spend a day preparing them all at once, it won't seem as much of a chore as it is to do it bit by bit. When you're through, you'll have many things ready on which to do your decorative painting.

Before stripping old, previously decorated tinware, consult with antique dealers or museum curators. Your piece may be worth restoring. Should you wish to restore a period piece with authenticity, your librarian can direct you to several excellent books, written by knowledgeable authorities, on early decorative painting (also see the Suggested Readings); a museum curator may be able to recommend a skilled restorer. If the piece is not worth restoring, perhaps at least a tracing of its design is in order.

Preparing Old Tinware

Old tinware will be found in various stages of disrepair—some pieces needing quite a bit of preparation, others needing very little. If your tinware has never been painted and is not rusty, you can begin its preparation with the detergent scrub described below in step 3. If paint removal is necessary, begin with step 1.

1. For large pieces, use a paint stripper or a homemade concoction of 3 cups of TSP to 1 gallon of *hot* water. (You'll find both the stripper and the TSP at a well-supplied hardware store). Wear rubber gloves and use steel wool or a wire brush to loosen and remove all paint. To strip a bunch of small pieces quickly and easily, put them in a large pot of the TSP solution on the stove and bring the liquid to a boil. Reduce the heat to a simmer

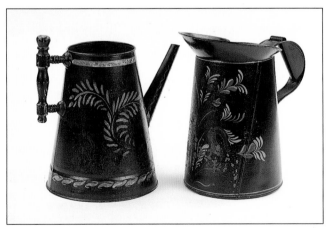

Before stripping old, already decorated tinware, consult with a knowledgeable source.

Tinware, both old and new, is more plentiful around your home than you might imagine. Everything from Band-Aid boxes, spice tins, and peanut butter jar lids to tinware items made especially for decorative painting are candidates for your decorative touch.

and watch the paint peel off. Rub off any tenacious bits of paint with a steel wool pad. I have even had some luck removing baked-on enamel from tins with this method, but it's not always effective.

2. Rusty or pitted surfaces require extra care. After removing paint, work with a wire brush and Naval Jelly or Rust-i-cide to remove all traces of rust.

3. Wash the item in strong detergent and water, removing completely the Rust-i-cide or Naval Jelly, or just the years of accumulated grime. Note: If you can wait 24 hours before continuing, leave the Rust-i-cide on to etch the metal.

4. Rinse the item in equal parts of water and cider vinegar to remove any lingering oil. Then rinse in clear water. Dry overnight (longer if there are seams and crevices in which water may linger). You can use a warm oven (200°F) to dry the pieces. If the tin has been soldered, be cautious about using an oven as high heat will melt the solder. Don't rush this final cleaning and drying step. Any oil or moisture left on the tin will prevent paint from bonding properly.

5. A wash coat of a surface etching product (such as Rust-oleum Surface Etch) will provide tooth to very slick metal surfaces and thus facilitate the bonding of primer and basecoat paints if Rust-i-cide was not used in step 3.

6. To inhibit future rust development, apply a coat of metal primer, such as Krylon Sandable Primer, or Rust-oleum. Several coats may be necessary on badly pitted pieces. Sand with #600 sandpaper or #0000 steel wool between coats to smooth bumps or ridges. Select the appropriate primer for the type of metal you are refinishing:

 For galvanized metals, use an alkyd-based primer of zinc dust and zinc oxide

 For steel or iron, use an alkyd-based primer of red oxide and zinc chromate

7. Brush or spray on the basecoat color of your choice using acrylics or satin finish enamel. Several thin coats are preferable to one thick, ridgy one. Avoid a flat paint finish as it is a more difficult surface on which to learn, and from which to remove mistakes. Also avoid using high-gloss enamel, as its slickness interferes with some painting techniques. If you spray on the basecoat, follow the suggestions for working with spray paints (see "Paint Smart!" page 103).

8. Sand after each coat of paint has dried with #600 wet-and-dry sandpaper or #0000 fine steel wool. Remove sanding dust gently with a tack cloth. Apply the next coat of paint.

9. Allow the final basecoat to dry thoroughly. The project is now ready for decoration.

Preparing New Tinware

1. A thin film of oil covers most new, unpainted tinware to prevent rust. Remove this coating with a detergent-and-water wash.

2. Follow steps 4 through 9 above. Or, instead of priming and painting the tinware, give it a luminous, transparent finish, as was often done by early decorators. Mix gloss or satin spirit varnish with any of the following artist oil colors: alizarin crimson, Prussian blue, verdigris, Indian yellow, gamboge, or raw umber. You can also use asphaltum, a colored varnishlike substance once popular as a translucent tinware basecoat (available from Crafts Manufacturing Co.) to obtain a traditional look. Apply an even coat over the clean, shiny, tin. Test the transparency of your mixture on a shiny tin can. Remember to ascertain the lightfastness of your brand and color of oil paint.

Decorating Factory-Primed and Prepainted Tinware

Some companies sell ready-to-decorate preprimed and basecoated tinware in a limited selection of attractive colors. No preparation is needed on your part. If, however, you are inclined to touch up mistakes or paint out passages and begin again, you would be wise to apply a basecoat on top of the factory-applied one. That way, you can be sure to have an exact color match for touching up.

Finishing Tinware

A protective finish will preserve your lovely handwork. Refer to Chapter 14, "Finishing Techniques." If your tinware has intricate features or lace-edge cutting, you may find that spray varnish is more suitable and easier to use than a brush-on finish.

Punched or Pierced Tin

SUPPLIES

Tin, aluminum, *or* copper flashing (sheet metal) or foil

A craft knife

#000 or #0000 steel wool

Duct tape, carpet tape, *or* wide, heavy masking tape

A scrap of lumber slightly larger than the metal to be punched

Transfer paper (optional)

A hammer

An awl *or* a large nail

Inexpensive wood chisels (optional)

A double-pronged corn-on-the-cob holder (optional)

The popularity of punched tin resulted from both its decorative appeal and its functional use. Lamps, lanterns, candlesticks and sconces, cheese molds, foot warmers, jelly cupboards, and pie safes were among the items decorated with punched designs. The designs, characteristically Pennsylvania German, permitted light to flicker through the punched holes in lamps and lanterns. The rays of light created decorative, mosaic-like patterns on walls and ceilings while illuminating the area. The ventilated designs in the foot warmers permitted heat to escape from the hot coals they contained. The oft-times elaborately punched panels in pie safes and jelly cupboards served our American ancestors as a forerunner to today's woven mesh screens. The airy panels protected freshly baked goods and jellies from creepy, crawly beasties and flying creatures while simultaneously providing ventilation. Traditionally, the tin was pierced from the back, instead of from the front (as is more popular today). This created a raised, rough surface on the front that better prevented insects from crawling through the holes. I prefer the traditional look and feel of punching from the back, but I enjoy combining both the traditional and the contemporary styles.

The punched tin cabinet project on pages 164–167 (Advanced Cherries) will give you a chance to combine both "innies" and "outies," and then decide which one you prefer. With just a hammer, a nail, and a piece of metal, you can recreate the charm of this early American decorative art form. Use your paints to add further embellishments. Although untraditional in concept, the cabinet is a delightful way to combine both tin punching and decorative painting. The pattern for tin punching the bird is on page 315; however, you can adapt any pattern you wish for punching. You can add or omit detail, punch large or small holes, and create different effects with wood chisels and other implements to suit your taste. Consider making punched panels to insert in window shutters or in cabinet doors. Enlist the aid of a youngster for the repetitive pounding. They'll love the feeling of accomplishment when they complete the project.

Punching Metal

While written specifically for the punched tin and painted cabinet on page 167, the following directions will enable you to tin-punch any design for any project. Before you start, also read "Hints for Punching Tin," page 165.

1. Cut the metal to size by first scoring it with a craft knife. Slide the knife blade along a straight edge such as a ruler. Remove the straight edge and bend the metal gently back and forth along the scored line until it breaks. This is much easier than trying to cut it with tin snips or shears.
2. Buff the metal on what will become the front of the project with very fine steel wool. Protect your work area with newspapers, and be sure to wipe the metal thoroughly to remove all steel wool particles. If you would like to give your metal an aged appearance, read "Antiquing Metal" (page 101) before proceeding. Otherwise, go to step 3.
3. Use the tape to fasten the metal to be punched to the scrap of lumber. If you are punching a small item with a simple design, you can omit the tape. If you are punching a large piece, particularly one that requires a lot of holes, you may wish to anchor the metal to the lumber with small nails in the corners and in a few places along the sides. The more you pierce the metal, the more it will buckle. That may alarm you at first, but you can correct it easily later.
4. Transfer your design onto the metal using transfer paper. If you do not wish to preserve your traced pattern, tape the pattern to the metal and punch the holes directly through both.
5. Before punching a project, practice a little to get the feel of the tools and to learn your strength. It isn't necessary to strike the nail or awl powerfully or repeatedly with the hammer. One firm tap is sufficient. Keep in mind that the harder you strike, the larger the hole will be. Conversely, lighter pressure will yield smaller holes. The choice is yours. Spacing of the holes is also optional: tight together or far apart. I generally space the holes about 1/4 inch apart. Experiment with spacing on your test piece. When you are satisfied with your technique, punch your project.

Using Other Tools

To add variety, you may wish to try an inexpensive wood chisel. They're available with straight, curved, and V-shaped blades. (I used a straight one on the wings and beak of the bird on page 167; a sharpened screwdriver makes a good substitute.) You can just punch holes, however, if you do not have such a chisel. A sturdy, double-pronged corn-on-the-cob holder will enable you to punch two holes at once; this is especially handy for a double-holed border. Experiment with other tools, even creating your own for special effects.

Holes In or Out?

Another way to add variety is to punch part of your design with the holes facing in, and the other part with the holes facing out. Look closely at the punched tin on page 167. Can you see that the holes outlining the bird are facing out (toward the viewer); and the holes forming the oval outline are sunken in (facing into the cabinet)? That means that part of the pattern must be punched on one side of the tin and the other part on the reverse. To punch the bird, my piece of metal was face down on the lumber scrap; my traced pattern was also turned face down on top of the metal. This ensured that the bird would be facing toward the left, and that the rough, raised parts of the holes would face out. The thrust of the nail through the metal forced the raw edges of the pierced tin to open on

the front. To punch the oval border, I turned the metal over, so that the rough openings of those holes appear on what will become the back of the cabinet door. (But wait—we're not ready to punch the border yet!)

Eliminating Buckling

After punching the bird design—but not the oval border—remove the pattern and the tape. You may find that the metal has buckled. To eliminate some buckling and reduce the risk of scratches from the piercing, use the hammer to pound, gently, the rough edges of the holes on the protruding side. (Gentle hammering was sufficient to eliminate the buckles on the bird design.) If you add a lot more detail to the pattern, or punch a busier pattern, your metal may not totally unbuckle during the gentle hammering process. If not, use a rubber mallet to pound it, or use an old rolling pin to roll it flat, just as you would roll out pie dough.

After flattening the metal, you are ready to punch the border. To be sure that your border will align perfectly with the opening in the door frame, place the metal inside the frame. Use a pencil to mark a line indicating where the opening of the frame will sit. Remove the metal and sketch a second line approximately 1/4 inch inside the line you just drew. Punch holes along the inner line. This will allow some space between the punched border and the framework.

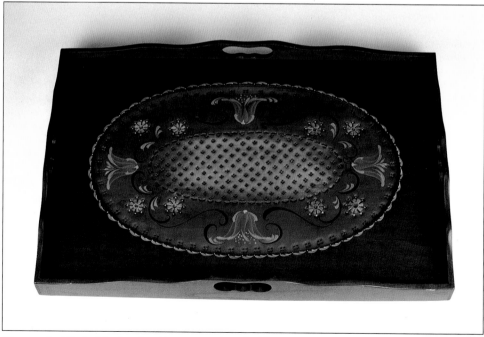

The punched tin in this glass-lined tray was antiqued with Brasso. A double-pronged corn-cob holder was used to punch the border and the center oval. Curved and pointed chisels were also used.

Rubber gloves

Liver of Sulphur (for copper; available at hardware and craft stores, and can be ordered by mail from Char-Lee)

Muriatic acid (for aluminum and tin; available at paint and hardware stores)

Brasso (for aluminum and tin; available at grocery and hardware stores)

A disposable foam brush *or* paper towels (for applying the antiquing solution)

Fine steel wool

Matte acrylic varnish

Oil paints

Clear Antiquing Glaze Medium (see page 293)

Antiquing Metal

If you prefer your metal to have the patina of age, following are a few of my favorite tricks for dulling the shiny newness.

Antiquing the metal may be done either before or after punching. If you plan to punch the holes facing out, however, it is best to antique *before* punching. (Buffing the metal over the raised holes is nearly impossible.) If you plan to punch the holes so that the raised part faces into the project, you may antique *after* punching, if you prefer. Antiquing with Liver of Sulphur or muriatic acid must be done *before* any decorative painting, while antiquing with Brasso or oil paints may be done *after*. Practice on a sample scrap of metal before antiquing your project.

As with every lesson in this book, experimentation yields fascinating results. Try buffing the metal with steel wool before treating it with chemical. Try different strengths of the Liver of Sulphur mixture. A weaker solution will give you a much different effect. (I wanted dark coloration behind my cherry leaves with the punched bird, so I used a stronger solution.) Try rubbing with the steel wool *before* the solution dries. Try dabbing and brushing the chemicals on; each creates different results. Several years ago, I totally immersed myself in tin punching and antiquing. We had experiments going on around the house all the time. The discoveries were always exciting. Do you know what happens if you heat copper in the oven, on a burner, or over the barbecue grill? Or how eggshells might affect the metals? How about Naval Jelly and gun-metal bluing? A world of fun awaits you.

A note of caution: For those processes that use chemicals, be sure that you have *abundant* ventilation and breathing protection, use rubber gloves, and follow the manufacturers' recommendations. Although the word "chemicals" always makes a process sound complicated, in reality the following processes could not be much simpler. So do not be dissuaded, just be judicious. Just as you protect your work area with newspapers, protect your health with good sense.

Copper

1. Thoroughly mix a small amount of Liver of Sulphur with water. You need only enough to cover your metal. For a 9 × 12 inch piece, $1/4$ cup of water with a capful of Liver of Sulphur should be sufficient. Use a disposable foam brush or a wad of paper towels to brush or dab the mixture onto the metal. It will immediately turn a dreadful-looking blackish gray. If the copper does not begin to discolor immediately, your solution may be too weak. Add a tiny bit more Liver of Sulphur and try again.
2. Let the metal dry. Buff it with fine steel wool until you achieve the patina you desire.
3. Spray with matte acrylic varnish. Then decorate with paint.

Aluminum

Muriatic acid works on aluminum in much the same way that Liver of Sulphur works on copper. Use extreme caution in working with the acid. The odor will be enough to remind you not to breathe the fumes. Work outside.

1. Using a disposable foam brush, brush the muriatic acid onto the aluminum. The reaction of the acid on the aluminum will create heat and vapor.
2. Let the metal dry.
3. Rinse with water. If the effect is not as aged-looking as you would like, apply a second coat of acid. Let dry, then rinse.
4. Wipe the metal dry, then buff with steel wool to get the desired patina.
5. Spray with matte acrylic varnish. Decorate with paint.

Tin

1. Rub Brasso vigorously on the tin until it turns a lovely pewter gray.
2. Let it dry over night. Avoid fingerprinting the grayish film.
3. Spray with matte acrylic varnish. Decorate with paint.

Glazing for an Antique Look

If you prefer to avoid chemicals but still want your punched metal to have a mellowed look, try glazing for an antique look with oil paints. See the section on "Antiquing" (pages 293–295) for instructions on how to make the antiquing glaze medium. If you will be decorating with acrylic paints, apply the glaze *after* completing the decorative painting.

Other Surfaces

Preparing Glass

Wash the glass with detergent and water. Rinse. Rinse again with a 50:50 solution of vinegar and water. Dry.

Painting on glass can be slippery business. Since glass is slick, it lacks tooth to grab and hold the paint. If you find the slickness frustrating, try one of the following:

- Paint on pre-etched or frosted glass.
- Etch the glass yourself, using an etching solution such as B & B Etching Cream (available at craft stores).
- Lightly spray the glass with satin varnish or clear acrylic spray. The spray will "frost" the glass slightly, leaving it no longer clear, but adding a little tooth to hold your paint.
- Brush on satin- or matte-finish varnish within the pattern area only. This will leave the remainder of the glass clear, but provide tooth where it's needed.

- Buff the glass with a paste made of cleaning fluid (such as Varsol) and talcum powder. Work with good ventilation and avoid breathing in the fumes of the cleaning fluid.

Preparing Notecards

Impress your friends and relatives with handpainted notepaper and envelopes. Working on notecards will give you the opportunity to develop your design and compositional skills with very little risk, and will make the recipient feel very special. And that's always a nice touch!

Keep a stack of stationery near your painting table. When you're practicing new flowers, stroke borders, and other motifs, you can practice on notepaper. If you're working with acrylics, you can work directly on the paper. If you're using oils, first squeeze them onto a paper towel to soak up excess oil, then lightly spray the notepaper with clear acrylic spray. This will prevent an oily halo from seeping out around your painted design.

A selection of painted notecards and stationery.

Paint Smart!

- **Avoid combining oils and acrylics.** Acrylics will not adhere forever (if at all) to an oil-based undercoat. Although they may appear to be stable for a while, delamination is a real possibility since each medium cures with a film characteristic to which the other mediums cannot easily bond. Don't disappoint a distant descendent by trying to paint acrylics over oils. All your hard work may peel off before your great-grandson inherits your masterpiece. If you use an oil-based product (such as an oil stain), isolate it with a layer of varnish or shellac after it has thoroughly dried and before decorating with acrylics. A light sanding of the varnish or shellac will provide tooth to which the acrylics can adhere.

- **Speed-drying oils.** If you are decorating with oil paints, avoid the practice of lightly spray-varnishing to rush the drying time. A little too much spray might create a film across the paint and trap the vapor in the oils. In time, a blister or crack might develop and the paint may begin to peel. The practice is risky, and thus best avoided.

- **Shellac.** Shellac has a specified shelf life, so check the can for an expiration date. Old shellac will not dry properly and should not be used. If in doubt, test it on a scrap of wood. If it dries within the time specified by the manufacturer, it is still okay to use. If it remains tacky beyond the stated time required for drying, throw it out; it cannot be reconstituted.

 Fine furniture craftspeople have long favored shellac as a sealer. It seals the pores of the wood, preventing resin and tannin from seeping through the basecoats to stain and spoil the final finish. (Excessively sappy knots should be sealed with aluminum paint to prevent them from bleeding through.) Shellac is a versatile and time-proven sealer/finish. It is not usually affected by the solvents in lacquer and it can be applied over oil paints and varnishes.

- **Tack cloths.** Keep tack cloths in a tightly sealed jar to keep them as fresh and as clean as possible.

- **Spontaneous combustion.** Cloths used with volatile substances should be rinsed with water to prevent spontaneous combustion. Never toss them, unrinsed, into the trash.

- **Turpentine, thinner, and mineral spirits.** What are the differences? Mineral spirits and paint thinner are essentially the same thing and can be used interchangeably. Gum turpentine is more expensive and may impair drying times.

- **Spray-painting techniques.** If done properly, spray painting will result in a smooth surface. Test the spray head to make sure it doesn't sputter. If it does, remove it from the can and try cleaning the opening with a fine pin or wire. Do not attempt to poke anything into the top of the can itself.

 Hold the can approximately 18 to 24 inches from the item to be sprayed. Begin spraying off the edge of the project. Sweep across and off the other edge. Never start or stop spraying while aimed directly at the project. Continue spraying back and forth, each time extending beyond the edges of the project. This will prevent a thick buildup of paint along the edges.

 Once you've finished spraying, invert the can, aim away from your project, and depress the spray nozzle until the stream of air runs clear. This helps prevent clogging of the nozzle.

 Note: The can of spray paint, the object being painted, and the surrounding temperature should be about 72°F.

- **Staying healthy.** The truly smart decorative painter will use precaution when working with surface preparation chemicals, paints, and varnishes. Proper ventilation, protective breathing gear, and gloves are essential. Read precautionary labels on all products and heed their advice. And please, be environmentally conscious when disposing of such materials.

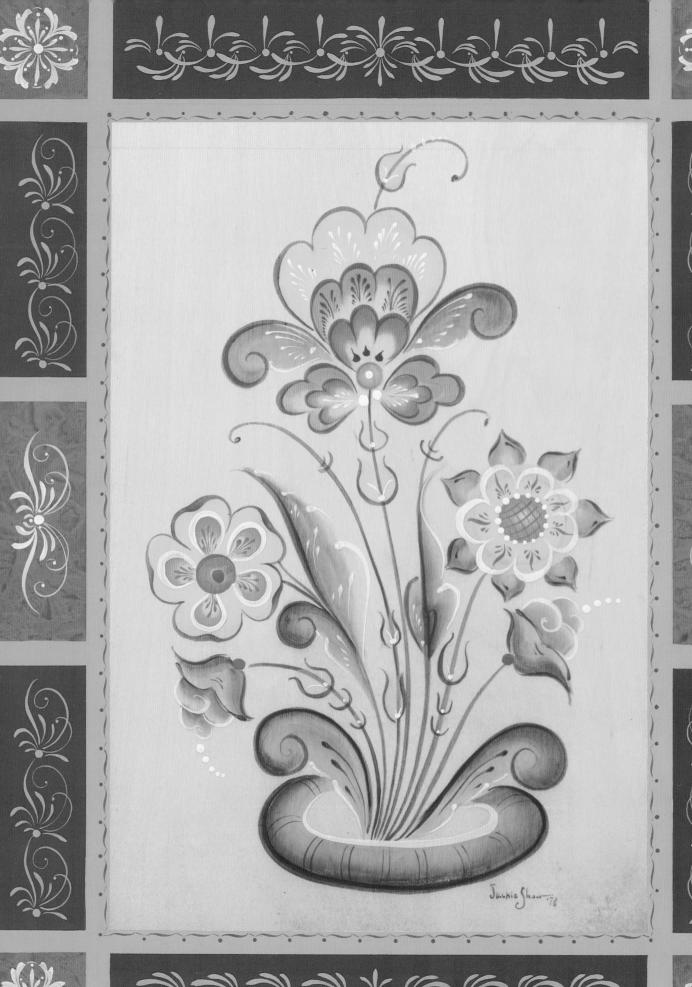

Chapter 7

Brushstroke Designs

With your new foundation of skills—color mixing, brush loading, brush control, blending, and surface preparation—you're ready to embark on a decorative painting adventure. In this chapter, you'll discover the excitement of combining basic brushstrokes to create designs. By using only a few carefully placed strokes—forming an economy of design—you can make an entire painting, simple, bold, and forthright.

As you begin your exploration, think of each variety of brushstroke as a distinct typeface. While some block-style alphabets are plain and unadorned, others, like ornate scripts, are more complex. By intricately combining our "letters," we can create an elaborate, flowery "text."

In the Quick and Easy brushstroke design, you'll discover how effectively a single stroke (the comma stroke) can be arranged and combined with others to create a simple but pleasing composition. The Intermediate and Advanced designs will give you an opportunity to experiment with a variety of brushstrokes. Creating your own designs is also fun. By selecting strokes to represent different types of petals and leaves, you can paint flowers that are similar to those in your garden as well as those that exist only in your imagination.

Since these projects will be your first encounter with patterns, you should read through Chapter 15, "Working with the Patterns" (pages 296–303), before you begin. You'll find the information on transferring, reducing, and enlarging patterns indispensable. Keep in mind that the patterns have been reduced to fit on the pages of this book, so if you plan to use a pattern exactly as it is shown in a project, you'll need to enlarge it first. If you have access to a photocopier that enlarges images, you can take advantage of the percentage for enlargement that accompanies each pattern so that you can use it at the "right" size for its particular project without having to rely on a pantograph or make a proportional grid.

With just a little experience, you can create elegant and imaginative brushstroke designs.

Practice Makes Perfect

To display both your realistic and imagined flowers effectively, learn to form graceful, flowing stem lines. Study the sample combinations of lines shown below. Then load your liner brush with thin paint and begin practicing. Begin each stroke at the base and pull to the tip. Think of it as painting the flower stems the way the flower grows—from the ground up. Practice painting groupings of three strokes repeatedly until you can consistently create pleasing, balanced clusters.

Next, add additional lines. Finally, add flowers and other strokes. Work to develop your skill so that you can create flowing designs spontaneously with your liner brush. Remember to include contrast: thick/thin, long/short, very curvy/not so curvy.

Practice painting designs such as the one shown at the top of the opposite page. These designs are nice to paint on the backs or undersides of things, and you can also use them to encase your signature.

Once you've learned to create pleasing and balanced arrangements of stem lines with the liner, substitute the flat brush and practice again, this time making S and scroll strokes.

Embellish the strokes with the liner brush. Avoid simply outlining all the strokes. To do so will make your work appear stiff, as though it were cut out of paper and stuck on your project. Breathe life and energy into it by leaving breathing spaces—little interruptions in the long outlining strokes. These interruptions not only give you a chance to catch your breath (you may find yourself tensely holding it when adding the embellishments), but they also provide areas where additional strokes can be worked into the design.

You can create entire designs based on scroll work. (An example is shown below, opposite. The pattern for this design is on page 305.) Choose a simple color scheme, and antique or not to suit your taste.

While you're developing your skill in painting graceful, flowing lines, also work to develop a collection of fun-to-paint flowers. I've included a few on pages 108 and 109 to get you started.

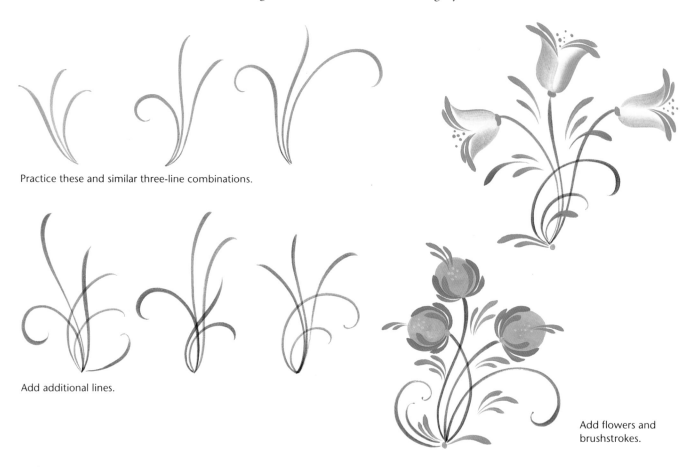

Practice these and similar three-line combinations.

Add additional lines.

Add flowers and brushstrokes.

106

Have fun creating designs such as this one.

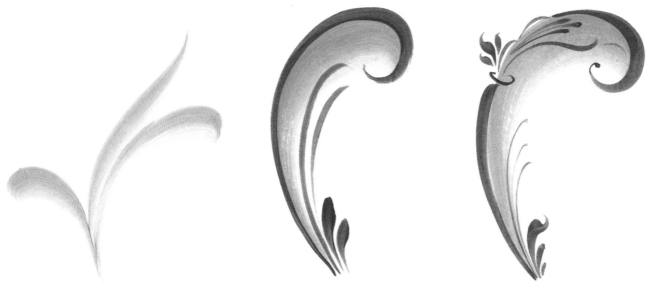

Use the flat brush to add weight and bulk to some designs.

The embellishment at left is too stiff and confining. Build breaks into the outlining, as in the example at right, to create interest and variety.

An entire design based on scroll work.

Quick and Easy Stroke Flowers

These flowers are composed entirely of comma strokes.

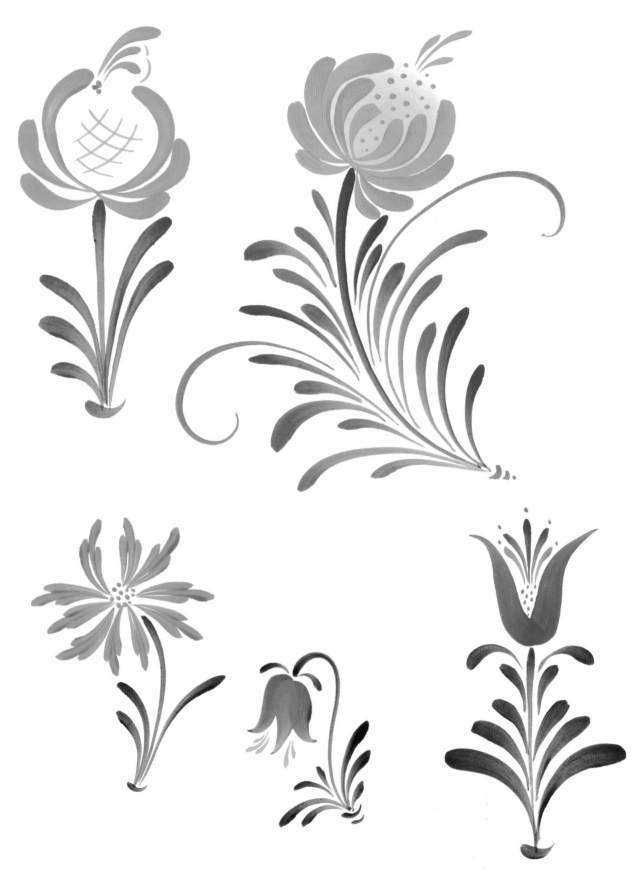

Intermediate/Advanced Stroke Flowers

The fanciful flower shown below contains a variety of strokes. Notice how crosshatching was used to provide a broad—but not too heavy—stem to support the large flower head.

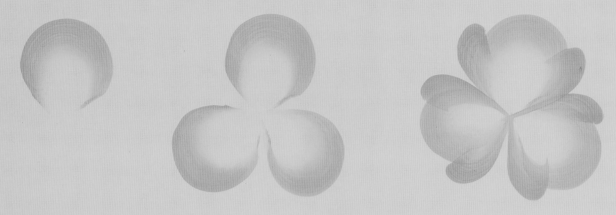

To paint the flower, start with the main, outside flat brushstrokes (such as the large crescent stroke above left). Paint that stroke for each section of the flower. Then, add lesser side strokes (such as the red scroll strokes).

Next, fill in the center. In the example at right, the suggested sequence of the strokes is numbered. Repeat each stroke in all sections before going to the next numbered stroke. Finally, add liner brush embellishments.

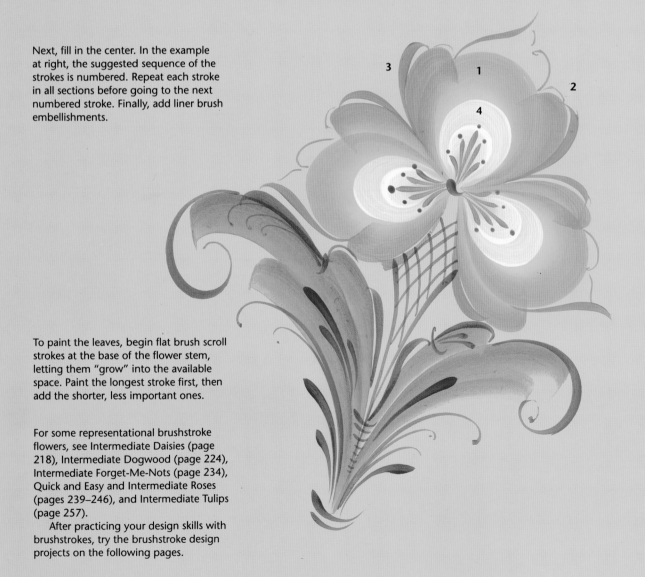

To paint the leaves, begin flat brush scroll strokes at the base of the flower stem, letting them "grow" into the available space. Paint the longest stroke first, then add the shorter, less important ones.

For some representational brushstroke flowers, see Intermediate Daisies (page 218), Intermediate Dogwood (page 224), Intermediate Forget-Me-Nots (page 234), Quick and Easy and Intermediate Roses (pages 239–246), and Intermediate Tulips (page 257).

After practicing your design skills with brushstrokes, try the brushstroke design projects on the following pages.

Quick and Easy Stroke Design

PROJECT
Folding step stool from
Crew's Country Pleasures

SKILLS NEEDED
Comma stroke
Lettering (optional)
Antiquing (optional)

PATTERN
Page 304

PALETTE
A Forest Green
B Rookwood Red
C Cadmium Red
D Country Red
E Evergreen
F Avocado

BRUSHES
Round: No. 3
Liner: No. 1

MISCELLANEOUS
Contact paper (for
making the circular
mask)

Masking tape

Commercial stain,
Wood 'n Resin Gel
Stain in walnut, *or*
burnt umber oil
paint (all optional)

Mineral spirits (to
thin the burnt umber
oil paint)

Cheesecloth (optional)

Clear Antiquing Glaze
Medium, page 293
(optional)

With the exception of the lettered quotation on the steps of the stool, this project contains only one type of stroke: the comma stroke. Beginning painters, or those who are unsure of their lettering skills, may omit the quotation and substitute in its place the design provided on the pattern.

The flowers in this design were inspired by the wonderful folk art of Hindeloopen, a delightful village in the Netherlands near the North Sea. To see a unique monochrome example of the traditionally brightly colored Hindeloopen style of folk painting, turn to page 10.

Surface Preparation

1. Seal the step stool. Let dry. Sand lightly.
2. With **A**, paint an 8$\frac{1}{4}$-inch-diameter circle in the center of the seat. (Mask the surrounding area with contact paper to make the basecoating easier. Refer to "Making Masks," page 92.) Also paint an inset on each step. Use $^3/_4$-inch masking tape to mask $^3/_4$ inches in from each edge, leaving a narrow rectangular band in the center. Paint this area with **A**. Remove the masks.
3. Stain the step stool with a commercial stain, with Wood 'n Resin Gel Stain, or with burnt umber oil paint thinned with mineral spirits. (Refer to the section on "Staining Raw Wood," page 96.) Apply stain more heavily near the edges of the green insets. Rub some of the stain onto the edges of the insets, fading gradually into the green background. Let dry.
4. Apply a coat of sealer or varnish to the seat and the steps to seal the stain before decorating with acrylics. Let dry.

Painting Instructions

Flowers

1. Using the round brush, undercoat the flowers with comma strokes of **B**. Start with a pair of comma strokes, leaving a space in the center.
2. Paint a short, fat comma stroke to fill the center.
3. Complete the undercoat with a pair of comma strokes, one on either side of the center strokes.
4. Use the liner brush and a mixture of **C+D** to paint highlighting strokes on one side of the flower. Keep the strokes thin and delicate. Add a dot at the base of the flower.
5. With a mixture of **B+E**, use the liner brush to paint shading strokes on the other side of the flower.

Leaves

1. Use the round brush to paint some single comma stroke leaves with **E**; paint others with a mixture of **F** plus a little **A**.
2. Paint stems and double-stroke leaves with the **F+A** mixture.

Lettering (optional)

Use the liner brush and the **F** plus a little **A** mixture to letter the following:

> All great accomplishments
> begin with the first step.

Antiquing (Optional)

After the painting has dried, use the cheesecloth to rub the antiquing around the outside edge of the seat and onto the top of the border to subdue it slightly. Also antique the edges of the steps. Let dry. Varnish the entire stool with several protective coats.

Quick and Easy Stroke Design

FLOWERS

1. Make a pair of comma strokes with **B**.

2. Fill in the center.

3. Add two more comma strokes.

4. Embellish with highlighting strokes of **C+D**.

5. Embellish with shading strokes of **B+E**.

LEAVES

Paint some comma strokes with **E**, others with **F+A**, to represent leaves.

Paint other leaves with pairs of strokes using **F+A**.

PALETTE A B C D E F

These flowers and leaves are composed entirely of comma strokes.

With the exception of the lettering on the steps, the motifs on this step stool (a Quick and Easy lesson) are composed entirely of comma strokes.

The completed step stool project.

Intermediate Stroke Design

PROJECT
Cut-corner beverage tray
(#30-383) from Cabin
Craft Midwest

SKILLS NEEDED
Scroll strokes
Crescent strokes
Leaf strokes
S strokes
Comma strokes
Fern strokes
Teardrops
Sideloading

PATTERN
Page 305

PALETTE
A Antique White
B Jade Green
C Gooseberry
D Sand
E Peaches 'n Cream
F Forest Green
G Colonial Green

BRUSHES
Flats: Nos. 12, 8, and 4
Liner: No. 1

Before starting this project, study the different types of Intermediate Tulips illustrated on pages 257 and 258. You can have fun substituting different flowers for those shown on the painted sample. It's also very easy to substitute a different color scheme, as shown in the photographs of the finished projects on page 114.

Surface Preparation

1. Basecoat the tray floor and top edges with **A**.
2. Basecoat the sides and underside with **B**.

Painting Instructions

1. **Scrolls.** Paint the large scrolls first, then the smaller ones. Fully load the No. 12 flat brush with **A**, then sideload it with a little **B**. Blend the colors on the palette to create a pale, dull green on one side of the brush. If needed, dip the other side of the brush in a droplet of water or extender to moisten and thin the paint. If the scroll strokes appear too dark, wash over them, when dry, with a thin layer of **A**.
2. **Large tulips.** Fully load the No. 8 flat brush with **A**, then sideload it with very little **E+D**. Paint the outside strokes first, then the inner ones.
3. **Small tulips.** Use the No. 8 flat brush, loaded as in step 2. Paint the two outside petals. Rinse the brush, then fully load it with **A** and sideload it with very little **C**. Paint two **S** strokes to form the center of the tulips.

4. **Small corner flowers.** Sideload the No. 4 flat brush with **E+D**. Paint five crescent strokes for each flower. To paint the ball shapes, load the brush with **A**, then sideload it with **C** and paint circle shapes.
5. **Center flower.** Fully load the No. 8 flat brush with **A**, then sideload it with very little **C**. Paint two long, narrow leaf strokes for each petal. Paint the center circle shape in the flower with the No. 8 flat brush loaded first with **A**, then sideloaded with **E**.
6. **Details.** Use the liner brush to paint the following:

 Center flower. Detail the center flower with teardrop strokes of **E+D**. Add more teardrops of **D**. Paint comma strokes on one side of each petal with **D** and add dots of **D** around the center.

 Tulips. Embellish the tulips with comma strokes, wiggly-tail teardrop strokes, and scroll strokes of **D**.

 Corner flowers. Embellish the corner flowers with crescent strokes and comma strokes of **D**.

 Scrolls. Embellish the scrolls with a mixture of **F+E+A**. Adjust the green so that it's slightly darker than the flat brushstrokes.
7. **Finishing touches.** Add additional strokes of **G+A** (crescents, chocolate chips, commas, sliding teardrops, and dots).

Intermediate Stroke Design

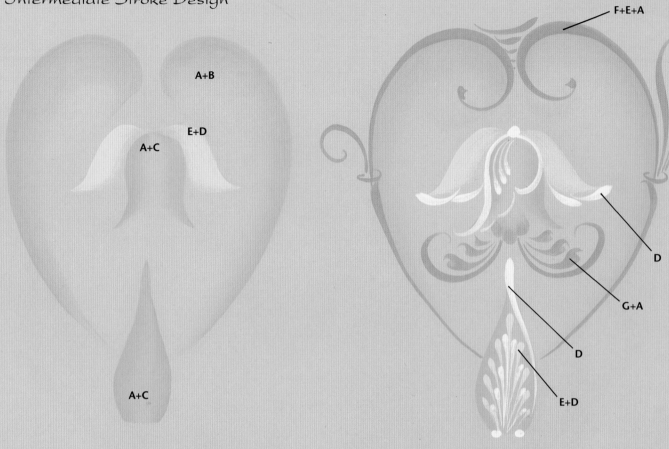

F+E+A

A+B

E+D

A+C

A+C

D

G+A

D

E+D

1. Paint all flat brushstrokes before adding embellishments.

2. Add embellishments with the liner brush.

PALETTE A B C D E F G

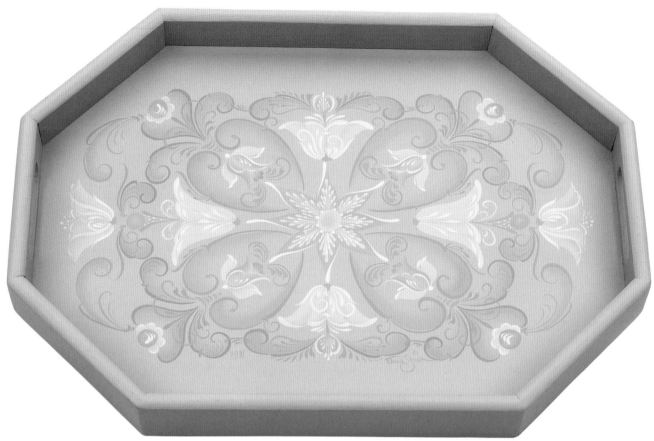

The completed cut-corner tray project.

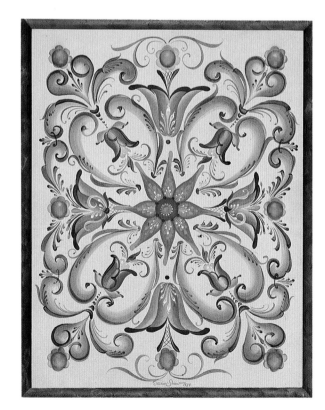

The cut-corner tray design painted in a door panel with a bolder color scheme.

Additional Intermediate Stroke Design

PROJECT
An 11¹/₄-inch circular tray, a 12-inch plate, or a similar-sized square surface. This design can be easily adapted to a larger project by adding borders as needed to fill the additional space.

SKILLS NEEDED
Flat brush scroll, crescent, and S strokes

All liner brush detail strokes

Marbling with crumpled plastic (optional)

Gold leafing (optional)

PATTERN
Page 306

PALETTE
A Midnite Green
B Rookwood Red
C Venetian Gold
D Glorious Gold

BRUSHES
Flat: No. 6
Liners: Nos. 1 and 10/0

MISCELLANEOUS
Gold leaf (optional; see pages 283–285)

Gold leaf size (optional)

If you are confident in your mastery of brushstrokes, you can complete the decoration of the tray shown on page 117 in two hours or less.

Surface Preparation

1. Basecoat the floor and outside edge of the tray with **A**.
2. Basecoat the inside wall of the tray with **B**.
3. Apply gold leaf to the inside wall. (Or omit the gold leaf and paint the inside wall with **D**. Let some of the red show through to give an aged appearance.)
4. Marbleize the outside edge of the tray by scumbling on thinned **C** and **D**, then pressing crumpled plastic wrap into the wet paint to lift out a pattern.

Painting Instructions

1. Sideload the flat brush with thinned **C**. Begin painting the crescent-shaped border design with the center flower. Since the design is symmetrical, paint one or two strokes on one side, then repeat them on the other side. (If you complete one whole side first, and then try to do the other side, you may discover it is difficult to match your strokes, especially if you improvise as you go along.) Keep the paint very thin so that details applied later will show strikingly.

2. Paint the asymmetrical motif at the top of the tray using the No. 6 flat brush sideloaded with thinned **C**.
3. Fully load the flat brush with **C** to paint your initial or monogram in the center of the tray. (Refer to Chapter 12, "Lettering.") Use the flat brush instead of the liner in order to form a more substantial letter.
4. Using **D**, embellish the scroll, crescent, and S strokes with your favorite liner brush detail strokes. Be sure to emphasize contrast among your strokes: thick/thin, long/short, very curvy/not so curvy. Leave some breathing room for your underlying strokes. Don't outline all the way around everything! Remember to paint just a couple of strokes on one half of the design and repeat them on the other half. It's easy to get carried away when doing the detail work; and it's hard to remember what strokes you put where when you embellish one entire side first, then try to do the other.
5. Use **D** to decorate your initial or monogram using the flowing lines you practiced on page 106. Add a few flowers and simple leaves with **C**. Use **D** for the detail work.

Finishing

Paint a pretty border on the back, sign it, varnish it heavily, and use it with joy!

Marbleize the sides of the tray with plastic wrap and light and dark metallic gold paints.

Additional Intermediate Stroke Design

An additional design to have fun with.

1. Undercoat the design with flat brushstrokes of **C**.

2. Using the liner brush, embellish the flat brushstrokes with **D**.

Use plastic wrap to marbleize the sides of the tray or plate with **C** and **D** thinned with water.

PALETTE A B C D

Additional Intermediate Stroke Design

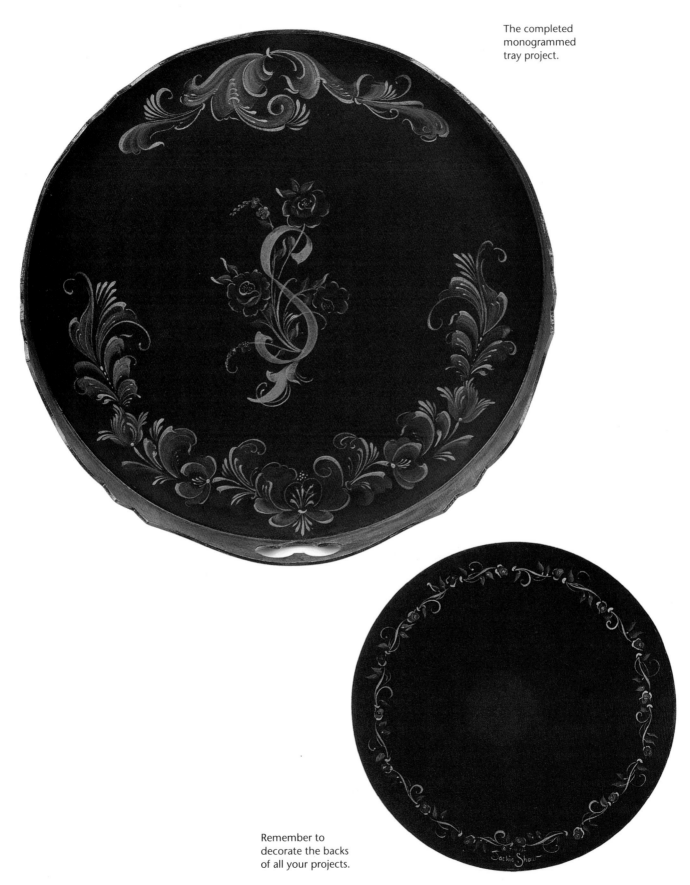

The completed monogrammed tray project.

Remember to decorate the backs of all your projects.

Advanced Stroke Design

During my early decorative painting days, two painting styles had a great impact on my emerging style: the simple stroke designs of early American country painting and the exuberant, flourishing strokes of Norwegian rosemaling (flower painting). It was the latter, as demonstrated by Norwegian artist and my friend, Sigmund Aarseth, which inspired my creativity with the paint brush and paved the way to finding real excitement in freehand brushstroke designing. The design in this lesson is inspired by the brushstroke work of rosemaling.

I encourage you to try to paint the design on the bucket without the pattern. Trying to paint free-flowing stroke designs within a pattern area is confining, and stifles your own creativity. If working the design freehand seems too intimidating at first, practice combining strokes to form portions of the design. Work with a large brush, which will force you to be a little freer. If you do trace the pattern onto your project, trace as few lines as possible. Then, when painting, don't worry if your strokes don't follow the lines exactly. Let the design change and develop as you go. Use a combination of liner brush detail strokes for embellishments.

Surface Preparation

1. Stain the bucket, leaving the band in the center lighter in color. Apply stain heavily around the top edge of the lid.
2. Seal the bucket and lid with one or two coats of sanding wood sealer. Dry each coat, then sand lightly and wipe with a tack cloth.
3. Paint the edge of the lid and the two bands on the bucket with a rich, dark brown mixture of **B+C**.

Painting Instructions

1. Sideload the 1/2-inch flat brush with **A**. In each portion of the design, paint the larger scroll first to establish the flow of the design; then add the lesser scrolls to fill out the shape. On the flower designs, start at the outside and work in toward the center.
2. Embellish the design with liner brush detail strokes. Use a dark brown mixture of **B+C**. Remember to take advantage of contrasting strokes (long/short, very curvy/nearly straight, thick/thin) to create interest. Be sure to leave some breathing spaces so the scrolls have a light, airy look to them. If you outline one side of a scroll heavily, use a delicate touch on the other side.

Don't forget to paint a border inside the bucket and another one under the lid.

Advanced Stroke Design

1. Begin with this stroke.
2. Add lesser strokes, placing them beside the main stroke.
3. Add strokes in opposing directions, making sure that they flow easily into the main scroll.

1. To make flowers, begin with main outside strokes.

2. Add inside strokes.

3. Add remaining strokes to fill and further develop the design.

These are a few detail stroke combinations to help you get started in embellishing your work.

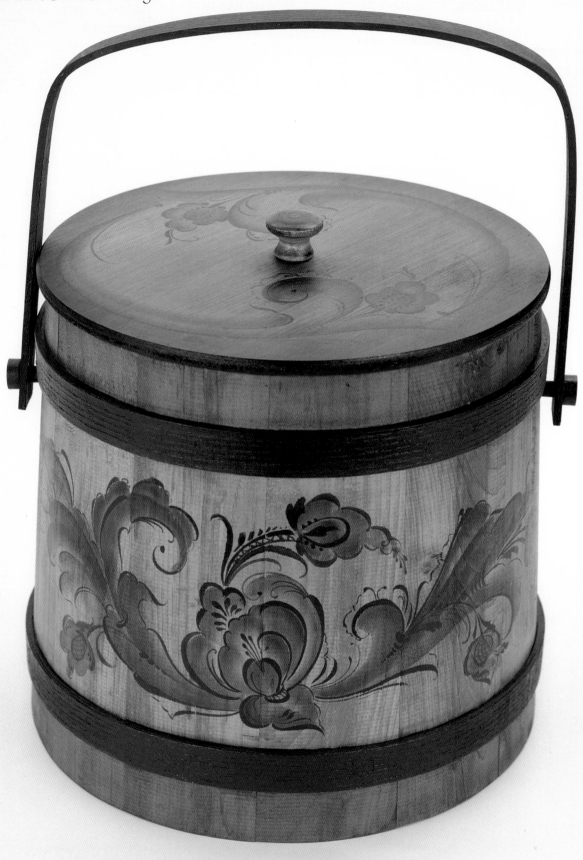

The completed 40-pound bucket with lid project.

Chapter 8

Developing Your Painting Skills

This chapter's step-by-step lessons and worksheets on leaves, ribbons, and waterdrops are intended to enhance and help you develop further the brushstroke and blending skills we've covered in the preceding chapters. These motifs and forms occur throughout the book, and in many ways serve as a summary of recurring challenges in color, value, blending, shading, highlighting, and relationships of light and shadow. The three chapters that follow focus on step-by-step lessons for painting a variety of fruits, vegetables, and flowers. Each subject is presented on three skill levels, and each lesson is included in a completed project to inspire you to use it to embellish and personalize your surroundings. (Reread "Getting More for Your Money," page 10, to review how to take advantage of the patterns and lessons for all three levels regardless of your skill.)

While you're working on your projects, don't try to make your paintings match the worksheets exactly. Each worksheet is just a guide, *one* way to paint the design; a map to get you from point A to point B. I find it difficult to paint an exact copy of something that I myself have previously painted, so it's reasonable for you to expect that you, too, might have difficulty duplicating a worksheet exactly. The important thing is that you learn and understand the techniques and how you can use them. There will, no doubt, be some frustrating times, but I hope there will mostly be times when the joy of discovery and accomplishment will buoy your spirits.

Before painting on your furnishings or other projects, be sure to read the chapters on surface preparation, lettering, special effects, finishing techniques, and patterns, where you'll find a wealth of information to help you make the most of your decorative painting.

Once your confidence has grown and your skills have flourished, explore your creative potential by painting various combinations of the realistic motifs that are covered in this chapter.

Coping with Frustration

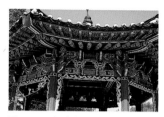

The wonderful patterns and colors on this Korean temple inspired the decoration for the dragon pull toy below.

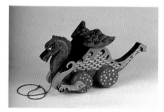

Color-book painting techniques, combined with some scumbling and a little brushstroke work, turned this pull toy into an eye-catching collection of bold colors and simple designs.

If some skills or concepts elude you entirely at first, don't worry—and don't try to learn or understand it all, all at once. If you are new to painting, it will be like learning an entire new language, as indeed you will be. Be patient with yourself. Give yourself permission to be a learner, approaching your study with the curiosity, enthusiasm, and patience of a child. As adults, I fear, we too often think we should already be able to do and to know all things; and we aren't willing to subject ourselves to the possibility of failure. We're too impatient, wanting success and perfection without being willing to work for it, to stretch beyond the safe and the comfortable.

While you struggle with new concepts and skills, hold a mental picture in your mind of the determination of a toddler just learning to walk. Sure, the toddler will stumble and fall, and sometimes even cry. But in his or her desire to gain a new skill, the toddler will be resolute; in spite of the failure, the bumps, and the frustrations, the toddler will finally succeed. So did you once, and so will you once again!

No matter what level of painter you are, realize that it is common to be frustrated and dissatisfied with your work. It only means that you are aspiring to a level that causes you to stretch, and that's good. When you grow complacent, you will no longer grow. Or, as it has been so aptly said, "When you know you're green, you'll grow. When you think you're ripe, you're rotten." There are so many wonderful paths to follow with a paintbrush in your hand that I hope you will continue to think you're "green."

I got precariously close to rotten once in a postgraduate art class during an assignment that covered several weeks. After rendering a still life of five pumpkins in my home studio in several different media, as required, I was to do the final rendering in pastels. I did what I thought was a superb job, spending an inordinate amount of time and effort. By that time, I was intimate with each pumpkin

in the still life and could duplicate their every wart and wrinkle precisely. Full of satisfaction, I carried my work to class, only to be told by the professor that if he had wanted a color photograph, he would have taken one. He emphatically sent me home to portray feelings and emotions about that still life. Having had my pleasure and pride dashed, I was, by then, feeling strongly about those pumpkins, all right—strong purples and blues and angry reds, and strong slashing horizontal and vertical lines. I did things with the new drawing that I didn't even realize I was capable of doing. That professor had made me produce a more powerful drawing, full of emotion and feeling. He had pushed me into growing, into reaching beyond my comfort zone. It took a while for me to appreciate the lesson, but through my frustration, I had grown.

Your efforts may not always be right on target, either. Frustration may seem to ooze from your palette. You'll be convinced that the paint and brush companies include it in their manufacturing process. Just remember that while confidence, control, and creativity will not develop overnight, with every effort, your eye-hand coordination will improve, your brushstroke mastery will develop, your technique will evolve, and your understanding of color will increase. The more you paint and experiment, the more capable you'll become at expressing your own creativity.

When you get into a slump, slip off to your local library and immerse yourself in resource books on the different folk arts from other countries. Study not only the painted arts but also those involving fabric, clay, metal, wood, and other materials. You'll gain marvelous new insights and inspirations, and return to your paints with renewed vigor. The photographs above left show how studying new art forms can provide inspiration.

Now turn the page, squeeze out some paints, shake the frustration out of your brushes, and have fun.

Leaves

In this section, we'll focus on techniques for painting leaves, both stylized and realistic. The stylized leaves are created by combining various brushstrokes. Most of the brushstroke leaves can be used interchangeably with any of the brushstroke fruit or flower designs. Brushstroke leaves are used throughout the Quick and Easy and Intermediate lessons.

The Advanced lessons deal with realistic fruit, vegetables, and flowers. It is important, therefore, that the leaves that accompany them appear realistic as well. Realistic leaves are as exciting to paint as the fruit and flowers they complement; yet many students respond with dread at the first mention of leaves. This is partly a reaction to having tried to paint leaves with side-by-side or wet-in-wet blending methods. Inexperienced or overly ambitious blending results in pasty-looking leaves that have been blended, and blended to death. It is also a result of thinking of leaves as plain *green*—period! As you will see, the use of a variety of colors on the leaves, through the application of multiple, thin color washes, makes leaves visually exciting. By working with washes, rather than trying to blend two wet colors side-by-side or wet-in-wet, we can create a much wider variety of subtle color changes. I think you'll find the wash technique for painting leaves fun and virtually foolproof, as long as you can keep yourself from lapsing into blending your colors into oblivion.

The painting sequence for working through the leaf lesson, as proposed later in the chapter, is designed to enable even beginning painters to build skills gradually and confidently. So regardless of your skill level, be sure to spend some time working on these lessons. The skills you develop in painting leaves will ensure your success in painting fruit, vegetables, flowers, brass

Making Your Leaves Believable

Listed below are some points to ponder when painting or designing with leaves, particularly with realistic leaves. Many of the points are valid, as well, for use with stylized brushstroke leaves, though they are not as critical there.

- Leaves are not all the same size or shape, even those on a single branch. Avoid monotony in your drawing and painting by making some leaves large, some small and tender new growth, some turned over, some in profile, some torn or insect nibbled.

- Details on all of the painted leaves should not be equal. Leaves closest to the center of interest should have the sharpest detail (except for those in shadow). Leaves away from the center of interest should have less contrast in detail, color, and value.

- Leaves are not all seen in their entirety. They are clustered in masses, and some are hidden partially behind the fruit or flower. Don't make your leaves appear to be attached to the edges of flower petals. Avoid making all leaves appear whole and forward facing. Strive for variety.

- Be sure to allow space for the gentle breezes to pass through your leaves. Solid masses of leaves are overwhelming and unnatural-looking.

- If your painting is realistic—rather than stylized—use the proper leaf for your subject matter. A leaf with a smooth margin (edge) would look out of place, for example, with blackberries or daisies.

- While leaves are important to complement your fruit or flowers, be careful that they do not detract from them. Avoid extravagant use of detail, intense color arrangements, and sharp value contrasts on every single leaf. Unless the leaves are the center of interest, they should serve as a frame, attractively surrounding the center of interest and directing attention toward it.

- Work a little of the fruit or flower colors into your leaves. This will prevent the leaves from appearing too green, and will help unify them with the subject matter.

- After undercoating the leaves, use thin washes to vary the colors and add shading and highlights. Several layers of wash can be applied, one on top of the other, as soon as the previous layer is dry. The use of washes will prevent your leaves from all looking identical.

- Strive for a variety of color changes, some subtle, some more obvious. Try to work in a change of color every $1/2$ inch or so.

- One way to work color variety into your leaves is to undercoat them before starting to paint the main subject matter. Then, while painting, and before rinsing the brush to change colors, wipe thin traces

of color randomly on several leaves. These color patches will help inspire you when you begin working on the leaves. They will also affect the washes laid on top of them later, creating lots of subtle color changes.

- Make a collection of leaves during the spring and summer months for reference when painting in the winter. I have loose leaves in boxes, pressed ones in notebooks, close-up photographs in plastic files, and branches with leaves dried naturally, labeled, and hanging on my studio walls. The latter are especially helpful for studying leaf profiles and the way light and shadow play on the cluster. I've also made a collection of photocopies of real leaves. To make your own set, place the leaves on the copier with the backs facing down. The veins are more prominent on the backs of the leaves and will catch the light better, giving you an excellent picture of both the outline of the leaf and the vein structure.

- If you do not have easy access to a photo copier, make pencil rubbings of the backs of leaves. Place the leaf flat, face down, on a hard surface. Cover it with a piece of tracing paper. Hold the pencil parallel to the surface and, with even pressure, rub the lead over the leaf. Be sure to label the leaf for easy identification later.

- Note how much more prominent the veins are on the backs of the leaves. Also note the junctions where the lateral veins meet the center vein. Are the lateral veins opposite one another or are they staggered?

- Study the leaves on a branch on a sunny, still day. Notice how the sunlight peeks between the leaves and appears in strong, sharp patches on some of them, surrounded by shadows. (Look at the leaves on the Advanced Apples, page 149, and the Advanced Cherries, page 167, to see how you can make effective use of these special highlights.) If the day is windy, cut off a small branch and take it indoors. Hold the branch in front of a sunny window and study it. Squint your eyes, almost closing them, to block out extraneous detail, and focus only on the lights and darks.

Reference materials are an invaluable aid to effective painting. Shown here: pressed leaves, loose leaves, a dried leaf branch, photocopied leaves, leaf rubbings, and leaf photographs.

COMMA STROKE LEAVES

Use individual comma strokes to represent leaves in stroke designs, or to represent ferns.

Or pair two comma strokes together to form a more substantial leaf.

Or group multiple comma strokes to create multilobed leaves.

LEAF STROKE LEAVES

Learn to form the leaf stroke rapidly and smoothly to achieve pleasing, gentle curves. Add liner brush comma or S strokes to suggest a flipped edge.

HALF-A-HEART STROKE LEAVES

Place two half-a-heart strokes side by side, slightly overlapping the center to prevent leaving a gap unpainted. These make good leaves for violets and lilacs.

PIVOT-PULL STROKE LEAVES

Similar to the half-a-heart stroke leaves, these leaves are blunt—not rounded—at the stem end. The flat edge can be abutted against a flower to make it appear that the leaf is peeking from behind it. Be sure to overlap the centers of each stroke slightly or apply sufficient pressure on the brush to prevent gaps in the center. Add a comma stroke or S stroke flip to some leaves for variety. Or decorate with liner brush detail strokes for a more stylized effect.

BUMPY PIVOT-PULL STROKE LEAVES

These are similar to the leaves above, but have more variety. Apply lots of pressure at the beginning so the stem end will be broad, and will taper nicely to the tip. Do not try to make each half of the leaf identical. Variety is nice.

These leaves serve well for a variety of fruits and flowers, and are less stylized looking than some of the previous ones. Add thin color washes and veins to make them more interesting.

Quick and Easy and Intermediate Brushstroke Leaves

TRIPLE-STROKE LEAVES, VERSION 1

Combine three strokes—crescent, S, and flat comma—to make this leaf. Press hard to flatten the strokes sufficiently to avoid leaving open gaps in the center.

TRIPLE-STROKE LEAVES, VERSION 2

Combine two crescent strokes and an S stroke to make this stylized leaf. Add liner brush detail strokes for variety.

QUADRUPLE-STROKE LEAVES

This leaf is a variation of the triple-stroke leaf. Combine two crescent strokes and two leaf strokes, curving the ending of the second leaf stroke to align it with the first one.

SCROLL-STROKE LEAVES

Scroll strokes, used singly or in multiple combinations, make graceful, flowing representational foliage. Place the strokes close together. Embellish with liner brush details.

Quick and Easy and Intermediate Brushstroke Leaves

S-STROKE LEAVES

A single, broad, long S stroke makes a good blade-type leaf for tulips, daffodils, and hyacinths. For a broader leaf, combine two strokes.

Or combine several S strokes to form a serrated-edged leaf. Doubleload the brush for variety.

DIPPED CRESCENT LEAVES

To make stylized leaves, start and complete the dipped crescent at the same spot to form a point.

To make leaves appear to be *behind* a fruit or flower, leave the ends spread apart and place the stroke tight against the subject.

SEPALS AND BRACTS

Use S strokes, comma strokes, or variations of either to add sepals and bracts to flowers and fruit.

Realistic Leaves

Daisy leaf.

Pear leaf.

Forget-me-not leaves.

On the following worksheets, you will see two approaches to working with color wash layers. The first, dogwood leaves, is very simple, and should be tried before going on to the other leaves in the Advanced lessons. This simple, predictable, more direct approach can be substituted for any of the leaves in any of the lessons. If the more casual, random approach, and the multilayered washes of leaves such as those in the Advanced Apple and Advanced Roses lessons seem daunting at first, rely on the procedure outlined for the dogwood leaf. Even brushstroke leaves may be enhanced with the shade/highlight/accent wash techniques shown here. This easy technique can also be successfully accomplished by a beginning painter with a little sideloading experience.

After successfully painting the dogwood leaves, paint additional leaves in the following sequence to build your skills gradually: daisy leaves, page 218; pear leaves, page 172; and radish leaves, page 201. Finally, return to the apple leaves lesson that is illustrated in this chapter. The apple leaves and the rose leaves, page 251, are painted with a free and loose application of color washes, requiring a little daring and some confidence, as well as a knowledge of colors and the effects they have as washes. By following the sequence suggested above, you will gradually develop your skills and gain confidence. The comfortable handling of washes through the painting of leaves will be a great benefit to you in painting the advanced fruits, vegetables, and flowers.

Before you start to paint, make a study of the colors you will be working with and how they react to one another. Mix pairs together, perhaps adding a third color to the mixture. Paint a broad strip of leaf undercoat color. Brush thin washes of your colors and mixtures over it. Let them dry. Over parts of the dried washes, lay other color washes. Be sure to record the colors you use, and note the combinations that please you.

Keep in mind that the colors I've used in the leaves on the worksheets were chosen with that project's background color in mind. If you use the same palette of colors, but work on a different color background, expect your leaves to look different.

The detail photographs at left and below will enable you to study the effects of subtle color changes resulting from layers of thin color washes. Compare the different leaves. Notice how they relate to the background color, to the colors of the fruits, vegetables, or flowers to which they belong. Observe the different shapes, leaf margins (edges), and sharp and subtle highlights and shadows.

Follow This Plan To Develop Your Leaf-painting Skills

Quick and Easy	Dogwood leaves	Page 131
Intermediate	Daisy leaves	Page 218
	Pear leaves	Page 172
	Radish leaves	Page 201
Advanced	Apple leaves	Page 133
	Rose leaves	Page 251

Radish leaf.

Rose leaves.

Dogwood Leaves

SKILLS NEEDED
Sideloading
Wash
Drybrushing
Leaf stroke (optional)
S stroke (optional)

PATTERN
Copy the leaf shapes
from the worksheet,
or see the Advanced
Dogwood pattern
on page 326.

PALETTE
A Midnite Green
G Avocado
I Russet
J Taffy Cream

BRUSHES
Flat: No. 8
Liner: No. 1 *or* 2

These are the easiest of the realistic, advanced leaves, in this book, to paint. They are also very easy to design using S or leaf strokes. The simplified technique you learn on these leaves can be used for painting other leaves in the Advanced lessons. You can also use the shading and highlighting techniques to enhance any of the brushstroke-style leaves.

Painting Instructions

1. Load the flat brush with **G**. Beginning at the base of the leaf, paint two side-by-side strokes. Use S strokes, leaf strokes, or a combination of both. Let the strokes curve and bend to make leaves with a variety of shapes. For smaller leaves, a single leaf stroke or stubby S stroke is sufficient. If you have not yet mastered the S and leaf strokes, simply fill in the pattern lines, color-book style.
2. Sideload the brush with a thin, reddish wash of **I**. With the color side of the brush facing the tip end of the leaf, brush a tinge of color on the tip, fading it quickly into the leaf. Add a blush of the color elsewhere on at least some of the leaves.
3. Mix **G+J** with plenty of water to create a thin wash. Don't worry about it being too thin; if necessary, you can apply another layer. Brush the cream color onto the leaf roughly in the highlight area. If it puddles,

it's okay; that will just add to the variety of color. At this point, the leaf will look splotchy. Avoid the temptation to "fix" it. You would only blend away all the pretty variations you put in it.

4. Mix together **A+G** to make a dull, dark green. Thin it with water and load it on the liner. Paint dark veins on the tops of the leaves. Make the veins flow *through* the leaves, not *lie* on top in stiff, straight lines, and make sure that they do not appear to cut the leaf in half visually. Don't paint the center vein all the way to the tip of the leaf.

 To paint the veins for those leaves whose undersides are exposed, mix **J+G** to make a light green color. Thin with water. Use a liner brush.
5. Merge colors together with a wash of **G+A**. Use the flat brush to float this color on the entire leaf. Then shade with **A**. The washes will help unify the colors previously applied, subduing both the highlighting and shading. To make parts of the leaf even darker, sideload the brush with **A** and reapply after the first coat is dry.
6. The backs of dogwood leaves are soft and slightly fuzzy in appearance, lacking the sharper detail of the tops. To duplicate that soft effect with paint, drybrush the backs of the leaves with **J** near the base and **I** near the tip.

Now lean your work against the counter and get up and walk away for a few minutes. After working closely and intensely on something for a long spell, we tend to be unable to see it objectively. In some cases, we overlook obvious flaws that are more readily noticed with a fresh eye. Other times, absence truly does make the heart grow fonder, for we are often overly critical of our efforts, and view every painted stroke as being poorly executed. Whichever way you lean, by getting away from your work, or even just standing back to view it, you will see it from a new viewpoint. If there *are* flaws, you'll see them; otherwise, you'll see that what disturbed you actually enhances the finished work.

Dogwood leaves.

Dogwood Leaves

1. Paint two short, fat S strokes or leaf strokes for the large leaf and a single one for the small leaf. Use **G** with the flat brush.

2. Sideload the brush with **I**. Tinge the tips of the leaves. Also, brush some **I** randomly on some of the leaves.

3. Brush a watery layer of **G+J** on the leaves to lighten them.

4. Draw veins with the liner brush and a mixture of **A+G** on the tops of the leaves; use **J+G** on the backs of the leaves.

5. Merge colors together using washes of **G+A**. Then add washes of **A** to darken the shading.

6. Drybrush the backs of the leaves with **J** near the base, and **I** near the tip.

PALETTE A G I J

The dogwood leaf is the easiest of the advanced leaves and should be attempted first. It provides an opportunity to test your skill in working with thin washes of color; in addition, it's almost impossible to spoil the leaf if you keep your colors watery.

Apple Leaves

SKILLS NEEDED
Sideloading
Doubleloading
Drybrushing
Wash

PALETTE
A Peaches 'n Cream
B Light Avocado
C Burnt Sienna
D Coral Rose
E Gooseberry
F Moon Yellow
G Taffy Cream

BRUSHES
Flat: No. 8

Liners: Nos. 1 *or* 2
and 10/0

Painting Instructions

1. Undercoat the leaves with **B+D**, **B+C**, and/or **B+D+F**. Do not create these mixtures in quantity or with a palette knife. Instead, pick up a little of each color and gently blend them together on the brush each time you reload. By brush mixing, you will create a variety of subtle color changes. Remember that the undersides of leaves are usually paler than the tops; also, leaves underneath other objects will usually be in shadow, and hence be darker.

 Undercoat the leaves before starting to paint the main subject matter. This will help you unify the painting, allowing you to work colors from the fruit or flowers into the leaves as the painting proceeds.

2. While working on the fruit or flowers, and before rinsing the brush to change to another color, brush thinned color washes randomly onto scattered leaves. Although the crazy-quilt patches of color may look garish at first, they will create a pleasing variety in your leaves, and will help suggest where you might accent colors. If you don't care for a particular patch of color when you begin the final work on the leaves, subdue it with a wash of an undercoat color mixture. The worksheet sample shows thin color washes of **E**, **B**, and **F+B**. You could also use **A**.

3. Brush on thin washes of shading colors. The worksheet sample shows **B** applied in two successive washes to intensify the color. Also, mixture **B+C** is placed under the flipped edges of both leaves and along the left side of the vertical leaf.

4. Highlight the leaves with a loose wash of **F+B**. Highlight some areas, such as the flip illustrated, more precisely.

5. Vein the tops of the leaves with a dark-value mixture, **B+C+E**. Use the chisel edge of the flat brush, sideloaded. Hold the brush exactly perpendicular to the leaf and drag the color off the tip of the corner. This will create a vein of slightly varying width that will not appear as stiff and unrealistic as veins made with a liner brush. Do not draw the vein solid from base to tip. To do so would visually cut the leaf in half. Instead, draw a broken line. Vein the undersides of the leaves with a mixture of **B+F**.

6. Strengthen highlight areas with a light-value mixture, **F+G+B**, brushing over some veins to soften them. Also highlight the veins on the undersides of leaves with **F+G** plus very little **B**. Use a liner this time, and paint along the center ridge of the veins with a hit-and-miss action. With very thin paint, and working from the tip of the brush, add spider-web thin veins between the more prominent veins.

7. Strengthen accent colors. Washes of colors **D** and **E** are shown on the worksheet.

 On the backs of the leaves, shade the triangular areas at the junctions of the veins with a thinned dark-value mixture, **B+C**.

8. Adjust the overall color of the leaf with additional washes. Greens will help merge other colors together for a more unified look. On the worksheet, I used **B+D** for a mellow green, and **B** for a truer green.

 The backs of leaves are often fuzzier, softer, and less slick than the tops. Gently drybrush a light-value color—**G** is shown on the worksheet—over the veins to mute them.

 To create insect-nibbled holes, paint a dab of whatever color is under the leaf wherever you want the hole to be. Outline these bug bites with broken edges of **C+B** on a liner brush.

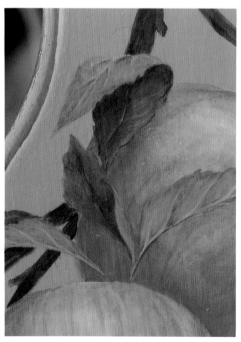

Apple leaves.

Apple Leaves

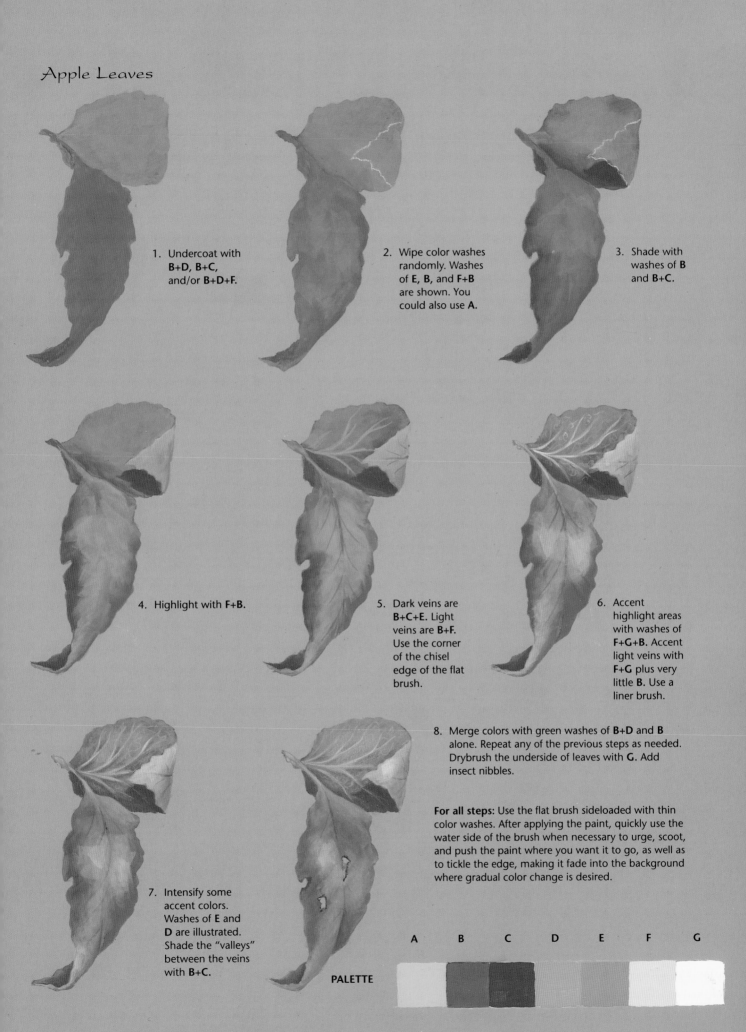

1. Undercoat with **B+D, B+C,** and/or **B+D+F.**

2. Wipe color washes randomly. Washes of **E, B,** and **F+B** are shown. You could also use **A.**

3. Shade with washes of **B** and **B+C.**

4. Highlight with **F+B.**

5. Dark veins are **B+C+E.** Light veins are **B+F.** Use the corner of the chisel edge of the flat brush.

6. Accent highlight areas with washes of **F+G+B.** Accent light veins with **F+G** plus very little **B.** Use a liner brush.

7. Intensify some accent colors. Washes of **E** and **D** are illustrated. Shade the "valleys" between the veins with **B+C.**

8. Merge colors with green washes of **B+D** and **B** alone. Repeat any of the previous steps as needed. Drybrush the underside of leaves with **G.** Add insect nibbles.

For all steps: Use the flat brush sideloaded with thin color washes. After applying the paint, quickly use the water side of the brush when necessary to urge, scoot, and push the paint where you want it to go, as well as to tickle the edge, making it fade into the background where gradual color change is desired.

A B C D E F G

PALETTE

Brushstroke Ribbons

The study and painting of ribbons gives artists a great opportunity to learn to see and to paint subtle variations in colors and values. Once you learn to model the dips and turns of a ribbon, you should be able to paint other things with ease. This section will give you an opportunity to learn to paint ribbons in both brushstroke and blended techniques. The latter will help prepare you for the advanced painting lessons.

There are many ways to approach the painting of ribbons. If you can paint crescent and S strokes, you'll have fun painting brush stroke ribbons. Use a liner or round brush for slender ribbons; use a flat brush for wider ones. See the worksheet on the opposite page, and use the ribbons in the photo below for inspiration. For a blended ribbon, you can choose whether to undercoat it. You could

start from the dark value and work up to the highlights, start from the light value and work down to the darks, start with the medium value and work up to the lights and down to the darks, or use various combinations of these approaches. You may find one way more satisfying than another, depending on the colors you're using. You may also be more adept and more comfortable with some blending techniques than with others. I approach each ribbon a little differently, sometimes combining techniques, sometimes keeping the approach quite simple. The important thing is to become skillful in blending colors through doubleloading and sideloading the brush, and through wash and drybrush techniques. Then you can readily call upon these skills to create the subtle color variations of light and shadow on a twisting, turning ribbon.

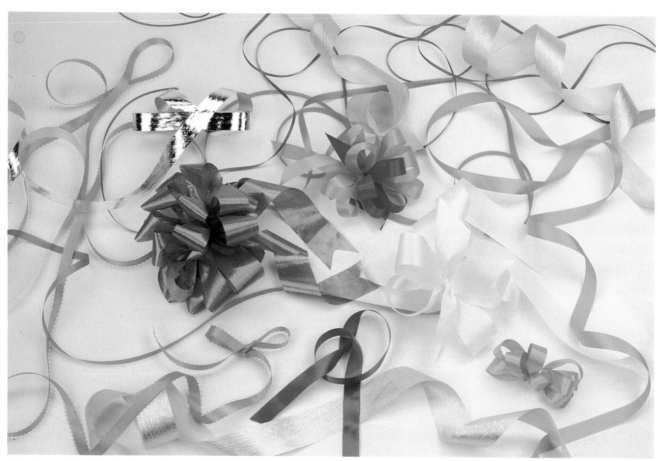

Select one of the ribbons shown above and follow it as it meanders up and down, over and under. Notice the color and value changes; study the highlights and shadows. Then study an actual ribbon if you have one handy.

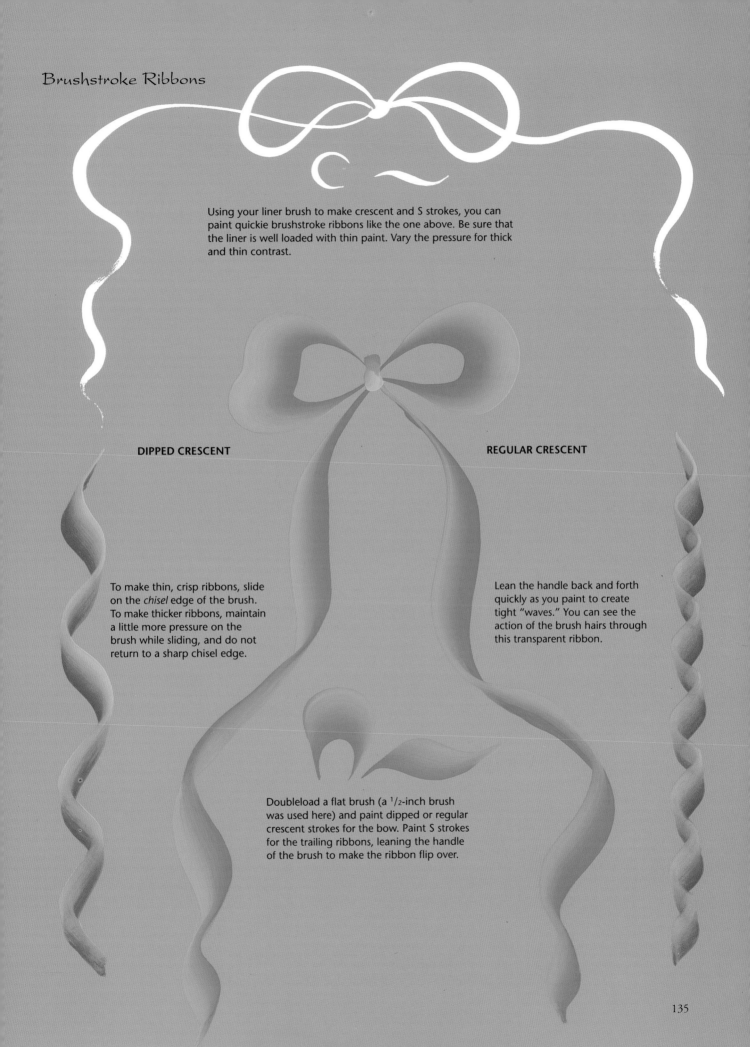

Brushstroke Ribbons

Using your liner brush to make crescent and S strokes, you can paint quickie brushstroke ribbons like the one above. Be sure that the liner is well loaded with thin paint. Vary the pressure for thick and thin contrast.

DIPPED CRESCENT

REGULAR CRESCENT

To make thin, crisp ribbons, slide on the *chisel* edge of the brush. To make thicker ribbons, maintain a little more pressure on the brush while sliding, and do not return to a sharp chisel edge.

Lean the handle back and forth quickly as you paint to create tight "waves." You can see the action of the brush hairs through this transparent ribbon.

Doubleload a flat brush (a ¹/₂-inch brush was used here) and paint dipped or regular crescent strokes for the bow. Paint S strokes for the trailing ribbons, leaning the handle of the brush to make the ribbon flip over.

Blended Ribbons

Good News!

When you can sideload, doubleload, and wash to create a smoothly blended ribbon, you should be able to accomplish the blending required for any of the advanced projects.

Painting Instructions

The ribbon demonstrated on the worksheet is undercoated with a medium/light value. To give the ribbon dimension, there must be at least three values. Since we're beginning with a medium/light undercoat, we'll add shading to create the medium and dark values, and add highlights for the lightest value. Study the color worksheet as you read the following directions.

1. Undercoat the ribbon with its general color, **A.** (Remember, the undercoat may be light, dark, or medium value.) Apply a second coat to all areas but those that will be in the deepest shading. The dark background color showing through the ribbon in those areas will add to the shaded effect. (If you're working on a light background color, however, make sure that the areas to be shaded are also thoroughly covered so that the background color is obliterated.)

2. Begin adding the medium values to all but an area about 3/4 inch wide in the center of the forward curve of the ribbon. Sideload the brush with **B.** With the water side of the brush facing the center of the ribbon and held to the left of the area to remain unpainted, apply a shaded stroke across the width of the ribbon. Lean more heavily on the paint side of the brush, letting the water side follow along, gently blending and smoothing the color application. The resulting application of paint will be a thin wash that lets the color underneath reflect through it.

 Rinse the brush, sideload again with **B,** and repeat the process, avoiding the center area, having the color side of the brush facing the right and brushing color onto the right side of the ribbon.

 If the change from light to medium value (that is, from the undercoat **A** to the sideloaded wash **B**) is not smooth, let the paint dry. Then doubleload those two colors on the brush and blend over the spot where the change in value is abrupt. Walking the brush slightly left and right will help soften the change of color.

3. Begin shading. Doubleload **B** and **C** on the brush and stroke across the width of the ribbon, aligning the first stroke so that the **B** on the brush will be placed on top of the **B** applied above (not on top of **A**) and **C** will face the shaded end of the

ribbon. Shade both sides of the ribbon by stroking toward each end as in step 2.

4. Darken the shading with **C** and **C+D** doubleloaded on the brush. Use this darkest value, also, to shade under the turned part of the ribbon. Let the shading there form a somewhat triangular shape. Darken the triangle's shading even further with a mixture of **D** plus a little **C**.

5. Add highlights as follows:
 • Drybrush **E** in the center of the ribbon, on the area left unshaded in steps 2 through 4.
 • Paint reflected lights, if desired, using very thin **F+A**. The color will show up more intensely when dry, so use very little paint. If the color appears too intense, wash over it, when dry, with **C.**
 • Outline the forward facing edges of the ribbon to reflect the light and set off the shaded, turned-under portion. Use **B** on the liner brush.

 Hint: Before adding final highlights, check that all of your value changes work to make the ribbon curve the way you wish. If not, straddle any rough areas with a brush doubleloaded with the two values involved. Stroke the area, moving slightly to the left and to the right, as described in step 2.

About Highlights

Drybrushed center highlights give the ribbon a soft look, creating the illusion of a velvety nap. This is especially true if some of the drybrushing is carried over onto the medium and dark values of the ribbon. Enhance the suggestion of a thick, soft ribbon by adding a little more width to the highlighting strokes applied along the edges.

On the other hand, *crisp highlights* just softly blended at the edges make shiny, satiny ribbons. Such highlights are made with a brush sideloaded with the lightest value. Apply the highlight in the center of the light area before painting step 2. With the light value on the sideloaded brush at the center, work away from the center for approximately 1/2 inch.

Immediately flip the brush over, and again, starting from the center, slightly overlap the original highlight stroke. Then work toward the other side, stroking for about 1/2 inch. Keep the forward facing edges very thin to increase the illusion of shiny crispness.

Blended Ribbons

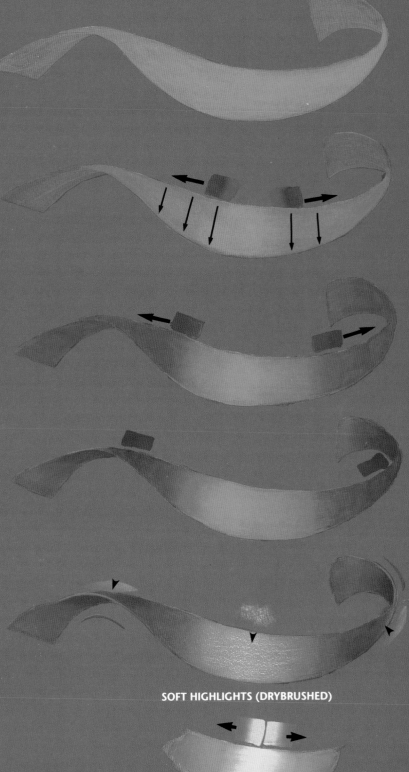

1. Undercoat the ribbon with **A.** Apply a second coat. It's not necessary to recoat areas that will be in darkest shadow.

2. Sideload the brush with **B.** Beginning a little to the left of what will be the highlight area, and with the water side of the brush facing the center, stroke across the width of the ribbon repeatedly, moving gradually toward the left. Rinse the brush, sideload again, and this time stroke toward the right with the color on the right side of the brush. In both cases, use as many or as few strokes as needed.

3. Doubleload the brush with **B** and **C.** With **B** toward the center, begin stroking at the left arrow and, again, work toward the left. Rinse the brush, doubleload again, and begin at the right arrow and work toward the right. Notice that the starting positions of the first strokes on the left and right have moved farther from the center.

4. Follow the process above with a doubleload of **C** and **C** plus a little **D.** Begin at the arrows. Use a little more **D** in the mixture to shade the darkest areas under the turned part of the ribbon.

5. Highlight as follows:
 - Drybrush the center with **E.**
 - Add reflected lights with **E+A.**
 - Paint a thin line of **B** along the forward facing edges.
 - Optional highlight: Read about crisp highlights on the opposite page. Use **E** sideloaded on the brush.

SOFT HIGHLIGHTS (DRYBRUSHED)

CRISP HIGHLIGHTS (SIDELOADED)

PALETTE A B C D E F

Waterdrops

SKILLS NEEDED
Sideloading
Wash

PATTERN
None needed; see painted examples on Advanced Pears (page 176) and Advanced Roses (page 253).

PALETTE
Medium and dark values of your background color; white or creamy white. Colors shown on the worksheet, and listed in the directions, are:
A Burgundy Wine
B Buttermilk
C Cranberry Wine
D Midnite Green
E Raspberry
 (background color)

BRUSHES
Use the largest brush you can handle for the size of the teardrop you are painting. I used a No. 8 flat brush for the sample shown on the worksheet.

Before starting to paint this lesson, drip water on a lot of different surfaces and colors. Then study all those drops. Where are they lightest? Why? Where are the darks, the shadows? What do the drops look like inside? How does the surface appear through the drop? How many highlights do you see? Are they all the same intensity? What shapes are the drops? How do they follow the contours of the object they're on? What do they look like when they start to "run"? When you've absorbed all the inspiration you can, mop up the mess and paint a waterdrop.

Determine the position of the light source. Be sure it corresponds with the light source used in the rest of your painting. When the light strikes a waterdrop from the upper left, for example, it passes through the drop and illuminates the lower right side and bottom of it (see the example below). The waterdrop then casts a shadow in the same direction.

In this example, light strikes the waterdrop from the upper left, illuminating the lower right and bottom of the drop and casting a shadow below and to its right.

The color of the surface upon which the drop rests is intensified by the wetness of the water. Upon close inspection, you may notice the magnification of tiny details under the drop.

Painting Instructions

1. In a color slightly darker than the color of the surface on which the waterdrop will rest, apply a thin wash of **A** in the shape of the waterdrop. Apply the wash a little heavier on the highlight side of the drop.

2. Sideload the brush with a very thin wash of white or creamy white **B**. Use much less color than you would think necessary. The white will appear much stronger after you paint the shadow. Start at the top of the waterdrop on the side opposite the light source, and on the chisel edge of the brush. Pull the stroke down and curve around the bottom edge, forming a sort of scroll stroke. Use the water edge of the brush if needed to soften any hard edges near the center of the drop, but avoid playing with the application of color.

3. Sideload the brush with a dark value of the teardrop's background color, **C**, plus very little **D**. With the color side of the brush next to the waterdrop, paint the shadow. Work from the bottom up along the side. This will give you a shadow that fades into the background color—a nice subtle effect when soft shadows are desired. To make a hard-edged shadow as illustrated, turn the brush over and paint the shadow edge, or use a No. 2 flat brush, fully loaded. Starting at the base of the teardrop, press the brush down to form the wide shadow area, then pull the brush and release the pressure as you slide up the side.

4. Load a little white or creamy white on the corner of the flat brush. With one deft swipe at the waterdrop, apply a strong highlight of **B**. Then wipe most of the color from the brush; thin whatever remains in the brush slightly with water to paint the lesser highlight near the base of the drop.

Waterdrops

1. Undercoat the waterdrop with a thin wash of color (**A**) slightly darker in value than the background (**E**).

2. Apply a sideloaded brushstroke of thin white or creamy white (**B**) along the side and across the bottom.

3. Paint the shadow with a dark-value color (**C** plus a little **D**).

4. Add highlights with white or creamy white (**B**).

Remember—water is *wet*, not *white*. Use white sparingly.

PALETTE **A** **B** **C** **D** **E**

Note that the colors you select will depend on the surface color on which you are painting the waterdrop.

Watching the Water Run

Paint a piece of cardboard the background color on which you plan to paint waterdrops. Eliminate all but one source of light in the room. Drip water on the painted cardboard. Tip it gently so that droplets to begin to run. Hold it at different angles to the light to study changes in light and shadow. Let drops run up, down, and sideways on the board while you study them. Then wipe the board dry and try to paint the colors, values, and shapes you saw.

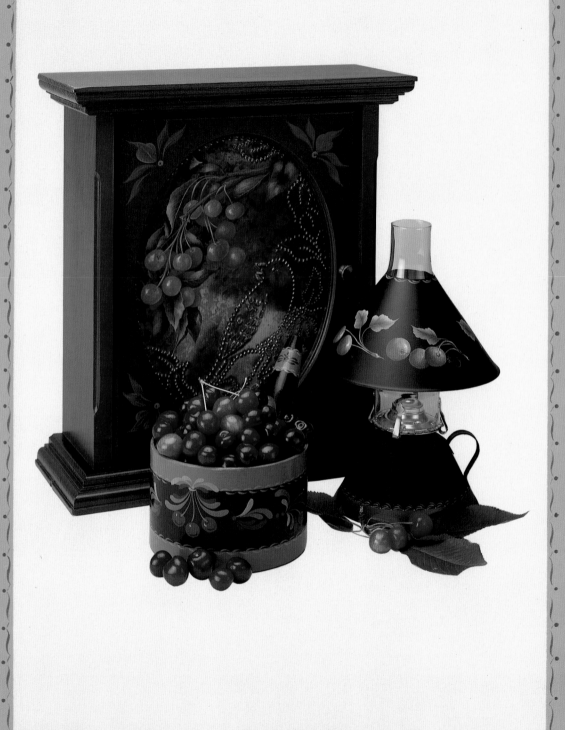

Chapter 9

Fruit Designs

For many of us, certain fruits evoke happy childhood memories. What could be more fun on a hot summer day than sitting barefoot on Grandma's porch, surrounded by favorite cousins, eating icy cold watermelon, and seeing who can spit seeds the farthest? And have you ever braved the brambles and the chiggers to pick a bucketful of blackberries? As a child, finding them growing in the wild was like receiving a special gift from Mother Nature. Today, my garden provides berries enough to last a full year, but picking them in the hot sun still reminds me of my youthful summers. I can also remember the first time my best friend and I picked pears from her grandfather's tree. They were hard and green, but we ate them anyway, and agonized later through the consequences of our inevitable bellyaches.

Slip back in time as you paint. Which of the fruits featured in this chapter summons a favorite memory for you: apples, blackberries, cherries, pears, or watermelons? Buy some of the fruit and study it closely. Feel the texture of the skin, and look at the subtle variations in color, the bumps and bruises, the blossom end, the stem and its depression. Shine a light on it to see how the shadows fall. Slice it open to study the flesh, the seeds, and the core. Smell it. Taste it. Use as many of your senses as you can. The more senses that you involve in learning about that fruit, the greater your understanding of it. Then select a pattern and skill level, and paint it.

Use your memories to add special personal interest to your paintings by jotting them on a card and attaching it to the back of the piece. These memories will give your project more character and significance than could be achieved by your painting skills alone. If you'd like to share your memories with me— I'd love it!—copy down some of your thoughts and send them to me at the address listed on the back of the title page.

For detailed instructions on how to make each of these projects, see pages 159–160 for the piggin (Quick and Easy Cherries), pages 161–163 for the Molly Pitcher lamp (Intermediate Cherries), and pages 164–167 for the punched tin curio cabinet (Advanced Cherries).

Quick and Easy Apples

Painting Instructions

Apples

1. Basecoat the lathe-turned or cutout apples with **A.**
2. Add streaky coloring. Use a large flat brush, preferably an old one with splayed hairs, or a rake or fan, to brush on **B.** Load the brush skimpily, so that it's almost dry. Practice painting a streaky stroke on paper first. This is where the splayed hairs of an old brush (or those of a rake or fan) come in handy.

 An optional method for streaking is to work with a round brush and very thin, wet paint to paint each streak separately.
3. Brush **C** on streakily, beginning at the top of the apple and letting the streaks fade toward the center. Then begin some strokes at the bottom and fade toward the center. Try to vary the length of the strokes so that they do not all end at the same place.
4. Add dark streaks with **D.** Be careful not to make the apple too dark.

Use any of **A, B, C,** or **D** as needed to adjust the colors on your apple to suit your taste.

To suggest that an apple has been bitten, mix Snow Tex with very little **B.** Apply the Snow Tex with the palette knife in short jabs to create an uneven surface. (You can also substitute white acrylic paint for the Snow Tex.)

Stems

Paint the stem on the cutout apple with a brown mixture of **A+E.**

Leaves

Silk flower leaves painted with acrylics make nice accents for the lathe-turned or three-dimensional apples as well as the cutout ones. Paint both sides of the leaves with **E.** This will coordinate the leaves with the apples better than if they are left unpainted. Shade the center of the leaf along the vein line with **F.** Apply the same varnish finish to the leaf as you do to the apple.

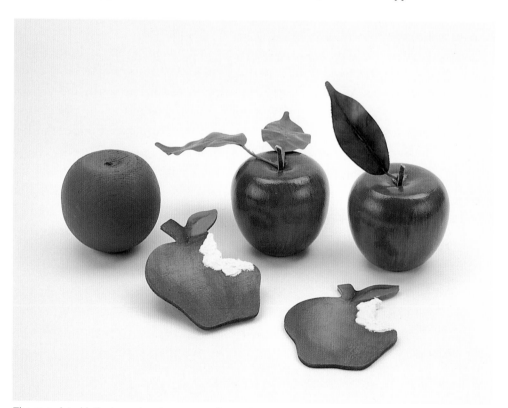

The completed lathe-turned and cutout apples projects.

Quick and Easy Apples

APPLES

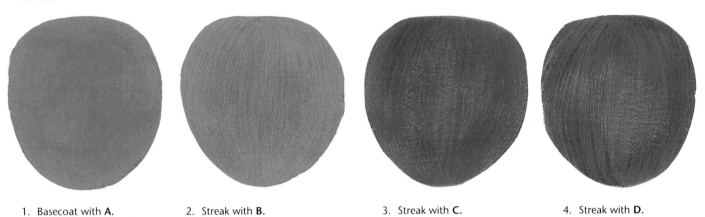

1. Basecoat with **A.**

2. Streak with **B.**

3. Streak with **C.**

4. Streak with **D.**

LEAVES

1. Basecoat with **E.**

2. Shade center with **F.**

For the optional bite: Dab on Snow Tex or white acrylic paint mixed with very little **B.**

PALETTE A B C D E F

Intermediate Apples

PROJECT
Pie basket/small lap desk
(#22) from Greenfield
Basket Factory

SKILLS NEEDED
Circle stroke
Comma stroke
Leaf stroke
Sideloading
Lettering
Antiquing

PATTERN
Page 310

PALETTE
A Toffee
B Colonial Green
C Sable Brown
D Rookwood Red
E Light Avocado
F Taffy Cream

BRUSHES
Flats: Nos. 12 and 8
Round: No. 3

MISCELLANEOUS
Compass
White chalk
Plastic wrap
Burnt umber oil paint

This project, which is entitled "As American As Apple Pie," is as easy as pie to make. With the exception of the lettering, it is also an ideal beginner-level project.

Surface Preparation

1. Basecoat the lid with **B** and the band and handles with **D**.
2. To create the pie, use the compass and chalk to draw a circle 8 inches in diameter in the center of the lid. Paint the pie with **A**.
3. Draw a line $3/4$ inch from the edge of the box to create the border. Paint the border with **A**.
4. Use a damp sponge to dab thinned **C** on the pie, creating a mottled appearance. Also, wipe the border with the sponge and **C** to color it lightly.
5. Find the center of the circle and use the chalk to divide the pie into eighths.
6. Using the chalk, draw concentric circles *within* the pie with the following diameters: $6^1/2$, 4, 3, and $2^1/2$ inches. Then draw concentric circles with the following diameters *outside* the pie for the lettering: $10^1/2$, 10, and $9^1/2$ inches.

Painting Instructions

1. Use the chalked guidelines to place the apples within the pie. They should be centered between the eight dividing lines and positioned between the two outermost concentric circles. Load the No. 12 flat brush with **D**. Paint a "careless" circle stroke (see box, below). Press moderately hard on the brush to spread the hairs sufficiently wide to cover the apple, or simply fill in the apple in color-book style.
2. Mix brown for the stems with **D**+**E**. Use the No. 3 round brush. Alternate the stems, facing left and right, one standing taller, the other leaning lower. (The $2^1/2$- and 3-inch chalk circles will guide you in painting stem heights.)
3. Using a sideloaded No. 8 flat brush, paint the leaves with **E** to form a leaf stroke (see page 70). Paint the leaf stems in **E** with the liner brush.
4. Paint the highlight on the apple with **F** sideloaded on the No. 8 flat brush.
5. Load the No. 3 round brush with **C**, then tip it in **A**. Paint comma strokes to represent the crust edge of the pie and to decorate the center. The long center strokes should reach the 3-inch chalk circle.
6. Use the handle end of the brush to paint **C** dots between the comma strokes on the crust and among the comma strokes in the center of the pie.
7. With the liner brush, paint wavy lines along the chalked pie section lines using **C**.
8. Using the liner brush, paint the lettering with **A**. Paint a stroke border design in the area remaining between the two lettered sections.
9. Fully load the No. 12 flat brush with **D**. Paint the checkered squares in the border. Pull a short broad stroke for each square. Start along the back edge of the lid. Don't measure and try to paint precisely. Just go. You may have to scrunch or stretch a couple when completing the border. Since this is a primitive piece, it shouldn't look too precise.

 Hint: Be sure to paint inside the lid; someone will check to see if you did.

Antiquing

Antique the project with burnt umber oil paint (see "Antiquing," pages 293–295).

The "Careless" Circle Stroke

The brush begins with the flag pointing toward 12 o'clock. (Review "Flagging Your Brushes," page 61.) Rotate the brush clockwise around the circle until the flag begins to approach 6 o'clock. Slide upward slightly, then back, to create a dip at the base of the apple. Then continue up the left side of the circle. Don't worry about ending the stroke with the flag precisely at 12 o'clock. The variations in the circle strokes will give the apples a more interesting (rather than perfectly round) appearance.

Intermediate Apples

1. Paint a careless circle stroke with **D** and the No. 12 flat brush.

2. Mix brown using **D+E**. Paint comma stroke stems with the No. 3 round brush.

3. Paint leaf-stroke leaves with **E** and the No. 8 flat brush. Add stems with a liner brush.

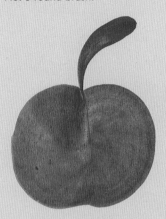

4. Paint highlights with a No. 8 flat brush sideloaded with **F.**

5. Load the No. 3 round brush with **C**, then tip in **A**. Paint the comma stroke crust.

6. Paint **C** dots with the handle end of the brush.

7. Paint wavy lines along pie sections with a liner brush and **C**.

8. Use a liner brush and **A** for lettering (see below).

9. Use the No. 12 flat brush and **D** to paint the checkered border.

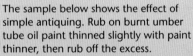

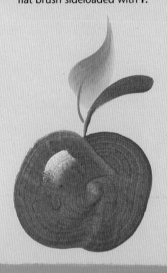

The sample below shows the effect of simple antiquing. Rub on burnt umber tube oil paint thinned slightly with paint thinner, then rub off the excess.

PALETTE	A	B	C	D	E	F

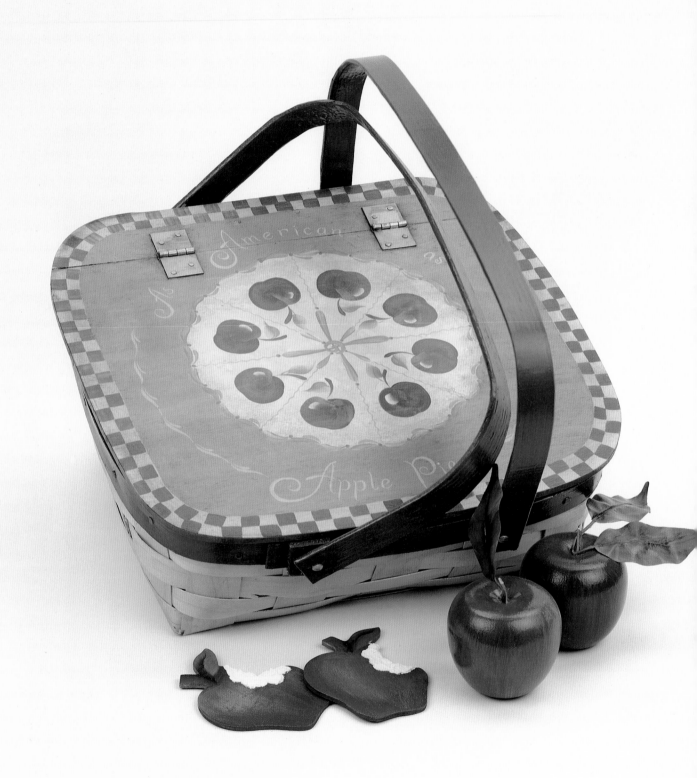

The completed pie basket/lap desk project.

Advanced Apples

PROJECT
Recipe card/book shelf
(#36-005) from Cabin
Craft

PATTERNS
Page 311

PALETTE
A Peaches 'n Cream
B Light Avocado
C Burnt Sienna
D Coral Rose
E Gooseberry Pink
F Moon Yellow
G Taffy Cream

BRUSHES
Flats: Nos. 12 and 8
Round: No. 3
Detail: No. 2/0

Contour Lines

Follow the contour lines when painting streaks on the apple. Notice that the center line on the front of the apple and behind the stem depression is straight. On the front of the apple the lines curve *toward* the center line, bracketing it like parentheses. Behind the stem depression, the lines curve *away* from the center line.

In this contour line drawing of an apple, notice how the lines curve, helping to create the illusion of a form.

The coloring of York apples is soft and streaky, and easily correlated with the burnt sienna–tan color scheme on this recipe box/book holder.

Surface Preparation

1. Basecoat the sides and the drawer of the book shelf with a tan mixture of **A+B**.
2. Basecoat the remainder of the project with **C**.

Painting Instructions

Leaves

1. Quickly and loosely undercoat some leaves with a thinned mixture of **B+D**; undercoat others with a mixture of **B+C**. The blocked-in leaves will help you to balance colors as you work on the apples.
2. After painting the apples, return to the leaves. (Follow the general leaf directions on page 132.)

 Hint: When I finish working on one leaf, I wipe any paint remaining in my brush onto another leaf. The color is thin, so there is no paint buildup; but enough color is laid down to give me ideas later when I get to that leaf. I can always change it. Floating other colors over these "wiped-off" colors adds variety to the leaves. Remember to introduce subtle or dramatic color changes to the leaves every 1/2 inch or so.

Apples

1. Undercoat the apples with **A**. Let the flow of the strokes follow the contours of the apple. This will suggest shape later when you paint stripes on the apple (see "Contour Lines," at left).
2. Apply a thin wash of **D** over each apple, again following the contours. Fully load the brush with thin paint.
3. Paint the shadow areas with **E** sideloaded on the No. 12 flat brush. Let dry. Then darken the shadows with **E+C**.
4. Use the No. 3 round brush and thinned **C** to paint streaks. Again, follow the contours of the apple. Make sure that the streaks are *not* regular: Some should be thick, some thin, some long, some short, some very faint, others a bit stronger. Use mostly water with very little paint at first. When you feel confident with your streaking technique, add a little more pigment. If you're not pleased with the

direction a line takes, or if it appears too dark, blot it quickly with your finger.

5. Repeat step 4 using a greenish tan mixture of **B+A**. Do not paint too many stripes. Also use this color to paint the stem depression, pulling the color out onto the apple, following the contour lines.
6. Sideload the **B+A** mixture on the No. 12 flat brush. Float this color over the shading applied in step 3. It will give the apple a misty or cloudy appearance, and will help soften or lose (fade) some hard edges.
7. Wash a thin layer of **D** over the mixture applied in step 6 to create a softened reddish color, and to pull all the colors and streaks together. Pull some of this color, streakily, down into the stem depression.
8. Brush thinned **F** loosely over some areas to give the apple a golden glow.
9. Repeat any of the above steps in any sequence. Work with very thin washes to adjust the colors and values. Add deeper shading by using a mixture of **C+E**. For still darker coloring, mix **C+B**. Highlight with **G**. Add freckles with a mixture of **B+A**.

Branches and Stems

1. Mix a variety of browns using combinations of various reds (**C, D, E**) and green (**B**). Mix the darkest brown with **C+B**. Add **F** to any mixture to warm it. For lighter browns, add some **G** or **A**.
2. Use the No. 3 round brush to paint the branches. Change colors frequently, being careful not to let the branches become too dark and overpowering. If this should happen, apply a thin wash of **G** or **A** over the offending area.

Other Design Areas

Use a green mixture to paint the stroke design on the drawer and under the cutout hearts. Paint a single apple on the other side of the shelf.

Hint: Don't worry about matching exactly the coloring on the worksheet sample. Follow the first eight steps, then begin playing with the modeling of the apple by repeating any of the steps in any sequence. Work with very thin washes of color. They'll dry quickly so you can easily lighten or darken areas without a buildup of paint ridges. The many thin washes of color will make each apple you paint slightly different—as real apples are.

Advanced Apples

1. Undercoat the apples with **A**.

2. Wash over with **D**.

3. Shade with **E**, then with a mixture of **E+C**.

4. Paint streaks with **C**—thick, thin, long, short.

5. Paint the stem depression and streaks with **B+A**.

6. Float the **B+A** mixture over shaded areas.

7. Wash over color applied in the previous step with **D**.

Brush **F** in some areas for a golden glow.

Repeat any of the above steps as needed. Add **G** for highlights; **B+A** for freckles.

Refer to the worksheet for Apple Leaves, page 133.

PALETTE A B C D E F G

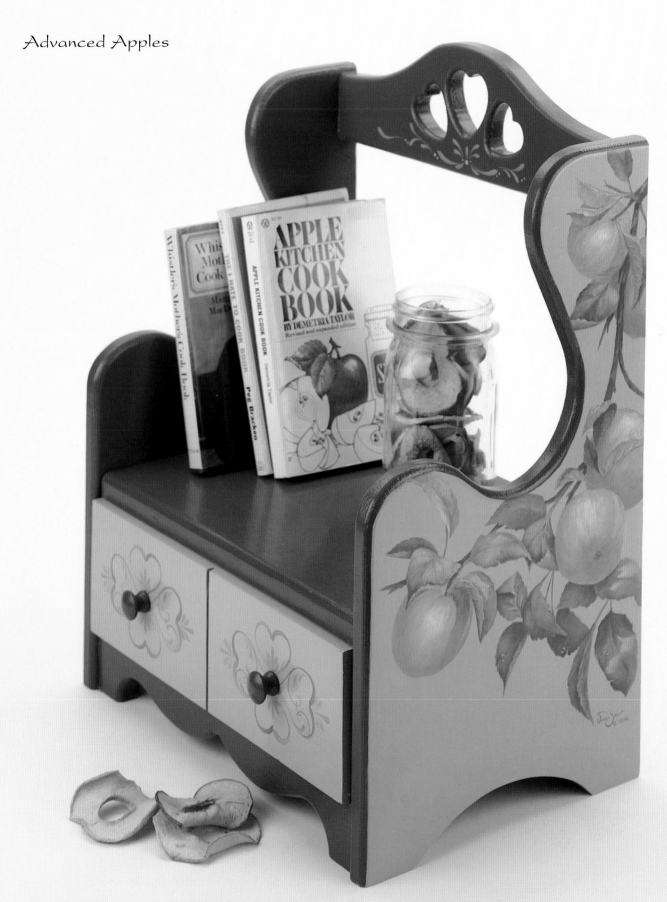

The completed recipe box/book holder project.

Quick and Easy Blackberries

PROJECT
9³/₄-inch casserole carrier (#72D) from Designs by Bentwood

SKILLS NEEDED
Comma strokes

Wash/floated color (minimal)

Marbleizing; color lifting (optional)

PATTERN
Page 312

PALETTE
A Taupe
B Calico Red
C True Blue
D Evergreen
E Baby Pink
F Taffy Cream

BRUSHES
Flat: No. 4
Round: No. 3
Liner: No. 1

MISCELLANEOUS
Brush 'n Blend Extender
1-inch poly foam brush
Plastic wrap
Compass

If you can paint a blotch and press a pencil eraser onto it, you can paint these blackberries. These pencil-eraser berries are so easy, in fact, that even children have fun painting them.

Surface Preparation

1. Basecoat the casserole carrier with **A**.
2. Mix a rich purple with **B+C**, then thin with extender. Use the 1-inch poly foam brush to paint the mixture quickly on the band. Work in sections, doing about one-fourth or one-third of the band at a time. Then immediately press wadded plastic wrap into the wet paint to create a pattern. Repeat for remainder of the band. (See "Crumpled Plastic Wrap," page 274.)
3. Use the compass to mark the lower boundary of the border design approximately ¹/₂ inch from the bottom.

Painting Instructions

Leaves

1. Using the round brush and **D**, paint the large, straight comma strokes in the border.
2. Use the liner and **D** to paint the stems. Stay up on the tip of the brush. Don't try to follow the pattern lines precisely; it's better to ignore the lines and paint with a sure stroke.

3. Use the round brush to paint the comma stroke leaves. Each large leaf contains six strokes; the small leaves contain two strokes. (See "Comma Stroke Leaves," page 125.)

Blackberries

1. Undercoat the berries carelessly with **E**. Avoid trying to paint each little bump in the outline of the berry. Just paint an uneven edge. (A hard, round edge will look unattractive in the finished berry.) Paint a few berry shapes on paper to practice the following steps.
2. Find a well-used, somewhat rounded pencil eraser. (Or wear one down by rubbing it on an emery board, nail file, or piece of sandpaper.) Dip the eraser tip into a purple mixture of **B+C**. Tap it on the palette once or twice to remove excess paint. Press the loaded eraser onto the edge of the berry shape. Push hard enough to deposit a ring of dark paint and leave just a hint of color inside the ring. It's a good idea to practice on paper first to learn how hard to press the eraser to form the ring, and how much paint to have on the eraser. (The harder you press, the larger the berry drupelet will be, and the riper and juicier it will appear. Faint presses will result in tiny, hard-looking berries.) Make a ring of drupelets on the outside edge of the berry.
3. Make another ring of drupelets inside the first ring. Then fill in any space remaining.
4. After the berries have dried, wash a thin layer of the deep purple mixture over the bottom third of each one to shade.
5. Add highlights of **F** to the drupelets in the top third of the berry.

Inside Border

Use the deep purple color mixture plus extender to paint a border around the inside edge of the container.

Note: This casserole carrier is made to fit a Corningware Visions casserole dish. Fill it up with good things to eat and come for a visit. I haven't cooked for a year!

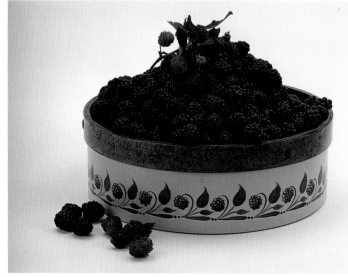

The completed casserole carrier project.

Quick and Easy Blackberries

Paint the comma stroke border first. Then add stems and dots. Next, add leaves (see below).

Paint a pair of comma strokes.

Add a stroke inside the pair.

Then add another.

Continue adding strokes until the leaf appears complete. For small leaves, place two comma strokes side by side.

1. Undercoat the berry with **E**.

2. Print drupelets around the edge with **B+C**.

3. Print another ring of drupelets, then fill in the center.

4. Shade the lower third of the berry with **B+C**.

5. Highlight the upper third of the drupelets with **F**.

Basecoat the band with **A**.

Quickly brush on a thin wash of **B+C**.

Press crumpled plastic wrap into the still wet paint.

PALETTE A B C D E F

Intermediate Blackberries

PATTERN
Page 312

PROJECT
9½-inch double-beaded
plate from Walnut Hollow

SKILLS NEEDED
Sideloading
Wash
Bumpy crescent stroke
Leaf stroke

PATTERN
Page 312

PALETTE
A Jade Green
B Buttermilk
C Evergreen
D Baby Pink
E Baby Blue
F True Blue
G Calico Red
H Avocado
I Moon Yellow
J Taffy Cream
K Blush

Note: You could omit **D**, **E**, and **J**, and mix close approximations by lightening **G**, **F**, and **I**. If you really enjoy mixing colors, you could also omit **A** and **H**, and mix them by using **C**, **B**, **I**, and **G**.

BRUSHES
Flat: No. 4
Liners: Nos. 1 and 10/0

Surface Preparation

1. Basecoat the top of the plate with a pale green mixture of **A+B**.
2. Paint the beaded edges and back of the plate with **C**.

Painting Instructions

Leaves

1. Sideload the flat brush with **H**. Have sufficient water on the brush so that the green will be translucent. (Review the stroke leaves on page 126.)
2. Using thin washes of red-violet and blue-violet mixtures of **F+G**, add touches of color to the leaves. Also use a wash of **K** in some areas. Add highlights to some areas on the leaves with thin washes of **J**.

Stems and Tendrils

Use the liner brush to paint the stems a variety of greens. Mix **H** with the violet mixtures used on the leaves. Mix some lighter greens using **J+H**.

Sepals

With the corner of the flat brush, paint the sepals on the calyx with **H** thinned with water.

Blackberries

1. Mix a variety of pale red-violets and blue-violets using **D+E**. Undercoat the berries carelessly, making some pinkish and some lavenderish.
2. Wash a variety of thinned colors over the dry berries. On some berries, use a single color; on others, try two or three colors, each on a different area of the berry. Leave parts of some berries uncovered. Use the following colors and mixtures: **F+G**, **G+F**, and **K**.
3. Find a well-used, somewhat rounded pencil eraser. (Or wear one down by rubbing it on an emery board, nail file, or piece of sandpaper.) Mix several red-violet and blue-violet mixtures using **F** and **G**. Dip the eraser tip into one of the violet mixtures. Tap it on the palette once or twice to remove excess paint. Press the loaded eraser onto the edge of the berry shape. Push hard enough to deposit a ring

of dark paint and leave just a hint of color inside the ring. Practice on paper first to learn how hard to press the eraser to form the ring, and how much paint to have on the eraser. (The harder you press, the larger the berry drupelet will be, and the riper and juicier it will appear. Faint presses will result in tiny, hard-looking berries.) Make a ring of drupelets on the outside edge of the berry, barely overlapping the undercoated edge. Then begin filling in the center of the berry.
4. Let the berries dry. Then wash a thin layer of the deep violet mixtures over the bottom third of each berry, using red-violet on some berries, blue-violet on others.
5. With the corner of the flat brush or the edge of the liner brush, add highlights of **J** to the drupelets in the upper third of the berry. Make the highlights irregular shapes, not tidy round dots.

Flowers

1. Sideload the flat brush with **B**. Make a small dot in the center of each flower. Start at the dot and paint a bumpy crescent stroke, pulling it to end also at the dot. Paint four or five petals for each whole flower. (Partial flowers can have fewer petals.) If the brush is carefully sideloaded, the project's basecoat color will show through, adding depth and dimension to the flower.
2. Mix a rich, golden brown by adding a little of the **F+G** mixture to **I**. Use the liner brush to paint stamen.
3. Add dots of **I** to the ends of the stamen.

Border

1. Use the liner brush to paint an undulating line through the center of the border area. Try to keep the spacing fairly consistent. If you don't trust yourself, divide the area with chalk before starting to paint.
2. Using the flat brush, paint single-stroke leaves using the leaf stroke (see page 70) in each hollow of the wavy line.
3. Use the liner brush to add thin stems and curly tendrils. Let there be some variety in the tendrils to prevent the border from appearing too rigid.

Intermediate Blackberries

BERRIES

1. Undercoat the berries with **D+E**.

2. Wash a variety of colors on the berries. On some berries, use a single color; on others, use several. Leave parts of some berries uncovered.

3a. Use a pencil eraser to print a ring of drupelets around the berry's outside edge.

3b. Print a second ring inside the first.

3c. Fill in the remaining area.

4. Wash deep violet over the lower third.

5. Add highlights of **J** to the upper third.

FLOWERS

1a. Sideload the flat brush with **B**. Paint a ruffle-edged crescent stroke.

1b. Paint four or five strokes per flower.

2. Stamen are mixture of **F+G+I**.

3. Add dots of **I**.

Sepals are painted in **H**.

LEAVES

1a. Sideload the flat brush with **H**.

1b. Use two strokes to paint each leaf.

2. Add color washes to suggest tints *(left)*, shading *(center)*, and highlights *(right)*.

PALETTE	A	B	C	D	E	F	G	H	I	J	K

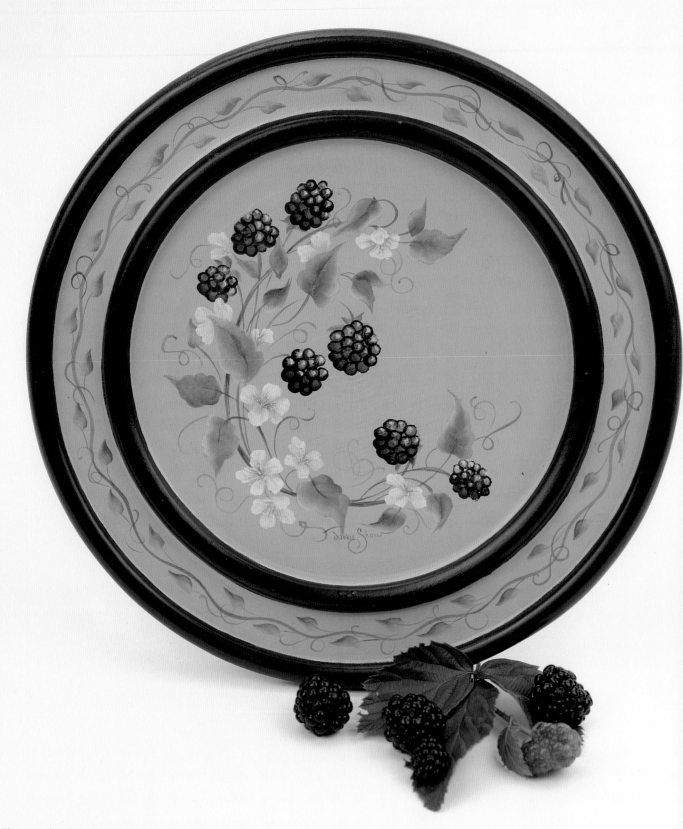

The completed double-beaded plate project.

Advanced Blackberries

PROJECT
Carved wooden decoy
from Stoney Point

PATTERN
Page 312

PALETTE
A Avocado
B Olive Green
C Black Forest
D Midnite Green
E Ebony Black
F Buttermilk
G Taffy Cream
H Moon Yellow
I Medium Flesh
J Blush
K Berry Red
L Cranberry Wine
M Dioxazine Purple

BRUSHES
Flats: Nos. 6 and 1
Detail: No. 2/0

MISCELLANEOUS
White chalk
Brush 'n Blend Extender
Burnt umber oil paint
Latex gloves

In this lesson, you can experiment with painting several stages in the ripening process of the blackberry. I've varied the painting sequence somewhat for the different berries so you can see how versatile the technique is. Ultimately all berries have an undercoat, shading, one or more color washes, highlights and reflected lights, and perhaps additional highlights. Vary the sequence to suit yourself; you can be very flexible with the berries.

You should have a marvelous time painting these berries. If you find you're having trouble, you're probably trying too hard for perfection and thus overpainting. If you try to form each drupelet perfectly, the berries will look rigid and unreal. The accidental shapes that occur when you highlight and wash over that highlight make the berries interesting and realistic-looking. So loosen up and have fun.

Surface Preparation
Since it was so attractive and unobtrusive, I decided to leave the grain of the wood on the decoy's back and beak un-basecoated. The design is painted directly on the shellac sealing coat. If you like this effect, use a piece of chalk to delineate the area you will leave unpainted. Basecoat the head, chest, and sides with a deep, rich green mixture of **C** plus a little **A**. Or, if you prefer, pick up one of the colors from the berries to substitute for the green.

Painting Instructions
For all berries and leaves, apply undercoats and color washes with the No. 6 flat brush. Paint crescent stroke circles for the berry drupelets and add highlights with the No. 1 flat brush. Thin the highlight color with water and, using just the corner of a sideloaded No. 1 flat brush, paint the reflected lights. Use the detail brush to paint the fine "hairs" on the berries and delicate veins on the leaves.

Leaves
Review the general worksheets for leaves on pages 125–128, then follow the steps below.
1. Undercoat the leaves with **A**.
2. Shade along the central and lateral veins with a mixture of **C+D**. Sideload the mixture onto the brush with extender.
3. Highlight with **B**.
4. Wash portions of some leaves with **C**.
5. Wash some areas with **J**, and some with **L**.
6. Outline holes in some leaves with a mixture of **L+A**.
7. Outline the color in step 6 with a mixture of **I+H**.

Additional steps for the undersides of leaves:
8. Exaggerate the veins when the underside of the leaf is showing. Use more of **B** and **G**.
9. Use the colors from step 8 to paint the very delicate small veins. Thin, meandering lines will serve the purpose.
10. Shade the crotch where the lateral veins join the central vein, using **C** and **K**.
11. Drybrush **B** across the underside of the leaf. The color will catch on the slightest elevated layers of paint and add a nice texture to the leaf.

For all leaves:
12. Use the dark greens and green/red mixtures to add shading where leaves are in shadow.

Berries

Green (Unripe) Berries
These berries are hard, tight, and rather dull in comparison to the more mature, large, soft, juicy berries. As a result, their highlights are understated.
1. Undercoat with a mixture of **B+G**.
2. Shade drupelets with a mixture of **A+K**.
3. Highlight all drupelets with a mixture of **H+G**.
4. Apply a wash of **A** over the entire berry; then shade the shadow side (right side and bottom) with **C**.
5. Highlight the upper-left third of the drupelets with **G**. Paint the very fine hairs a brown mixture of **A+K**.

Pinkish Green Berries
These berries are just beginning to ripen. Soft reds intermingle with the greens. The berries are a little fuller and larger, and their highlights are a little more obvious.
1. Undercoat the berry with a mixture of **H+G+A**.
2. Shade the drupelets by defining them with the No. 1 flat brush sideloaded with the following colors: a mixture of **A** plus a little **J**; a mixture of **J** plus a little **A**; and with **J**. This step will give you a variety of green and red drupelets.
3. Wash over the entire berry with **J**.
4. Highlight all of the drupelets with **G**.

5. To add further depth, wash **J** on the red drupelets and **A** on the green ones.
6. Add **F** highlights to the upper-left third of the drupelets. Paint thinned **F** reflected lights on all drupelets.

Red Berries
These berries are halfway ripe. Some of the drupelets may have begun to turn a deep red wine color.
1. Undercoat the berry with **I.**
2. Wash over the berry with **J.**
3. Shade the drupelets with **K** sideloaded on the No. 1 flat brush.
4. Highlight all drupelets with **F.**
5. Wash **J** over the entire berry; then shade the lower and right-hand side with **L.**
6. Add highlights and reflected lights with **F.** Add some color variety, if desired, by painting a few drupelets with a sideloaded brush of **L.**

Wine-colored Berries
The drupelets are even fuller and squishier at this stage. Some of the berries will be somewhat elongated; and some will be turning deep purplish black.
1. Undercoat the berry with **I.**
2. Wash over the entire berry with **L.**
3. Shade the drupelets with **L** or a mixture of **L+M** (for deeper colored drupelets).
4. Highlight all drupelets with **H.**
5. Wash **L** over the entire berry. Highlight the drupelets in the upper third with **G.**
6. Brighten the berry with a wash of **J.** Add strong highlights to the drupelets in the upper third, and reflected lights to all drupelets with **F.**

Black Berries
In some varieties, the ripe blackberry is quite elongated and the drupelets are very full. It's fun to combine the colors from the previous wine-colored berry with the ones in this procedure.
1. Undercoat the berry with a blackish mixture of **M+K+E.**
2. Suggest the drupelets by painting dabs of highlight color with a gray mixture of **E+F.** These dabs should form irregular patches, which will create a variation in values as the drupelets take shape.
3. Add more highlights with a lighter gray; add more of **F** to **E.** Work with thinned paint, and paint crescent strokes on the left side of each drupelet. The drupelets should now be starting to take shape. Still, don't be too fussy.
4. Wash over the entire berry with a deep, dull purple mixture of **M+E.**

5. Add highlights and reflected lights with **H.** This step further helps to round out the drupelets.
6. Add strong highlights to the upper third of the drupelets with **F.** Wash over the lower third with very thin **L.**

With the exception of the greenish red berry, I've kept the berry colors on the worksheet simple. In other words, the black berry is only black, and the wine berry is only wine. Look closely at the berries on the decoy, however, and you will see that I've intermingled the colors on the drupelets.

Once you've painted through each of the berry sequences, you will understand how you can mix and match parts of some sequences to create a variety of coloration in your berries. The berries do, after all, ripen gradually, and each one appears a little different throughout the process. Don't try to carefully follow the steps; instead, paint by instinct. If you've started painting a berry black and decide you want some red drupelets in it, highlight the area more heavily, then wash some red or wine color over it. Experiment with colors, washes, and highlights.

Calyxes
On the ripened berries, the calyxes have begun to dry out. They fade from green to a pale straw color.
1. Undercoat the sepals in the calyx with a mixture of **H+M+F.**
2. Highlight the tips of each sepal with **F,** then shade toward the center very faintly with **A.**
3. Paint the center with a mixture of **A+F+H.** Paint the tiny hairlike filaments with a brownish mixture of **L+A.**

Shadows
If you'd like to add another dimension to the leaves and berries, use a very thin wash of brown (mix reds and greens together) to suggest shadows. Keep them understated so that they don't detract from your design.
Note: If you painted your design on a colored background, adjust your shadow color to correspond to it.

Antiquing
Refer to the section on "Antiquing," pages 293–295. Protect your hands with latex gloves. If you don't have gloves, cover your hands with some sandwich baggies. Antique the decoy with burnt umber oil paint. Do not apply the antiquing glaze over the berry/leaf design.

Advanced Blackberries

GREEN (UNRIPE) BERRIES
1. Undercoat with **B+G**.

PINKISH GREEN BERRIES
1. Undercoat with **H+G+A**.

RED BERRIES
1. Undercoat with **I**.

WINE-COLORED BERRIES
1. Undercoat with **I**.

BLACK BERRIES
1. Undercoat with **M+K+E**.

2. Shade with **A+K**.

2. Shade with **A+J**, **J+A**, and **J**.

2. Wash with **J**.

2. Wash with **L**.

2. Highlight with **E+F**.

3. Highlight with **H+G**.

3. Wash with **J**.

3. Shade with **K**.

3. Shade with **L**, or with **L+M**.

3. Highlight with more **E** + more **F**.

4. Wash **A** over all. Shade with **C** on right and bottom.

4. Highlight with **G**.

4. Highlight with **F**.

4. Highlight with **H**.

4. Wash with **M+E**.

5. Highlight with **G**. Paint hairs with **A+K**.

5. Wash **J** on red; **A** on green.

5. Wash **J** over all. Shade with **L** on right and bottom.

5. Wash with **L**; highlight with **G**.

5. Paint highlights and reflected light with **H**.

CALYXES
1. Undercoat with **H+M+F**.
2. Highlight with **F**. Shade with **A**.
3. Paint the center with **A+F+H**; hairs with **L+A**.

6. Paint highlights and reflected light with **F**.

6. Paint highlights and reflected light with **F**. Color some drupelets with **L**.

6. Wash with **J**. Paint highlights and reflected light with **F**.

6. Highlight with **F**. Wash the lower third with **L**.

A B C D E F G H I J K L M

PALETTE

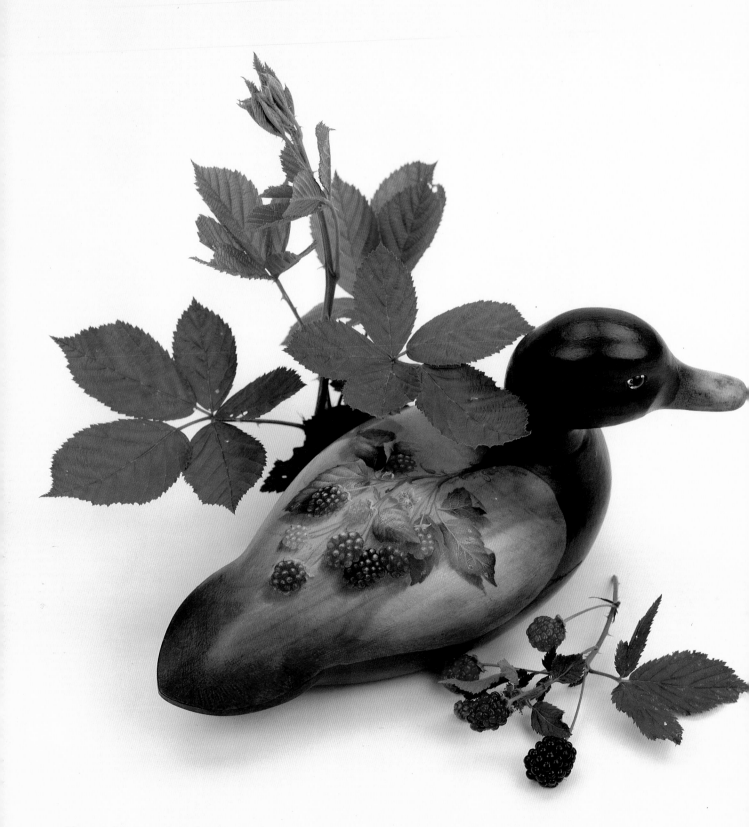

The completed carved wooden decoy project.

Quick and Easy Cherries

PROJECT
Small piggin (#31S)
from Designs by
Bentwood

SKILLS NEEDED
Comma strokes
Circle strokes (optional)

PATTERNS
Page 313

PALETTE
A Ebony Black
B Light Avocado
C Rookwood Red
D Antique Gold
E Jade Green

BRUSHES
Flat: No. 4
Round: No. 3
Liner: No. 1

The colors and simplicity of the design for this project were inspired by the toleware painted by the early colonial settlers. Working on a black background, folk artists often used a dull red, an avocado green, and an antique gold.

Surface Preparation

1. Basecoat the project with **A**.
2. Mark ³/₄-inch borders along the top and bottom edges. Mask the border area with masking tape if desired. (See "Making Masks," pages 92–93.) Basecoat the borders, as well as the borders on the handle, with **B**.

Painting Instructions

Cherries

1. Using the flat brush, paint the cherries with **C**. Use a circle stroke or simply fill in the shape.
2. Mix **C+A** to make a deep red. Paint small comma strokes with the liner brush near the bottom of each cherry. Paint a thin crescent stroke to suggest the stem depression on some cherries.

3. Dab a highlight of **D** near the top of each cherry.

Stems

Use the liner brush to paint long, thin comma strokes for stems in **B**.

Leaves

Paint the comma stroke leaves with the round brush in dark, medium, and light value greens. For dark green, mix **B+A**; for medium green, use **B**; for light green, mix **B+E**.

Dots

Use the handle end of the brush to paint dots with **C**.

Comma Stroke Border

Use the liner and **D** to paint the comma strokes in the border. Since it's so easy to see inside the piggin, it's a good idea to paint a border there, too. Use **B**. Keep it simple so it won't detract from the main design.

Handle

Decorate the handle with a simple stroke design.

Sign your name with a smile on your face!

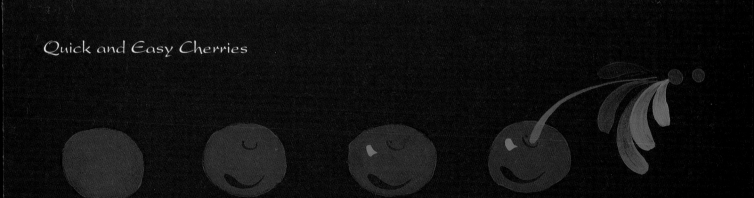

Quick and Easy Cherries

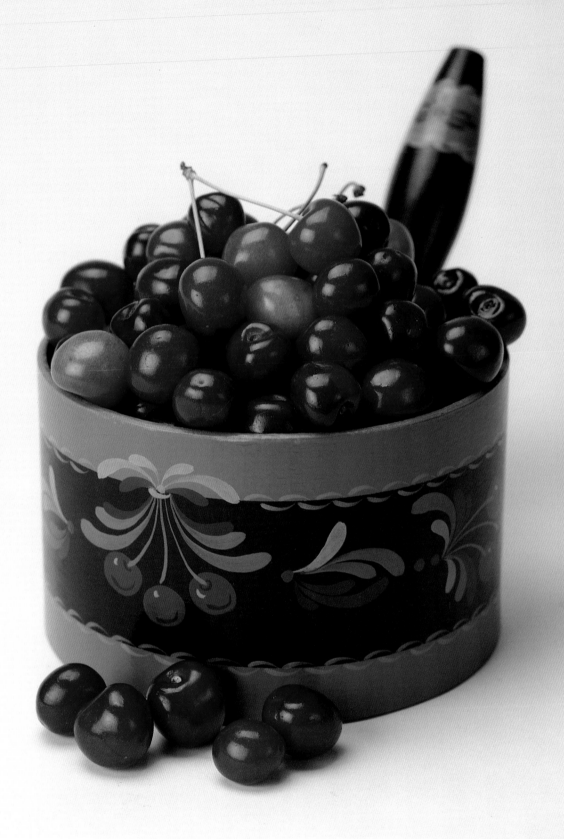

The completed piggin project.

Intermediate Cherries

PROJECT
Molly Pitcher lamp from
Crafts Manufacturing

SKILLS NEEDED
Sideloading
Doubleloading
Drybrushing
Crescent stroke

PATTERN
Page 314

PALETTE
A Ebony Black
B Peaches 'n Cream
C Spice Pink
D Blush
E Country Red
F Cranberry Wine
G True Blue
H Desert Turquoise
I Taffy Cream
J Avocado

BRUSHES
Flats: Nos. 8 and 4
Liner: No. 1
An old, frazzled brush

MISCELLANEOUS
White chalk
Masking tape (optional)
Brush 'n Blend Extender

Surface Preparation

If you are working on the Molly Pitcher lamp, it is available with its surface already prepared. If you are preparing an object yourself and like the effect of bright red cherries on a black background, then basecoat the project with **A**.

Paint a ³/4-inch border along the base of the lamp with **J**. Highlight the top portion of the border by adding a little **I** to the **J**.

Painting Instructions

Cherries

Light Values

1. Undercoat the cherries with **B**. Recoat them as needed, although perfectly opaque coverage is not necessary.

Medium Values

2. Sideload **C** on the No. 8 flat brush. Apply the pink heavily to the lower left of the cherries, fading slightly as you proceed toward the upper right, but nevertheless still laying down some color. Let dry.
3. Apply **D** the same as in step 2.
4. Sideload the No. 8 flat brush with **E**. With a separate brush, apply a thin layer of water in the upper-right third of the cherry. Return to the No. 8 flat brush and apply the red, beginning at the lower left and fading into the water.

Dark Values

5. Sideload the brush with **F**. Apply as in step 4. Also use this color to shade any berry that lies behind another.
6. *Stem depressions.* Refer to the pattern and draw the stem depressions with chalk. Wipe away any excess. Sideload the No. 4 flat brush with **F**. Paint a crescent stroke with the darkest value toward the bottom of the stem depression.
7. *Shading.* Mix **F+G** to create a rich violet. Sideload the violet onto the No. 8 flat brush. Shade the lower edges of the cherries and deepen the stem depressions.

Color Correction

8. Adjust the coloring on any cherries you are not pleased with by floating on thin washes in any of the colors used in steps 2 through 7. To make the cherries darker, use **F** or **F+G**. To make them a brighter red, use **E**. To make them a soft, warm red, use **D**. Use **C** if you have obscured the light area in the upper right.

Reflected Light

9. Sideload the No. 8 flat brush with thinned **H**. Paint a subtle crescent stroke along the lower left edge to suggest reflected light. Use much less color than you think necessary. You might wish to fill the brush with extender before picking up the blue color.

Highlight

10. Use a frazzled old brush to apply drybrushed highlights. Load **I** onto the brush, then rub most of it off. Gently buff the light yellow onto the upper right side of the cherries.
11. *Accent highlights.* Cornerload the No. 4 or 8 flat brush with a little **I**. Flick a strong highlight into the center of the drybrushed highlight area. Try to do this with a single, sure stroke. Don't fuss over it.

Stems

1. Mix an assortment of brownish greens using the green and red colors. Add the light yellow for light values. Load a couple of the mixtures onto the liner brush. Paint the stems, rolling the brush as you go to create color variations.
2. Add highlights to the stems by brushing on more **I** and a little more **J**.
3. Add shading by brushing on more of **F+J**.

Leaves

1. *Brushstroke leaves.* Doubleload the No. 8 flat brush with **J** and a mixture of **J+I**. Paint the leaves with bumpy pivot-pull strokes.
2. *Color accents.* Add a tint of reddish color by sideloading the No. 8 flat brush with extender and **D**. Brush small amounts of this color onto leaves nearest the cherries.
3. *Highlights.* Emphasize the highlights by sideloading the No. 8 flat brush with extender and a mixture of **J+I**.
4. *Shading.* Shade along the vein with a mixture of **J+G** plus very little **F** sideloaded onto the brush with extender.

1. Undercoat with **B**.

2. Starting at the lower left, wash with **C**.

3. Wash with **D**.

4. Wash with **E**.

5. Wash with **F**.

6. Add stem depressions with **F**.

7. Shade with **F+G**.

8. Adjust colors by repeating any previous steps.

9. Add reflected lights with **H**.

10. Drybrush highlights with **I**.

11. Add strong accent highlights with **I**.

STEMS

Undercoat

Highlight

Shade

Undercoat leaves with **J** and **J+I**.

Tint with **D**.

Highlight with **J+I**.

Shade with **J+G** plus very little **F**.

PALETTE A B C D E F G H I J

The completed Molly Pitcher lamp project.

Advanced Cherries

PROJECT
Ashford curio cabinet from Walnut Hollow Farm

PATTERNS
Pages 314–315

PALETTE
A Evergreen
B Russett
C Coral Rose
D Cadmium Red
E Berry Red
F Cranberry Wine
G Taffy Cream
H Avocado
I Jade Green
J Midnite Green
K Raw Sienna
L Desert Turquoise

BRUSHES
Flat: No. 8
Round: No. 3

MISCELLANEOUS
Brush 'n Blend Extender

SUPPLIES FOR PUNCHING METAL
A 9 × 12 inch piece of copper flashing (plus a scrap for practice)

A hammer

A large nail or awl

Heavy tape (duct, carpet, or masking)

Steel wool

Liver of Sulphur

Rubber gloves

Paper towels

Matte acrylic spray varnish

Transfer paper

An 11 × 14 inch scrap of lumber

It's delightful to stand under the trees in an orchard and see how the light glitters through the foliage, creating interesting, broken patterns on the leaves and fruit. It's also fun to capture bits of that dancing light in decorative painting. Don't be afraid to try it. You can always submerge it under a thin wash of color if you are not satisfied with your efforts.

This lesson combines the decorative painting of cherries with punched copper. You can do either part of the lesson as a separate project, or combine the two for a special effect. Read about "Punched or Pierced Tin," pages 99–101.

Surface Preparation

1. Basecoat the top, base, door, and interior of the cabinet with **A**. Basecoat the sides with **B**.
2. Prepare the copper flashing for painting. (See pages 99–101 for complete instructions on the following: rubbing with steel wool, treating with Liver of Sulphur for an antique effect, buffing, spraying with acrylic varnish, and punching.)

Painting Instructions

Cherries

Use the flat brush for all the following steps.
1. Undercoat with **C**. Apply several coats if necessary; note that totally smooth coverage is not critical.
2. Paint some cherries with a wash of **E**, some with a wash of **D**, and some with layers of both. Notice the subtle color variations in step 2 on the worksheet. Thin the paint with extender.
3. Shade with a mixture of **E+F**. Use the mixture sparingly on the cherries in the foreground; use more on the cherries in shadow. Shade the stem depressions.
4. Add highlights (they'll be faint) and secondary lights with **C**. Apply the paint randomly on all the cherries except those in deepest shadow. Use a drybrush technique or apply the paint semi-opaquely with extender. (It will look somewhat spotty.)
5. Add reflected lights on the lower right sides of the cherries with very thin **C** sideloaded on the brush. Let dry.

6. Wash over the cherries with **D**.
7. Repeat any of the previous steps to deepen shadows, brighten highlights, and adjust colors. Play with transparent washes and semi-opaque scumbling and drybrushing, then watch the cherries start to glow. Let dry.
8. Add a thin sideloaded wash of **L** over the reflected lights. Be careful that the bluish reflected lights don't overpower your work. They should be subtle, barely obvious. (If this is a scary step for you, substitute **D** for **L**.) Add a final, strong highlight of **G**.

Now stand back and study the cherries to be sure you have a variety of colors and shades. Some cherries should appear to be obviously "out front." Others should be quite dark and duller so that they recede into the background. If they are too bright, add a small amount of **A** to either **F** or **E**, and apply a thin wash of the mixture to any areas you need to subdue. To brighten any areas, brush on more **C**; let dry, then apply a wash of **D**.

Leaves

Before beginning to paint the leaves, review the worksheet on page 133.
1. Undercoat the leaves with **H**.
2. Shade with a mixture of **A+F**.
3. Highlight with a mixture of **H+G**.
4. Create some color variety by adding blushes of color. Use **C**, as well as mixtures of **H+C** and **H+E**. Thin the colors with extender. Broken patches of color (sometimes subtle, sometimes strong), prevent your leaves from looking overblended, boring, and predictable. Without measuring, make an effort to paint a change of colors every $1/2$ inch or so.
5. Paint veins and strong lights with mixtures of **H+I** and **I+G**. Wash over the lights with thinned **H**.
6. The backs of the leaves are a little lighter, and less colorful, than the fronts. Use more **I** in your mixes. Paint the veins more prominently, especially the center vein, and where it joins the lateral veins. To suggest fine, delicate veins, doodle with the liner brush loaded with very thin light-value green in the spaces created between the lateral veins. Shade the

corners created at the intersections of the lateral veins with the center vein. For a shading color, add a touch of **D**, **E**, or **F** to your green mixture to deepen it and lower the intensity.

Branches

Use the round brush for all the following steps.

1. Mix together various combinations of the greens and reds and the sienna to create several different browns. Fill in the branches with the medium values.
2. Use the dark-value browns in a sideloaded wash to shade along the right (shadow) side and to suggest other shadow areas.
3. Add **G** to one of the warm yellow-brown mixtures to create a highlight color. Brush this along the sunny side of the branch and on the edges of the branch where the cherry stems join it. This color will appear to really "pop." Don't worry; washes will subdue it.
4. Give the cherry branch a reddish glow by brushing a wash of thinned **D** over it.

Stems

Use the round brush for all the following steps.

1. Mix a variety of greens, dulling them with the red and rose colors. Undercoat the stems.

2. Highlight the stems with **I** and **I+G**.
3. Shade the stems with **J** and **A**, and with mixtures of them added to **F**, **E**, and **D**.
4. Wash over the stems with **H** and/or **K** thinned with extender or water. This will add a sunny glow to the stems.

Corner Designs

Paint the stroke leaf designs in the four corners of the door with either the round brush or the flat brush and a medium dark-value green. Test your mixture by painting one corner design on a piece of acetate. Tape it in place, then stand back to study the overall effect. If it is too light or bright, it will detract from your main design. Use a value as close as you dare get to the value of your basecoat. After painting all four corners, stand back and check again. If necessary, you can wash a thin layer of the basecoat color over the designs to further submerge them.

Side Panel Scrolls

Use the round brush and the basecoat color from the front, top, and base. Review page 68 for hints on painting scrolls smoothly and gracefully. A suggested sequence for painting the strokes is shown on the pattern.

Hints for Punching Tin

- If you're planning to do a lot of punching, consider using a small, lightweight hammer. Since heavy pressure and strong blows are not necessary, the lighter hammer will be easier on your shoulder.
- If you have a choice of sheet metal weights, choose the lighter weight. Unless it is terribly flimsy, it should serve well, and it is easier to punch than thick, heavy metal or flashing.
- If you grip the hammer, awl, or nail too tightly, your hands and fingers will ache and tire quickly. Relax your grip.

- If you are working with a large nail instead of an awl, push it through a cork to give yourself a more ample "handle" to hold. It will be easier on your hands.
- Try to develop a rhythm as you punch. It will aid precision and speed. Imagine that you are a sewing machine working in a steady, but slow-to-moderate, speed.
- After punching and antiquing the metal, but before painting on it, consider wrapping the edges with masking tape. This will prevent your being scratched or cut by sharp edges during the decorating process.

Advanced Cherries

1. Undercoat cherries with **C**.

2. Wash with **D** or **E**, or both.

3. Shade with a mixture of **E+F**.

4. Add highlights with **C**.

STEMS

1. Undercoat the stems with a variety of greens.

2. Highlight the stems with **I+G**.

3. Shade the stems with **J** and/or **A**, each mixed with **D**, **E**, or **F**.

4. Wash over the stems with **H** and/or **K**.

5. Add reflected lights with **C**.

6. Wash with **D**.

7. Repeat any of the previous steps to emphasize lights and darks, and to adjust colors.

8. Brush **L** over reflected lights. Add a strong highlight with **G**.

Wash

Highlight

Shade

Undercoat

See the Apple Leaves worksheet on page 133.

PALETTE A B C D E F G H I J K L

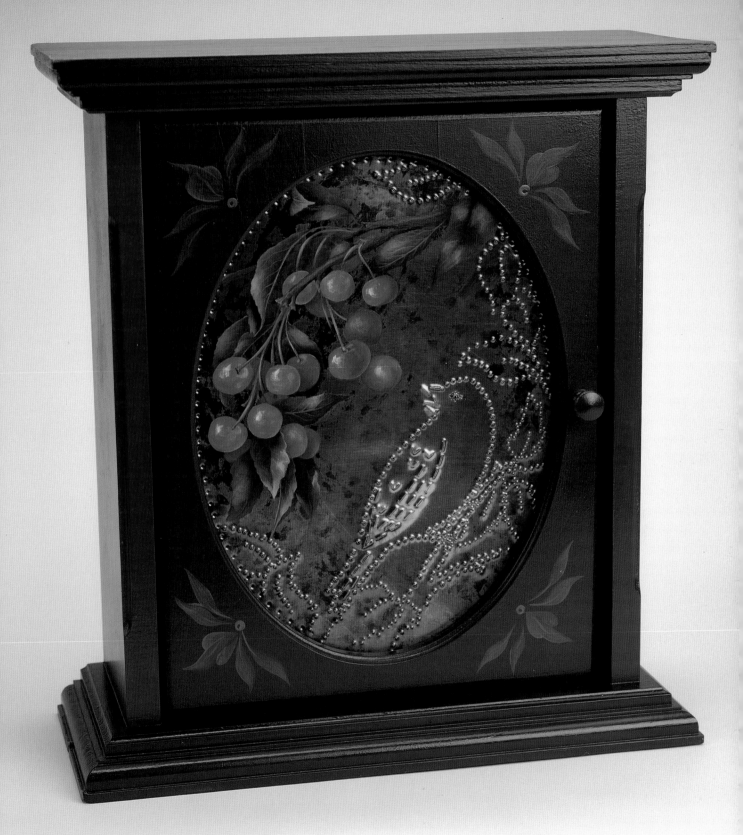

The completed punched tin curio cabinet project.

Quick and Easy Pears

Hand-carved or lathe-turned pears are fun to paint, forgiving of unsure brushwork, and can be completed quickly.

Painting Instructions

Pears
1. Basecoat the pears with **A**.
2. Brush **B** highlights on what will become the center front of the pear, on both the upper and lower portions. Let dry.
3. First dip the brush in extender, then load it with **C**. Beginning on the back, cover the entire pear with a transparent coat of **C**. Handle the brush loosely, in a "slip/slap" scumbling manner, allowing the brushwork to be evident. Do not try to stroke the color carefully and blend it into boredom. The obvious brushstrokes will help give the pear character. Tap your finger or a damp tissue on the highlight area to remove some of the wet gold color.

4. While the paint is wet (if you prefer, you may wait until it dries), brush on a blush of **D** thinned with extender in a few scattered places around the pear.

Leaves
1. Cut out a leaf shape from heavy paper, or use a leaf from a silk flower. Paint the paper or silk leaf with **E**.
2. Loosely brush a little **F** thinned with extender in the center of the leaf. Although the silk flower leaf may be a pretty green, it will suit the painted wooden pear better if it, too, is painted (then varnished later, right along with the pear).

Hint: To give yourself a handle to hold while painting, stick a pushpin in the base of the pear. When your painting is complete, set the pear on a small glass or jar to dry.

The completed lathe-turned pears project.

Quick and Easy Pears

1. Basecoat the pears with **A**.

2. Add highlights with **B**.

3. Cover with a transparent coat of **C**.

4. Add a blush of **D**.

Basecoat the leaf with **E**.

Shade along the center of the leaf with **F**.

PALETTE A B C D E F

Intermediate Pears

PROJECT
Collector's cabinet
(#31-585) from Cabin
Craft

SKILLS NEEDED
Sideloading
Doubleloading
Leaf stroke
Comma stroke

PATTERNS
Page 316

PALETTE
A Russett
B Moon Yellow
C Taffy Cream
D Antique Gold
E Burnt Orange
F Avocado
G Midnite Green

BRUSHES
Flats: Nos. 10, 8, and 6
Round: No. 3
Liner: No. 1

MISCELLANEOUS
Contact paper
Brush 'n Blend Extender
Masking tape
Ruler

Surface Preparation

1. Stain the cabinet doors a warm brown. (See "Staining Raw Wood," page 96.)
2. Basecoat the cabinet and the oval insets on the doors with **A**. Cut masks from contact paper and place on each door in order to paint a precise oval shape. (See "Making Masks," pages 92–93.)

Painting Instructions

Note that the worksheet shows the pear as painted for the left door. Reverse the pattern and the placement of highlights and shading for the right door. Use the No. 10 flat brush to paint the large pears, and the No. 6 flat brush to paint the small ones.

Pears

1. Undercoat the pears with **B**. Apply two or more coats as needed for smooth coverage.
2. Highlight with **C** sideloaded on a damp brush. Place the water side of the brush toward the outside edge of the highlight. Work around the highlight, keeping the color toward the center and gradually fading it out. The highlights may appear too strong. Leave them alone; future steps will subdue them. Let dry.
3. Shade with the flat brush filled with extender, then sideloaded with **D**. Begin painting on the shadow side of the pear with the gold toward the outside edge. Start at the top of the pear and stroke down toward the bottom. Return to the top and paint another stroke down toward the bottom. Continue working across the pear, allowing the color to fade gradually as you approach the highlight side. (Pick up more extender and less paint as you near the highlight area.) Paint over the highlights. Then, while the paint is still wet, tap your finger on the highlight areas to gently remove some of the gold. Let dry.
4. Brush a reddish glow on the shadow side. Dip the brush in extender, then sideload it by dipping one corner first into **D**, then the same corner into **E**. Blend the colors on the palette, keeping them on one side of the brush. Brush this color along the shadow side of the pear. If there is a distinct line of color where you stop painting the orange mixture, tap your finger along the edge of the wet paint to help merge it into the gold color previously painted.
5. Dip the corner of the flat brush in **C**. Dab strong highlights in the center of the previously highlighted areas.

Stems

Mix a brown with **D+E+F**. Use the corner of the No. 6 flat brush or the liner or round brush to fill in the stem. While the paint is wet, mix in a little **C** to highlight the stem.

Leaves

Doubleload the No. 8 flat brush with **F** on one side and **G** on the other. Place the dark value toward the center of the leaf. Paint two leaf strokes side by side. Be sure to flip the brush so the dark value remains in the center when you paint the second stroke. For the small leaves on the top pattern, use the No. 6 flat brush, doubleloaded as above, but paint only a single leaf stroke for each little leaf.

Comma Strokes

Use the No. 3 round brush and **G**, as well as a mixture **G+F**, to paint a variety of large comma strokes. Use the liner brush and **F** to paint the smaller, finer comma strokes.

Rectangular Insets on the Cabinet's Sides

Tape along the edges of each side with ³/₄-inch masking tape to create a rectangle approximately 6¹/₂ × 2¹/₂ inches. Basecoat the inset with **D**. Divide the area into ten 1¹/₄-inch squares, leaving the excess space at the bottom of the rectangle for your signature. Dip the No. 10 flat brush into extender, then sideload it with a mixture of **D+E**. Paint the left side and across the bottom of every square. Using the liner brush, paint the fine lines dividing the squares with **F**. Decorate the squares with comma strokes of **G**. Add dots of **F** in the centers of the stroke designs.

Intermediate Pears

Undercoat the pears with **B**.

Highlight with **C**.

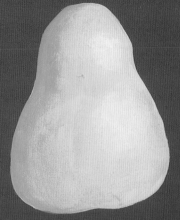

Apply a thin layer of **D** over all. While the paint is still damp, blot off the highlight by tapping with your finger.

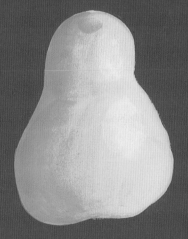

Shade with **D**, then **E**. Also, paint the crescent-shaped stem depression.

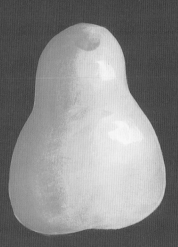

Add strong highlights with **C**.

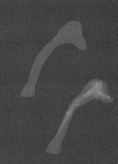

Basecoat the stems with a mixture of **D+E+F**. Highlight with **C** while the basecoat is still wet.

Doubleload the No. 8 flat brush with **F** and **G**. Paint two leaf strokes side by side, leaving the dark value in the center.

Basecoat with **D**. Stripe with **D+E**. Add lines Paint strokes
 with **F**. with **G**.

PALETTE A B C D E F G

171

The completed collector's cabinet project.

Advanced Pears

PROJECT
Salt box from
Norwegian Wood

PATTERNS
Page 317

PALETTE
A Blueberry
B Navy Blue
C Warm Neutral
D Burnt Orange
E Moon Yellow
F Taffy Cream
G Antique Gold
H Light Avocado
I Raw Sienna
J Dioxazine Purple
K mixture of **A+B+D**
L Glorious Gold

BRUSHES
Flats: Nos. 6 and 10,
and ³/₄ inch
Round: No. 3
Liners: Nos. 1 and 10/0

MISCELLANEOUS
Brush 'n Blend Extender
³/₄-inch masking tape
Plastic wrap
Natural sea sponge

Make this painting lesson more meaningful by having several real pears nearby while you paint. (There are many different varieties, each with diverse colors and distinctive shapes.) Look at all the freckles, brown age spots, dents, and scars. Real pears are irregular in shape, not symmetrically formed as the lathe-turned wooden pears in the Quick and Easy Pears lesson. Notice whether and where blushes of green or red occur on your pears. Where do the shadows fall? Move the light source and watch what the shadows do. Enjoy the scent of the pears as you work, and then feast on them when you're finished! (Just be sure not to handle them with painty hands.)

Be adventurous in experimenting with transparent washes of color. The more layers you build (up to a point, of course), the more interesting your pears will become. Each thin layer of color adds dimension and depth to your pears. As you wash colors on, then wash other colors over them to lighten, darken, or otherwise alter them, you may well require more than the nine steps shown on the color worksheet. At that stage, it's a matter of "playing" with the colors to create the effect you like. Be sure, however, to quit before you overdo it and spoil your efforts. Use my painted sample only as a guide to get you started. It would be difficult—and not much fun—to try to duplicate it exactly. The many variations possible in the sequence of layering on transparent and translucent washes and opaque passages offer multiple possibilities for the final effect.

Surface Preparation

1. Basecoat the box a dull blue (a mixture of **A+B+C**). (See the background color of the worksheet.) Let dry thoroughly.
2. Apply ³/₄-inch masking tape along the edges of the front and the two sides to create the insets. Brush on a thin dark blue mixture of **A+B+D**. (See **K** on worksheet.) While the paint is still wet, marbleize the inset using plastic wrap. (See "Marbleizing," page 278.)
3. Use the dark blue mixture from step 2 to paint the corners of the lid and the edge of the top.

Painting Instructions

Pears

Use the No. 10 flat brush for all the following steps. Follow steps 1 through 3 on the Intermediate Pears worksheet. The Advanced Pears worksheet begins with step 4. Note that the highlights are on the left side for the Advanced Pears.

1. Undercoat the pears with **E**. Apply several thin coats if necessary, although it is not important that the coverage be perfectly solid. Any imperfections in the undercoat will create variety and character in the pear, and prevent it from appearing overblended or stylized.
2. Highlight with **F**. Sideload the brush, using the water side to feather out the color slightly as you paint.
3. Apply a thin wash of **G** over the pears. Immediately blot the wet color off the highlight area with your finger, or use a paper towel or a tissue.
4. Paint the cast shadows with the dark blue mixture used for the trim and marbleizing. Make the shadows darkest where they touch the edge of the pear casting the shadow.
5. Use the sea sponge to dab on a mixture of **D+G** thinned with extender or water.
6. Also sponge onto the highlight area **F** mixed with very little **G**. No thinning is necessary.
7. Add tints of color by brushing on a mixture of **G+H**. Dip the brush in extender then sideload it with the green mixture.
8. Deepen the pear's local color by brushing on **I** sideloaded onto the brush with extender.
9. Strengthen color tints, highlights, and shading, as necessary or desired, with the following colors or mixtures, sideloaded onto the brush with extender:

 I+H to deepen the greens

 D to brighten the orange blush

 I to add more depth of color

 E to strengthen the highlights

 J+D to accent shadows

 B+D+J to cast a shadow onto the "behind" pear and to shade the blossom and stem ends

If the shadow on the "behind" pear needs further deepening, wash a thin layer of the dark blue shadow mixture up onto the pear. If it appears too strong when it dries, wash a thin layer of **H** over it to submerge it slightly.

Stems

1. Use the No. 3 round brush to undercoat the stem with a mixture of **H+I**. While the green is wet, proceed to step 2.
2. Begin shading with dark browns and brownish greens in thin, lengthwise strokes. Use various combinations of the following to mix the shading colors: **B, D, H, I,** and **J.** Use your darkest brown mixture to shade the right side of the stems.
3. Mix **H** plus very little **F** to create a highlight on the stem and to fill in the cut end. Add stems for the leaves.

Leaves

Work with the No. 6 flat brush. Mix greens in a variety of values and hues by picking up a little of two or more colors on your brush and gently mixing them together on the palette. See how many different greens you can create using the following colors: **A, B, E, F, G, H, I, J,** and **K.** Mix each color individually with the green (**H**), then mix multiple colors together. Try to use as much variety in your leaf painting as possible.

When you paint the following steps, watch what happens as you lay on the thin washes. Often the color puddles in a way that suggests the placement of highlights or shadows. If you like what you see, let it dry, then emphasize it with another application of color.

1. Undercoat the leaves with **H.**
2. Highlight with a mixture of **H+E** sideloaded on the brush.

3. Shade with a mixture of **H+A, H+B, H+J,** and/or **H+B+J** in the shadow areas and along the vein line, leaving the vein unpainted for now. Be careful not to let the vein or any shading cut the leaf visually in half.
4. Add accent color with **I+J,** letting the color overlap previous washes somewhat.
5. Using a liner brush, outline insect nibbles with **J+D.** Then tinge the edges of those areas with a thin wash of **J+D.**
6. Tie the colors together with a thin wash of **H.** Paint veins using very thin **H+E** on the tip of a liner brush. They should be barely visible.

If necessary, repeat any of the above steps to strengthen highlights, shades, and accent colors. If you need to subdue highlights, shades, and accents, brush over them with a thin wash of **H.**

Waterdrops

Refer to the Waterdrops worksheet on page 139.

Surface Line Behind Pears

Sideload a large flat brush with the dark blue mixture used for marbleizing and trimming. Apply the stroke, beginning at the edge of the pears and letting it fade before you reach the edge of the lid.

Scrollwork Embellishments

Use a liner brush and **L.** Be sure to emphasize thick and thin variations in your stroke work. When you finish embellishing the front, top, lid, and sides, turn the box around and do a little something on the back, and something inside the lid. Somebody is sure to look!

Advanced Pears

For steps 1 through 3, see the worksheet for Intermediate Pears.

4. Add cast shadows with **A+B+D**.

5. Sponge on a reddish blush with **D+G**.

6. Sponge on highlights with **F** plus a little **G**.

7. Add a greenish tinge with **G+H**.

8. Cover with a deep golden wash of **I**.

9. If necessary, strengthen color accents, highlights, and shading by repeating any of the preceding steps.

1. Undercoat with **H**.

2. Highlight with **H+E**.

3. Shade with **H+A, H+B, H+J,** and/or **H+B+J**.

4. Accent with **I+J**.

5. Outline nibbles with **J+D**.

6. Unify with a wash of **H**. Paint veins with **H+E**.

Undercoat with **H+I**.

Shade with any mixture of **B, D, H, I,** and **J**.

Highlight with **H** plus a little **F**.

Paint scrolls with the liner brush and **L**.

Refer to the worksheet for Waterdrops on page 139.

PALETTE	A	B	C	D	E	F	G	H	I	J	K	L

Advanced Pears

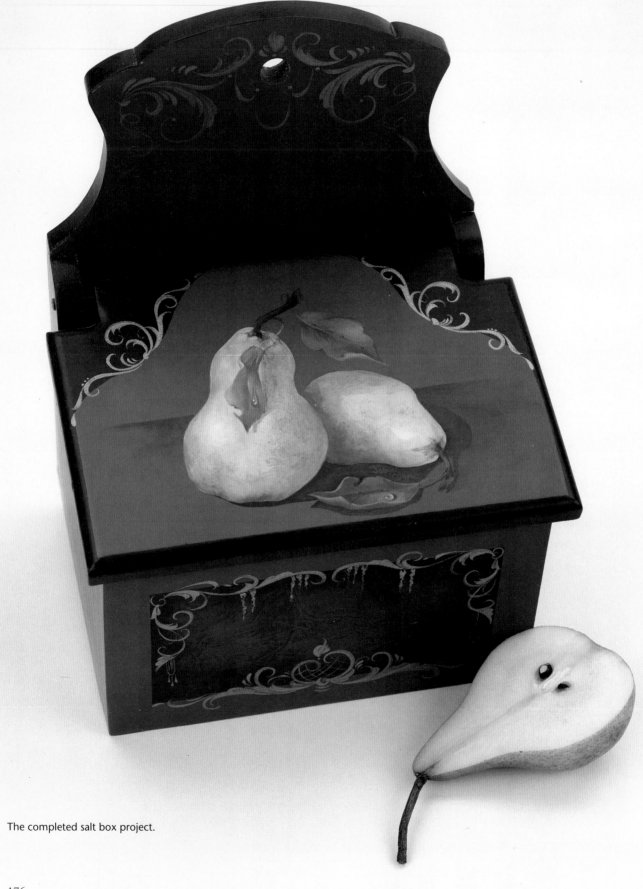

The completed salt box project.

Quick and Easy Watermelons

PROJECT
Firewood "watermelon" slices (either with or without the bark)

SKILLS NEEDED
None

PATTERN
None

PALETTE
A Blush
B Country Red
C Rookwood Red
D Evergreen
E Olive Green
F Taffy Cream

BRUSHES
1-inch poly foam brush *or* an old large flat brush

MISCELLANEOUS
Watermelon seeds *or* black oil sunflower seeds

This project is such fun to do that you will want to make a basketful of them. Take a trip out to the wood pile and find a quarter-split log. Use a saw to cut off slices. The larger the log, the thicker you can cut the slices. We used a chain saw to cut the 10-inch-wide by 2-inch-thick ones shown here. The cuts do not have to be smooth—in fact, the coarser, the better.

Surface Preparation

Brush away loose sawdust from the cut firewood.

Painting Instructions

1. With an old large flat brush or a poly foam brush, randomly dab on **A**, **B**, and **C**, overlapping strokes to merge colors slightly.
2. Brush a mixture of **E+F** along the bottom edge to create the white part of the flesh.
3. Paint the rind edge with **D**. Drybrush on stripes of **E**.

Finishing

Varnish the watermelon slice, then glue on the seeds.

The completed firewood "watermelon slices" project with real watermelon slices in the foreground.

1. Randomly dab on
 A, **B**, and **C**.

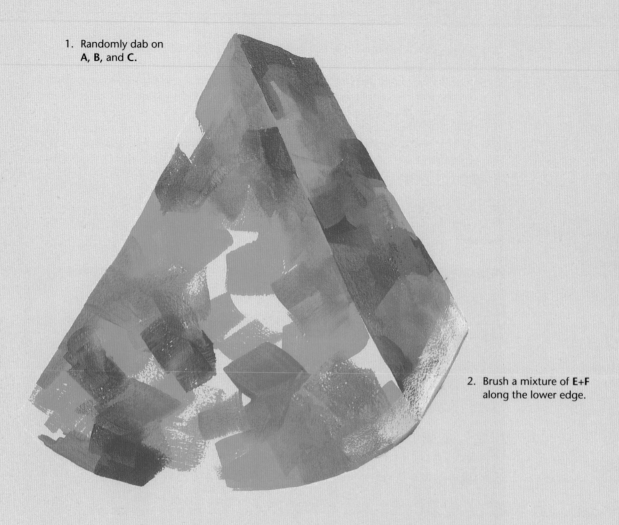

2. Brush a mixture of **E+F**
 along the lower edge.

3. Paint the rind edge with **D**.
 Drybrush on stripes of **E**.

PALETTE A B C D E F

Intermediate Watermelons

PROJECT
Watermelon sign
(#93-JS-2) from Sunshine
Industries Unlimited

SKILLS NEEDED
Sideloading
Crescent strokes
Sponging

PATTERN
None

PALETTE
A Blush
B Country Red
C Rookwood Red
D Evergreen
E Olive Green
F Taffy Cream
G Ebony Black
H Neutral Grey

BRUSHES
Flat: No. 10

Round: No. 3

1-inch poly foam brush
or an old flat brush

MISCELLANEOUS
A sponge, either
household or natural

White chalk

This project is painted on old, weathered barn boards, cut in the shape of a watermelon. If you don't have access to that kind of roughened board, the Watermelon sign from Sunshine Industries is an excellent substitute.

Surface Preparation

If you have access to old, weathered barn boards, you might want to do as we did, and create your own sign. Paint the cut edges with **H** to make them match the gray face of the board. Likewise, if you're working on a new wood sign and would like to imitate the color of old wood, paint the entire sign with **H**. Rough up the edges a little with a rasp to make them look a bit worn.

Painting Instructions

Flesh and Rind

1. Dip a very wet sponge alternately into **A**, **B**, and **C**, dabbing each randomly on the lower half of the watermelon. Leave approximately 3/4 inch unpainted for the white part of the flesh. If you are working on old barn board, it will be quite dry and will readily soak up the

paint. If you're working on new wood, your sponge shouldn't be as wet.

2. Mix a pale whitish green with **E**+**F**. Use the sponge to paint the white part of the rind. With the flat brush, paint a thin line of **D** along the bottom edge.

3. Paint the rind with a wet sponge, dabbing alternate stripes of **D** and **E**. Let dry.

4. Use chalk to outline the lettering for "Ice Cold Watermelon" and "5¢," and to indicate the placement of the seeds.

5. Using the No. 10 flat brush, paint crescent strokes of sideloaded **C** around each chalked watermelon seed that is not a part of the lettering and the numeral.

6. Sideload the No. 10 flat brush with **A**. Paint a highlight around each seed depression painted in step 5.

Seeds

Be sure that the watermelon is dry before painting the seeds.

1. Undercoat the seeds with **G** by painting short, fat teardrops with the round brush.

2. Mix a little **G**+**H**. Paint a light gray area on each seed. Also, paint a thin gray line along one edge of each seed.

3. Paint a strong highlight of **F** on each seed.

The completed watermelon sign project.

Intermediate Watermelons

1. Sponge **A**, **B**, and **C** randomly on the old, weathered wood. (The porous wood will provide a more subtle effect than you see here.)

2. Sponge a mixture of **E+F** on the cut edge of the rind, and paint **D** along the edge.

3. Paint alternate stripes of **D** and **E** using a very wet sponge.

4. With a piece of chalk, mark the positions of the seeds, lettering, and numeral.

5. Paint crescent strokes of **C** around all the seeds except those that comprise the letters and the numeral 5.

6. Paint a highlight of **A** around each seed depression.

1. Undercoat the seeds with **G**.
2. Highlight with **G+H**. Also, paint a thin gray line along one edge.
3. Add a strong accent highlight of **F**.

PALETTE A B C D E F G H

Advanced Watermelons

PROJECT
11½-inch bowl from
Weston Bowl Mill

PATTERN
None

PALETTE
A Peaches 'n Cream
B Olive Green
C Taffy Cream
D Blush
E Berry Red
F Burgundy Wine
G· Evergreen

BRUSHES
Flats: Nos. 8 and 10
Round: No. 3
Detail: No. 00

MISCELLANEOUS
Natural sea sponge
White chalk

An Idea!
Consider painting several accessory pieces to go with your bowl, including napkin rings, candlesticks, placemats, and trays.

This project is a fun spoof on the more realistic painting of a watermelon. Place a real watermelon slice on your painting table, so you can refer to it as you work. Cut a real watermelon in half across the short dimension. Study the color and the position of the seeds, the scroll-like curves of the fibers that divide the melon into thirds, the texture and color of the flesh, and the mottled pattern on the rind.

Surface Preparation

1. Basecoat the inside of the bowl with **A**.
2. Basecoat the rim and outside of the bowl with **B**.

Painting Instructions

Flesh

1. Cover the rim and inside of the bowl with a mottled sponging of **C**. The paint should be rather dry on the rim, but juicy (with a wetter consistency) on the inside of the bowl. The basecoat color should still show through this sponged layer. Sponge **C** heavily from the edge of the rim down into the bowl about 1 inch. Let dry.
2. With a wet sponge, dab **D** all over the inside of the bowl except for the rim. Let dry.
3. Repeat step 2 three or four times. With each repetition, the sponged color will appear more intense where it overlaps previous sponging. Let dry.
4. With a wet sponge, dab **E** over the entire inside of the bowl. While it is wet, proceed to the next step.
5. In five or six areas inside the bowl, sponge **F** into the wet **E**. Let dry.
6. With a piece of chalk, divide the inside of the bowl into thirds.
7. Mix **C+D** to paint the scroll-like fibers. Use the liner brush, making the lines thick in some places, thin in others, double in some places and broken in others. Let dry.
8. Sponge a mixture of **C+D** in scattered places over the scroll-like lines and in the center of the bowl. Let dry.
9. Sponge thinned **D** over the entire inside of the bowl.
10. Repeat steps 8, 9, and even 4, if needed, to adjust colors to suit your taste. If you're

painting from a real watermelon and wish to match its color exactly, you may need to alter your palette (depending on the degree of ripeness and the type of watermelon).

Seeds

1. Mix **G+F** to create a deep brown. Use the round brush to fill in the seed shapes. Do not paint comma or teardrop strokes as they will appear too regular. Try to make the seeds different shapes and sizes. Let the brown color appear streaky in places on the seeds.
2. Paint some seeds very thinly by watering the mixture. While the seed is still wet, blot it with a tissue. These will appear to be slightly beneath the watermelon's flesh.
3. Paint seed depressions with the No. 8 flat brush sideloaded with a mixture of **F** plus a little **G**.
4. Highlight one side and one edge of each seed with a light brown mixture of **F+G+C**. Thin the mixture with water. Use the detail brush.
5. Add a strong highlight of **C**.
6. Make the seeds appear to be attached to the flesh by sponging a little of mixture **D+C** over each tip.

Bowl Rind

1. Brush thinned **B** on the rim of the bowl. Let dry.
2. Sideload the No. 10 flat brush with **G**. With the dark color side of the brush to the outside edge of the bowl, shade the rim.
3. Turn the bowl over and use chalk to draw sixteen lines radiating from the center, as if slicing a pie. (The sections do not need to be equal; some can be fat, and others thin.)
4. Sponge on thinned **G** in every other section. Don't try to stay within the lines. Irregular edges are more interesting. Let dry.
5. Repeat step 4 in the same sections, using a little less water, so that the paint is thicker and darker. Let dry.
6. With very thin **G**, sponge the entire outside of bowl.

Don't worry if the green tends to drip or run on any of the last three steps. It will add an interesting pattern. You can control the runs by tipping the bowl.

FLESH

1. Sponge **C**.
2. Sponge **D**.
3. Repeat step 2.
4. Sponge **E**.
5. Sponge **F**.

6. Divide the bowl into thirds with chalk.
7. Paint scroll-like fibers in **C+D**.
8. Sponge **C+D** over the scroll lines.
9. Sponge thin **D** over the entire bowl.

SEEDS

1. Paint seeds with **G+F**.
2. Paint some seeds very thinly.
3. Paint seed depressions with **F** plus a little **G**.
4. Highlight with **F+G+C**.
5. Accent the highlight with **C**.
6. Sponge **D+C** over the seed tips.

BOWL RIND

Divide the outside of the bowl into sixteen sections. Sponge thin **G** in every other section.

Sponge more **G** onto the same sections with thicker paint.

Sponge very thin **G** over the entire bowl.

PALETTE A B C D E F G

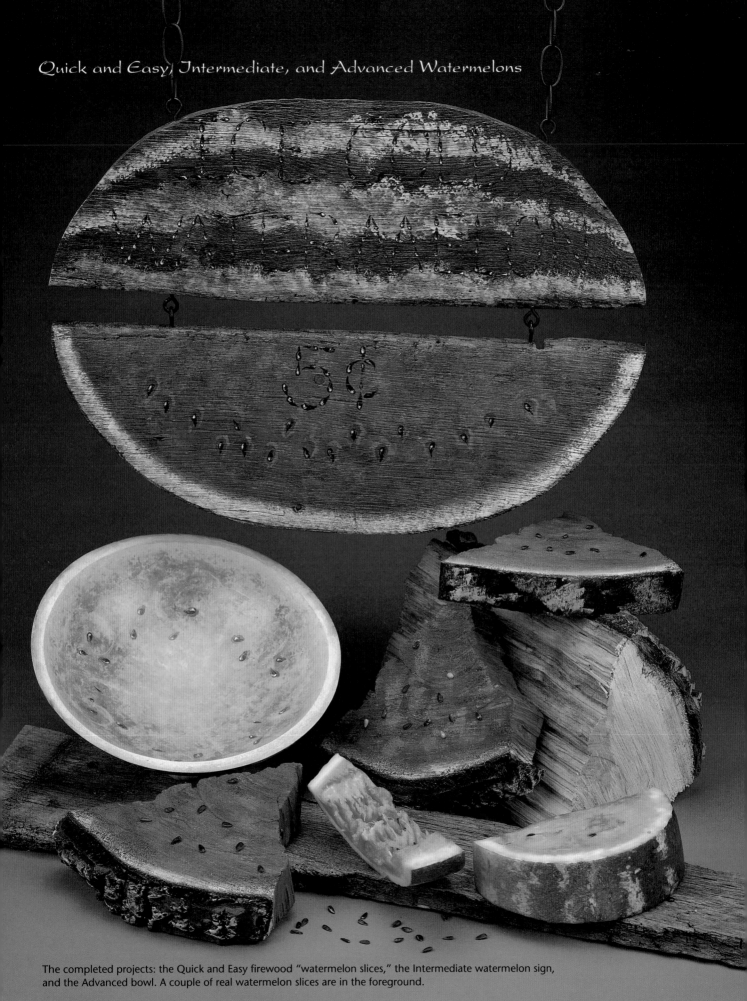

The completed projects: the Quick and Easy firewood "watermelon slices," the Intermediate watermelon sign, and the Advanced bowl. A couple of real watermelon slices are in the foreground.

Chapter 10

Vegetable Designs

For this chapter, I thought it would be fun to introduce you to some different techniques which, once learned, could be used on other projects and patterns in the book. The lessons in all three skill levels involve compositions consisting of several different vegetables.

In the Quick and Easy lesson, you will learn a simple technique of painting boldly with flat colors, then antiquing, then painting again to add highlights. It's a different way of working with antiquing, but I think you will enjoy the results. The Intermediate lesson introduces you to the delightful technique of French wash, or ink and wash, giving you the opportunity to work with a crow quill pen and India ink. In contrast to the Quick and Easy project, which is heavy, dark, and subdued, the French wash is delicate, light, and airy. The Advanced lesson involves the more realistic painting of a composition of vegetables, and calls upon all your blending and brushstroke skills.

You can easily substitute one technique for another in these projects. For example, you can try French wash on the pattern for the Quick and Easy lesson, or use the unusual antiquing technique in the Quick and Easy lesson on the Advanced project. You can also apply these techniques to any of the other designs in the book. You can also substitute techniques on the three mushroom projects at the end of the chapter. For example, if you lack the skills to paint the Advanced Mushrooms, use that pattern with the techniques suggested for the Quick and Easy or Intermediate levels. Or, an advanced-level painter could use the Advanced techniques to paint either of the other two projects.

The completed granny's bucket project for the Advanced Vegetables lesson (see pages 193–203).

Quick and Easy Vegetables

PROJECT
Narrow cabinet with shelves from Crew's Country Pleasures

SKILLS NEEDED
Comma strokes

Minimum confidence with the liner brush to paint quick, flowing lines for the raffia (the fiber used to tie the vegetables together)

PATTERNS
Page 318

PALETTE
A Desert Turquoise
B Moon Yellow
C Burnt Orange
D Berry Red
E Spice Pink
F Mistletoe
G Leaf Green
H Mink Tan

BRUSHES
Flat: No. 8

Liner: No. 1 *or* 2

Round: No. 3

Mop brush (optional)

An old round brush (optional) for antiquing

ANTIQUING SUPPLIES
Water-based varnish

Burnt umber artist's tube oil paint

Paint thinner *or* mineral spirits

Clear Antiquing Glaze Medium (see page 293)

1-inch poly foam brush

Cheesecloth

Cotton swabs

Lemon oil *or* furniture oil

3M Home 'n Hobby Pad (fine grade) *or* #0000 steel wool

Vinegar

Spirit *or* spray varnish

MISCELLANEOUS
A crumpled 4 × 4 inch piece of aluminum foil

The antiquing technique for this project—a slight variation on the usual routine—is fun, and the results are dramatic. You may simplify that part of the project by following either the two-step or four-step antiquing processes outlined on pages 294–295, and eliminate the final highlighting step.

Surface Preparation

1. Basecoat the cabinet with **A**.
2. Basecoat the stile, which is the vertical piece to which the hinges are attached, with **B**.

Painting Instructions

1. Use the flat brush to undercoat all the veggies with two coats as follows, reserving the colors in parentheses for highlighting *after* antiquing:

 Carrots—**C** (**C+B**)

 Carrot stems—**F**

 Radishes—**D** (**D+B**)

 Radish roots—**E**

 Radish leaves—**F** (**F+B**)

 Green peppers—**F** (**F+B**)

 Onions—**B**. Using the round brush, paint the onion by following its contour lines. Load the brush heavily on one side so that the paint is applied in pronounced ridges. These ridges will antique beautifully. No highlight color is needed for the onions after antiquing.

 Raffia—**H+B**. To paint the raffia, load the liner brush with thin paint. Paint long, flowing, but carefree lines. Do not try to follow the pattern closely.

2. After painting everything listed above, paint the carrot leaves. Dip the crumpled tin foil into **G** and tap excess paint off on the palette. Dab the foil several times onto the project to suggest the carrot's fernlike leaves. Replenish the foil with paint and continue. Then repeat the process using **F**. Repeat once more using very little **B**, scattering it in a few places. The paint in the foil prints will be thick, so it will require some time to dry completely.

3. Paint a comma stroke border with **B** along the sides of the cabinet, and a small stroke design on its ends.

4. Paint a comma stroke border along the painted yellow stile using **A**.

5. Set the project aside and let the paint dry thoroughly. Your next step will be to antique the project. You will add the painted highlights to the veggies later.

Antiquing

Before beginning this section, read the section on "Antiquing," pages 293–295.

1. Remove the pattern lines.
2. Apply one coat of water-based varnish. Let dry.
3. Mix burnt umber oil paint thinned with paint thinner or mineral spirits with Clear Antiquing Glaze Medium. With the poly foam brush, brush the colored antiquing glaze heavily onto the project. Wait a few minutes, then . . .
4. Remove excess glaze with cheesecloth, rubbing harder in those areas where you want the original paint color to show through. Leave the antiquing dark around the outside edges of the veggies.
5. Use a cotton swab to remove glaze from the centers of the veggies. This will appear to highlight the veggies slightly.
6. Set the project aside to cure for approximately three days.
7. Pour a little lemon oil on a 3M Home 'n Hobby (fine grade) or #0000 steel wool pad. Rub gently over the entire project in a circular motion, removing the antiquing from the uppermost layers of paint (the textured strokes). Wipe up residue frequently so you can see your progress. Be careful not to remove too much antiquing.
8. Wipe the project with soap and water, then with a 50:50 vinegar-and-water solution to remove the oil. Let dry.
9. Intensify the antiquing around vegetables. Use an old round brush to work the antiquing glaze into tight areas. Feather it out by rubbing with a cloth, or by brushing with the mop brush.
10. Let dry overnight, or longer if needed.
11. Spray on a coat of varnish to isolate the oil paint. Let dry.
12. Highlight the veggies by brushing the original undercoat color on the centers of each. Highlight that color further by mixing it with the lighter value (enclosed in parentheses) in the color list above.
13. Apply two (or more) coats of spirit or spray varnish to protect your work.

Quick and Easy Vegetables

Undercoat veggies.

Brush on antiquing, then begin to wipe it off.

Polish with a 3M pad to bring out more highlights. Add dark antiquing around the veggies. Strengthen highlights with more paint.

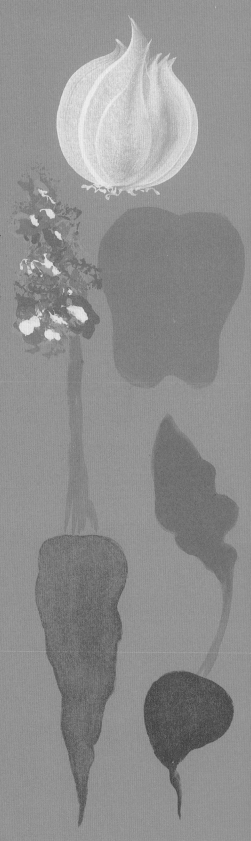

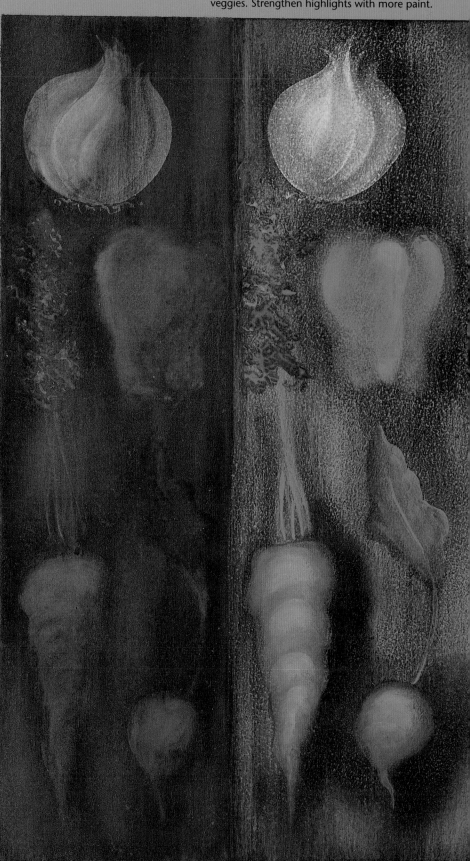

PALETTE A B C D E F G H

The cabinet before *(left)* and after antiquing was applied.

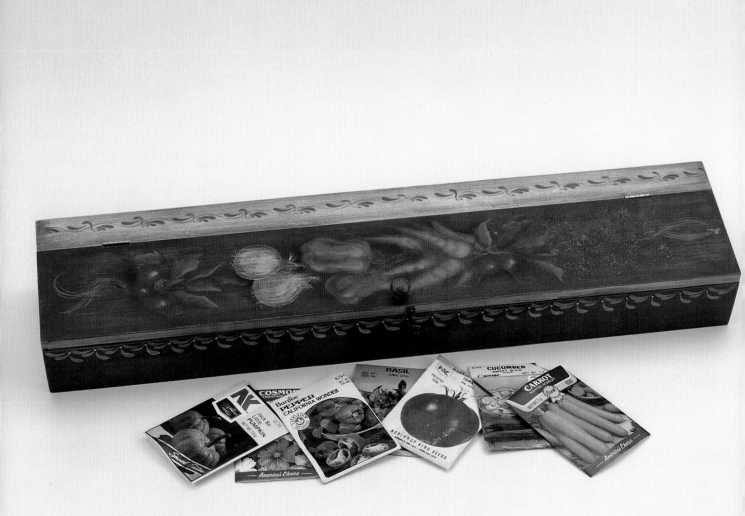

The completed narrow cabinet with shelves project.

Intermediate Vegetables

Here is something a little different for you to try. This ink and wash technique, sometimes called French wash, is a delightful way to render a design in soft pastels. In the early 1970s, the technique was generally done with oil paints over the inked design. Working with the oil paints and ink is both satisfying and relaxing, as the oil technique is very forgiving and allows for easy reworking or changing. For that reason, I will include instructions for using oil paints, as well as acrylics, in this lesson. With the current popularity of acrylics in decorative painting, we need make only slight alterations in the oil technique. If you have oil paints in addition to acrylics, you might enjoy trying the techniques for both media. After experimenting, you will see how easy and fun it can be to use the ink and wash method for other patterns and projects in the book.

Surface Preparation

While preparing your surface for decorating, also prepare a piece of scrap wood to use for practicing and experimenting. Make your mistakes on the scrap sample so that you can be sure of your technique when working on your project.

1. It is imperative that the surface be as smooth as possible so that the inking can be done without mishap. Grooves or flaws in the surface can cause the pen to skip and spatter the ink. Therefore, after sealing the wood, apply several coats of gesso, sanding between coats, and building to a fine, smooth surface. (*Gesso* is a liquified form of plaster of Paris that is frequently used as a base under paintings. It can be built up by applying several layers that are each sanded smooth.)

2. Then apply a light-value basecoat, such as a cream or off-white. I used **A** on the sample shown on page 191.

3. Buff the painted surface with a fine 3M pad or very fine sandpaper. Wipe away dust with a damp cloth. Avoid touching the area to be inked. Oily fingerprints will interfere with the adhesion of the ink.

4. Copy the pattern for the Advanced lesson onto tracing paper, making the following changes: *(a)* Delete the onions on each side of the pattern, substituting leaves in their place. *(b)* Replace the single mushroom on the left with one of the onions.

5. Transfer the pattern by rubbing the back of the tracing with pencil. (See page 299.) Lightly wipe over the penciling with tissue to remove excess graphite. This step is very important. The transferred pattern lines must be thin and faint. Ink will not adhere well to heavy graphite lines. Use a fine-pointed stylus to transfer the pattern gently. Be careful not to indent the pattern lines into the surface of the project.

Inking and Painting Instructions

Before inking the design, read this entire section to determine which procedure you wish to follow.

Inking

The following are some hints for working with the crow quill pen and ink:

* Ink those elements that have wavering lines first, such as leaves. That way you can get some reassuring practice in before inking smooth forms such as radishes and peppers.

* Do not try to follow pattern lines precisely. To do so will result in stiff, unsure-looking lines. Remember that veggies and leaves have all sorts of lumps, bumps, and irregularities. Any that you inadvertently add to the design will add character. So go ahead and ink with a carefree spirit.

* Ink the heavier outlines first, saving the finer details and shading until last (when you will have developed more control).

* To make thick lines, hold the pen back in your hand. Experiment on your scrap sample; apply heavy then lighter pressure.

* To make fine, wispy lines for details and shading, hold the pen nearly upright and close to the point (nib).

* To make even finer lines, turn the pen over so you are working on the top side of the point. (This doesn't always work with all pen nibs, but when it does, it's wonderful.)

* Each time you dip the pen in ink, carefully shake the excess back into the

bottle, taking care not to damage the point. Make a short stroke or two on tracing paper to test the ink load. Making a big, thick ink line on your design where you had planned for a thin one can be disappointing, and dropping a big blob of ink in the middle of a painstakingly executed design is devastating. Test first to avoid surprises. Don't test on a paper with a high rag content; the fibers will clog the nib and cause blurred lines.

- If your lines seem to be growing thicker, check the pen nib to see if you've picked up a small fiber, which can cause the ink to spread.
- When you finish inking, clean the pen nib with ammonia. Set the project aside for a day or so to let the ink harden and cure.

Oil Technique

If you plan to use oil paints to paint the design, do the ink work first. Let it dry thoroughly. Erase pattern lines gently, or wipe them away with paint thinner on a cotton swab. You can then work with the oils directly over the ink. The paint or paint thinner will not affect the dry ink lines.

Acrylic Technique

If you plan to use acrylics, follow either Option 1 or Option 2 below to ensure that you do not smudge the ink lines. Even though the ink is permanent, it will sometimes bleed when used with watermedia. (Note that Option 2 is the less risky of the two.)

- *Option 1.* Ink the pattern lines. Set the project aside to dry thoroughly. Carefully erase pencil tracing lines. Spray lightly with clear acrylic sealer or varnish to protect the inked lines. (Do not use brush-on water-based varnish.) Let dry. Buff with a 3M pad to create some tooth to which the thinned paint will adhere. Paint with thin washes of color (see painting instructions below).
- *Option 2.* After transferring the pattern to the project and before inking the design, paint it with thin washes of color. Then ink the design. Let the ink dry, then carefully erase pencil pattern lines. Spray with clear acrylic sealer or varnish to protect the ink lines. Then varnish with brush-on water-based varnish if desired.

Painting

Oil Technique

Thin the oil paints with mineral spirits or paint thinner. The paints should be thin enough not to leave ridges, but not so thin as to run or leave puddles. Ink lines should show through the paint. Pastel colors will be a natural result of the wiping out process, so do not add white to any of your mixtures. White is opaque and will obscure your ink lines.

Brush the paint into a small area at a time (such as a couple of leaves or radishes). Allow the paint to "set up," or begin to lose its shine. Then use a cotton swab or a tissue (folded to a neat point for tight corners) to rub out excess paint and create highlights. Leave the color slightly heavier where shading is desired. Pounce the cotton swab gently to merge darker areas gradually into the highlight areas. If lighter highlights are desired, wipe them out with a bit of thinner.

Acrylic Technique

Since acrylic paints dry quickly, it is not as easy to wipe out highlights as with the oil technique. Therefore, we must build up colors with thin washes to achieve that soft, pastel, wiped-out look. Apply several thin layers, letting each dry, until you gradually build up the depth of color you desire. You can build up layer after layer of a single color, or you can build layers of different colors. The first layer should be so thin that there is just a hint of color. Remember, you can add layer upon layer to achieve darkness in the shadow areas, but you cannot remove layers to get back to pastel.

Special Tips for the Basket Project

The sample shown on the opposite page was painted with acrylics, with the exception of the foreground, which was painted in oils. It was added after the rest of the painting was completed.

To begin, apply a contact paper mask to the surface, leaving the arc in the center exposed. Using the 3/4-inch brush, paint the arc with **E** thinned with extender and water. The extender will enable you to blend out the color to achieve the transparency desired. If you need to continue reworking the color, pick up a little more water on the brush to loosen the extender and paint. The mask will

allow you to work quickly without worrying about staying within the lines. After you paint the arc, remove the mask, then transfer the pattern for the letters. Paint them with the project's basecoat color, then tint them slightly with a wash of one of the other colors used in the design. (I used a brown mixture of **E**+**B**.) Finally, outline the letters with ink.

The following colors were used on the rest of the project. *(Note:* When two or more colors are listed, use the first one for the first thin wash. Repeat with additional washes in that color if desired. Use the other colors for accenting or deepening the washes.)

Leaves—**E**

Carrots—**B**, **C**. Deepen with **D**.

Radishes—**D**

Green pepper—**E**, **F**. Blush with **D**.

Red pepper—**D**, **C**; seed pod—**G**, **H**.

Mushrooms—**G**, **H**

Cornucopias—**G**. Shade with **F**+**C**.

Tomato—**C**+**D**

Beets—**D**+**F**

Produce spilling from cornucopias—Assorted colors used in the project

Paint the foreground a brownish mixture of **C**+**E** and/or **C**+**F** thinned with water and extender. Add darker shadows, **D**+**E** or **F**, under the veggies, or use burnt umber oil paint to color the foreground. Wipe away excess with a soft cloth or tissue, rubbing to blend the color into the background.

Finishing
After allowing the paint to dry, spray lightly with clear acrylic. Then apply several coats of brush-on varnish to protect your project.

The completed large lap desk project.

Intermediate Vegetables

OIL TECHNIQUE

Ink the pattern before painting.

Fill in the design with oil paint thinned with mineral spirits or paint thinner. Set aside until the paint loses its wet shine and looks dull.

Wipe out highlights with a soft cotton swab. Use a tissue folded to a tight point to work in narrow spaces. If necessary, moisten it with thinner to remove more paint.

ACRYLIC TECHNIQUE

Paint the pattern before inking. Apply a very thin wash of color.

Apply another thin wash of the same color, emphasizing the areas to be shaded.

Apply additional color washes if desired, then ink the design. *Note:* You may ink the design for the acrylic technique before painting if you follow the inking with a protective coat of spray acrylic sealer or varnish. (Refer to the instructions on page 190.)

PALETTE A B C D E F G H

Advanced Vegetables

PROJECT
Granny's bucket
(#U-135) from
Basketville

PALETTE
The colors for each
vegetable are listed
separately with each
lesson. The colors used
for the mushrooms on
the bucket were **A, E, D,**
and **G,** as shown on the
worksheet for Advanced
Red Peppers, page 203.

MISCELLANEOUS
Plastic *or* masking tape
(to wrap the bucket
handles)

I thought you might enjoy painting a selection of vegetables as a composition on a single project, so I combined all the vegetables into one pattern for this large gathering bucket. The pattern could be used on a large cabinet drawer, an above-door plaque, or a sign. It would also work nicely as a center design for a table.

If you prefer to paint a less ambitious project, and perhaps just a single vegetable, the lessons are designed to accommodate you. With individual worksheets and color palettes, each vegetable is a separate lesson. The colors used throughout all the Advanced Vegetables lessons are coordinated to work together for the single composition. I've built a challenge for you into the mushroom lesson, which I will explain shortly.

If you would like to work on a different background color, keep in mind that the design colors suggested here are coordinated for use on the dark green background. You may need to adjust your colors and technique slightly to correspond with your background choice. (For example, look at step 1 of the red pepper. Since the background is dark, I was able to use the background to suggest depth and shadow inside the pepper. If you work on a light color background, you would need to block in the dark areas on your pepper, not the light ones as illustrated. On a light background, you may prefer less dark shading.) Keep your mind open and receptive to the idea of adjusting colors. Once you master the technique of working with light and dark values, changing colors should present no problem to you.

To give you some challenge in changing colors, I have included three mushrooms on the bucket from the Advanced Mushrooms lesson. (The step-by-step painting instructions for Advanced Mushrooms, on page 211, are coordinated for a blue background.) Although the technique for painting the mushrooms is the same for the sign and the bucket, the colors are slightly different. The ones for the sign are cooler in temperature, with

more blues and black-grays, while the ones for the basket are warmer, with more yellow-tans.

Here, then, is the challenge: Paint all the vegetables on the bucket, saving the mushrooms until last. By then, you should have a clear idea of the process of laying down an opaque undercoat, washing over it with transparent color, shading, highlighting, and making final color adjustments. From the colors used on the bucket, try to determine which would work best for painting your mushrooms. Then, try to paint them without referring to the step-by-step worksheet. I think you will be delighted to find that what you are learning about transparent and semitransparent washes, and the buildup of colors can be easily transferred to other subject matter.

If you get stuck on the technique, a little more practice is all you need. If you need help selecting the colors, the ones I used are listed in the box at left under "Palette," but try not to peek. You will learn more by trying to work out a solution yourself. Notice that I said *"a* solution" not *"the* solution." There is no one single solution. Try it. Then give yourself a pat on the back. As long as you use only the colors used in the rest of the painting, you shouldn't get into too much trouble, since they all harmonize with one another.

Surface Preparation

1. Wrap the rope handles with plastic or masking tape to prevent soiling them while basecoating.
2. Basecoat the center panel, the two handles, and the inside and bottom of the bucket with **I** from the Advanced Carrots worksheet palette (see page 195).
3. Basecoat the upper and lower bands of the bucket with **J**, also from the Advanced Carrots worksheet palette.
4. Scumble **J** and **E** from the Advanced Carrots worksheet palette in the center panel, creating a deep, rich, mottled green.

Advanced Carrots

PATTERN
Page 320

PALETTE
A Pumpkin
B Tangerine
C Burnt Orange
D Burgundy Wine
E Black Forest Green
F Taffy Cream
G Avocado
H Mistletoe
I Midnite Green
J Forest Green

BRUSHES
Flat: No. 8

Liner: No. 1 *or* 2

Dagger striper
(optional): ³/₈ inch

Painting Instructions

Carrots

1. Undercoat the carrots with **A**. Apply a second coat if needed, although totally smooth coverage is not important.
2. Fully load **B** onto the flat brush. Paint the light value in sections along the center length of the carrot, leaving unpainted spaces to define indentations in the carrot.
3. Wash **C** over the entire carrot. Then sideload **C** to paint shading along the edges of the carrot and to further define the indentations.
4. Intensify the shading by sideloading the brush with a mixture of **C+D+E**. Use very little **E** at this time. Place the paint filled side of the brush to the outside edge of the carrot.
5. Accent the highlight areas by drybrushing a mixture of **A+F**.
6. Use the liner brush and thinned **A** to paint hairlike roots.
7. Using **C** or **D**, wash over the carrot to adjust the color and merge previous applications.
8. To submerge some of the carrots or edges into the background, giving them additional shading, brush a thin wash of **E** over the area to be shaded. When dry, repeat if necessary.

Carrot Tops

1. Paint the background and beneath the foliage first. Use a mixture of **G+E+D** to make a dull green. Load thinned paint onto a flat brush or, preferably, onto a dagger striper. Work from the chisel edge of the brush, tapping formations of approximately six to nine "leaves" to a cluster. Also, paint a few stems.
2. Repeat the process, this time using a thinned mixture of **H+E**, a less dull green.
3. Finally, add the foremost leaves and stems with a thicker mixture of **H+E**, the brightest green.

Carrots (detail) from the completed project (see page 184).

Advanced Carrots

1. Undercoat with **A**.

2. Highlight with **B**.

3. Wash **C** over the entire carrot. Also, shade the edges and ridges with **C**.

4. Deepen shading with **C+D+E**.

5. Accent highlights with **A+F**.

6. Add hairlike roots with **A**.

7. Adjust color with a wash of **C** or **D**.

8. Add dark shading to add depth to the carrots with thinned **E**.

CARROT TOPS

1. Dab strokes of **G+E+D** for the area beneath the leaves.
2. Dab strokes of thinned **H+E**.
3. Add the foreground leaves with heavier strokes of **H+E**.

PALETTE A B C D E F G H I J

Advanced Green Peppers

PATTERN
Page 320

PALETTE
A Olive Green
B Avocado
C Burgundy Wine
D Mistletoe
E Taffy Cream
F Black Forest Green

BRUSHES
Flat: No. 8

Painting Instructions

1. Undercoat the peppers with **A**, leaving a thin space unpainted along lines demarking sections. Apply a second coat if necessary.

2. Wash a thin layer of **B** over the entire pepper. Let dry, then shade along the indented sections using **B** sideloaded on the brush.

3. Intensify the shading in random areas with a mixture of **B+C**. If you would like to make the pepper appear to be turning red in some places, use a greater proportion of **C** in the mixture and brush it on more generously.

4. Add a richer green to the pepper with a wash of **D** sideloaded on the brush. Generally, you should place this color along the outside edges of the pepper sections.

5. Drybrush highlights of **A** onto the pepper, placing the strongest highlights toward the front. Strengthen these highlights by drybrushing on a mixture of **A+E**.

6. Add some strong green accents with thinned **F** sideloaded on the brush. Use it sparingly, however. Brush over the highlights and any other area of the pepper needing to be "pulled together" with a thin wash of **B**.

Green pepper (detail) from the completed project (see page 184).

Advanced Green Peppers

1. Undercoat with **A**.

2. Wash over the entire pepper with **B**, then shade in sections with **B**.

3. Accent shading with **B+C**.

4. Wash over in random areas with **D**.

5. Add drybrushed highlights with **A**, then strenghten the highlights with **A+E**.

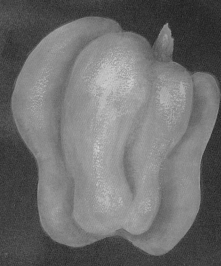

6. Add accents sparingly with **F**, sideloaded. Brush over the highlights with thin **B** to unify.

PALETTE A B C D E F

Advanced Onions

Painting Instructions

Onions

1. Undercoat the onion with long, flowing brushstrokes, working from the base to the top, following the contour lines. Use thinned **A**, sideloaded on the brush, but with some color extending all the way across the brush. This will help suggest the slight ridges in the onion and the delicate vein lines in the skin.
2. Apply a thin wash of **A** over the entire onion. Then sideload the brush with more **A** and paint the front edges of the onion top.
3. Wash over the entire onion with thinned **B+C**. Let dry, then repeat with a second layer. Notice on the worksheet how much color a second wash adds. For comparison, I applied the second wash to only the right half of the onion. Do not try to accomplish this depth of color in a single application. To do so would necessitate heavier paint, thus eliminating some of the luminosity.
4. Sideload the brush with a mixture of **C+D**. (Use very little **D** in the mixture.) Applying the color side of the brush to the outside edge of the onion, shade the sides, base, and inside the top.
5. With the **C+D** mixture still in the brush, slide the brush on the chisel edge, following contour lines, to suggest veins.
6. Add highlights with **A**. Either drybrush the color on or apply it in a wash, or both. Then sideload the brush and redefine the broken edges of onion skin near the top of the onion.
7. Add a thin wash of **C** to the onion to give it a warm glow. With your finger, tap off any paint that covers the highlight. If the highlights appear too strong, subdue them slightly with a thin wash of **B**. Add roots with the liner and a mixture of **B+A**.

Onion Sprouts

1. Undercoat with **A**. Apply a second coat.
2. Shade with a sideloaded wash of **E**.
3. Brush **B** thinly over the sprouts to adjust the coloring.
4. Accent the shading with a mixture of **E** plus a little **D**.

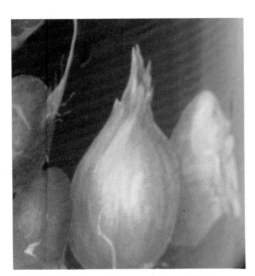

Onion (detail) from the completed project (see page 184).

Advanced Onions

1. Working from top to bottom, undercoat the onion with **A** sideloaded on the brush. Follow the contours, allowing the paint to streak.

2. Wash over the entire onion with thin **A**, then sideload the brush with **A** and accent the front edges of the onion top.

3. Wash over the entire onion with thin **B+C**, following contour lines. Let dry, then repeat. Note the depth of color achieved with the second wash, shown here on only the right half.

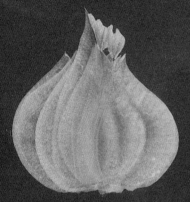
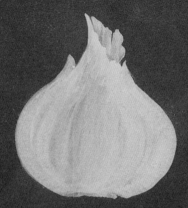
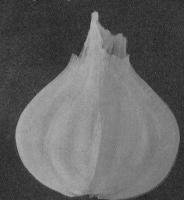

4. Shade the edges, base, and inside of the onion top with **C+D**.

5. With **C+D** still in the brush, slide on the chisel edge to paint thin vein lines, following contour lines.

6. Highlight with **A**. Apply in a wash to simulate a shine, or apply with a dry brush, or both. Then sideload **A**, brushing it thinly on the edges of the broken onion skin.

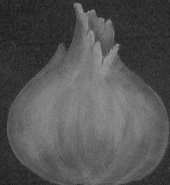

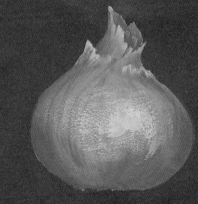

7. Wash **C** onto the onion to accent. Wash **B** thinly over the highlights. Add roots with **B+A**.

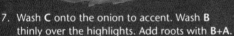
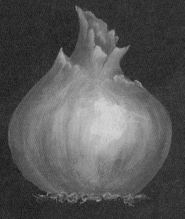

SPROUTS

1. Undercoat with **A**.

2. Shade with **E**.

3. Wash over with **B**.

4. Accent the shading with **E** plus a little **D**.

PALETTE A B C D E

Advanced Radishes

PATTERN
Page 320

PALETTE
A Spice Pink
B Burgundy Wine
C Black Forest Green
D Burnt Orange
E Avocado
F Olive Green
G Taffy Cream

BRUSHES
Flat: No. 8
Liner: No. 1 *or* 2

Painting Instructions

Radishes

1. Undercoat the radish with a solid coat of **A**, repeating if necessary for good coverage.
2. Cover the radish with a thin wash of **B**. Pick up a little more of the color on the side of the brush and shade the edges of the radish more heavily.
3. Mix **B+C+D** to create a rich, deep red. Sideload it on the flat brush and strengthen the shading on the edges.
4. Brush a highlight on the radish with **A**. Use the liner and **A** to paint hairlike roots. Sideload a mixture of **A+D** on just the corner of the brush to paint a reflected light.

Leaves

Paint the leaves loosely and keep them understated. Try not to work too hard on them. If you overblend and labor over them, they will appear stiff and thick; if you paint them too perfectly and with too much detail, they will detract from your radishes.

1. Sideload the flat brush with **E**. Brush the color loosely on the leaf, allowing the background color to show through in places.
2. Repeat step 1, allowing the second coat to provide more opaque coverage in some areas. Mix a deep green with **C+B**. Sideload the brush with the mixture and place some dark accents on the leaf, particularly along the vein.
3. Sideload the brush with **F** to highlight some areas of the leaf. Then accent other areas with a reddish mix of thinned **D** or **D+B**, sideloaded.
4. Add veins with the liner and a thinned mixture of **E+F**. If the veins show up too prominently, wash over them with thinned **E**.

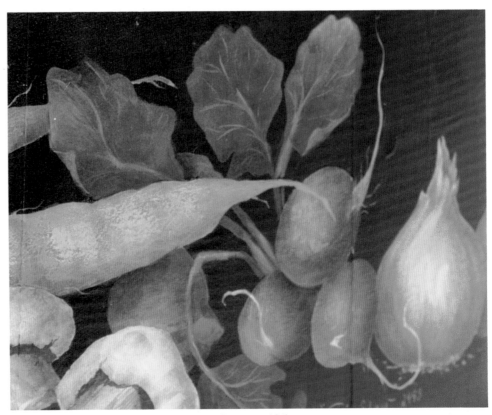

Radishes (detail) from the completed project (see page 184).

Advanced Radishes

LEAVES

1. Undercoat the leaves loosely with **E** sideloaded on the flat brush.

2. Brush on more **E** in some areas for more opaque coverage. Add **C+B** for dark accents.

3. Highlight with **F**, sideloaded. Accent with **D** or **D+B** in scattered places.

4. Add veins with the liner brush and **E+F**.

RADISH

1. Undercoat the radish with **A**.

2. Wash over the radish with **B**, shading edges more heavily.

3. Add deeper shading with **B+C+D**. Repeat for more depth.

4. Paint hairlike roots with the liner brush and **A**. Add a highlight of **A**, and reflected light with **A+D** at lower left.

PALETTE A B C D E F G

Advanced Red Peppers

PATTERN
Page 320

PALETTE
A Taffy Cream
B Moon Yellow
C Burnt Orange
D Burgundy Wine
E Terra Cotta
F Avocado
G Black Forest Green

BRUSHES
Flat: No. 8
Detail: No. 00

Completing the Project

To complete the bucket project, paint borders on the upper and lower bands and inside the top edge. Use a combination of the greens used in the vegetable lessons.

Painting Instructions

1. Paint the seed core in **A**. Repeat for solid coverage. Then sideload the brush with a wash of **A** and paint the skeleton of the pepper—the ribs and the flesh on the cut edge. (We will build the "ins and outs" of the pepper on this framework.) Next, outline the pepper with **B** to suggest the firm skin, then paint the raised sections behind the stem.

2. Cover the entire pepper, except for the seed core, with a thin wash of **C+D**.

3. To make the fleshy areas stand out, paint them with a doubleloaded brush with thinned **B** on one side and a mixture of **C+D** on the other. Slightly blur the edges of the inside ribs.

4. Apply a wash over the inside of the pepper with a mixture of **D** plus a little **C**. Then shade the bottom of the seed core with a mixture of **A+C+D**. (Load the brush first with **A**, then sideload it with the mixture of **C+D**.) Place the **C+D** side of the brush toward the bottom of the seed core.

5. Mix a deep, rich red with **D+G**. Sideload the brush and blend the color in behind the seed core, in the base, and up underneath the top of the pepper, then shade the elevated sections behind the stem. Brush some thinned **E** on the top of the stem.

6. Adjust the colors on the pepper with additional washes if needed. Highlight the cut edge of the flesh with a sideloaded wash of **B**. (Do not cover the entire area; that would look too stiff.) Apply a thin wash of **C** over the highlighted area. Add green touches to the stem with **F**, then shade this with a mixture of **G+D**. Suggest the textured web effect inside the pepper by applying thin dabs of **B+C+D** with the chisel edge of the brush.

7. Paint a row of seeds with the detail brush and **B**. Let dry.

8. Sideload the flat brush with **E** and brush a thin wash of shading over the seeds.

9. Paint another layer of seeds with the detail brush using a mixture of **B+A**. Add some fallen seeds inside the bottom of the pepper. Wash over the fallen seeds with **E+F**.

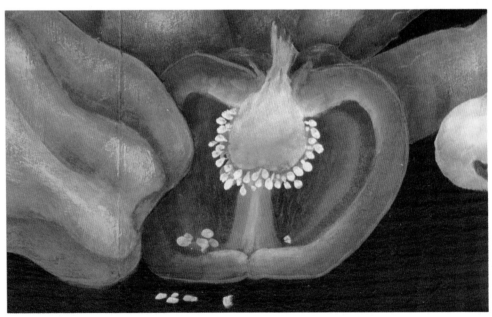

Red pepper (detail) from the completed project (see page 184).

Advanced Red Peppers

1. Paint the seed core with **A**, then sideload **A** to paint the ribs and the cut edge of the flesh. Paint the skin with **B**.

2. Wash thin **C+D** over the entire pepper except for the seed core.

3. Highlight the cut edge of flesh and the inner ribs with a doubleloaded brush: **B** on one side, and a mix of **C+D** on the other.

4. Shade inside more deeply with **D** plus a little **C**. Shade the bottom of the seed core with **A+C+D**.

5. For the deepest shading, use **D+G**. Shade the inside as well as the ridges on the top. Brush **E** over the top of the seed pod.

6. Adjust colors with additional washes of color. Lighten the flesh of the cut edge with a sideload of **B**, then wash over it with **C**. Add **F**, then **G+D**, to the stem. Add chisel-edge dabs of **B+C+D** to the inside of the pepper.

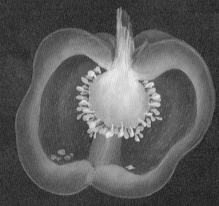

7. Paint the seeds with **B**, including those in the bottom of the pepper.

8. Wash over the seeds with **E**.

9. Paint another layer of seeds with **B+A**.

PALETTE A B C D E F G

Quick and Easy Mushrooms

PROJECT
18³/₄ × 8 inch mushroom board (#93-JS-1) and mushroom cutout (#93-JS-1A) from Sunshine Industries Unlimited

SKILLS NEEDED
Marbleizing (optional)

PATTERN
Page 321

PALETTE
A Russett
B Black Forest Green
C Ebony Black
D Colonial Green
E Jade Green
F Venetian Gold
G Sand
H Yellow Ochre
I Glorious Gold
J Mississippi Mud
K Cadmium Red

BRUSHES
Flats: No. 6; ¹/₂-inch
An old brush (to apply the Sparkling Sandstone; optional)

MISCELLANEOUS
Plastic wrap (for marbleizing)

A real mushroom

Golden Sparkling Sandstones (optional)

Assorted Stencil Pencil stamping tools by Lehman

A scrap of velvet or velvetlike fabric

Burnt umber artist's tube oil paint (optional)

Mineral spirits (optional)

Absolutely no painting skill is needed to complete this project. The only reason you need a brush for this project is for basecoating. All other design work is done by stamping—including the mushrooms, the comma strokes, and the border designs. Paint the chunky cutout mushroom with Sparkling Sandstones, if desired, to give it the appearance of stoneware. Marbleize the center oval to provide a busy contrast to the smooth "stone."

Surface Preparation
Before beginning this project, read the sections on "Gluing Wood" (page 92) and "Marbleizing" (page 278). Use the No. 6 flat brush for the ¹/₄-inch border; use the ¹/₂-inch brush for everything else.

1. Divide the plaque into segments as shown in the photograph on the opposite page: The gold border is ⁵/₈ inch wide, the light blue-green bands are ¹/₄ inch wide, and the dull red rectangles are 2 inches wide. Basecoat the ⁵/₈-inch-wide border around the plaque with **F**, the wide side bars with **A**, the four narrow borders with **E**, the oval with **D**, and the remainder of the center section with a mixture of **B+C**.
2. Marbleize the center oval by brushing on **B+C** slightly thinned with water over it. Since the marbleizing color is the same as the surrounding basecoat color, you need not worry if it should spread beyond the perimeter of the oval. Use the plastic wrap to marbleize.
3. Basecoat the dimensional cutout mushroom with **J**.

Mushroom Prints
Select a fresh mushroom to use for stamp printing. It should fit within the width of the wide bands on the left and right sides of the plaque. Cut the mushroom in half. Spread paint smoothly on the palette, using a mixture of **G+H** plus a little **J**. Press the cut side of the mushroom into the paint, pushing all areas down to ensure solid coverage. Make a test print on a piece of paper or clear acetate. Compare the size of the test print to the space allotted in the two side bars. If the print is too large, use a knife to trim the mushroom to an appropriate size. When you're satisfied with the adjusted size, press the mushroom again into the smoothly

spread paint, then press it firmly onto the project. Repeat for each print.

Let the stamped mushrooms dry. Use the old brush to apply a thin layer of Golden Sparkling Sandstones (optional) over the printed mushrooms. (This product tends to be very hard on brushes.)

Dimensional Cutout Mushroom
Using an old brush, paint the cutout mushroom with two or more coats of Golden Sparkling Sandstones. If you prefer not to use the Sparkling Sandstones, paint the cutout with the same mixture used for stamping the fresh mushroom.

Borders
You can embellish the borders quickly and easily by using design printing tools such as the Stencil Pencils by Lehman. There are oodles of shapes, sizes, and designs from which to choose. Make a stamp pad by pouring a couple drops of paint onto a scrap of fabric. (Velvet or velvetlike ribbon works wonderfully.) Rub the paint into the fabric with a palette knife. Then, while the paint is still wet, press the design tool into the paint and onto the project. Make dots by using the handle end of a paint brush or the tip of the Stencil Pencil tool.

Use the green mixture, **B+C**, for stamping the design on the gold border; use **I** for the design on the four narrow bands, and for the grouping of comma strokes in the four corners. At the base of the comma groups, paint a large dot of **A**. Place a small dot of **K+A** on top of it. Use **A** for the stamped strokes around the oval, placing dots of **K+A** between each one.

Routed Edge
Stain the edge with burnt umber oil paint thinned slightly with mineral spirits. Or, if you prefer, paint the edge with burnt umber acrylic paint thinned with water. The effect is not as rich as when painted with the oils, but it dries faster, and if you don't have oil paints on hand, it is a good substitute.

Finishing
Varnish the plaque, then attach the mushroom by gluing it in place, or by screwing it on from the back side of the plaque.

Quick and Easy Mushrooms

A quick way of painting mushrooms, without actually having to paint them, is to print them. Cut a mushroom in half, being careful to make a smooth, even cut. Spread paint evenly on the palette. Press the mushroom into the paint, then onto the surface to be printed. Test the size of the print first to ensure a proper fit. If the print is too large, trim the mushroom. *Hint:* Try other vegetable prints. For the placement of the borders and stamped designs, refer to the project photograph below.

The completed mushroom board with cutout mushroom project.

Intermediate Mushrooms

PROJECT
18³/₄ × 8 inch mushroom board (#93-JS-1) from Sunshine Industries Unlimited

SKILLS NEEDED
Sideloading
Bumpy crescent stroke
Crescent stroke
S stroke
Broad stroke
Marbleizing
Scumbling
Wash

PATTERN
Page 322

PALETTE
A Burnt Umber
B Dark Chocolate
C Black Forest Green
D Leaf Green
E Glorious Gold
F Antique White
G Yellow Ochre
H Raw Sienna
I Burnt Umber + Glorious Gold
J Venetian Gold

BRUSHES
Flats: Nos. 10 and 8;
No. 12 or ¹/₂ inch
Liner: No. 1
Round: No. 3

MISCELLANEOUS
Contact paper (to mask everything but the arc; optional)
Plastic wrap
Brush 'n Blend Extender (optional)
Burnt umber oil paint (optional)
Mineral spirits (optional)

These mushrooms are deceptively easy to paint. There are just two strokes—a broad stroke, and a careless, bumpy crescent stroke—both done with the flat brush. This project offers two different background treatments: marbleizing and scumbling. The lettering is done with a fine pointed round brush using S and crescent strokes. A confident, sure hand is helpful for painting these large letters.

Surface Preparation

1. Cut a contact paper mask to make basecoating and marbleizing easier. (See "Making Masks," page 92.) You'll be masking everything but the arc.
2. Basecoat the face of the board with **A**. Let dry thoroughly.
3. Apply the mask to the face of the board, leaving only the arc exposed. Basecoat the arc with **C**. Let dry.
4. Marbleize the green arc by brushing on **D** thinned with water. While the color is still wet, cover it with plastic wrap and marbleize. (See "Marbleizing," page 278.) Remove the mask carefully.
5. On the areas painted brown, scumble **B**. (See "Scumbling," page 271.)
6. Basecoat the ⁵/₈-inch border with **E**.

Painting Instructions

Mushrooms

Use the No. 10 flat brush unless otherwise noted.

1. To paint the stem, fully load the brush with **F**, then sideload it with **A**. Stroke it on the palette to merge colors in the middle. Paint a careless broad stroke with the dark value to the left. (Don't worry about forming a perfect beginning or ending.) To paint the cut end of the upside down mushrooms, paint two crescent strokes, with **F** sideloaded on the No. 8 flat brush, to form a broken oval.
2. To paint the cap, load the brush as in step 1 and paint a bumpy crescent stroke, placing the dark value on the top.
3. Shade the cap and stem by sideloading the brush with **B**. Shade across the top of the stem (under the cap) and along one side. Also, shade one side of the cap.
4. Highlight the mushroom by sideloading the brush with **G**. Stroke this color on the other side of the cap and near the bottom of the stem.
5. Adjust the color of the mushroom by applying a thin wash of color over the entire mushroom. Use **H** thinned with water or extender.
6. Accent the shadow side of the mushroom with liner brush outlining with a mixture of **B+C**. Also, draw some lines casually on the stem.

Border Strokework

Use **J** and color mixture **I** (**A+E**) to paint a subtle stroke border with the liner brush.

Lettering

Using a No. 3 fine-pointed round brush and **E**, combine S and crescent strokes to form the letters. Shadow under the left sides of the letters with **C** sideloaded on the No. 10 flat brush.

Routed Edge

Stain the edge with burnt umber oil paint thinned slightly with mineral spirits, or with burnt umber acrylic paint thinned with water.

Intermediate Mushrooms

Paint crescent strokes for the cut ends.

1. Fully load the brush with **F**, then sideload it with **A**. Paint a broad stroke.

2. Load the brush as in step 1, then paint a bumpy crescent.

3. Shade with **B**.

Basecoat the arc shape with **C**.

4. Highlight with **G**.

5. Mix **H** with water or extender. Cover the entire mushroom.

6. Outline the shadow side with a mix of **B+C**.

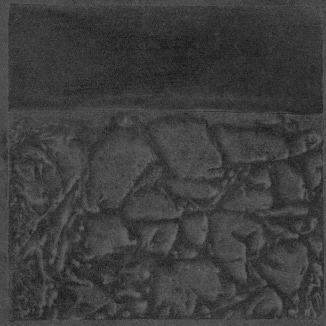

Marbleize it with **D** thinned with water.

PALETTE A B C D E F G H I J

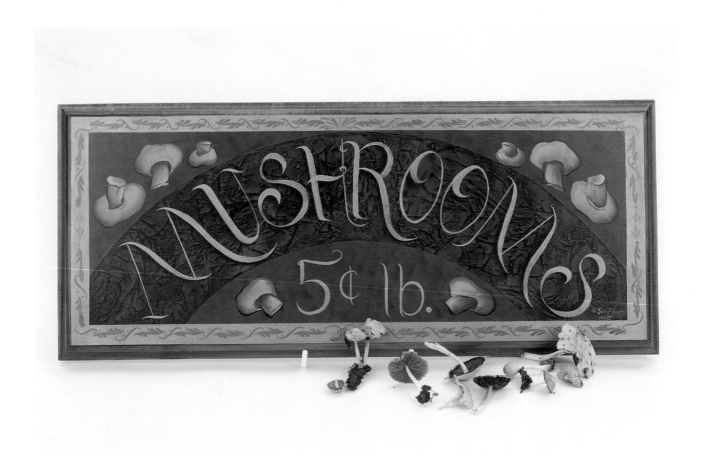

The completed "5¢ lb." mushroom board project.

Advanced Mushrooms

PROJECT
18³/₄ × 8 inch mushroom
board (#93-JS-1) from
Sunshine Industries
Unlimited

PATTERN
Page 323

PALETTE
A Blueberry
B Midnite Blue
C Salem Blue
D Rookwood Red
E Cadmium Red
F Neutral Grey
G Shimmering Silver
H Antique White
I Dark Chocolate
J Raw Sienna
K Taffy Cream
L Ebony Black
M Antique Gold

BRUSHES
Flats: Nos. 8 and 6
Round: No. 3
Liners: Nos. 1 and 10/0

MISCELLANEOUS
A small paint roller *or*
a natural or household
sponge

Brush 'n Blend Extender
(optional)

Contact paper (to mask
the top section in red)

Premixed stain *or* burnt
umber artist's tube oil
paint (optional)

Mineral spirits (optional)

Burnt umber acrylic
paint (optional)

Frankly, I think mushrooms were intended to be painted, not eaten! Otherwise, eating them in the wild wouldn't be such a game of risk.

Fortunately for both the eaters and the painters, mushrooms are available at the grocery store year 'round. Even if you plan to use the mushroom pattern provided, before painting this mushroom project buy about a half dozen mushrooms to study. Don't pick out the prettiest, most perfect ones. Look for ones with character, scars, and different shapes and sizes. And don't worry if the bagger at the market is a little rough with your precious produce. A few more bruises will add to their charm and color. Put the mushrooms in the refrigerator for a couple of days to let their bland whiteness mellow into a more interesting tone.

If you would like to try your hand at painting realistically, try these mushrooms. They are very forgiving. Misplaced strokes or colors add interest. The border and background treatments of this project demand a bit of skill and patience. You can simplify them, of course, or you can substitute the painting technique and patterns for these mushrooms for those in either of the two previous mushroom signs.

Surface Preparation

1. Basecoat the border with **F**, the top section with **D**, and the bottom section with **B**. Let dry thoroughly.
2. Cut a contact paper mask to cover the top section (in red). Highlight and shade the blue background to make it more interesting.

 To create a smooth transition from the light value (**C**) to the middle value (**A**) to the dark value (**B**), use a small paint roller. (If you don't have a small paint roller, you can achieve a similar effect by dabbing the colors on with a sponge.) Start with **C** in the upper-left side of the blue section. Gradually add **A**, picking it up on the roller. Quickly clean the roller and begin in the center with **A** and work toward the right, slowly adding **B**.
3. Create an interesting background for the upper portion of the sign by painting a profusion of strokes with the round brush and **E** thinned with water. Don't worry about following any particular pattern; just start painting and let the strokes spill and meander. Be sure to keep the paint thinned so that the design will be subtle.

Painting Instructions

Mushrooms
Use the No. 8 flat brush except where otherwise noted.

1. Undercoat the mushrooms with **H**. Using the round brush, undercoat inside the cap with a mixture of **I+B**.
2. Paint the gills inside the cap with the liner brush, first with **I**, then with **I+H**. Keep the lines very thin and slightly curved.
3. Cover the cap and stem with extender or water. Thin **J** with extender and water, or with water only. Brush it loosely onto the cap and stem in broken patches. Leave the highlight area uncovered or with just a hint of color.

 (Hint: When using extender, handle your brush very lightly so as not to disturb previous applications of extender-thinned color underneath. Use a hair dryer to speed up drying and help set the color.)
4. Shade with **I**, and with mixtures of **I+B** and **I+J**. Work with very thinned paint (using extender and water, or water only) to build up the shading gently. Slide the flat brush on the chisel edge to paint grooves or tears in the mushroom. Let some of the shaded edges of some mushrooms disappear into the shadows as lost edges.
5. Highlight with dabs of **K**.
6. Accent lights, darks, and any interesting colors. Make random strokes, dabs, and jabs with a variety of the palette colors. Don't overblend. Patches of color will suggest dents, folds, turns. Too much blending will make the final product appear dull, stiff, and unrealistic. Watch what happens when you lay one color over another. Let the colors dry thoroughly. Don't be in a hurry to

overpaint or "fix" things. Wonderful accidents happen if you give them a chance. If an area becomes too dark, brush on a little of **H**, **H+J**, or **H** plus very little **I**.

7. Paint the shadows with a mixture of **B+L**. Paint the darkest part of the shadow nearest the mushroom.

Lettering

Using the No. 6 flat brush and **M**, try to paint each part of the letter as a continuous, flowing brushstroke. Shade under the area where one letter overlaps another with **H** thinned with extender and sideloaded on the brush.

Border

Use the liner brushes and a variety of strokes to paint a random, busy border of delicate strokes. Let dry. Brush a thin layer of **L** over the border.

Routed Edges

Stain the edges with a premixed stain or burnt umber oil paint thinned slightly with mineral spirits, or paint the routed edge with burnt umber acrylic paint thinned with water. I prefer to use the oil paints, as I enjoy shading the edge darker in some places, lighter in others. Also, the oil paint creates a more lustrous finish.

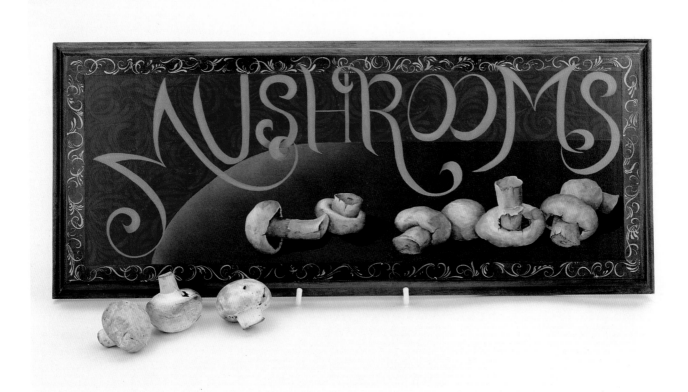

The completed realistic-style mushroom board project.

Advanced Mushrooms

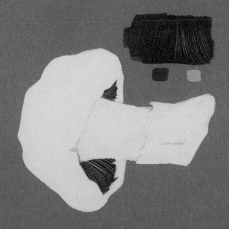

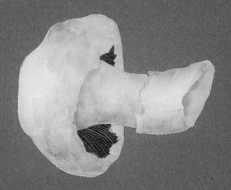

1. Undercoat the cap and stem with **H**. Undercoat the inside of the cap with **I+B**.

2. Paint some gills in **I** and others in **I+H**.

3. Mix **J** with extender. Cover the mushroom cap and stem unevenly. Leave the highlight areas uncovered.

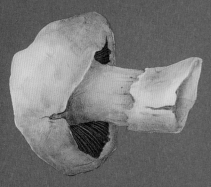

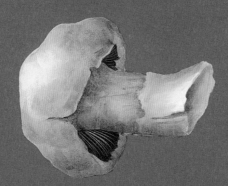

4. Shade the mushroom with **I**, and with mixes of **I+B** and **I+J**.

5. Highlight with **K**.

6. Accentuate details, shadows, and highlights by repeating any previous steps as needed.

7. Paint shadows with a mixture of **B+L**.

For the blended background treatment, see "Roller Blending," page 272.

PALETTE A B C D E F G H I J K L M

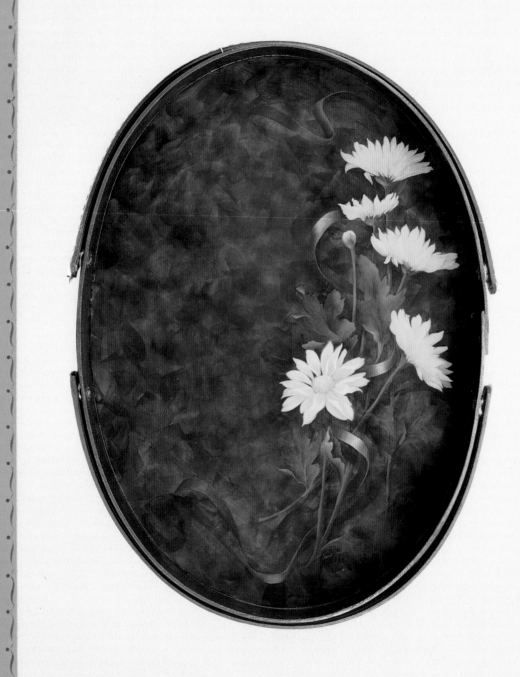

Chapter 11

Floral Designs

Have you ever considered how many ways flowers play a part in our lives? We give them to say, "I love you," "I'm sorry," or "I miss you." We give them to congratulate, to celebrate, and to offer hope and promise to the ill or grieving. We send them as house gifts and grow them in our gardens to bring joy to others. Sometimes, we give them "just because." We paint them for all those same reasons.

The most fantastic flower I ever painted was on a mural in the fourth grade. The teacher had assigned each student a task; mine was to paint the flowers. While we worked diligently, the teacher left the room to return later when the mural was nearly complete. I knew that the mural would be a great success because I had worked hard to create the most wonderful flowers ever. As the teacher, whom I idolized, walked into the room, her expression grew dark and she blurted with disgust, "Why would anyone paint a flower larger than the door of the house?" I was devastated. Convinced that I couldn't draw or paint correctly, I put away my art supplies and for the next eleven years anxiously avoided anything related to art. Not until my final year of college, when forced by the requirements of an education major, did I attempt artistic expression again. I regret all those lost years of creativity, but I wouldn't hesitate a moment now to paint a flower larger than even the *side* of a house. The Swedish folk artists do just that, and with great flourish. So go ahead: Let *your* flowers really bloom. Remember—in art, there are no rules!

The completed handled tray project for the Advanced Daisies lesson (see pages 219–220).

Quick and Easy Daisies

PROJECT
Round basket with hinged cover (#A-265) from Basketville

SKILLS NEEDED
Comma strokes (perfection not necessary)

PATTERN
None needed

PALETTE
A Antique White
B Gooseberry Pink
C Burnt Umber
D Teal Green
E Deep Teal

BRUSHES
Round: No. 3
Liner: No. 1

MISCELLANEOUS
A paper doily

A stylus

Clear spray sealer, varnish, *or* spray paint (any color)

Krylon Spray Adhesive, Blair Stencil Stik, *or* double-sided cellophane tape

Masking tape (to mask the border of the hinged cover)

A natural *or* household sponge

Compass

Chalk

Brown paste wax shoe polish

Burnt umber artist's tube oil paint

This project will give you a chance to try sponging through a doily, and antiquing with wax shoe polish. Both of those techniques, however, can be omitted if you just want to paint fast, simple daisies. You don't have to make perfect comma strokes to paint these daisies effectively. The dabbed-on centers will cover any imperfections in the endings of your strokes.

Surface Preparation

Basecoat the project with **A**. Note that the basecoat color will become the color of the stenciled doily and the border around the edge. The color applied on top of the doily stencil will become the background color.

Stenciling the Doily and Border

1. It's fun, and makes for a more exciting design, to trim the doily into an interesting shape. Cut away just one or two of the elements at a time until you get a pattern that pleases you.
2. Use a stylus to punch out any portions of the doily that were not completely removed in the manufacturing process. Also, use the stylus to open any partially closed holes.
3. Spray the top of the doily with clear sealer, varnish, or any color spray paint. The coat of spray will help seal the doily and prevent it from absorbing paint and causing blurred edges when you use it as a stencil. (You can omit this step if you use a precoated or metallic doily.)
4. Spray the back of the doily with a repositional adhesive, such as Krylon Spray Adhesive or Blair Stencil Stik, or

apply a few tiny pieces of double-sided cellophane tape to the back.
5. Position the doily in the center of the basket lid. Press firmly to secure it in place.
6. Apply a 3/4-inch-wide masking tape mask around the edge of the project, pressing narrow pleats as needed to ease the fullness of the tape. A brushstroke or dot border later will camouflage any unevenness.

Sponging the Background

1. Dip a sponge in water to soften, then squeeze dry. Wrap it in a towel and squeeze again. Too much moisture will cause paint to run under the doily stencil and blur the edges of the design.
2. Spread a smear of **B** on the palette with a palette knife. Dab the sponge into the paint then onto the palette a couple of times to work off any heavy concentrations of paint.
3. Pounce the sponge gently on and around the doily. Do not try to get total coverage on the first sponging; to do so may cause excess paint to run under the doily. Repeat the sponging lightly several times until the area is thoroughly covered. Remove the doily and the masking tape border. Rinse the sponge.

Drawing the Design

1. Find the center of the circular basket lid. Then use a compass and chalk to scribe a circle in the center of the lid about 7 1/2 inches in diameter. (Or, draw a circle 1 7/8 inches in from the edge of the basket.) This circle will serve as a guide to the positioning of the daisies.

Let the petals curve left and right and overlap.

Avoid the "pinwheel effect" of having all petals go in the same direction.

Also avoid rigid, straight petals.

2. Make a dot to indicate the placement of each daisy center along the circle. Then draw a circle to represent the size of each daisy. (A chalk line around a 2-ounce squeeze bottle of paint is a good size.)

It's very easy, at this point, to paint the daisies freehand, so I hope you'll try it. If you're feeling timid, lay tracing paper over one of the daisies on the worksheet and create a skeleton pattern by drawing a line through each petal. Use this bare-bones pattern to suggest the placement and size of the comma stroke petals.

Painting the Design

1. Load extra paint (**A**) on the round brush so that the daisy petals will have a thick texture. This adds a nice touch, especially for pieces that will be antiqued. Paint a layer of daisy petals. Let them be a little floppy, curving both left and right.
2. Paint a second layer of floppy comma strokes, also in **A**.

3. Use a cotton swab to dab **C** in the daisy's centers. Then dab a little **A** in the middle of the centers. For the daisies on the side of the basket, dab the centers with **B**.
4. Use the liner brush and **D** and **E** to paint the decorative comma strokes and dots, as well as the stroke stems and leaves on the side of the basket.

Antiquing

I completely changed the character of this basket, from quiet, almost dusty colors to happy, fiesta colors by antiquing it with brown paste wax shoe polish. First, I varnished the basket, then I rubbed the shoe polish onto the painted design. To darken the edge on the basket lid, I rubbed on burnt umber oil paint.

Be sure to experiment with your shoe polish on a painted scrap first, so you will know in advance what the outcome of the antiquing will be. (See also "Antiquing," pages 293–295.)

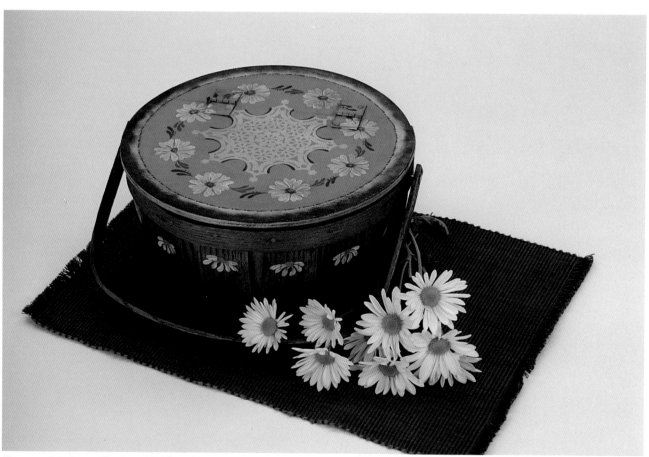

The completed round basket with hinged cover project.

Quick and Easy Daisies

Basecoat the project the color you want the doily to be. (The sample shown on the previous page is painted in **A**.)

Then sponge over a paper doily with the color you want the background to be, in this case **B**.

Draw a circle, then mark positions along it for the placement of the daisies.

DAISIES ON THE LID

Add another layer of comma strokes, letting some flop over the tops of others.

Using **A**, paint comma strokes, pulling their tails into the center of the circle. Let the strokes curve in different directions.

Use a cotton swab to dab **C** in the center. Then dab a little **A** in the center of that.

DAISIES ON THE SIDES

Paint long, thin commas in **D**. Use the liner.

Add leaves with **D** and **E**.

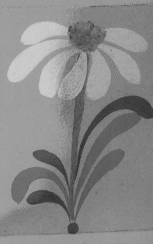

PALETTE A B C D E

Paint daisies with **A**. Paint the centers with **B**. (I shaded this one with **C** to keep it from becoming lost on the worksheet.)

Antique the project with brown shoe polish.

216

Intermediate Daisies

PROJECT
Calendar (#53-0193)
from Paintin' Cottage

SKILLS NEEDED
Leaf stroke
Liner scroll stroke
Liner S stroke
Liner comma stroke

PATTERN
Page 324

PALETTE
A Blueberry
B Cool Neutral
C Midnite Green
D Coral Rose
E Yellow Ochre
F Bright Green

BRUSHES
Flats: Nos. 12 and 6
Liner: No. 1

MISCELLANEOUS
A natural *or* household
sponge

White chalk, graphite,
or transfer paper (to
transfer the pattern)

A stylus (optional)

Recently, I saw the following thought-provoking statement on our church bulletin: "If tomorrow were the very last day, it would be extremely busy!" What an understatement. There would be no idle time for plucking daisy petals to determine whether "he loves me, he loves me not." Instead, we would all be doing those things we had postponed doing until that elusive day, Tomorrow.

With that thought in mind, and the fact that I love to include quotes and inspired ideas on many of my painted projects, I lettered this daisy-embellished calendar to remind us that we should live today so we'll have no regrets tomorrow. That means we must take advantage of the time and opportunities we have been given. Most important, we must leave no kind thought unspoken, no thoughtful deed undone. We must be generous with our praise, gracious with our "thank yous," and unrestrained with our "I love yous;" always exercising understanding, compassion, patience, and forgiveness. And all without procrastinating! Someday, Tomorrow will come. When it does, our loved ones will have no need of plucked daisy petals to know of our love; we would have assured them all along. And when Tomorrow comes, we'll have no regrets.

Surface Preparation

1. Mix two middle-value colors, **A+B** and **F+B**. Sponge these onto the wooden calendar to create a mottled effect. (Refer to the border of the worksheet.) Let dry.
2. Apply a thin wash of **C** over the sponging. (Notice the center area on the worksheet.)
3. Using chalk, graphite, or transfer paper, transfer only a skeleton of the pattern by running a single line through each stroke. These lines will suggest stroke placement, but will allow you to work freehand rather than be forced to "fill in."
4. Paint the edges around the calendar with **A** plus a little **F**.

Painting Instructions

1. Use the No. 12 flat brush to paint the heart with **B**. Apply two or more coats for even coverage.
2. Paint the comma stroke stems and the scroll work with the liner and a middle-value green-blue mixture of **B+F** plus a little **A**. Add blue-green strokes of **B+A** plus a little **F**. Add some pale green strokes of **B+F**.
3. Use the No. 6 flat brush to paint leaf-stroke flower petals with a mixture of **B+D**.
4. With the liner brush and **B**, paint vein lines beginning at the base of the flower petals (at the flower's center) and pulling toward the tip.
5. With a mixture of **E+B**, paint the daisy centers with the handle end of the brush or a stylus.
6. Paint a border of miniature daisies on the sides of the calendar. Use the liner brush and some of the mixtures used above. Space the daisy centers about 1¼ inches apart.
7. Draw chalk guidelines across the bottom of the calendar as a guide to the position of the lettering. Use the liner brush and **B** to letter your "thought for the day."

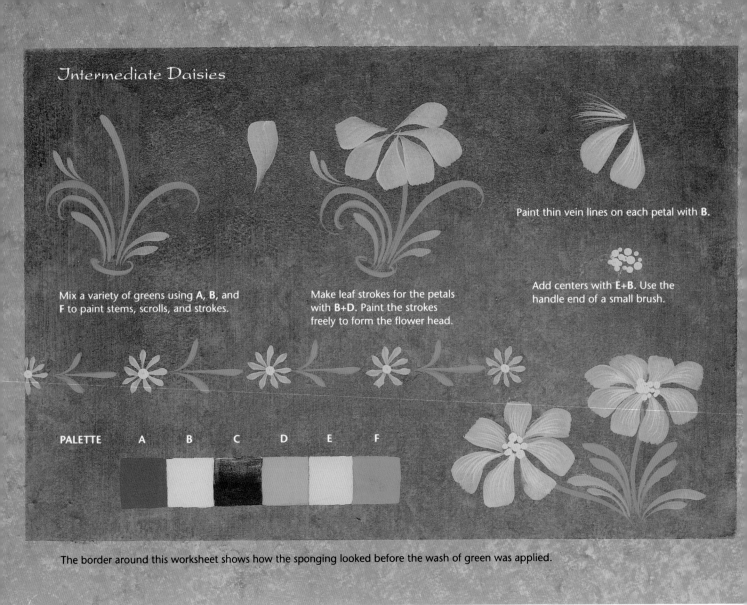

Intermediate Daisies

Mix a variety of greens using **A**, **B**, and **F** to paint stems, scrolls, and strokes.

Make leaf strokes for the petals with **B+D**. Paint the strokes freely to form the flower head.

Paint thin vein lines on each petal with **B**.

Add centers with **E+B**. Use the handle end of a small brush.

PALETTE A B C D E F

The border around this worksheet shows how the sponging looked before the wash of green was applied.

The completed calendar project.

Advanced Daisies

PROJECT
Tray (#26) from Designs
by Bentwood

PATTERN
Page 324

PALETTE
A Viridian Green
B Dioxazine Purple
C Snow White
D Cadmium Yellow

BRUSHES
Flats: Nos. 6 and 8;
1-inch
Round: No. 3

MISCELLANEOUS
An old toothbrush

Lace and ribbon trim
(optional)

This lesson, which features a complementary color scheme, was designed to give you an effective color mixing workout using a limited palette of only three colors and white.

Surface Preparation

1. Basecoat the sides of the tray and the handles with an avocado green mixture of **A+D+B**. Let dry.
2. Spatter the sides (and the handles, if you're not planning to cover them with lace) with a cream-colored mixture of **C+D** plus a small amount of **B**. Thin the color slightly with water and load it into an old toothbrush. (See "Spattering, Splattering, or Fly Specking," page 272.) Protect the surrounding area and the inside of the tray from spatters by spreading newspapers and laying an old towel inside the tray.
3. Basecoat the inside of the tray with a bluish mixture of **A+B** plus a little **C**. Let dry.
4. Scumble the following blue, purple, green colors and mixtures onto the tray, keeping the color predominantly dark in value: **A**, **B**, **A+B**, **B+A**, **A+B+C**, and **B+A+C**. (Use **C** sparingly.) By varying the proportions of colors in the mixtures, you will obtain a variety of colors. Lean mostly toward purple and blue-violet, to create a striking, complementary background for the yellow flowers.

Painting Instructions

Flowers

1. Use the round brush and **D** to build up rich color on the daisy petals gradually, letting the cool complementary color of the background show through in places. Pull strokes from the tip of the petal to the base in a long, flowing motion. Lay strokes side by side to cover the width of the petal. Veinlike streaks will appear naturally. In some cases a flip or turn of a petal may suggest itself to you. Paint it deftly, with a single stroke, and with a little extra paint loaded on the brush.
2. Repeat step 1, creating more depth by gradually building up the layers of paint. Repeat again, if needed, letting strokes fade slightly near the base of the petals.
3. Use a mixture of **D+C** to paint the turned edges and raised areas of the petals.

4. Make a lighter-value yellow by mixing **C** plus very little **D**. Highlight turned edges and raised portions of any petals you would like to accent, particularly those receiving the strongest light.
5. Apply a wash of **D** over all the flower petals to unify the highlight areas with the rest of the petals and fill in fine gaps between them. This is particularly important on the four side-view daisies. Otherwise, each petal will be too distinct and appear sharply outlined, especially if you were very precise in building up the layers of paint. The wash will soften the effect.
6. Shade with a very thin wash of **B**. Apply with either the round brush, using the paint to nudge color where you want it, or the No. 6 flat brush, sideloaded.
7. Repeat any previous steps to strengthen light and dark values.

Centers

1. Load the round brush with **D**. Hold the brush perpendicular to the surface and pounce, creating miniature flower blossoms in the daisy center. This technique actually works best after you've been using the brush a while and the paint has started to thicken or dry on the brush hairs. Practice by starting in the middle of the flower center. (That area will ultimately be covered with dots, so any mistakes made there will soon be hidden.) Use the handle end of the brush and a mixture of **D+C** to fill the center with dots.
2. Apply a wash of **D** over the center.
3. Shade the outside edge of the center with a wash of **B**. Shade the handle dots with **D+A+B** (a light green mix).

Leaves

1. Undercoat the leaves with an avocado green mixture of **D+A+B**.
2. Brush thinned **B** and a mixture of **B+A** randomly over the leaves.
3. Build up light areas with the green mixture plus more **D**.
4. Shade areas on the leaf with mixtures of **B+A** and **A+B**.
5. Add veins and strengthen highlights with the green mixture plus plenty of **D**. Use the chisel edge of the No. 6 flat brush to paint the veins.

Ribbon

Before starting, refer to "Blended Ribbons," pages 136–137.

1. Undercoat the ribbon with **B**.
2. Using a **C+B** sideloaded on the flat brush, highlight the center of the raised area of the ribbon. Place the color side of the brush at the center of the ribbon, then work away from it, along one half. Then flip the brush over and work in the other direction, letting the color fade as you move away from the center point. If you need to merge the light color into the dark of the undercoat, load **B** on the other side of the brush and work gradually back up the ribbon toward the center.
3. Shade the darkest areas of the ribbon with a mixture of **B+A.**
4. When the highlighting and shading are dry, wash a thin layer of **B** over the ribbon. This will impart a brilliant glow to it. Let the portions of ribbon near the forward-facing flower be the most intense to help focus attention there. Tone down the highlighted areas near each end of the ribbon by mixing a little **A** in with the **B** for the wash. If needed, apply a second wash layer. The subdued color and heavier wash will prevent drawing the viewer's attention away from the center of the design.

The completed handled tray project. (Note the spattering on the sides.)

Advanced Daisies

1. Using **D** and the round brush, pull strokes from the tip to the base.

2. Repeat step 1 to build up color. Repeat again if necessary.

3. Paint the petals' flips and raised areas with **D+C**.

4. Accent raised areas further with **C** plus very little **D**.

CENTERS

1. Dab **C** around the edge; fill in the center with dots of **D+C**.

2. Wash **D** over all.

3. Shade the outside with **B** and the inside with **D+A+B**.

5. Wash over all with **D**.

6. Shade with **B** in a thin wash.

7. Repeat any previous steps to adjust colors and strengthen highlights and shadings.

LEAVES

1. Undercoat with **D+A+B**.

2. Brush on **B** and **B+A**.

3. Highlight with the undercoat color plus more **D**.

4. Shade with **B+A** and **A+B**.

5. Add veins and more highlights with the green mixture (**D+A+B**) mixed with more **D**.

Undercoat the ribbon with **B**.

Highlight with **C+B**.

Shade with **B+A**.

Wash over with **B**.

I've applied **A** and **B** in thin washes over a white stripe so you can see their hues. They are clear and transparent. Similar dark hues lacking that clarity will not result in the same crisp colors.

Quick and Easy Dogwood

PROJECT
Casserole Carrier (#72-B)
from Designs by
Bentwood

SKILLS NEEDED
Comma strokes
Scumbling

PATTERN
Page 325

PALETTE
A Jade Green
B Cool Neutral
C Buttermilk
D Evergreen
E Mink Tan

BRUSHES
Flat: No. 12
Round: No. 3
Liner: No. 1

MISCELLANEOUS
Brush 'n Blend Extender

A small, cheap
watercolor brush

White chalk

With only 108 strokes (all commas) plus a few thin lines, this is probably the fastest project to paint in the book.

Surface Preparation

1. Basecoat the entire project with a mixture of **A+B**.
2. To serve as a guide for the placement of the simple dogwood stroke flowers, draw a chalk line around the middle of the side of the project. Mark the center of each flower on the line, spacing it between the brass rivets on the container. Draw two intersecting lines through each center mark. Make each line about 1 inch long. Do not try to make each pair of crossed lines identical and precise. Variety will make the flowers more interesting.

Painting Instructions

Dogwood Flowers

1. Each petal consists of a pair of comma strokes formed in the shape of a heart, with the point toward the center of the flower. Paint very curvy comma strokes with the round brush and very thick **C** heavily loaded onto the brush. Turn the project as you work so that you always pull the tails of the strokes toward you. This will give you better control. Don't worry if the tails are not perfect. The flower centers will cover the ends of the tails.

2. Fill the liner brush with thinned **C** to paint a few very fine vein lines in each petal. Let the lines curve, following the contour lines of the petals.
3. Dip an inexpensive (children's watercolor dime-store variety) brush into **E**. Tap off excess paint, then dab, stipple, or pounce the color onto the center of the flower.

Stems

1. Use the liner brush to paint three stems on one side of the flower and two on the other with **E** thinned considerably with water.
2. After painting the leaves (see below), paint along the leaf stem lines, made in step 1, with a mixture of **A+D** mixed slightly darker than the leaves. Let some of the brown color show through in places. Carry the green line onto the leaf.

Leaves

1. Mix **A+D** to make a green a little darker than the basecoat color. (Remember: Acrylics dry darker.) Use the round brush well loaded with very thin paint to paint two adjoining comma strokes for each leaf.

Band

1. Load the flat brush with extender, then pick up a little **C**. Brush the color loosely around the band in short, choppy, scumbling strokes. (See "Scumbling," page 271.) Paint the top edge of the band in solid **C**.

The completed casserole carrier project.

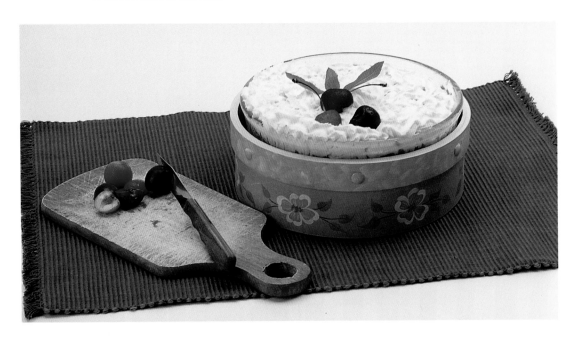

222

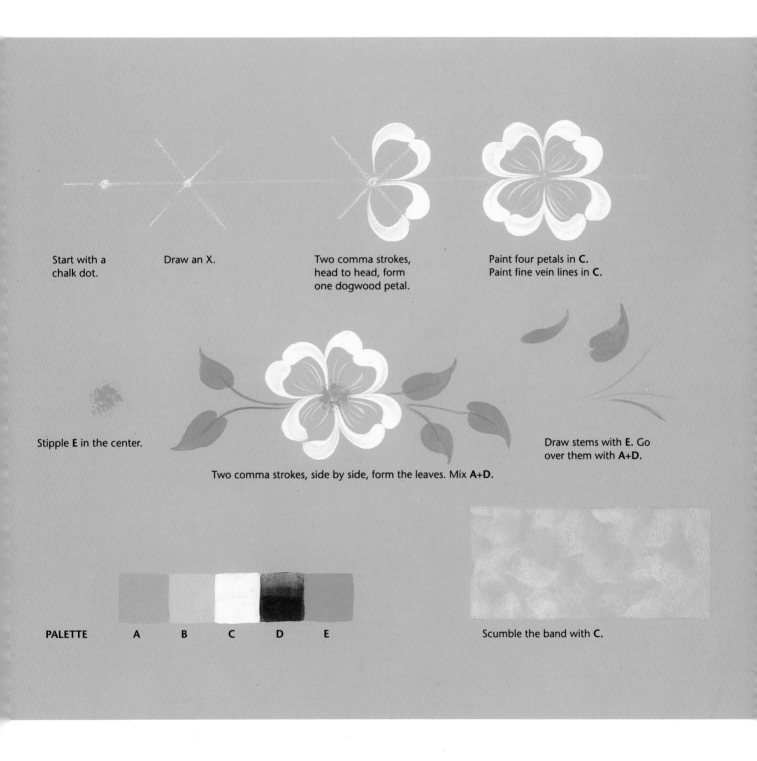

Start with a
chalk dot.

Draw an X.

Two comma strokes,
head to head, form
one dogwood petal.

Paint four petals in **C.**
Paint fine vein lines in **C.**

Stipple **E** in the center.

Two comma strokes, side by side, form the leaves. Mix **A+D.**

Draw stems with **E.** Go
over them with **A+D.**

PALETTE A B C D E

Scumble the band with **C.**

223

Intermediate Dogwood

Surface Preparation

1. The inset on top of the clipboard is faux finished. (See "Scumbling" and "Marbleizing," pages 271 and 278 respectively.) Mask around the area to be marbleized with masking tape. Working quickly with the 1-inch brush, alternately scumble **B** and **C**, both thinned with water, within the unmasked area. While the paint is still wet, lay plastic wrap in it to create a marbled effect. Also marbleize the back of the box. *(Hint:* You may prefer to start on the back for practice.)

2. To decorate the edges of the box, work on one side at a time. Scumble thinned **B** and **C** quickly. While the paint is wet, drag a dried corncob through it in a zig-zag motion. (See "Corncob Graining and Printing," page 277.)

Painting Instructions

Flowers

1. Sideload the No. 10 flat brush with **D**. Paint four dipped crescent strokes for each complete flower. Partial flowers have fewer strokes. Use the No. 8 flat brush to paint the smaller flowers.

2. Use the liner brush to paint the indentations on the flowers with a mixture of **B+F**.

3. Drip dots of **B+E** in the center of the dogwood.

Leaves and Scrolls

1. Sideload the No. 10 flat brush with **E** for the scrolls. Use the No. 8 flat brush to paint the leaf-stroke leaves.

2. Using a mixture of **E+D**, embellish the scrolls and leaves with a variety of liner brush detail strokes.

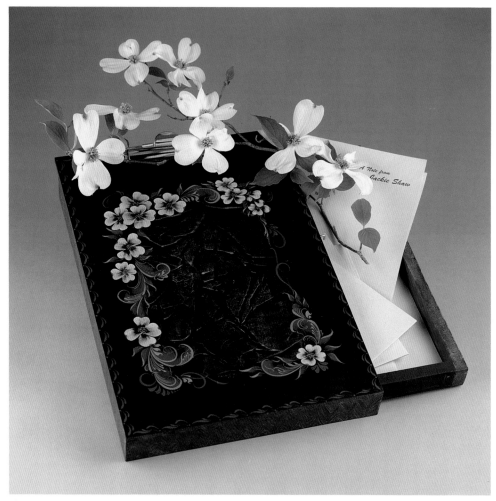

The completed clipboard box project.

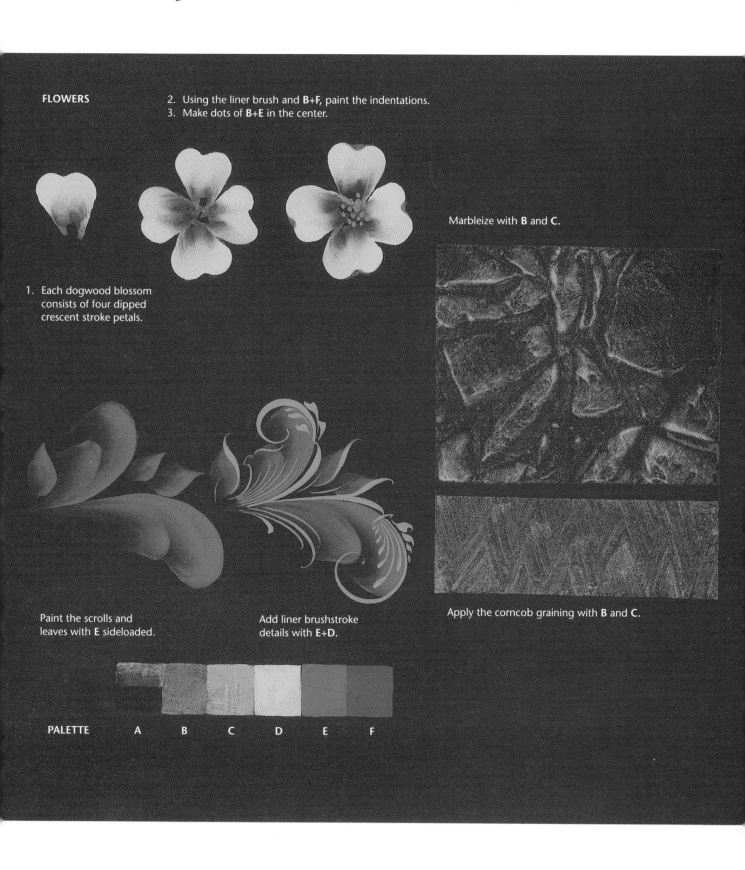

FLOWERS

2. Using the liner brush and **B+F**, paint the indentations.
3. Make dots of **B+E** in the center.

Marbleize with **B** and **C**.

1. Each dogwood blossom consists of four dipped crescent stroke petals.

Paint the scrolls and leaves with **E** sideloaded.

Add liner brushstroke details with **E+D**.

Apply the corncob graining with **B** and **C**.

PALETTE A B C D E F

Advanced Dogwood

PROJECT
Wickhambrook cabinet
(#17021) from Walnut
Hollow

PATTERNS
Page 326

DOGWOOD PALETTE
A Midnite Green
B Ebony Black
C Peaches 'n Cream
D Buttermilk
E Gooseberry
F Boysenberry
G Avocado
H Raspberry
I Russett
J Taffy Cream

BRUSHES
Flats: No. 6; 1-inch
Filbert: No. 8
Round: No. 4
Liner: No. 1

MISCELLANEOUS
Masking tape (to mask
the light source on the
panel)

To add some challenge to these dogwood blossoms, the easiest advanced flowers in this book, I've included a trompe l'oeil brass vase and gold necklace. Because painting metal requires deft handling of washes and confident modeling techniques, I've divided the lesson into two parts, each with its own worksheet and palette listing. With this setup, you can try your hand at either one or put both lessons together (see "Trompe l'Oeil," page 282).

I painted the brass vase and dogwood on a cabinet/shelf that hangs in a room where the light comes from the upper left and casts double shadows down to the right: one strong, the other faint. If you plan to use your painting as a trompe l'oeil, be sure to consider the light source where it will hang. You may need to alter the position of the shadows, highlights, and reflected lights in the pattern, and change the perspective in order to make your painting "read" correctly in its setting.

Surface Preparation

(Note: This particular cabinet has a tall open area in the center. I inserted an $8 \times 22 \times 1/4$ inch panel in front of it, on which I painted the picture.)

1. Basecoat the cabinet and panel with **A**.
2. Determine where the shadow lines will fall on the panel based on the location of your light source. Mask the area with tape. Use the 1-inch flat brush to paint the shadows cast by the sides of the cabinet and suggesting its depth. For the darkest, deepest shadows, use **B+A**. For medium-dark shadows, use **A+B**. For faint shadows, use a wash of **A+B**. Indicate the floor line with a thin wash of **A+B**, pulling the color slightly toward the front and blending into a stripe of water to fade the color out.

Painting Instructions

Dogwood

1. Using the No. 6 flat brush, undercoat all the petals with **C**. Work from the base of the petal to the tip, following the contours. Slight ridges of paint will suggest the petals' vein lines. After the first coat is completely dry, apply a second coat. Don't worry about aligning the paint ridges; just make sure that you follow the contours of the petal.
2. With the round brush, dab thinned **D** at the base of each petal. Pull strokes of **D** toward the tip, following the contours of the petal. Dab full-strength **D** at the tip of each petal.
3. With the filbert brush, loosely brush thinned **E** on each petal. Place the color randomly, and avoid the urge to blend it in smoothly; a blotchy effect is preferable. (Note the petals on the worksheet in step 3 at 9 and 12 o'clock.) Let dry, then brush thinned **H** over the entire petal except for the white tip. (Look at the petals at 3 and 6 o'clock.) Dab thinned **E** skimpily around the indentation at the tip of each petal.
4. To make the petals more pink, apply a thin wash of **F** randomly on each petal.
5. Use the liner brush and thinned **F** to draw deep pink vein lines.
6. With the round brush, dab a mixture of **G+D** around the indentation, leaving a bit of the creamy white color showing at the tip. If the mixture appears too green, dab on a little **D** to break it up.
7. With the round brush, dab thinned **D** at the base of each petal, then pull it slightly out into the petal between the vein lines.

Shade under any overlapping petals, or petals in shadow, with a mixture of **F+A**. Also, paint the shadows cast by the centers onto the petals.

Centers

1. Fill in the center with a mixture of **G+F**.
2. Using either the liner or the round brush, press elongated dots of **D+G+F**, beginning at the back edge of the center.
3. Fill in the rest of the center with irregular-shaped dots of **D+G+F**.
4. Dabble a little **F+G+D** around in the center.
5. Highlight the dots with thinned **D+G**.

Branches and Stems

1. Undercoat the stems with **A+E+G+D**.
2. Use the round brush to scatter thinned **G** randomly along the branches and stems.
3. Similarly, scatter a thinned mixture of **I+G+A** along the branches and stems, sometimes overlapping the green.
4. Loosely brush on **D+I+A**, then draw rings around the branches with **I+A**.

Leaves

These dogwood leaves are the easiest in this book. See pages 130–131 for the instructions and worksheet. Use **A, G, I**, and **J**.

Advanced Dogwood

1. Undercoat the flowers with **C**.

2. Dab thinned **D** at the base of the petal and pull toward the tip. Dab full-strength **D** at the tip.

3. Scatter thinned **E** over the petals randomly and at their indentations. Do not blend it in. Then cover the petals with thinned **H**. (See the petals at 3 o'clock and 6 o'clock.)

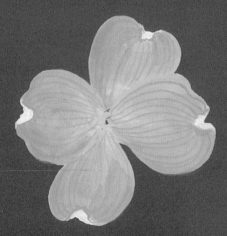

4. Apply a thin wash of **F** randomly on each petal.

5. Draw thin vein lines with the liner and thinned **F**.

6. Dab **G+D** at the indentations, leaving some of the creamy white undercoat visible.

7. Brush a very thin wash of **D** at the base of the petals, pulling between vein lines. Shade beneath the petals with **F+A**.

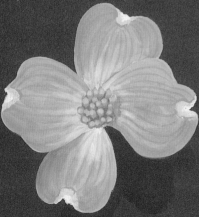

CENTERS

 1. Undercoat with **G+F**.

2. Dab on dots of **D+G+F**.

3. Dot on more **D+G+F**.

4. Dabble **F+G+D**.

5. Highlight with **D+G**.

STEMS

1
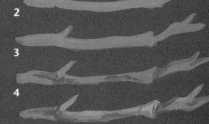

2

3

4

1. Undercoat with **A+E+G+D**.
2. Scatter on **G**.
3. Scatter on **I+G+A**.
4. Scatter on **D+I+A**. Draw rings in **I+A**.

PALETTE	A	B	C	D	E	F	G	H	I	J

Trompe l'Oeil Brass Vase

Painting brass is not accomplished in the eight distinct steps illustrated in the worksheet for this part of the project. It's necessary to work back and forth between the steps shown to build up bright highlights and deep shadows as well as strong and gentle reflected lights. I've tried to keep the steps uncomplicated in order to simplify the process as much as possible. Between step 8 and the finished piece, there are several repetitions of some of the previous steps. By layering transparent washes, we can create luminous color that gives a rich, warm glow to the brass.

To make highlights sparkle brightly, we must surround them with rich darks. Therefore, I urge you to try to paint your brass not by undercoating with a brassy yellow, but rather with a rich, dark brown created by mixing russett, a blackish green, and black. (Understand, however, that if we were painting brass on a red background, or a purple or pink one, we would be using those background colors in our work instead of the greens.)

Brass is not just a golden yellow. It is comprised of all the colors, lights, and shadows surrounding it. That's what makes it so exciting to paint. And it's much more exciting to paint brass while studying an actual subject, rather than by following a painted sample in a book. So if you've never tried to paint brass, read through the lesson to give yourself an idea of what to look for, then try to paint from your own setup. You can be your own best teacher. Painting a reflective surface forces you to observe very closely and really see, not just paint what you "know" or believe to be.

Painting Instructions

1. Undercoat the brass vase with a dark brown mixture of **A+B+C**. Undercoat the inside of the vase with thin **D**.
2. Paint the light-value areas with **D**. Use the filbert, if you have one, to paint softer edges than can normally be obtained with a flat brush.
3. Exaggerate parts of the areas painted in step 2 with a thinned mixture of **F+D**. Also, brush a little of this mixture on the inside of the vase to indicate highlight. Suggest the locations of the strong highlights with a full-strength smear of **F+D**.
4. Look for the darkest darks. Paint them with **C**.

5. Look for other dark areas. Paint some of these with **B** and others with **A**.
6. Add the reflected lights using a considerably thinned mixture of **H+B**. (Against my dark green background the reflected lights appear a cool blue-green.) These will be more apparent after the paint has dried than when it's wet. If it appears too strong or too blue when it dries, don't worry; you can adjust it later.

 You may be a bit discouraged at this point, since the vase will seem to be a long way from shaping up. Charge ahead. Next you'll be building the foundation for all the sparkly lights and darks.
7. Apply a thin wash of **D** over everything except the reflected lights. Also, wash **D** over the highlight inside the vase. Apply a thin wash of **B** over the reflected lights to soften them.
8. Add the reflections using **A** and **B**. (Note that these reflections, which fall within the highlight areas, correspond to the flowers in the vase and the room that the arrangement was in when I drew and painted it.) Strengthen highlights with **F+E** and/or **F+G**. Let dry. Wash over them with thinned **D**.

 For brilliant lights, use **I**. Let dry, then wash over them with **E**. Let some of **E** wash onto parts of the vase.

 Drybrushed highlights on the vase and reflections on the foreground are an effective addition. Use a very dry brush and **D**.

 Continue playing with washes, highlights, and drybrushing until your vase assumes the warm glow of brass. By repeating the steps above as needed, you can refine your vase from step 8 to the finished piece without using any new steps or colors. If your brass doesn't sparkle, try making the darks considerably darker.

 The cast shadows on the dark green background are **B+C**.

Necklace

Paint the necklace using the same process and colors as those used for the vase. For a more glittery and metallic gold effect, emphasize the highlights with **I**, scattering smaller highlights throughout and using plenty of **E** washes.

If you omit the necklace from your painting, be sure that you do not paint its reflection on the vase (as shown on page 230).

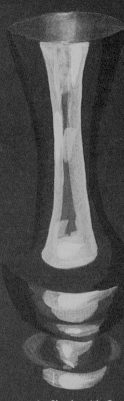

1. Undercoat the vase with **A+B+C**. Undercoat the inside with **D**.

2. Highlight with **D**.

3. Accent the highlights with **F+D**.

4. Shade with **C**.

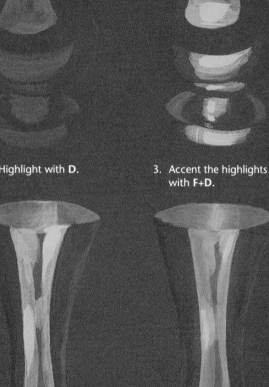

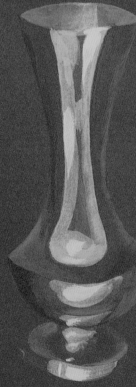

5. Shade with **A** and **B**.

6. Add reflected lights with **H+B**.

7. Wash **B** on the reflected lights, and **D** over the rest.

8. Add more lights, darks, and drybrushing.

PALETTE A B C D E F G H I

Advanced Dogwood with Trompe l'Oeil Brass Vase

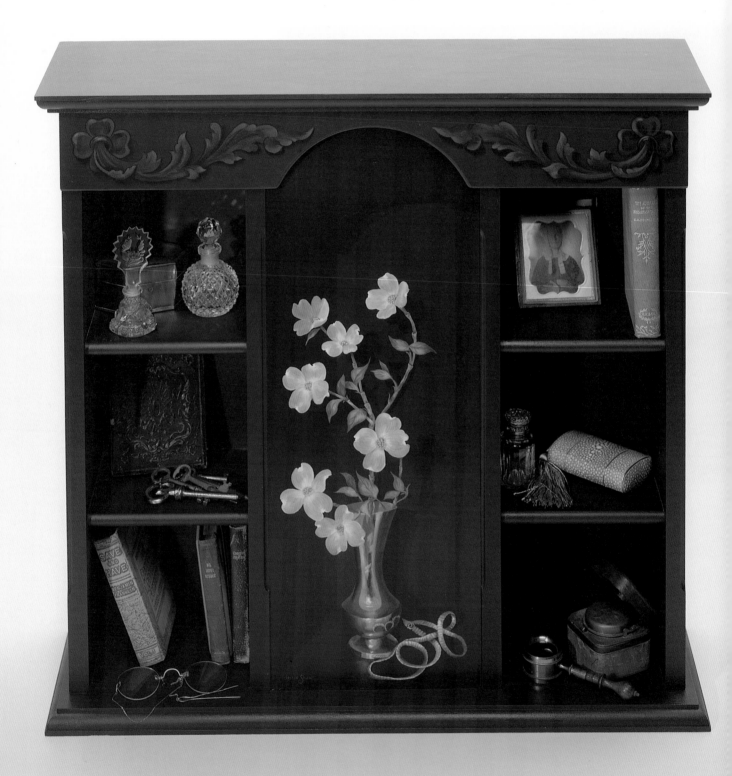

The completed trompe l'oeil cabinet project.

Quick and Easy Forget-Me-Nots

PROJECT
Child (31-017 and 31-333) and adult (31-169) wooden coat hangers from Cabin Craft Midwest

Twisted metal hooks from Oliver Trahan

SKILLS NEEDED
Comma strokes

PATTERN
None needed (use the designs on the worksheet as a guide).

PALETTE
A Cool Neutral
B Antique White
C Dusty Rose
D Buttermilk
E Country Blue
F Orchid
G Blue Haze
H Pineapple
I Blush

BRUSHES
Liner: No. 1

MISCELLANEOUS
A drill

Cotton swabs

Varnish

Glue (optional)

Lace and ribbon (optional)

Children love painting these cotton swab flowers. The next time your youngsters or grandchildren need entertaining, give them a few cotton swabs, some paint, and some blank note paper and envelopes to decorate. Show them how to dip the cotton swab in a little paint and press the round shape onto the paper. After that, leave them alone. They'll come up with their own designs and unique flowers, and they'll even figure out how to make leaves if they feel they're needed.

For your part (since adults are more inhibited and self-demanding than children), notice that the design and technique used on the large hanger in the photograph is the easier one of the samples shown because it is very precise. The process used on the small hangers is more loose and free, and for that reason slightly more intimidating to some. Try both methods, however. They are both easy and fun.

Surface Preparation

1. Drill holes in the tops of the wooden hangers so you can insert the hooks.
2. Basecoat projects with **A**, **B**, and/or **C**.

Painting Instructions

1. Mix blue, pink, and lavender combinations using **C**, **D**, **E**, **F**, and **I**. Dip the cotton swab in the paint and press onto the project to form petals. Reload with paint after every two or three petals.
2. Paint a small red dot in the center of the flower with **I+D**.
3. Surround the red dot with tiny yellow dots of **H**.
4. Paint small comma stroke leaves with a mixture of **G+H**, or mix other greens with **A**, **D**, **E**, **G**, and **H**.

 To paint the looser design on the children's hangers, scatter different blues, purples, and pinks in a cluster, giving some flowers only two or three petals or tiny, single dabs. Then paint five or six complete flowers (five petals each) on top. Add tiny comma stroke leaves of **G+H**.

Finishing

After varnishing the hangers, glue on the lace trim or ribbon along the edge. Embellish with ribbons.

Squeeze glue into the predrilled hole and insert a hanger hook.

The completed children's and adult wooden coat hangers.

Quick and Easy Forget-Me-Nots

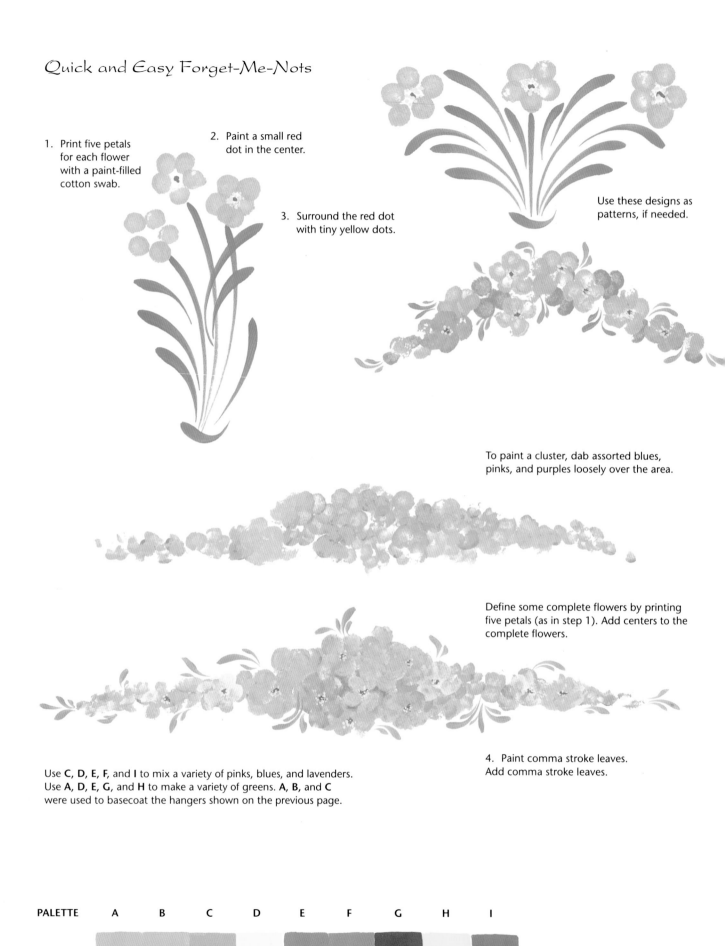

1. Print five petals for each flower with a paint-filled cotton swab.

2. Paint a small red dot in the center.

3. Surround the red dot with tiny yellow dots.

Use these designs as patterns, if needed.

To paint a cluster, dab assorted blues, pinks, and purples loosely over the area.

Define some complete flowers by printing five petals (as in step 1). Add centers to the complete flowers.

4. Paint comma stroke leaves. Add comma stroke leaves.

Use **C, D, E, F,** and **I** to mix a variety of pinks, blues, and lavenders. Use **A, D, E, G,** and **H** to make a variety of greens. **A, B,** and **C** were used to basecoat the hangers shown on the previous page.

PALETTE	A	B	C	D	E	F	G	H	I

Intermediate Forget-Me-Nots

PROJECTS
Candlesticks (16-0011),
round box (22-0010),
and wooden eggs
(21-0105) from Paintin'
Cottage

SKILLS NEEDED
Sideloading
Doubleloading
Crescent strokes
S strokes
Leaf strokes
Flat comma strokes

PATTERN
Page 327

PALETTE
A Cool Neutral
B Blue Haze
C Orchid
D Blueberry
E Snow White
F Blush
G Pineapple
H Mauve
I Buttermilk

BRUSHES
Flat: No. 2
Liner: No. 1

MISCELLANEOUS
Brush 'n Blend Extender

This lesson introduces the effective technique of loose shadowing, or shadow leaves, behind the subject matter. The shadow leaves step is optional and may be omitted. It does, however, give a soft, gentle look to the painting, as illustrated on the candlesticks on page 235. Without the shadow leaves, the effect is a little more stylized and stiff, as on the small box, but nonetheless still fun to paint.

Surface Preparation

1. Basecoat the candlesticks with **A**. Paint the contrasting bands with a mixture of **A+B**.
2. Basecoat the round box as follows:
 a. the top of the lid with **B+F**; then gold leaf (see pages 283–285)
 b. the side of the lid with **H**
 c. the side of the box with **H+E**
3. Basecoat the eggs with **H**, **H+E**, and **I**.

Painting Instructions

Shadow Leaves

Load the flat brush with extender, then sideload it with **B+C**. With the color side of the brush facing the edge of the flowers in the pattern, paint short, choppy strokes to represent fill-in foliage. Pull some strokes from the outside into the flowers. For other strokes, pull from the flowers outward. Try not to make consistent or predictable strokes, and don't worry if you obliterate some of your pattern. Having to "make do"

without it will help build your confidence in freehand painting. Soon you'll be able to brush shadow foliage on a project without a pattern, and then design it as you paint. Make the stems by holding the brush perpendicular to the project and sliding on the chisel edge.

Leaves

Mix **B+G** to make a soft, light green. Paint four to six leaves in the design using S, leaf, and flat comma strokes singly or in combinations. Keep the leaves understated in both color and design so they won't detract from your delicate flowers.

Flowers

Doubleload the flat brush with a dark value on one side and a light value on the other. Try combinations of **C+E**, **C+D+E**, and **D+E**. If you prefer the colors a little muted, add yellow to the purple mixes and red to the blue ones. Load extra–light value paint (or white) on the edge of your brush so that when you make the stroke it will leave a thin ridge of texture on the edge. Paint five crescent strokes to form a full flower; use fewer for partial or turned-away flowers. Paint the crescent strokes with reckless abandon; otherwise, all your flowers will look identical and wooden. Let them flop a little and be a bit imperfect. Paint dabs for buds.

Use the liner brush to paint a spot of **F+I** in the centers of some of the flowers. Surround it with tiny dots of **G**.

Intermediate Forget-Me-Nots

SHADOW LEAVES

1. Shadow behind the flowers with **B+C** sideloaded with extender. Place the dark side close to the flowers. Use short, broken strokes.

FLOWERS

3. Paint crescent stroke petals,

but do them quickly and carelessly,

with plenty of paint on the edge of the brush for texture.

Paint the stems by sliding on the chisel edge of the brush.

Flower colors: **C+E**, **C+D+E**, and **D+E**. Paint some flowers with only two or three petals, and whole flowers with five petals.

The center dot is in **F+I**; the surrounding dots are in **G**.

Do not paint centers in all the flowers.

LEAVES

2. Use **B+G** to make combinations of S, leaf, and flat comma strokes.

PALETTE A B C D E F G H I

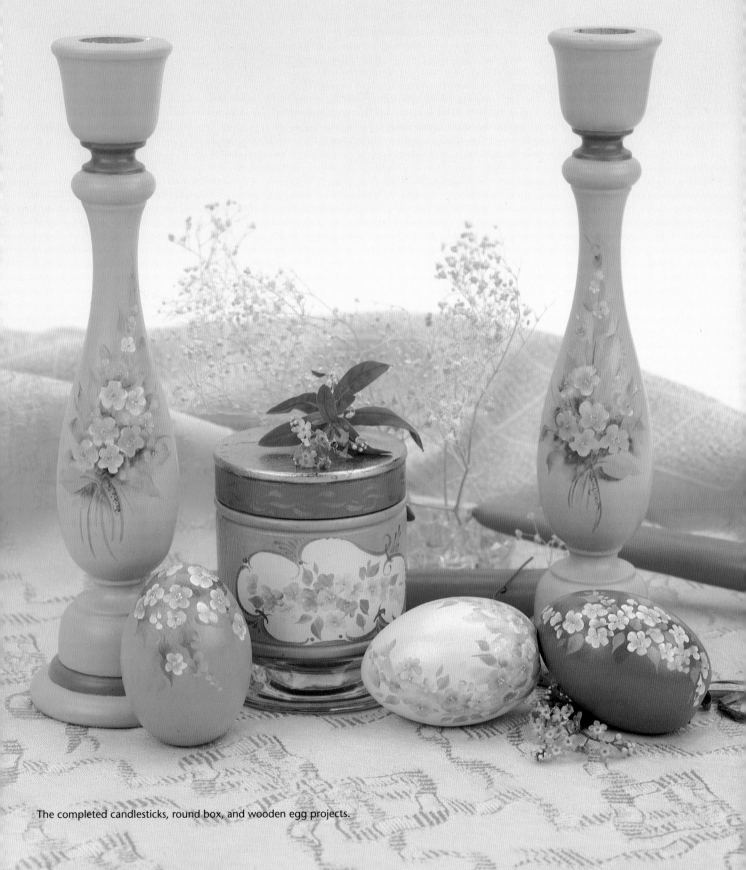

The completed candlesticks, round box, and wooden egg projects.

Advanced Forget-Me-Nots

PROJECT
Large scoop (#30-L)
from Designs by
Bentwood

PATTERNS
Page 327

PALETTE
A Desert Sand
B Blue Haze
C Deep Teal
D Evergreen
E Orchid
F Olive Green
G Blueberry
H Snow White
I Pineapple
J Blush

BRUSHES
Flats: Nos. 2 and 10
Liner: No. 1 *or* 2

MISCELLANEOUS
Masking tape, 1¹/₄ inches
wide (to mask the border
aligning with the base of
the handle)

Brush 'n Blend Extender

The forget-me-not is said to have gotten its name from the last words uttered by a drowning knight who had attempted to pluck the precious flowers from a brimming stream for his beloved lady. Had the knight painted the flowers instead of trying to pick them, he may have lived to enjoy his lady fair, and we may have called the flowers by another name.

Whatever we might call them, these little five-petaled flowers are a joy to paint. The majority of the flowers represented in the sample shown are painted with careless, scattered strokes; these become the background and turned-away flowers. The up-close and forward-facing flowers are painted a little more carefully, but still with looseness and with casual strokes.

Surface Preparation

1. On the outside of the scoop, approximately 1¹/₄ inches up from the bottom and centered on the handle, mask a border with masking tape about 1¹/₄ inches wide. Seal the edges tightly. Then paint the outside of the scoop with **B**. Remove the masking tape.

2. Paint the previously masked border, the handle, and the inside of the scoop with **A**.

Painting Instructions

Shadow Leaves and Leaves

1. Load the No. 10 flat brush with extender, then alternately pick up **B**, **C**, and **D** and scumble the greens lightly at first all over the area that will be behind the floral pattern. Let the color fade at the outer edges of the pattern area. (If necessary, loosely trace around the edges of your pattern so you will know how great an area needs to be scumbled.)

2. Randomly scumble on a little **E** thinned with extender.

3. Scumble **B**, **C**, and **D** boldly in the center of the cluster. This will give your painting depth. Let the scumbling dry, then trace the pattern onto the scumbled background.

4. Fill in the leaves with **D** and the No. 10 flat brush. Coverage does not need to be smooth or solid; in fact, brushstrokes will often suggest turns or flips that you can then incorporate into the final blending of the leaf. Let some of the shadow colors

behind the leaves show through and thus affect the final appearance of each leaf.

5. Brush on light areas of **F+D**.

6. Shade with **D**, **D+C**, **D+G**, and **D+B**. Do not overblend or labor too long over any leaf.

7. Add strong accent highlights of **F**, drybrushing it heavily in places to look like broken patches of sunlight on the leaves.

8. Using a liner brush and **D** thinned with water, paint stems and calyxes for the buds. If any stems appear too intense—either at this point, or when you've completed the painting—brush over them with thinned **A**.

Flowers

1. With the No. 2 flat brush, use a loose touch to brush in rough flower shapes using **B**, **G**, **E**, and mixtures of **G+E** and **E** plus a little **G**. Place the darker colors near the center of the design—among, behind, and over the bases of the painted leaves, but not on their tips. Place **E** and **E+G** near the clusters of the flowers.

2. Paint the buds with the No. 2 flat brush doubleloaded with **E** and **H**.

3. Following the instructions on the worksheet for Intermediate Forget-Me-Nots (page 234), paint full blossoms using the following mixtures: **B+H**, **G+H**, **E+H**, **B+G+H**, and **E+G+H**. Sideload additional white on the brush to create two values. Let some of these flowers overlap the leaves. (Wash the brush periodically, as it will get gummy several times before you fill in enough blossoms to make the bouquet.)

Add more background flowers, if necessary, to fill in. Try to vary some of the petals of both the background and foreground flowers to make them appear to be facing in different directions.

4. Sprinkle a little "sunlight" on the bouquet by doubleloading the No. 2 flat brush with **I** and extender and stroking it on the edges of some of the petals.

5. Paint the centers of some—not all—of the flowers. Make a red dot in the middle with **J+A**. Surround it with tiny yellow dots of **I**.

Border

Decorate the border with small clusters of flowers and trailing leaves following the same procedure described above. Paint small leaves, using the leaf stroke.

Advanced Forget-Me-Nots

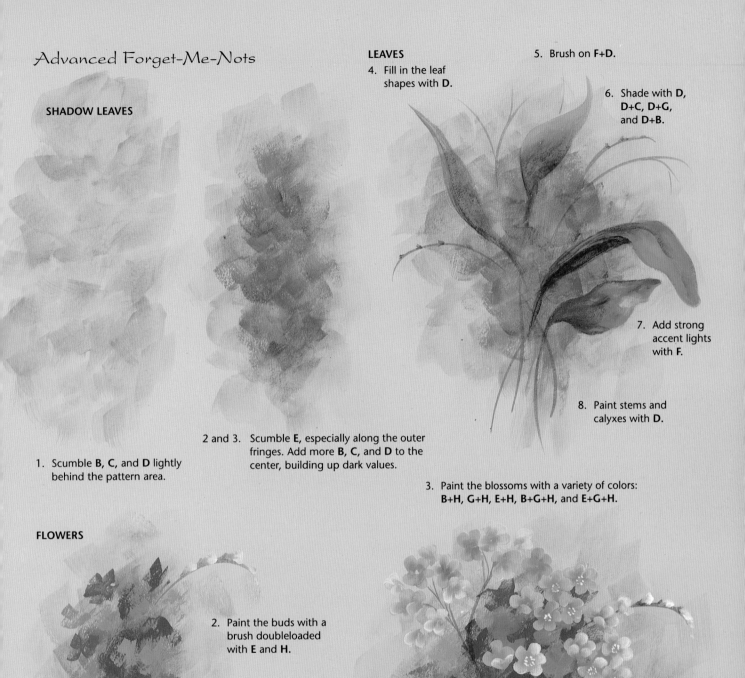

SHADOW LEAVES

LEAVES

4. Fill in the leaf shapes with **D**.

5. Brush on **F+D**.

6. Shade with **D**, **D+C**, **D+G**, and **D+B**.

7. Add strong accent lights with **F**.

8. Paint stems and calyxes with **D**.

2 and 3. Scumble **E**, especially along the outer fringes. Add more **B**, **C**, and **D** to the center, building up dark values.

1. Scumble **B**, **C**, and **D** lightly behind the pattern area.

3. Paint the blossoms with a variety of colors: **B+H**, **G+H**, **E+H**, **B+G+H**, and **E+G+H**.

FLOWERS

2. Paint the buds with a brush doubleloaded with **E** and **H**.

To highlight some petals, sideload additional white on the brush.

5. Add center dots of **J+A**. Surround them with tiny dots of **I**.

4. Use **I** with extender to add "sunlight" to the petals.

1. Fill in the background flowers with **E+G**, **B**, **G**, **E**, and **G** plus a little **E**.

PALETTE A B C D E F G H I J

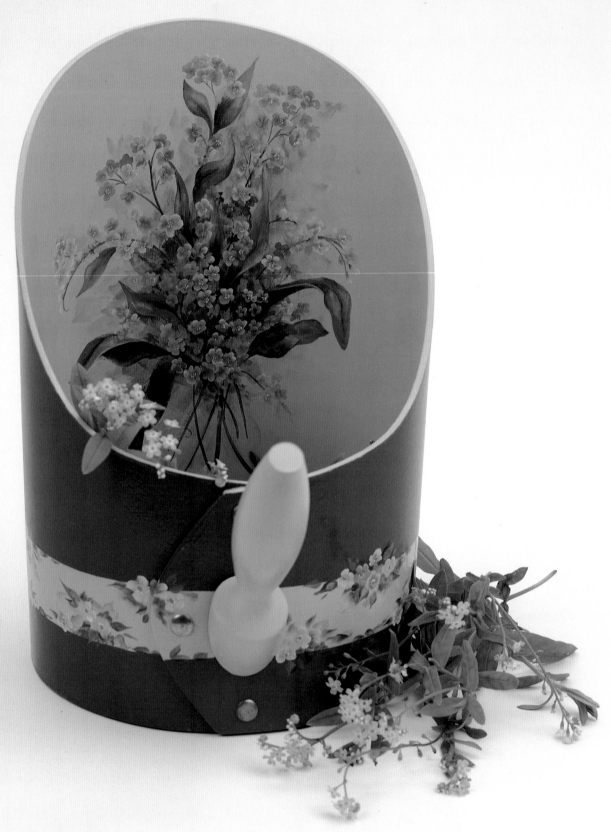

The completed large scoop project.

Quick and Easy Roses

PROJECT
Oval carrier (#3) from
Designs by Bentwood

SKILLS NEEDED
Comma strokes
Color mixing

PATTERN
Page 328

PALETTE
A Dioxazine Purple
B Blue Gray Mist
C Yellow Ochre
D Mauve
E Dove Gray
F Evergreen
G Buttermilk

BRUSHES
Flat: No. 10
Round: No. 3

MISCELLANEOUS
White chalk
A stylus

**LINING MATERIALS
(OPTIONAL)**
$^1/_2$ yard of fabric

Scissors

Thread

$2^1/_3$ yards of $1^1/_4$-inch
double-edged lace (with
openings for ribbon,
optional)

2 yards of $^3/_8$-inch ribbon

1 yard of $1^1/_2$-inch
ribbon

Clothespins

Designer Tacky Glue
and/or Hot Glue (Note:
The type of glue you use
is optional. I use both
types—Designer Tacky
Glue where I might want
or need to reposition
something, and Hot
Glue where I want an
instant bond.)

Tissue paper *or*
newspaper

Polyester quilt batting

Lightweight cardboard
or chipboard

A toothpick *or* small
palette knife

These primitive-style roses are so quick and easy to do that you will have plenty of extra time to line the project with fabric, lace, and ribbon. If you plan to line your project, adjust the palette colors to coordinate with the colors in your fabric. Coordinating paint colors with fabric provides great experience in color mixing. (For a review of color mixing, reread Chapter 2.) You will need four values for the flowers and three values for the leaves. If you choose not to line the carrier with fabric, then paint the inside with one of the colors used on the project.

Surface Preparation

1. Basecoat the carrier as follows:
 a. Paint the side of the carrier with a mixture of **A+B** (see the worksheet for the background color).
 b. Paint the band with **A+C**. (See the worksheet, "Whoops!" section, for a sample of this color mixture.)
 c. Paint the handle with **D+E** (see the worksheet for the rose undercoat color). Be sure to paint over the edge and about $^1/_2$ inch inside on both the handle and the band if you plan to line the project with fabric. If you plan to omit the lining, paint both entirely.
 (Note: Mixture **D+E** will be the undercoat color for the flowers, and mixture **A+C** will be the shading color for the flower centers.)
2. Draw a chalk line around the middle of the carrier, dividing the side (excluding the band) in half.
3. Transfer as little of the pattern as you feel comfortable doing.
 a. Position and trace the open rose on the center of the side, under the handle.
 b. Align and transfer the large bud pattern along the chalk line, working from the right of the open rose and repeating to the center back. Do not trace the final rosebud on the center back seam at this point.
 c. Flip the large bud pattern over to create a mirror image and transfer it along the chalk line, working from the left of the open rose toward the center back, again omitting the final rosebud.
 d. In the space remaining at the center back seam, draw a circle to connect the

two stem/leaf patterns. Draw a round bud, facing upward, to fill the space.

Painting Instructions

Start at the back of the project, so that by the time you work your way around to the front you'll be an accomplished primitive rose painter!

Large Buds

1. With the flat brush, undercoat the buds and the large, open rose with a 50:50 mixture of **D+E**.
2. With the round brush, paint the flower centers and dark-value comma strokes with a mixture of **D** plus a little **E**. Pay careful attention to how the tails of the comma strokes swing. Note the diagrams on the worksheet, and study the "Whoops!" section.
3. Paint the highlighting strokes with a mixture of **D+G**. On the large, open rose, add more, random highlighting strokes to fill it in and fluff it out. (See the worksheet for an example.)
4. Shade the lower half of the flower centers with a mixture of **A+C**.
5. Add pollen dots with the stylus and **G**.

Leaves and Stems

Paint the stems with a medium-value green, and the leaves in the following three values of green:

Light value—mostly **B** plus a little **A+F**
Medium value—mostly **F** plus a little **A+B**.
Dark value—mostly **F+A** plus a little **B**.

Making the Fabric Lining

Sides

1. Measure the circumference and the height of the area to be lined. Cut a strip of fabric $1^1/_2$ times the circumference (length), and $1^1/_4$ inch greater than the height.
2. Stitch the seams together so that the strip of fabric forms a loop. Press the seam open. Fold the loop down 1 inch along the top edge. Press.
3. Run a long gathering stitch around the fabric loop $^3/_8$ inch down from the folded-over top edge. Pull the gathers to fit the fabric inside the container, leaving it just slightly larger than needed.

4. Cut the double-edged lace 1¹/₂ times longer than the circumference to be lined. Stitch the ends together to form a loop and press the seam open. *(Note:* You could combine this step with step 1 and eliminate steps 4, 5, and 6. I like the appearance of the fabric and lace gathered separately and so have included the extra steps here.)

5. Run a gathering stitch on both sides of the ribbon openings. Pull the gathers to fit the lace to the lining fabric.

6. Pin the lace to the lining fabric, letting the top edge of the lace extend slightly beyond it. Adjust the gathers in the fabric and the lace for an even distribution of fullness. Stitch them together along the gathering lines on the lace.

7. Run a piece of ³/₈-inch ribbon through the openings in the lace, leaving the ends unsecured until after the final fitting to the project. (You'll cover the ribbon ends with a small bow, so decide where you want the bow when you work on the next step.)

8. Fit the lining to the project, easing in the fullness if necessary, and holding it in place with three or four clothespins.

9. Run a bead of hot glue along the uppermost stitching line, then glue the lining in place, leaving ¹/₄ inch of fabric extended above the top of the edge of the project. Use clothespins to hold the fabric snugly to the project until the glue cools.

10. Fold under the ends of the ³/₈-inch ribbon and glue them in place. Glue a small bow on top.

11. Spread a thin layer of Designer Tacky Glue around the bottom of the project to anchor the side lining.

Base

1. Make a paper pattern for the inside base of the project. Place the project on a sheet of tissue paper or newspaper. Draw around the outside edge to get an approximate size and shape. Cut out the pattern. Place it inside the container and smooth it out. With a fingernail or pencil carefully score the pattern. Remove the pattern and trim the excess paper along the scored line.

2. Place the pattern for the base on the fabric and cut around it, allowing 2 inches all the way around for turning under. Run a long gathering stitch around the fabric ¹/₂ inch from the edge.

3. Place the pattern on polyester quilt batting and cut one or two layers (depending upon how "fluffy" you want the padding). Cut the batting 1 inch wider than the pattern all the way around.

4. Place the pattern on a piece of lightweight cardboard or chipboard. Trace around it. Cut out the tracing ¹/₄ inch smaller all the way around.

5. Place the fabric face down. Lay the batting, centered, on top of the fabric. Then place the cutout cardboard shape on top of the batting. Pull the batting and fabric up over the edge of the cardboard. Pull the gathering threads to ease the fullness around the cardboard base.

6. Test the fit of the covered base inside the project. If no adjustments are needed, remove the covered base and glue the fabric along the gathering line to the cardboard. Spread Hot Glue or Designer Tacky Glue inside the bottom of the project. Ease the covered cardboard base into position, then press it into the glue.

Handle

1. Measure the length and width of the handle. Cut a strip of fabric the length of the handle plus 1 inch by the width of the handle plus 1¹/₂ inches. Fold under ¹/₂ inch on each end and ³/₄ inch along each side. Press.

2. Stitch double-edged lace to the top of the fabric strip, sewing along both sides of the ribbon openings. Thread ³/₈-inch ribbon through the openings. (Leave an inch or more of the lace on each end of the fabric strip if you want to extend the lace to the very ends of the handle.)

3. Spread Designer Tacky Glue on the underside of the handle. Attach the fabric/lace strip, holding it in place with clothespins. Slit the extra length of lace at the ends and spot glue it to the back of the handle. You'll need a toothpick or a small palette knife to work it into the tight area.

Bow

Use the 1¹/₂-inch-wide ribbon to make a bow to embellish the inside of the carrier.

Quick and Easy Roses

1. Basecoat the rose with a mixture of **D+E**.

2. Paint the shadow side and the center of the rose with strokes of **D** plus a little **E**.

3. Paint strokes on the highlight side with a mixture of **D+G**.

4. Shade the center with **A+C**.

5. Add dots of **G**.

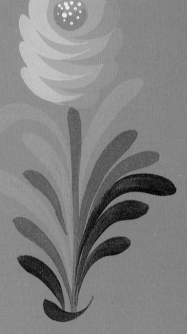

WHOOPS!

THIS WAY

These strokes are heading downward too sharply. They're also too far over the edge.

These stroke tails are curving upward too abruptly. There's also too much space between the heads. They should touch.

Think of the strokes as a mother's arms cradling a baby.

LEAVES AND STEMS
Paint these with three values: (1) **B** plus a little **A+F**, (2) **F** plus a little **A+B**, and (3) **F+A** plus a little **B**.

(Note: The color mixture used on the band of the carrier is the same as that used for the sample strokes above.)

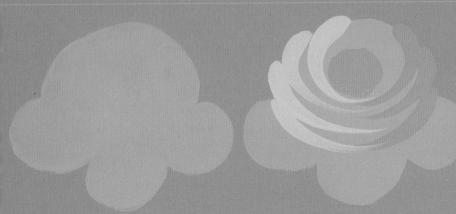

Undercoat the open rose.

Then follow steps 2 and 3 above.

Add more light petals, then the centers.

PALETTE A B C D E F G

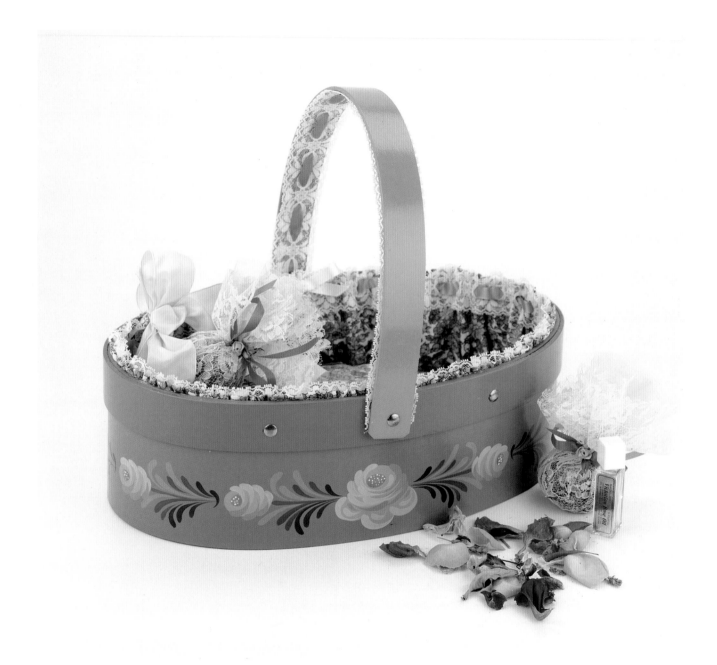

The completed oval carrier project.

Intermediate Roses

PROJECT
Tin candle sconce
(#108) from Crafts
Manufacturing
Company

SKILLS NEEDED
Doubleloading
Sideloading
Bumpy crescent strokes
Leaf strokes
Flat comma strokes

PATTERN
Page 328

PALETTE
A Cool Neutral
B Peaches 'n Cream
C Sand
D Gooseberry
E Jade Green
F Light Avocado
G Colonial Green

BRUSHES
Flats: Nos. 8 and 4
Liner: No. 1 *or* 2

MISCELLANEOUS
A sketchbook *or* stack of
paper (for practice work)

Paper towels

For Lefties

Photocopy the
worksheet onto clear
acetate, then flip it over
and follow the directions
as they appear on the
back. This will enable you
to form the strokes more
comfortably, and to see
them as you make them.
Where references are
made to the clock face,
transpose those directions
to the other side of
the clock (for example,
when you're asked to
rotate the flag from 12
to 8 o'clock, yours will
rotate from 12 to 4).

This brushstroke rose involves only three
different strokes and nine steps. If you have
difficulty painting strokes 6, 7, and 8, omit
them in the beginning. You can paint a
passable rose with the first five steps.

Surface Preparation

The surface of this particular candle sconce is
already prepared and basecoated. If you prefer
to decorate another tin project, see "Tinware,"
pages 97–98. Then basecoat the project with **A**.

Painting Instructions

Roses

First, a few hints for success:

- Light and dark contrast is very important.
 In steps 1–5, use more dark value than light.
 Then in steps 6–9, use more light value.
- Think of the rose as a cup and saucer.
 Steps 1–4 should form an oval, which is
 the cup portion. The strokes in step 5 form
 the saucer. Keep the two parts distinct.
- Step 6 must fit entirely in the cup,
 otherwise the distinction between cup
 and saucer is destroyed, and the rose will
 lose its definition.
- Make sure that steps 7 and 8 do not get
 into the cup. In particular, watch the dark
 side of the brush when painting them.
 There is a tendency for it to slide over the
 edge of the oval formed by steps 1–4,
 spoiling the shape.
- Follow the worksheet on page 245. Do
 not try to make brushstrokes match the
 drawn pattern exactly. The pattern is just
 a guide to help you with positioning and
 proportion. Ideally, you should try to paint
 this rose and the leaves and buds freehand.
- Put a flag on your brush handle to help
 you understand some of the brush action
 required. (The instructions will assume
 that the top of the rose corresponds to
 12 o'clock.) For some strokes you'll be
 advised to rotate your work to give you
 an improved advantage in handling the
 brush. No matter which way the work is
 turned, imagine that the clock face turns
 with the rose. Always load the paint on
 your brush with the light value on the
 same side of the brush as the flag.

1. Doubleload a No. 8 flat brush with **C**
 (a dark-value color) on one side, and a

mixture of **B+D** (a light-value color) on
the other side. (For steps 1–5, load the
brush predominantly with the darker
color. For steps 6, 7, and 8, use more of
the lighter color.) With the light value
toward the top, paint a bumpy crescent
stroke, forming an inverted U.

2. Let step 1 dry, then paint a smaller bumpy
 crescent stroke just inside the first one.

3. With the dark-value corner of the brush,
 dab paint to fill in the gaps, forming a
 rough oval shape.

4. With the light value toward the top and
 the chisel edge starting on an angle
 where the stroke in step 1 began, paint a
 bumpy crescent stroke, this time forming
 a U right-side up. With practice, you
 will soon be able to make the top edge
 of the stroke bumpy while keeping the
 bottom edge smooth. You should now
 have an oval shape formed by steps 1–4.
 This is the "cup."

5. This step forms the "saucer." It may
 require three to five strokes to wrap
 around the base of the cup, and possibly
 more for larger roses.

 When painting the strokes in this step,
 press the brush down, then pause to let
 the hairs fan out in order to make a fuller,
 fluffier rose. Slide the brush slightly if
 necessary, scooting back toward the cup as
 you paint the ruffles, to avoid leaving any
 large gaps between the cup and the saucer.

 To paint the first stroke in the saucer,
 turn the rose so the top of it faces left.
 This will allow you to look down on your
 work and watch the formation of the
 stroke more easily.

 Pay particular attention to how the
 brush rotates, and its starting and ending
 positions as indicated by the bold black
 lines. Note that the first ruffle starts with the
 chisel edge of the brush standing along
 the edge of the cup where the first and
 fourth strokes began. The flag on your
 brush should be pointing toward the top
 of the rose (12 o'clock). Press the brush
 down and pivot about one quarter of a
 turn, simultaneously pressing, pulling,
 and releasing to form ruffles. The flag is
 now moving from 12, to 9, to maybe 8
 o'clock. (Make sure that the brush does
 not rotate a full half circle and point to

the inside of the rose—a common mistake. If this happens, the light value will move too much in toward the cup, creating confusion visually.) Bring the brush back up to its chisel edge.

To start the next stroke, rotate the top of the rose slightly back to its original position. The flag should still be pointing away from the rose, toward 9 or 8 o'clock. Rotate the brush slightly as you form the ruffles in the stroke, moving from your starting position to about 6 o'clock. For this and all remaining strokes in the saucer, you will not pivot a full quarter turn as you did for the initial stroke, but rather swing gradually around the edge of the cup.

Start the next stroke where you stopped the previous one, rotating slightly and ruffling. Repeat as often as needed to complete the saucer. The final stroke will end with a fairly straight edge at about the middle of the first and fourth strokes, with the flag pointing to about 3 o'clock. At this point, the saucer will look unbalanced. Its beginning (on the left) will be nicely rounded and slightly higher on the cup. The ending (on the right) will be flat and abrupt, and will stop lower on the cup. That is as it should be. The seventh stroke will fill in the gap.

6. Before painting this step, wipe the brush on a damp paper towel to remove excess paint so that you can reload and paint the last three steps with crisp definition. If the brush seems excessively gummy, rinse it completely, then reload. Pick up a little extra **B** to strengthen the light value.

This stroke is the most troublesome, but you'll get it with practice. Stand the brush on the chisel edge at an angle near the base of the cup. The flag should point to about 10 o'clock, with the light value toward the top. Press the brush down, rotate, and bounce a little more than a quarter of a turn; then, while gradually reducing pressure, slide the brush toward the top of the cup. The stroke should end where the first and fourth strokes ended. Make sure that this stroke stays *in* the cup. If it spills outside the edge anywhere along the cup, it will spoil the shape of the rose.

7. Rotate the top of the rose so that it faces the left. Begin this stroke with the chisel edge aligned along the stopping point of the first and fourth strokes. Press and rotate the brush slightly, bouncing and sliding down the outside edge of the cup. At about 4 o'clock, begin lifting the dark-value side of the brush and dragging the light-value corner to trail off the stroke. Make sure it doesn't spill into the cup. Pay particular attention to the dark-value side of the brush.

8. This is a repeat of the seventh stroke, but on the opposite side. Keep the top of the rose facing left. Begin the stroke a little lower, with the chisel edge of the brush midway along the edge of the cup. Rotate and bounce down the edge of the cup, and trail off underneath the seventh stroke. Be sure to leave a little separation between the lower parts of the seventh and eighth strokes.

9. Using the light-value corner of the brush, dab little bits of pollen in the center of the rose, and you're through!

Buds
Paint the buds with steps 1 and 4. Then use the corner of the flat brush to drag green sepals along the edges of the bud.

Leaves
After completing the roses and buds, dip the brush in water and make a wet, pinkish puddle on the palette. Then partially clean the brush, leaving some pink in the hairs. This will add variety to the leaves, softening the green slightly.

1. Using the slightly dirty No. 8 flat brush, load it with **B**, then sideload it with one or more of the following greens: **E**, **F**, and **G**.

2. Skip around the design, painting leaves in a variety of greens. (See "Bumpy Pivot-Pull Stroke Leaves," page 126.) The leaves nearest the rose should be the strongest in contrast, while those on the extreme edges of the design should be less dominant.

3. Add a blush of color to many of the leaves by loading the brush with extender and one of the following: **B**, **C**, **D**, **C+F**, **F+G**, and **B+E**. Use plenty of extender in the brush to keep the added color transparent.

4. Use the pinkish puddle of water on your palette to dilute the paint whenever needed. This step will help the rose and leaves relate to one another through color.

Stems
1. Load a mixture of **D+F** plus extender into the liner brush. Paint the stems by drawing with the liner, rolling it at times to create a more natural, less stiff, look.

2. Add any of the colors suggested in step 3 above to shade or highlight the stems.

Intermediate Roses

STROKES

(Note: The black lines indicate the angle at which to start strokes.)

1

2

3

Doubleload a No. 8 flat brush with a light-value color (**B+D**) on one side and a dark-value color (**C**) on the other.

1. Paint a primarily dark bumpy crescent stroke. Let dry.

2. Lay a smaller bumpy crescent on top of the first stroke.

3. Fill in gaps at the bottom to create an oval shape.

4

4. Begin and end this stroke where step 1 began and ended, forming a "cup."

5

5. Wrap the "saucer" around the cup, keeping the light value toward the outside edge.

6

7

6. Paint a curved, bumpy leaf stroke, keeping within the boundary of the cup.
7. Swing a flat comma stroke from the right.
8. Then swing one from the left, keeping both outside the cup.
9. Add pollen dots.

8

9

BUDS
Paint steps 1 and 4.
Add green sepals with the corner of the brush.

PALETTE A B C D E F G

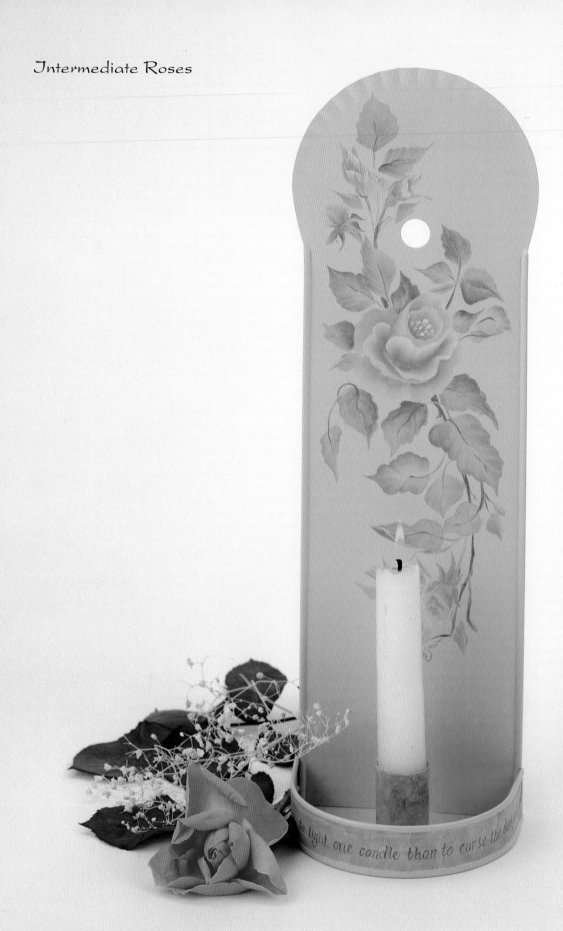

The completed tin candle sconce project.

Advanced Roses

PROJECT
Extra-large museum box
(#50) from Designs by
Bentwood

PATTERNS
Page 328–329

PALETTE
A Teal Green
B Red Iron Oxide
C Flesh Tone
D Boysenberry
E Midnite Green
F Black Forest Green
G Deep Teal
H Leaf Green
I Baby Pink
J Spice Pink
K Burgundy Wine
L Red Violet
M Blush
N Colonial Green
O Buttermilk
P Snow White
Q Avocado
R Dark Chocolate
S Glorious Gold
T Venetian Gold

BRUSHES
Flats: 1-inch; Nos. 8 and 2
Liner: No. JS 1

MISCELLANEOUS
Gold leaf

Gold leaf size *or* spirit
varnish

Old No. 1 and 6 flat
brushes (for applying
the size)

A old rag (for rag rolling)

Cotton swabs

A natural or household
sponge

An old toothbrush (for
spattering)

Varnish

Burnt umber and raw
umber artist's tube oil
paints (optional)

White chalk

Material for the inner
lining (optional)

This lesson assumes that you are considerably skilled in handling washes and floated color, in sideloading the brush, and in blending, and that you are knowledgeable in working with color to suggest form. Painting with acrylics to suggest the delicacy and softness of the rose requires a light touch, very thin layers of paint, and a process of tickling the colors into place. Tickling is always fun, and I think you'll enjoy doing it to a rose.

Although the shapes of the roses on the project differ, the process of painting them is the same. Practice first with the one illustrated on the worksheet. Don't worry about reproducing the sample exactly since the layering of washes and floated colors will yield slightly varying results. Concentrate, instead, on the placement of the lights and darks in order to suggest dimension. Build the values slowly through thin layers of paint, thereby making adjustments gradually. Be careful not to overblend. Let color changes enhance your work.

Paint the sample rose several times, if needed, to become comfortable with the procedure. Be daring on your practice sheets, experimenting with color placement, with shadows, and with the rolling of petal edges. Find out what works and what doesn't. Since you'll be using thin color, you can easily correct poor decisions. Besides, correcting a passage often results in just the right "look," and you'll learn a lot in the process.

Surface Preparation

Lid Top
1. Trace the gold leaf border outline onto the lid. Do not trace the scrolls and details.
2. Basecoat the area to be gold leafed with **B**.
3. Basecoat the remainder of the top (the area behind the roses) with **A**. Let dry.
4. Using the 1-inch flat brush, scumble in the following colors with a sideloaded or doubleloaded brush: **E, F, G, H,** and **A**. Work with thin paint to avoid building up paint ridges. Let some **H** shimmer through brilliantly near the top of the background area. Apply **E** liberally in the lower third of the background. Apply a few strong strokes of **H** in the upper third. After the scumbling is dry, scumble on some **L** in a few places to represent leaves in shadow. Don't be startled by its intensity. It will dry duller and darker.

5. Following the directions on page 284, apply the gold leaf. *(Note:* To eliminate the risk of damaging the leafed surface, you can delay this step until *after* you've completed the decoration of the top and sides of the lid.)

Lid Sides
1. Basecoat the sides of the lid with **C**.

Bottom of the Box
1. Basecoat with **F**.
2. Using the 1-inch brush, scumble on thinned **F** and **H**. While the paint is still wet, rag roll it (see page 273).

Because it's a little tricky working around a large curved object such as this, you'll find it helpful to divide the area roughly into five or six sections. Plan to do a section at a time, starting at the back. Have something handy to prop up the box as you work around it. Before actually applying the paint, a "practice run" will help you think through the process and prepare you to work quickly so that you can complete the project without creating any apparent seams or overlaps. Apply the thinned paint quickly to an area, leaving a ragged edge at the end of the section. Roll the crumpled rag through the wet paint, then quickly move on to the next section.

Painting Instructions

Roses
Before you begin, experiment with the colors in the palette to see how they affect one another as washes, since the majority of your painting will involve applying washes. Using the No. 8 flat brush, paint strips of each of the following colors: **D, I, J, N,** and **O**. Brush a thin wash of each of the following colors over the painted strips: **A, D, I, J, K, L, M, N,** and **O**. Experiment further by laying one colored wash over another, or by mixing two colors together to create a wash. Jot notes beside each experiment to remind you later of the colors you used. Work with thin paint, sideloaded on the brush. Use the water side of the brush to tickle the color into place or fade it out.
1. Undercoat the rose with **J**. Apply second or third coats as needed for adequate coverage. Avoid building up ridges. If some of the background still shows through slightly, don't worry. It will enhance the finished product by creating a little variety.

2. Begin placing the darks and shadows with **D.** Apply the color thinly at this stage, using a sideloaded brush. You'll note that some of the shaded areas fade gradually into the undercoat, while others, particularly some of the cast shadows, end with defined edges.

 The purpose of this step is to help you determine the shapes and positions of the petals. (You'll intensify the darks later.) If, after placing several of the shaded areas, you become confused by the numerous petals, skip ahead to the next step—highlighting—and return to *this* step when you determine where else you need to add shading. Remember, your acrylics will dry a little stronger than they appear when wet, so work with thin paint.

3. With a sideloaded brush, begin establishing the highlights with **I.** Build up the light values gradually, as they, too, will dry to more intense colors than they appear when wet. Work back and forth between steps 2 and 3 until you are satisfied with the shape of the petals.

4. To give portions of the rose a warm glow, brush on a thin layer of **M.** Use it sparingly so that those areas covered will stand out as being slightly different. Remember that too much of a good thing lessens its impact, so don't cover the entire rose.

5. Gradually darken the darks further by adding several layers of transparent color. Use the following colors and mixtures: **K, K+L,** and **K+D.** For cooler darks, try **L+A, D+A,** and **K+A.** Refer to your experiments with the colors and washes to help you determine how you'd like to combine the layers. If you make any of

Scumbled patches of color make the background more interesting. (Note that **L** has not yet been added.)

the shadows too dark, let them dry, then wash over them with **D, I,** or **J,** or any combination of those colors.

6. Slowly, through successive washes, strengthen the highlights. Use a mixture of **I+J.** Should any of your highlights dry too strong, simply wash over them with **D, J,** or **M** to merge them back into the petal.

7. Enhance the illusion that the petals are three-dimensional and that they are rolling or turning by brushing on a cool bluish pink (use a mixture of **J+A**). For darker values, use **D+A;** for lighter values, use **I+D+A.**

 Add spiderweb-thin veins on the petals using the corner and/or the chisel edge of the No. 8 flat brush and very thin **D.** Repeat, using very thin **I.** Do not try to draw precisely. The flat brush will help prevent too careful precision. Just meander. Be sure to keep the veins understated. If they seem too prominent after they've dried, wash over them with **I, J,** or **I+J,** or whatever color is closest to the color of the affected petal.

 To paint the prominent, and more precise, veining on the top rose in the pattern, use the liner brush. Paint the veining, highlighting it, and shading down in the valleys between the veins using the same techniques as shown for the veins on the backs of leaves. (See the worksheet for Apple Leaves, page 133.)

Leaves

Review the general directions for Apple Leaves on page 132. For blocking in the leaves, use the following colors, either separately or in mixtures: **A, E, F, G, H, N,** and **Q.** Add accents with **D, I, J, K, L,** and **M.** Shade with **E** and **F.** For highlights, use **N** and **O.** Use various greens (use **Q** sparingly) to wash over the leaves for variety.

Stems and Thorns

Use the same colors as you used for the leaves. Tinge the thorns with **M** or **J.**

Waterdrops

Follow the general directions for Waterdrops on page 138. Use the corner of the largest brush you can handle for the size of the waterdrop you're painting. working from the edge or corner of the waterdrop. Resort to the No. 2 flat brush only when necessary. In addition to the colors used on the rose petal or leaf on which the waterdrop rests, you'll use **P** to highlight the waterdrop.

Floral Border on Side of Lid

1. Use a variety of pink and pink-violet washes (**D, I, J,** and **D+N**) and greens (**A, F, G,** and **N**) to paint, very loosely, the meandering floral border. Keep shading to a minimum in order to keep the border understated. To paint the white berries, dip a cotton swab into **O** and press it onto the design area.

2. Outline the border flowers with very thin **R** on the liner brush, and doodle in some scrolls and fine details.

3. When the painting is dry, submerge the border design slightly into the background by dabbing over it with a sponge dipped in the background color, **C.** This will give a softened, rubbed-off look to the design without actually sandpapering it.

4. Add a dusting of pink to the border by spattering densely with a slightly thinned mixture of **D+J.**

5. Spatter again with **S.**

Scrolls on Gold Leaf

After gold leafing the top of the lid, apply a protective coat of varnish. Then use **R+F** to shade and outline the scrolls. If you have oil paints, you can use a mixture of raw umber plus burnt umber. (I prefer to use oils on top of gold leaf because of the richer, clearer color they impart. Burnt umber and other brown acrylics become somewhat cloudy in thin washes over gold leaf.)

Stroke Borders and Lettering

1. With chalk, draw the following guidelines for borders and lettering:
 - For the bottom guidelines of the lower stroke border: $1/2$ inch up from the bottom edge of the box
 - For the lettering: 2 and 3 inches up from the bottom edge of the box
 - For the center guideline of the upper border: 4 inches up from the bottom edge of the box

2. Use the liner brush and **S** to letter the quotation. Use **S** and **T** to paint the stroke borders.

 Do not complain that the rosebush has thorns, but rejoice that it has roses.
 —Unknown

Lining the Box

Give your museum box a lovely finishing touch by lining it with fabric. Follow the procedure described on page 239 (Quick and Easy Roses). To determine the length of fabric needed to make soft gathers, allow $1^{1}/2$ to 2 times the circumference of the box.

Advanced Roses

FLOWERS

1. Undercoat the roses with **J**.

2. Shade with **D**.

3. Highlight with **I**.

4. Wash **M** on the petals where a warm glow is desired.

5. Accent darks using a variety of mixtures: **K, K+D, L+A, D+A, K+A,** and **K+L**.

6. Strengthen highlights with **I+J**.

7. Roll some petals by brushing on **J+A**. For darker rolls, use **D+A**; for lighter rolls, use **I+D+A**. Suggest vein lines with the chisel edge of the No. 8 flat brush and very thin **D**. Go over the veins again with thin **I**. Repeat any earlier steps to strengthen or soften colors as needed.

PALETTE A B C D E F

G H I J K L M N O P Q R S T

Advanced Roses

LEAVES

1. Undercoat the leaves with **G, F,** and **Q** (illustrated here). For variety, also use **A, E, H,** and **N.**

2. Add accents with **K, Q,** and **A+N** (illustrated here). For variety, also use **D, I, J, K, L,** and **M.**

3. Shade with **E** and **F.**

4. Highlight with **N** and **O.**

5. Wash over all with **H** to merge colors.

6. Strengthen accents, shading, and highlights.

7. Add center veins with **N** and lateral veins with **E,** using **E** on the tops of the leaves and **N** on the undersides.

8. Using **Q** sparingly, wash various greens over different sections to adjust colors to suit you.

BORDER

1. Undercoat the pattern loosely with thin pink and lavender washes of **D, I, J, D+N,** and green washes of **A, F, G,** and **N.**

2. Outline with **R.**

3. Sponge over with **C.**

4. Spatter with **D+J,** then with **S.**

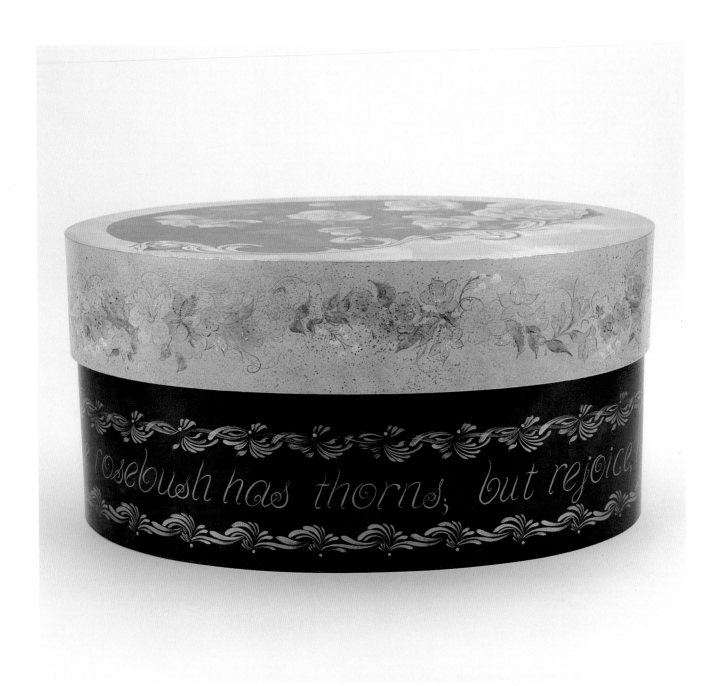

(Above) The completed museum box project. *(Opposite)* A view of the lid top.

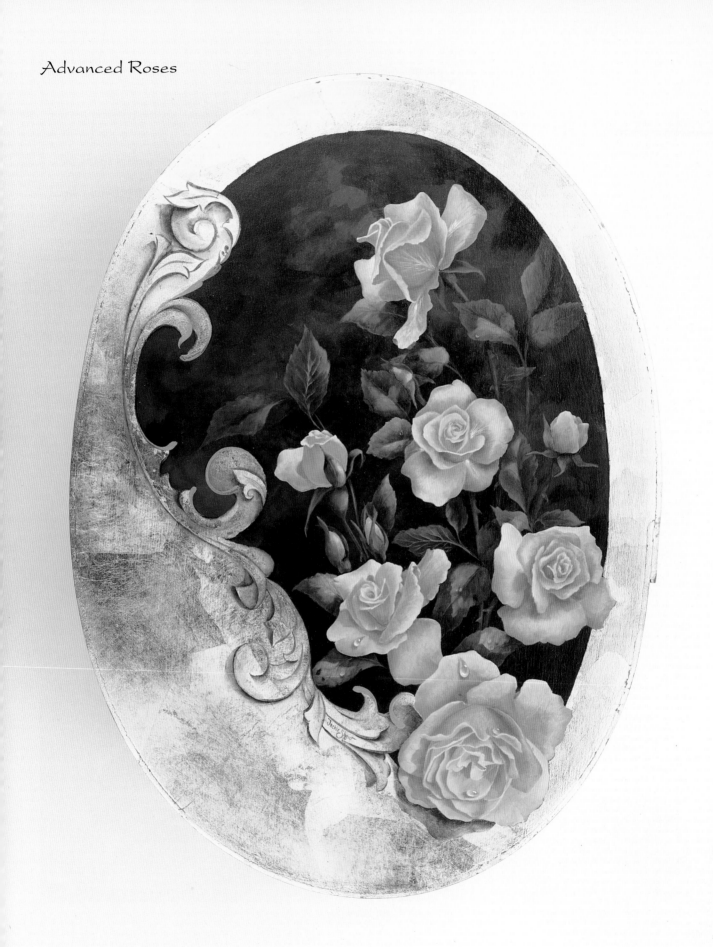

Quick and Easy Tulips

PROJECT
Tulip cutout (#93-JS-3)
from Sunshine Industries
Unlimited

SKILLS NEEDED
Comma stroke

PATTERN
Page 330

PALETTE
Assorted colors of your
choice

BRUSHES
Liner: JS No. 2

MISCELLANEOUS
White chalk

Surface Preparation

Basecoat the tulip cutouts in colors that
coordinate with the room in which you plan
to use them.

Painting Instructions

1. If necessary, use the chalk to mark
 dividing lines on the cutouts to help you
 paint the strokes evenly. Do not draw
 each stroke on the cutout, however. Paint
 them freehand. It will help build your
 confidence.
2. Use a combination of comma stroke sizes
 and directions for variety.
3. Add combinations of any other strokes
 you are learning. The photograph below
 will give you some ideas. Use other
 strokes as substitutes for the comma
 stroke designs on the worksheet.

Helpful Hints

- Paint some extra cutouts to use as markers
 in your garden.
- Experiment on the cutouts with various
 faux finishes.
- If you have access to a scroll saw or jig
 saw, use it to cut out other flower shapes.
 Decorate them with various stroke designs.
- Decorate a windowsill with a row of
 cutout flowers. For added interest, include
 some cutout wooden leaves. Attach the
 flowers and leaves to dowel "stems." Drill
 holes into a ³/₄-inch-thick board cut to fil
 the windowsill, then insert the stems into
 the drilled holes.
- Next time you give a friend a plant as a
 gift, personalize it by including a specially
 decorated cutout flower lettered with your
 friend's name. She'll love it!

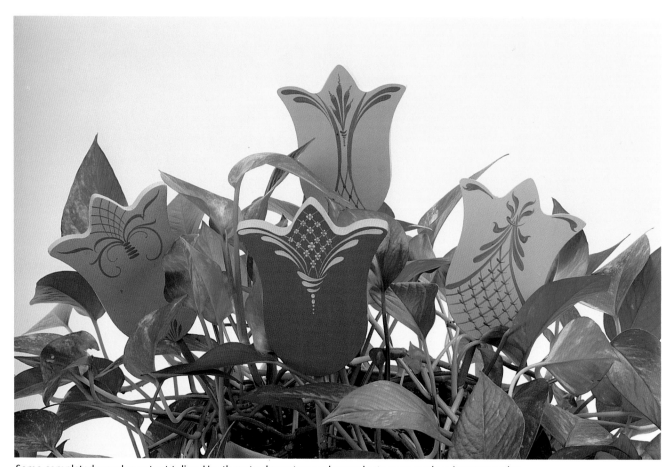

Some completed wooden cutout tulips. Use them to decorate your houseplants or as markers in your garden.

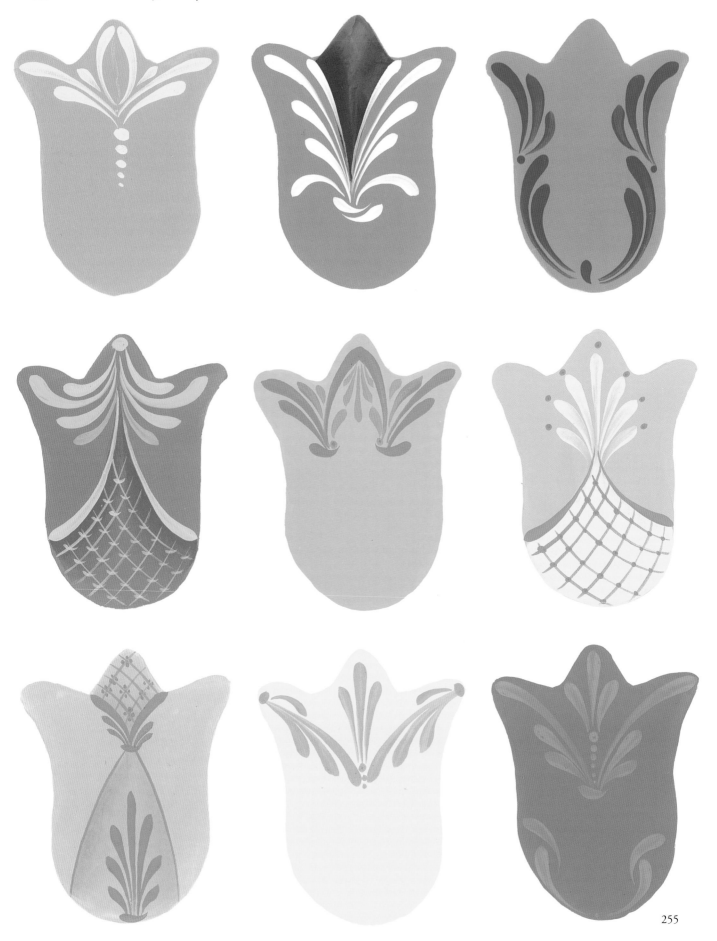

Intermediate Tulips

PROJECT
A half bucket (#U-323.5)
from Basketville

PATTERN
Page 330

SKILLS NEEDED
Sideloading
S stroke
Half-a-heart stroke
Comma stroke
Liner brush details

PALETTE
A Midnite Blue
B Wedgewood Blue
C Williamsburg Blue
D Cranberry Wine
E Baby Blue
F Blush
G Avocado
H Evergreen

BRUSHES
Flats: Nos. 8 and 10
Liner: No. 1

MISCELLANEOUS
Plastic wrap *or* masking
tape (to cover the
handle while painting)

A stylus

A Note to Beginners

This project can be simplified so that it can be quickly and easily painted. Paint the tulips with pairs of comma strokes, eliminating the doubleloaded S strokes. Paint the heart color-book style, rather than with half-a-heart strokes. Omit the liner scrolls.

A great part of the appeal of folk art, whether in painting, needlework, masks, rugs, beadwork, paper cutouts, or pottery, is its fresh and often naive use of color. Brushstroke flowers, such as these tulips, offer artists an opportunity to experiment with different color patterns. If you find yourself in the safe, comfortable rut of always working with certain tried and conservative color schemes, why not use this lesson to work with colors you may find unpredictable?

To make the lesson even more fun, close your eyes and grab about six to nine bottles of paint. From among those colors, imagine which you might use for the background, which for the flowers, the leaves, and the hearts. You might decide to mix a couple of the colors to create additional colors. Be careful, however, not to overdo the mixing and color coordinating or you'll end up with a carefully controlled—rather than a fresh and innocent—color scheme.

With your randomly selected colors, paint several pieces of poster board, each with a different color. Then sketch the design onto each colored sheet. Work up a different color scheme on each sheet, using the colors you selected originally. Notice how the colors react to each background color and how the elements of the design are made more, or less, important by the colors in which they are painted. You'll probably like some combinations better than others. Set them aside for a while, and look at them again later with a fresh eye. They might inspire you to think of additional combinations you would enjoy working with. Why not substitute one of your "new found" color schemes for the colors suggested in this project?

This lesson also provides an easy opportunity for you to do some "safe" designing on your own. Transfer only a skeleton pattern. The scant lines will serve as guidelines, enabling you to freehand paint the rest of the design confidently. You may wish to replace the comma strokes, or at least some of them, with scroll strokes. You may prefer to group the commas differently. You may want to paint a more elaborate tulip, as shown on the Intermediate Tulip worksheets. All sorts of variations and combinations of tulips, strokes, and colors are possible. Try it—you'll have fun!

Surface Preparation

1. Wrap the rope handle with plastic wrap or masking tape to protect it while painting.
2. Basecoat the center strip and the two bands on either side with **A**.
3. Basecoat the inside and the remainder of the half bucket with **B**.

Painting Instructions

The directions and colors suggested below correspond to the example in the photograph on page 260. However, practice through the first two Intermediate Tulip worksheets before improvising on your own to gain a broader understanding of the design possibilities.

Tulips

1. Fully load the No. 8 flat brush with **B**, then sideload it with **C**. Blend on the palette to merge colors in the center of the brush, keeping the darker color on one side and the lighter one on the other. Paint pairs of **S** strokes for each tulip, placing the light side of the brush toward the center of the flower.
2. Using the liner brush, decorate each tulip with overstrokes of **E+C**.
3. Add dots and teardrops with the stylus and **F**.

Hearts

1. Load the No. 10 flat brush with **D**. Paint pairs of half-a-heart strokes to form hearts.
2. Using the liner brush generously filled with paint, overstroke the hearts with comma strokes of **F** and **E+C**.
3. Paint a heart on each side of the bucket under the rope handle. Decorate them with strokes.
4. Also, paint a heart-and-stroke border inside the bucket.

Leaves, Stems, and Dots

1. Using the liner brush, paint some comma strokes with **G**, some with **G+H**, and some with **H**. Remember to scoop extra paint onto the tip to paint full-looking comma strokes.
2. Repeat the same colors, in the same positions, on each half of the design.

Intermediate Tulips

See page 70 for help in learning to paint the flat S stroke. You can use either a flat brush or a round brush, whichever you prefer. Use a liner brush to paint the embellishments.

(Hint: Most painters find that it's easier to make S strokes in one direction than in the other. If that's true for you, turn your work upside down to paint the "other" stroke.)

These tulips were painted with a sideloaded No. 8 flat brush.

Begin with an S stroke.

Add another S to form a basic tulip shape.

Make a fuller tulip leaving some space in the center.

Fill in the center with another pair of S strokes.

Make the tulip even fuller by adding short S strokes to the sides.

Variations. Instead of (or even in addition to) the second pair of S strokes in the center of the tulip, the following variations also make effective combinations for brushstroke tulips.

The leaf stroke (see page 70).

The flat dipped crescent (see page 71).

The flat crescent (see page 71).

Three slender S strokes.

Flat scroll strokes (see page 70).

Pivot-pull strokes (see page 73).

A tall S stroke between two short ones.

Leave the center open, to be decorated with liner brush embellishments.

Place a piece of tracing paper over this page and practice these stroke combinations. Sideload, doubleload, or fully load the brush. Each technique will result in a slightly different effect.

Intermediate Tulips

You would never see *real* tulips like this, which makes them all the more fun to create. No one can judge them as inaccurate, so enjoy yourself.

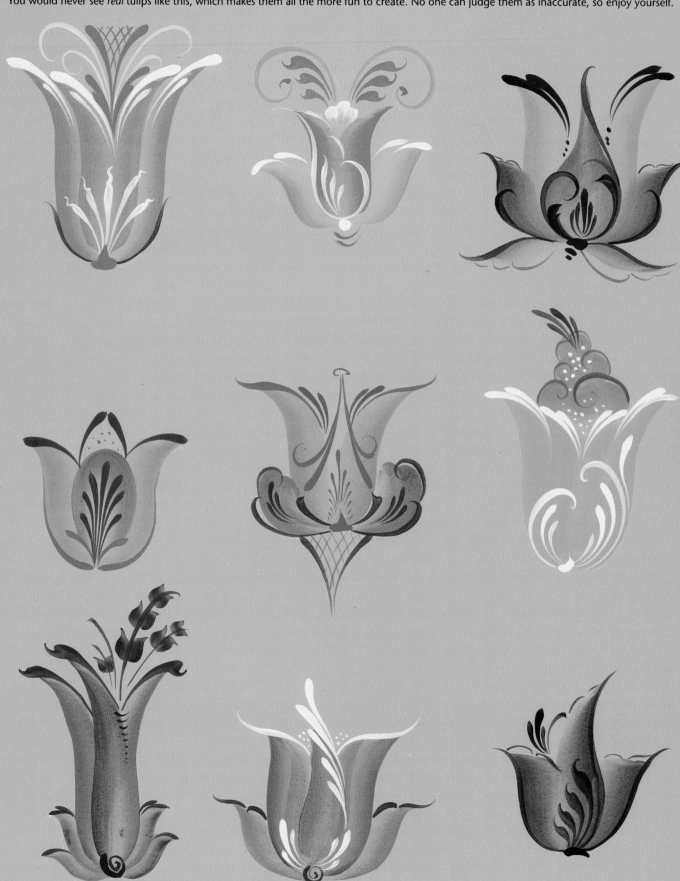

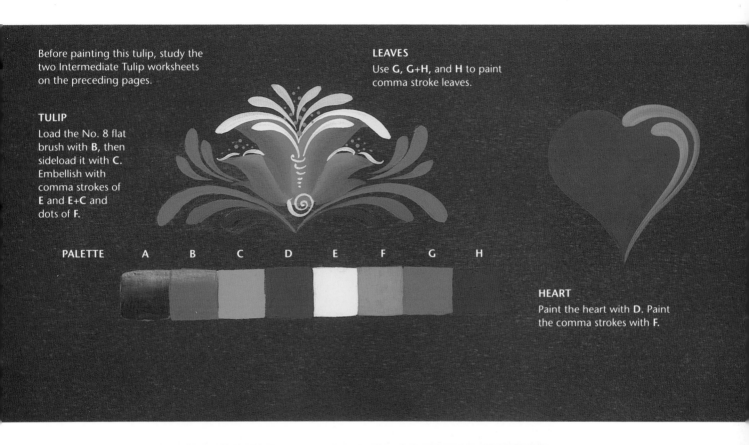

Before painting this tulip, study the two Intermediate Tulip worksheets on the preceding pages.

TULIP

Load the No. 8 flat brush with **B**, then sideload it with **C**. Embellish with comma strokes of **E** and **E+C** and dots of **F**.

LEAVES

Use **G**, **G+H**, and **H** to paint comma stroke leaves.

PALETTE A B C D E F G H

HEART

Paint the heart with **D**. Paint the comma strokes with **F**.

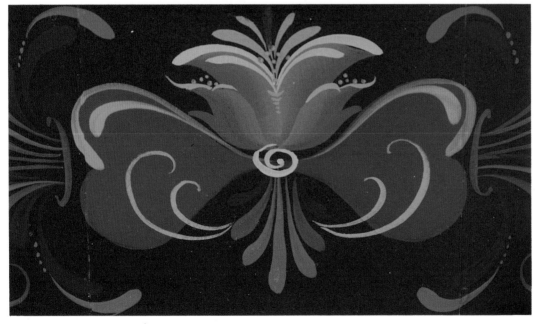

Detail of a decorative brushstroke tulip, from the completed project shown on page 260.

The completed half bucket project.

Advanced Tulips

PROJECT
Pencil/candle box (#34-064) from Cabin Craft Midwest *(Note: This item is similar to the one shown in the photograph on page 263, which is no longer available.)*

PATTERNS
Page 331

PATTERN
A Midnite Green
B Flesh
C Taffy Cream
D Dusty Rose
E Spice Pink
F Salem Blue
G Jade Green
H Moon Yellow
I Mauve
J Cranberry Wine
K Buttermilk
L Glorious Gold

BRUSHES
Flats: Nos. 8, 12, and 4
Liner: No. 1, 2 or 10/0

MISCELLANEOUS (OPTIONAL)
Gold leaf

Gold leaf size or spirit varnish

An old ¹/₂-inch brush (for applying the size or varnish)

A 4-inch square of velvet (for polishing the gold leaf)

Surface Preparation

1. Basecoat the box with a mixture of **G+K**.
2. Basecoat the lid with **A**.
3. After completing the decorating, trim the edge with gold leaf (see page 284) or with **L**.

Painting Instructions

Use the No. 8 and 12 flat brushes for all the work on the tulips, leaves, and ribbon. Use a No. 4 flat brush for the stems. Use a No. 1 or 2 liner brush for the decorative scroll designs.

Tulips

1. Undercoat the tulips with **B**. Apply a second coat. You may still see some of the dark background color through this coat. It will add color variations, so don't worry about it.

 Sideload the brush with **B** and paint the highlighted areas along the petal edges.
2. Sideload the brush with **C** and further accent the petal edges as illustrated on the worksheet.
3. Apply a very thin wash of **D** to the entire tulip.
4. Apply a thin wash of **E** in scattered places on the tulip, particularly in areas to be shaded.
5. Paint vein lines in the petals with **B** sideloaded on the brush. Hold the brush perpendicular to the tulip, with the color toward the top edge of the petal. Paint a ruffle on the edge, then skim the brush toward the center base of the petal, lightly dragging the paint corner of the brush's chisel edge and forming a vein. Repeat across the top of each petal. The veins should be subtle. Reload the brush, forming it to a crisp chisel edge, and paint the center veins. These can be more prominent than the others. (Avoid working with the liner brush for the vein work, as it will cause the veins to appear too stiff and precise.) Wash over the tulip randomly with **H**.
6. Shade the tulip with a wash of **D+F** sideloaded on the brush. Use the water

edge of the brush to tickle the edge of the color to merge it into the petal. Wash over the shading with **D** to submerge it slightly.

 For added highlights, drybrush **C** on some areas. Also use **C** to redefine any ruffles as needed.

Stems

1. Undercoat the stem with **G**.
2. Shade the stem with **A**.
3. Highlight the stem with **C**.

Leaves

1. Undercoat the leaves with **G**.
2. Highlight the body of the leaf with very thin washes of **B**, and the edge of the leaf with a heavier application of **B**.
3. Apply a thin wash of **G** over the highlights.
4. Scatter a pinkish blush of **D** in a very thin wash on parts of the leaf to create some color variety.
5. Shade and streak the leaf with thinned **A**.
6. For more color variety, brush thin **F** along the spine of the leaf and in the interior.
7. For additional color accent strength, drybrush on **H** and **D**.

Ribbon

A portion of the ribbon is shown on the worksheet for color reference. Refer to the Blended Ribbons worksheet, page 137, for a demonstration of ribbon painting.

1. Undercoat the ribbon with **D**. Apply two or more coats if needed for smooth coverage.
2. Shade with **I**.
3. Shade the darker areas with **I+J+A**.
4. Shade the darkest areas with **J+A**.
5. Highlight by drybrushing with **B**.

 Wrap the ribbon around the side of the box and onto the back. (Transfer the ribbon pattern for the back of the box near its bottom edge. Draw the connecting section of ribbon for the side of the box freehand.)

Strokework Trim

Using **L** and the liner brush, decorate the box with scrolls and detail strokes.

Advanced Tulips

1. Undercoat the tulips with **B**. Apply a second coat. Apply a third coat to the highlight areas.

2. Apply **C** to the highlight areas.

3. Cover the entire tulip with a wash of **D**.

4. Apply a thin wash of **E**, making it heavier in the shadow areas.

5. Paint veins with **B** on the chisel edge of the flat brush, pulling color along the ruffle edge down into the petal. Then wash **H** randomly.

6. Shade with **D+F**. Let dry. Wash over the shading with **D** to submerge it. Let dry. Accent the edges of some of the petals with **C**. Drybrush **C** on some areas for highlights.

LEAVES
1. Undercoat with **G**.
2. Highlight with **B**.
3. Wash in highlights with **G**.
4. Add a blush of **D**.
5. Shade and streak with **A**.
6. Streak with **F**.
7. Drybrush accents with **H** and **D**.

RIBBON
1. Undercoat with **D**.
2. Shade with **I**.
3. Deepen shading with **I+J+A**.
4. The darkest shading is in **J+A**.
5. Add drybrush highlights with **B**.

PALETTE A B C D E F G H I J K L

The completed pencil/candle box project.

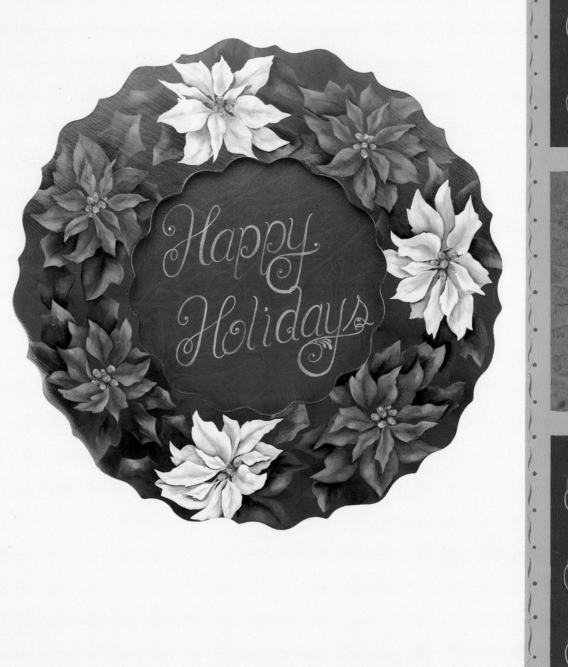

Chapter 12

Lettering

It's said that "a picture is worth a thousand words," and that may well be true. But I also think that sometimes a few words can have a greater impact than a thousand pictures. Consider, for instance, any one of the projects in the book where I lettered a quotation. I could have painted flowery pictures instead, but they wouldn't have conveyed nearly the message that a few words can impart.

It's very satisfying to personalize decorative painting with favorite quotations, messages, monograms, and initials. Once you learn how easy lettering can be, you'll discover what fun it is to letter not only small accessory items and furniture, but also walls, door frames, and even the outsides of buildings. If you can paint S and comma strokes, you can paint the alphabet, and that will open many more doors for you in decorative painting. You can adapt what you learn about lettering with a liner for use with your flat or round brushes and be able to letter large signs. (Just be careful not to let anyone know you can do this, or you'll be at the top of everyone's list for signmaker, especially if you fancy it up a bit with stroke flowers and designs.) Besides lettering everything in sight, you'll also have fun developing your signature hallmark.

Letter a message or quotation to suit a special occasion, or to express your creativity.

Learning to Letter

Practice is essential for the mastery of lettering skills.

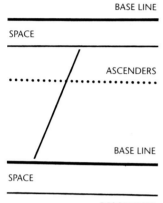

Spacing guidelines for lettering.

It doesn't matter if you've never taken a calligraphy course—you can still learn to letter with the liner. Do the warm-up exercises on page 64, then practice S and crescent strokes going in all directions as shown at left. Next, print the alphabet with the liner following your usual stroke succession, but substituting the thick-thin (pressure-release) of the crescent and S strokes. Finally, tilt the letters at a slight angle and experiment with flourishes, expressive curves, and additional embellishing strokes. When you see how much fun it is to letter with a brush, you may want to join a calligraphy class to learn the finer points and different styles of lettering.

To letter in a straight line, draw upper, lower, and middle guidelines with chalk. Dust over the lines with a soft brush to remove loose chalk. To determine the spacing of lines while you're learning, paint a few lowercase letters (such as a, c, e, m, n, and o)

with your favorite liner brush, making them whatever size you can accomplish most easily and confidently. Determine the average height of your brushstroke letters; then, on a fresh sheet of paper, draw top and bottom guidelines to accommodate that height. To make guidelines for the upper limits of the capital letters and the *ascenders* of the lowercase letters (those parts that extend above their main bodies), draw a line creating a slightly narrower space than that allowed for the main bodies. Draw a similar narrow space to accommodate the lowercase letters' *descenders* (those parts that extend below the base of their main bodies). This space will also serve as the space between lettered lines.

Thin your paint to an inklike consistency and fully load the liner brush. (A JS No. 1 liner was used to paint the alphabets shown below and opposite.)

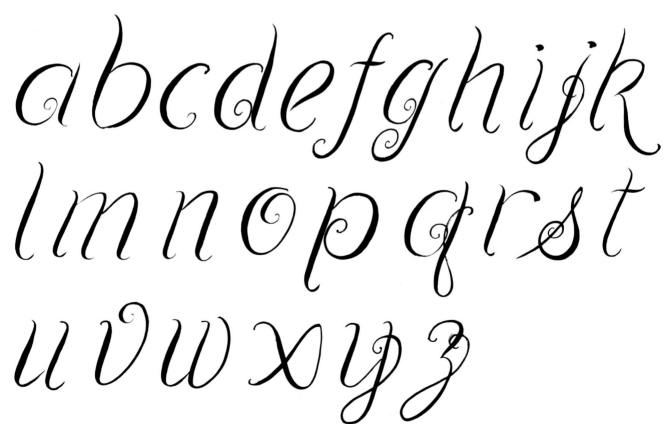

A sample lowercase brush alphabet.

A B C D E
F G H I J K
L M N O P
Q R S T U V
W X Y and Z

Now I know my ABC's.

A sample uppercase brush alphabet and lettered quote.

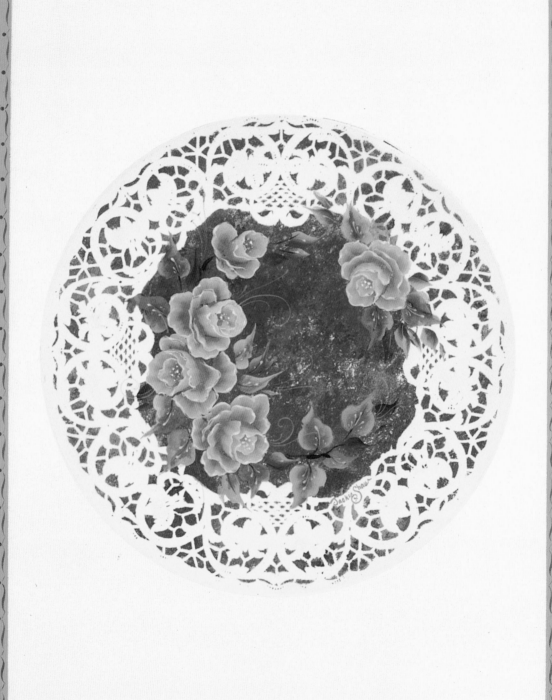

Chapter 13

Special Effects: Faux Finishes, Trompe l'Oeil, and Gold Leaf

In this chapter, you will learn about painting things to *look* like what they are *not* (faux finishes and gold leaf), and about painting and embellishing things that are *not* to look as if they *were* (trompe l'oeil). Confused? You should be, because this chapter is about trickery in painting.

You have probably been fooled by faux (French for "false") finishes more often than you might guess; they are frequently used to decorate banks, offices, and apartment building foyers, as well as mansions and palaces.

Trompe l'oeil (a French phrase that means "deceive the eye") is a painting technique that creates such a strong illusion of reality that the viewer is at first unsure whether the scene or object depicted is real. You'll find many occasions for using faux finish techniques in trompe l'oeil painting.

The appeal of gold leaf as decorative ornamentation dates back to the ancient Egyptians and Asians. Perhaps it is that ageless attraction that causes many beginning decorative painters to believe that leafing is a mysterious, difficult technique, when it is actually a simple process.

In this example of doily sponging (see page 279), the center of the doily was removed and the remainder was placed on a Bentwood box that had been painted white. Deep burgundy and pink were sponged on top to create the background for the stroke roses.

Faux Finishes

Thirty years ago, before I knew about the art of deception in painting, and before faux finishing became a popular hobby craft, I toured the exquisite, marble-laden Palace of Versailles in France. When I leaned against a marble door frame, it felt warm, not cool like marble. A couple of raps with my knuckle produced a wooden sound. Surprise! I spent the rest of the tour feeling and rapping the marble walls, woodwork, and pillars. Discovery is such fun. Keep your eyes open for such trickery in painting—and have fun using it yourself. The directions for a variety of quick and easy faux finishes that follow are for you to use to enhance your painted projects. Some of the finishes do not imitate other materials; their textures simply provide a more interesting background than a flat basecoat would.

Edges, insets, and backgrounds, as well as the insides of drawers and the backs and underneaths of projects, are especially appealing when treated with something more than simple basecoating. For example, with thinned paint, plastic wrap, and a feather, you can paint wood to look like marble. With sponges, corncobs, cheesecloth, paper towels, old bags, doilies, and toothbrushes, you can do a myriad of things to add excitement to your decorative painting. (If you work with children, you'll find they have a natural affinity for experimenting with these techniques.)

Some of the techniques in this section can be used on a much larger scale—namely, to decorate your walls. (We have sponged, marbleized, rag-rolled, and bag-rolled several walls in our home and church.) For economy's sake, if you use these techniques on walls, use interior house paint (latex or enamel) instead of your artist's paints, which are more expensive. Basecoat a scrap of wood or cardboard to match your project or wall, and practice the technique first. This will help you decide how thick or thin your paint must be to achieve the result you seek. It also will give you the opportunity to perfect the process without experimenting on—and thus possibly spoiling—your project while you're still learning.

Samples of a few of the faux finish techniques discussed in this chapter are shown at left and below.

A selection of faux finishes: *(Top left)* A rag-rolled heart on our studio wall. *(Bottom left)* A project textured with paper toweling: *"Lord please let my words be sweet, soft, and lovingly tender today, for tomorrow I may have to eat them!" (Right)* Marbling provides a hasty way to decorate a Christmas tree (project from Peco's Pine).

Scumbling

Use a large, flat brush (a No. 12 or a ¹/₂-inch brush are both fine for most average-sized projects). Hold the brush loosely. Paint short, random strokes approximately ³/₄-inch long, going in all directions, and gently overlap and blend them to soften their blunt ends. For variety, use several related colors (for example, blues, greens, and grays; or reds, pinks, and oranges). You also can use complementary colors, but do so without overblending, or instead of sparkling, your colors will become muddy.

Some examples of scumbling: Quick and Easy Watermelons, page 178; Intermediate Mushrooms, page 206; and Advanced Roses, pages 247–253.

Drybrushing

For large areas, use a ³/₄- or 1-inch soft-haired stencil brush. For smaller areas, use an old, splayed artist's brush. Dip just the tips of the hairs into paint, then rub in a circular motion on paper towels to remove most of it. Remove the paint from the brush in two more places on the paper towels (left). The paint should be barely visible.

Rub the brush vigorously on the basecoated project to deposit a slight "glow" of color (right). This is an easy way to simulate fabric, to add a blush to cheeks, or to highlight anything.

Example of drybrushing: Highlights and foreground reflections of brass, Advanced Dogwood, pages 228–229.

Spattering, Splattering, or Fly Specking

No matter what you call it, you probably did this as a youngster in school or scouts. Cover your work area well with newspapers, put on your old clothes and shoes, move everything precious out of the way, then jump in and have fun. Dip an old toothbrush into slightly thinned paint. Hold it above the project to be spattered and move your thumb or finger across the bristles toward you. If you're not fond of getting paint on your fingers, drag the bristles across a brush handle or palette knife, or rub them across a screen. You can vary the effect by how near to the project you hold the brush, the angle at which you hold it, and how thick or thin your paint is. Too thick paint will fall onto your project in blobs, while too thin paint will drip and form large splotches. Experiment.

Examples of spattering: the side of the Advanced Daisy tray, page 220; and the floral border on the side of the museum box lid, Advanced Roses, page 252.

Roller Blending

An expanse of flat background color can be made more interesting by adding highlights and/or shading in selected areas, using a small 1$^1/_2$-inch paint roller. The example at right shows a light blue being rolled onto a dry, medium-blue basecoat to create a gradually changing tone. If desired, more than one color can be used.

To roller-blend a basecoated area, load the color you want to use for shading or highlighting onto the roller. Roll it onto the background beginning at the point where you want the strongest shading or highlighting.

To begin to merge the added color into the background color, gradually pick up more and more of the background color on the roller as you work, until finally only pure background color is being applied.

An example of roller blending: Advanced Mushrooms, page 210.

Bag Rolling

On a dry, basecoated area, brush a thin layer of paint *(left)*. While it is still wet, roll a crumpled, brown paper bag through the paint, applying pressure as you roll *(right)*. If you want to bag-roll an entire wall, enlist the aid of a helper to roll or brush the thinned paint onto a 1- or 2-foot-wide section ahead of you.

With the crumpled bag, start at the bottom of the freshly painted wall and roll upward. The upward rolling motion lets you apply pressure more easily. The more pressure you apply, the more paint the bag will lift off the wall. If you roll downward, the bag tends to fall.

Rag Rolling

This technique is executed in the same way as bag rolling, but results in a softer appearance. Through a wet, thin layer of paint *(left),* roll a wadded-up section of old sheet, a T-shirt, or corduroy, burlap, or other fabric *(right)*. Different types

of fabric will produce slightly different textures; experiment with some remnants from your sewing and mending.

Example of rag rolling: the green side of the museum box (first scrumbled, then rag-rolled), Advanced Roses, page 252.

Crumpled Plastic Wrap

The two ways of using a wad of crumpled plastic wrap result in vastly different effects.

- **Method 1: Lift Off.** First apply a thin layer of paint over a dry basecoat *(top right)*. While the paint is still wet, press a clean wad of crumpled plastic wrap into the paint and lift off *(center right)*. Repeat, quickly covering the entire wet area. The design will be affected by three factors: (1) *The brand of plastic wrap you use.* Some form large crinkles, especially microwave wraps; others form small, and sometimes patterned, crinkles. (2) *The thickness or thinness of the paint.* Very watery paint will lose its form somewhat, merging back together after you lift off the plastic wrap, leaving a soft, blurred pattern. Heavier paint will result in crisper detail. (3) *The amount of imprints you press into an area will affect whether each imprint is clear.* Many imprints applied on top of one another result in more of a sponged appearance.

 Examples of the lift-off crumpled plastic wrap method: the Additional Intermediate Stroke Design, page 115; and the border for the Quick and Easy Blackberries project, page 151.

- **Method 2: Print On.** In this case, the plastic wrap is used to *make* a print instead of to *lift* a print. Press the crumpled plastic wrap into a thin layer of paint on your palette. Dab it a couple of times on the palette to even out the distribution of the paint, then print with it on a dry basecoat *(bottom right)*. If you wish to leave a distinct pattern, make only one or two stamped impressions before reloading the wad of wrap to keep the color uniform. Or use juicier paint and random dabbing to create mottled color similar to the sponged effect used on the Advanced Watermelons, page 182.

For another use of plastic wrap in faux finishes, see "Marbleizing," page 278.

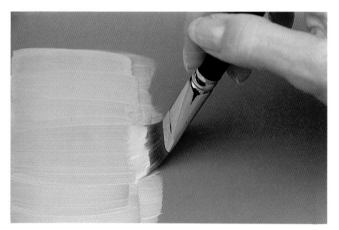

This technique works best on small, flat areas. Apply a thin layer of paint over a dry basecoat *(above left)*. Immediately lay a paper towel onto the wet paint and press it flat with a book or board *(above right)*. (Don't press it with your hands—you'll leave handprints on the pattern.) Lift up the book or board and peel back the paper towel to reveal a pattern of dots *(left)*. There are many different types and textures of paper towels. Experiment to discover the brand that suits you. I find that cheap towels have the most pronounced texture and work the best.

The pigskin-like texture left by the paper toweling was perfect for the pig project below (from Peco's Pine) and on page 270.

Cheesecloth

The two methods of using cheesecloth will result in different effects. (Note that you can also substitute cheesecloth with gauze, burlap, flat cotton lace, or rickrack.)

- **Method 1: Lift Off.** Like the paper toweling technique, this method is best used on small areas. Apply a thin layer of paint over a dry basecoat *(top right)*. (Though it doesn't matter which is dry and which is wet, for your first experiment use two colors of strongly contrasting values.) While the paint is still wet, lay a piece of cheesecloth carefully on top of it. Immediately cover the cheesecloth with a book or a flat board (as with the paper toweling process). Press down. Lift up the board and peel back the cheesecloth to reveal a very delicate, woven pattern *(center right)*.
- **Method 2: Print On.** To print a woven pattern with the cheesecloth, spread a thin layer of paint on your palette. Press a folded pad of cheesecloth or gauze onto the paint, then press onto a dry basecoat *(bottom right)*.

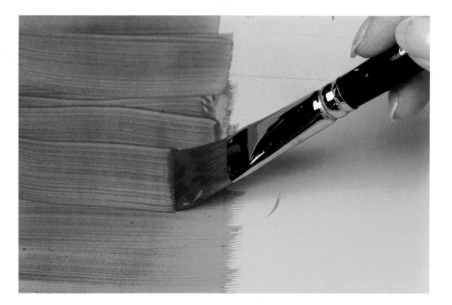

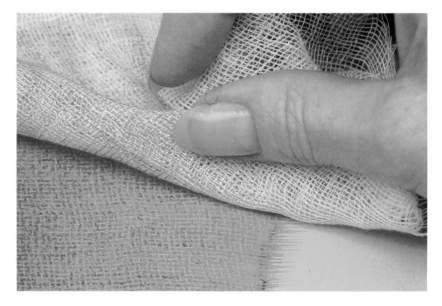

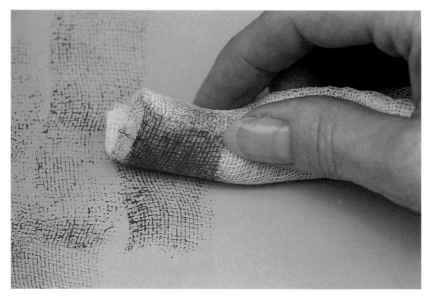

Corncob Graining and Printing

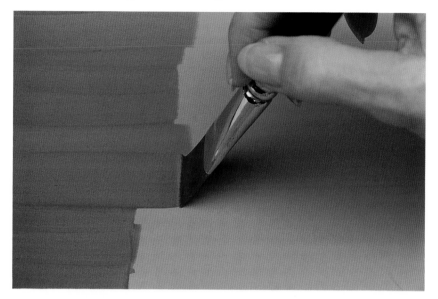

Yes, we can use some of the most unlikely stuff to paint with. A dried corncob offers wonderful texture that leaves folks wondering how you achieved *that* effect. As with some of the other techniques, we can lift the paint off, move it around to create the appearance of texture, or print it on.

- **Method 1: Graining.** Apply a thin layer of paint over a dry basecoat *(top left)*. While the paint is wet, either: (1) Stand the corncob on its end and twirl it around *(center left)*, or (2) lay the corncob on its side and drag it through the wet paint.
- **Method 2: Printing.** You can also use the corncob to print a pattern. Load one or more colors of paint along one edge of the cob, then print three or four impressions *(bottom left)*. Reload, then print some more.

For an example of corncob graining, see the worksheet for Intermediate Dogwood, page 225. For an example of corncob printing, see the edge of the clipboard box, Intermediate Dogwood project, page 224.

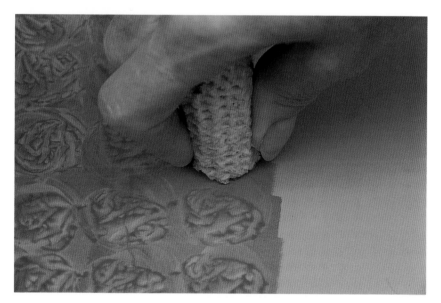

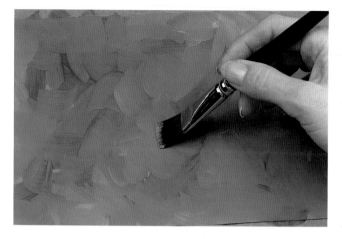

This technique, a fun, quick way to imitate marble, is an effective, versatile treatment for many decorative painting projects that requires no skill.

Quickly apply a thin layer of paint over a dry basecoat *(top left)*. Try light over dark, dark over light, metallics over any color, thin paint, thicker paint, heavy and thin plastic wrap, or a single color or several colors scumbled quickly on. While the paint layer is still wet, immediately lay a piece of plastic wrap onto it. Use your fingers to push the wrinkles around to create an interesting pattern *(top right)*. Don't be shy about readjusting the wrinkles to suit your taste. (Haven't you always wanted to readjust your wrinkles?) If all the creases seem to be heading in the same direction, interrupt them to create a more varied pattern. When the arrangement pleases you, gently rub your hands across the plastic wrap, forcing paint up into the wrinkles but no longer moving them around, then peel up the plastic wrap *(bottom left)*.

If your wet layer of paint was very watery, the pattern will soften as the paint flows back together. This makes a good background behind painted designs such as fruit. If the paint was medium in consistency, it will leave beautifully shaded wrinkles and strong light and dark areas. The marbleizing will be too busy to paint a design on, but is lovely for use as an inset or trim. If the wet paint was thick, it will give a leathery appearance—a nice way to imitate leather straps and insets on a trunk.

To add a touch of realism to very thin- and medium-consistency marbleizing, dip the tip of a feather into thinned paint. Drag it across the marbleized piece, following some of the wrinkle lines. Randomly apply and release pressure to form wide, narrow, and unpredictable veining in the faux marble texture *(bottom right)*. For this technique, it's best to work with paint that's too thin rather than too thick. Paint may be feathered onto wet or dry marbleizing.

Some examples of marbleizing: Advanced Pears, page 173; and Quick and Easy Mushrooms, page 204.

Sponging

There are natural sea sponges (my favorite), cellulose sponges, and foam sponges, and each will leave a slightly different result when used for printing. Experiment to see which you like best.

Dip the sponge into paint, tap it on the palette a couple of times to remove the excess, then dab it onto a dry basecoat color to create a mottled effect *(left)*. To create a busy pattern, dab just a few times; for a softer effect, dab repeatedly to merge the prints together. Print with a single color, or use several. Don't bother to rinse the sponge between colors. The intermingling of the colors on the sponge will help to blend them on the project. If you work with complementary colors, be careful not to overwork your sponging lest you end up with a muddy color. If you use several colors, save the complementary one till last and work it in sparingly. The effect will sparkle if it isn't overworked. The consistency of your paint will also affect your results: Thin paint will puddle together, creating a soft effect, while thicker paint will leave a more distinct pattern.

Examples of sponging: Advanced Watermelons, page 182; and the side of the museum box project, Advanced Roses, page 252.

Doily Sponging

To create the impression of a doily on your painted project, basecoat the surface the color you want the painted doily to be. Position the doily and hold it in place with tiny bits of double-sided tape (or folded-over rolls of tape), or spray the back of it with a repositional spray adhesive such as Blair Stencil Stik. Select the color paint you want for the background. (Do not thin the paint; it shouldn't be runny.) Dip the sponge in the paint (you can work with several colors if desired), then dab it on the palette several times to remove the excess. Dab the sponge onto the background through the doily, applying gentle pressure *(left)*. If you press too hard, have too much paint on the sponge, or work with runny paint, the edges of the doily print will be blurred. After you finish, carefully peel up the doily to avoid smudging any areas that might still be wet *(below left)*. The original background color is now the doily color, and the sponged color is the background color.

Note that you can reuse the doily often; simply store it flat for future use. *(Hint:* To make your doily nonabsorbent, spray it with any color of paint, sealer, or varnish before using it.) In addition, instead of using a sponge, you could substitute the mini–paint roller you used for roller blending (see page 272), using little paint and little pressure.

Examples of doily sponging: Quick and Easy Daisies, page 214; and the Bentwood box on page 268.

Creating the look of old, weathered, paint-peeled, barn wood is relatively simple. Basecoat your project a dark color such as burnt umber *(top left)*. Let dry. Apply a thick, even coat of DecoArt's Weathered Wood, which is a clear, gluelike substance *(top right)*. Let dry. With sure, even strokes, brush on a layer of acrylic paint in your choice of color. (Avoid brushing over an area once you have applied paint to it.) As the paint begins to dry and pull away from the gluelike size, hairline cracks will begin to form *(above)*. *(Hint:* For fine, closely spaced cracks, apply thinned paint over the Weathered Wood. For a bolder cracked pattern, use thicker paint.) Let the paint dry several hours, then spray with a clear acrylic sealer. After you seal the weathered wood, you can apply thin color washes or paint over it. The horse puzzle from Peco's Pine at right was basecoated dark brown, then covered with clear Weathered Wood. When dry, it was painted an antique white, sealed, then glazed with light brown (on the horse) and light green (on the base).

Color Washes

All of the faux-finish techniques can be further enhanced or dramatically changed by adding a thin color wash *(left)*. Before you start, let the faux finish dry thoroughly. Use a large brush and very thin paint to brush over the finish. Experiment to discover wonderful possibilities. Wash a thin layer of the original background color over the faux finish or apply a wash of one of the colors used in the faux finish to subdue it a bit. Or apply a wash of a totally different color. Note the variations created by the various color washes, all applied over the same marbleized background *(below left)*.

As you can see, these quick and easy faux finishes give you endless possibilities and combinations to work with. This is not an area where you should be timid about thinking, "What if . . . ?" Just jump in and experiment. What would you get if you tore little bits out of a sponge hair roller, stuck a pencil or brush handle through the center, and rolled it through the paint? What effect would you get rolling a small paint roller over a nylon onion bag from the grocery store? What else could you push around in the paint besides a corncob? How might you use crumpled tin foil? What could you do with a cork? Let yourself wonder, then try it! The backs of projects are a great place to experiment, and an easy way to show that you cared enough to do something interesting to a rarely seen part of your work. Remember, somebody's bound to look.

Trompe l'Oeil

Trompe l'oeil, which was practiced as early as 400 B.C., was apparently appreciated by the ancient Greeks and Romans. This technique reached the height of its popularity in Europe in the seventeenth and eighteenth centuries, with popularity in the United States lagging just slightly behind. Following the Industrial Revolution and the widespread application of its methods of mass production, interest in trompe l'oeil and the skilled craftsmanship for executing it waned. This was also the case for other fine crafts that could then be quickly and inexpensively mass produced.

Today, a fascination with this realistic trickery continues to linger. It's fun to see and even greater fun to try to paint. As the artist, you must pay close attention to perspective, lighting, and shadows, and depict details precisely and convincingly. You must execute your painting without a buildup of textured brushstrokes that would make it appear obviously painted and thus spoil the deception. The placement of your finished work for viewing must also be carefully considered beforehand so that the shadows and perspective are believable. The feeling of accomplishment when you hear an admirer say "I thought that was real" is a great reward for all your painstaking study, planning, and effort. The skills you will gain in the trying, however, are the greatest reward of all.

If you're interested in trompe l'oeil, you'll enjoy reading *Trompe L'Oeil: The Eye Deceived* by Martin Battersby (New York: St. Martin's Press, 1974). Also look for trompe l'oeil paintings in museums and in art books featuring works by William Harnett, Alexander Pope, Gabriel Gresley, Edward Collier, Jean-Baptiste Oudry, and Charles Wilson Peale, among others. In addition, look at some of the decorative paintings that are executed both in and on buildings, samples of which are shown below. If you'd like to try a trompe l'oeil painting lesson, see the Advanced Dogwood project for the dogwood and brass arrangement, page 230.

(Right) Located on the wall of a cafe in Frederick, Maryland, this trompe l'oeil painting features a wood duck and an open window. *"Egress," from the "Angels in the Architecture" mural series, Frederick, Maryland. Designed by William M. Cochran and painted with Colleen Clapp and Carolyn Parker. © William M. Cochran, 1988.*

(Far right) In this trompe l'oeil painting, only the leaves at the top of the image are real. *"Earthbound," from the "Angels in the Architecture" mural series, Frederick, Maryland. Designed by William M. Cochran and painted with Paul F. Wilson. © William M. Cochran and Paul F. Wilson, 1989.*

Gold Leaf

Embellish some of your favorite projects with gold leaf by following the easy steps presented below. Look for gold leaf at art or craft stores, or ask sign painters (look in the yellow pages of the phone book) where gold leaf can be purchased in your area. Or contact a mail order firm, page 334.

There are several types of leaf, including: *23-karat gold leaf, glass gold leaf* (an especially fine and flawless form of leaf for use on glass), *patent gold leaf* (which comes adhered to a sheet of tissue, making it ideal for use outdoors in the wind and for beginners), *silver leaf* (which tarnishes quickly), *aluminum leaf* (a popular nontarnishing substitute for silver leaf), and *composition leaf* (often called Dutch metal). Real gold leaf (the 23-karat variety) has a deep, rich luster, unmatched by the imitation composition leaf, but it is expensive. The composition leaf, which is more commonly available (especially in craft stores), and at less than one-fifth the cost of real gold leaf, is an adequate substitute.

Metal leaf is packaged in small booklets, with pages of tissue separating the sheets of leaf. The composition leaf and the aluminum leaf measure 5¹/₂ inches square; 23-karat gold leaf, patent gold leaf, and glass gold leaf measure 3³/₈ inches square. There are twenty-five sheets of leaf to a package. The process used to manufacture gold leaf is fascinating. If you're interested in learning more, you can look up "Goldbeating" in your encyclopedia.

Some Hints for Success

- **Work on a smooth ground.** Any imperfections in the surface on which you lay the leaf will be obvious through it. Therefore, it's important that you take a little extra care in preparing a smooth surface, especially if it's rough. Apply several coats of gesso, sanding between each coat. When you're satisfied that the surface is smooth, apply a basecoat color. Allow the basecoat paint to dry thoroughly, then sand it with #600 wet-and-dry sandpaper dipped in water. Wipe away the sanding film. Let dry thoroughly.

- **Consider using red for the basecoat color under leaf.** I like to basecoat areas to be leafed with a dull, brick red to imitate the red clay ground onto which leaf was traditionally laid (see the example on the following page). The red base also provides a rich, warm glow through the leaf. Any fine hairline cracks in the leaf application expose the red and impart an antique look.

- **Work in a draft-free area.** At 0.000004 to 0.000005 inch thick, metal leaf is delicate and easily blown about by moving air. Before working with it, turn off the fan, close the window, and tell the kids not to chase the cat through the house. Then open the package gently, turning the tissue pages slowly so that the leaf doesn't crumple or fold over on itself.

- **Handle leaf as little as possible** and use talcum powder for easier handling. Avoid handling composition leaf with your fingers to prevent tarnishing. In addition, metal leaf has a propensity for sticking to anything it gets near—one of its characteristics that makes it seem difficult to work with—a real "Midas touch." There is an easy solution. Before applying the glue size or varnish, sprinkle talcum powder on your fingers and on the project to be leafed. Rub the powder around on the project, even in the area you intend to leaf. Then brush away the excess with a soft brush, leaving a dull film. The leaf will not stick to the talcum, and the talcum will not interfere with the varnish or glue size.

- **Transfer patterns to be leafed with chalk.** Chalk is preferable to wax-based transfer sheets, which leave sticky lines that will interfere with your leafing of a design or pattern. Apply the chalk pattern on top of the talcum dusting.

- **Brush varnish or size onto the area to be leafed.** Pour a small amount of spirit or oil-based varnish (such as McCloskey's Heirloom, gloss finish) or gold leaf glue size into a bottle cap or lid. Apply the varnish or glue size smoothly to the area to be leafed. The thin talcum film will not interfere with the adhesive. Avoid leaving ridges and thick areas of varnish or size.

Applying Gold Leaf

Step 1. Basecoat the project.

Step 2. Apply a smooth, thin coat of varnish or gold leaf glue size.

Step 3. Test the size for proper tackiness by touching it with your knuckle.

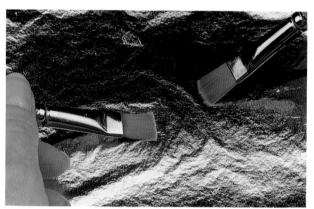

Step 4. Lay the gold leaf onto the tacky size, either using brushes charged with static electricity . . .

or using wax paper to carry the leaf onto the project.

Step 5. Burnish the leaf with a piece of velvet, silk, or a cotton ball.

- **Let the varnish or size dry to the proper tack.** As varnish sets up a little more slowly than glue size, it is ideal for large projects where more time will be needed for applying the leaf. The gold leaf glue size is white when first brushed on, then turns clear as it dries. Let the varnish or glue size reach the tacky stage. Test it by touching it with a knuckle. When you pull your knuckle off the size it should sound the same as if you were pulling it off a piece of transparent tape, making a "tisk"-ing sort of sound.
- **Lay the leaf onto the tacky size.** To transfer the leaf from the package to the tacky varnish without handling it with your fingers, try either of the following methods:
 1. *Static electricity method.* Rub a large flat brush in clean hair or on clothing to generate a static charge. Hold the brush just above the leaf in the booklet. The leaf will jump onto the brush. Move the leaf slowly to the project, then press it onto the tacky size. I sometimes like to use two clean brushes, one in each hand, to work more quickly (see the example opposite, top right). Use the brush to pull unused leaf away from whatever has adhered to the size, using it to leaf the next area. Recharge the brush if necessary.
 2. *Wax paper method.* Cut a piece of wax paper slightly larger than the size of the leaf. Lay the wax paper on top of the leaf and either rub gently with your fingers or press your palm onto the wax paper. Your body heat will cause the leaf to stick to the wax paper. Carry the leaf to the project by holding the edges of the wax paper (see the example opposite, center right). Lower the leaf onto the project and press it into the tacky size. Rub gently, then lift the wax paper. Any leaf not pressed into the size will cling to the wax paper and can be applied in the next area. *(Note:* Apply wax paper to the leaf in the booklet only as needed. Do not get ambitious and apply wax paper to the entire booklet of gold leaf. After a few days, the leaf will be permanently attached to the wax paper and will not transfer to a tacky size.)
- **Don't let wrinkles or tears alarm you.** As you lay the leaf onto the tacky size, it may wrinkle or tear. Such imperfections add character to the finished piece. Burnishing will smooth the wrinkles after you've finished leafing.
- **Cut the leaf into small pieces if needed.** Cut the leaf on the tissue backing or on the wax paper backing, in either case cutting through the paper. Place extra pieces to one side, making sure that the leaf side is facing up. Otherwise, the gold will stick to your work table. If you prefer, as I do, that the pieces of leaf not have straight edges, tear them before applying the leaf. I use two brush handles to pull the leaf apart, creating irregular shapes. Wooden chopsticks also work nicely.
- **Varnish or glue size dries quickly in small areas and more slowly in larger areas.** If you plan to apply leaf to a pattern design (rather than a large, broad area such as a box lid or an edge), be sure to paint the more delicate areas with glue size or varnish last. Then leaf them first.
- **Repair little spots where the leaf didn't adhere.** Exhale quickly a few times on the spot to revive the tack, then apply a scrap of leaf to the area. If the tack cannot be revived, you'll need to apply a thin film of varnish or size to the spot and wait for the proper tackiness to be reached.
- **Remove excess and loose pieces of gold leaf.** Use a piece of velvet, silk, or a very soft brush to whisk them away. I keep these in a small box to use for patching missed spots.
- **Burnish for added luster.** Set the project aside to dry several hours or overnight. Then burnish the gold leaf with a clean piece of velvet, silk, or—in a pinch—a cotton ball. Note that the latter is more likely to leave fibers behind if the size is not completely dry.
- **Apply a protective finish.** Varnish the project (see pages 288–292), then antique it if desired (see pages 293–295).

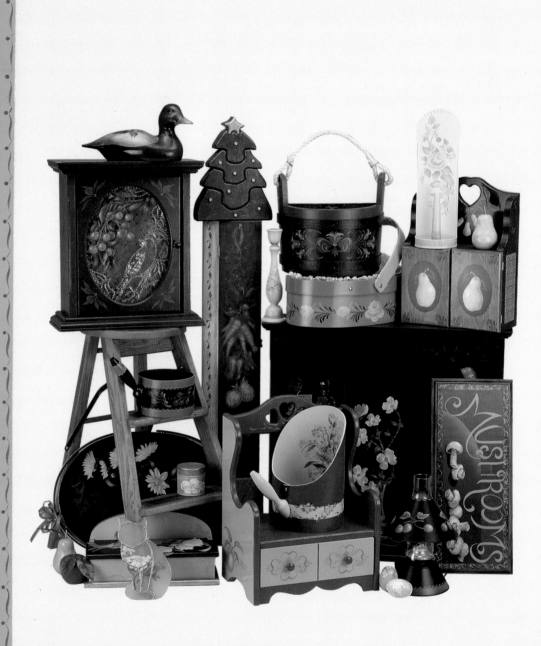

Chapter 14

Finishing Techniques

This chapter is all about finishes: how to select them to suit your particular needs, and how to use them for best results. When you finish decorating your project, you have one of three choices: (1) You can call it completed and leave it at that, (2) you can apply one or two coats of varnish to give it a protective finish and to bring the colors to life, or (3) you can go to the extra effort of applying several coats of varnish, sanding between them, and hand polishing at the end to give your work that fine artisan's touch of excellence. I hope that your choice will be the latter. As you become more pleased with your developing decorative painting skills, you'll want to protect your lovely work and ensure that it remains in good condition for your great-grandchildren to admire and enjoy.

Also included is a section on antiquing to help you add the warmth and patina of age to your paintings in two to four easy steps. You'll learn how to create your own colored antiquing glazes and how to antique with shoe polish, floor wax, and water-based stains. You'll have fun creating "instant antiques" with your handiwork.

From the moment you began working through this book, your lessons have been leading you to the final artistic touches you'll learn in this chapter. Like the addition of decoration to the backs and bottoms of your projects, your attention to a careful finish will make it obvious that you put not only your time but your heart into your work.

These projects were finished in a variety of ways. For details, refer to the lessons in Chapters 9, 10, and 11 (pages 140–263).

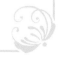

Varnishes

If you walk into the varnish section of a paint and hardware store, you'll immediately be confronted with a dizzying array of choices. Do you want a water-based, oil- or spirit-based, or synthetic resin varnish? Spray or brush-on? Nonyellowing? Waterproof? Indoor or outdoor? To add to the confusion, manufacturers release new products on the market all the time.

Depending on their contents, varnishes will dry at varying rates, by means of evaporation, oxidation, or polymerization, or a combination of any of these processes. Varnishes containing spirits, such as alcohol and turpentine, dry through evaporation. Varnishes containing oils, such as tung oil and linseed oil, dry by oxidation, a more prolonged process. Varnishes containing synthetic resins dry through polymerization, a process involving the combining of molecules to form a more complex molecular structure. The synthetic resin varnishes are quick drying.

Following are some tips that can help you make informed decisions about varnishes:

- **Water-based varnishes,** like their synthetic resin counterparts, dry through polymerization. Popularly available in arts and crafts shops, most of these "craft finishes" dry in approximately 30 minutes, thereby allowing for the buildup of several coats in a single day. Water-based varnishes can be carefully wet-sanded to a fine, smooth finish, and can be cleaned up with soap and water.

 Some water-based varnishes are formulated for use over oil paints. These varnishes contain petroleum-based products such as ketone and toluene. When using a water-based varnish over oils, you must ensure that your oil paint is thoroughly dry and cured. Note that dry to the touch is not the same as "cured." When trapped under a layer of varnish, gases released from the drying oils can create vapor pressure, causing the varnish to lift. Even a thin layer of oil paint should be allowed to cure for several days before varnishing. For compatibility's sake, I prefer to use water-based finishes only over water-based paints.

- **Oil- or spirit-based varnishes** are slower drying than water-based varnishes, requiring approximately six to eight hours or more. Building up several coats may require days, but the finish is lovely, hard, and can be wet-sanded to a beautiful luster. Cleanup is with mineral spirits or paint thinner. Oil- and spirit-based varnishes work well over both acrylics and oils.

- **Marine spar varnishes** are formulated to provide a weatherproof finish for outdoor weather conditions. They never harden completely, remaining pliable to fluctuate with changing temperatures. Most will yellow with age. They are not ideal for use indoors; a varnish that dries to a hard, protective film can better survive the day-to-day licks it's likely to receive. Use marine spar varnishes only for projects that will stay outdoors.

- **Polyurethane finishes** generally yellow with age, and are sometimes incompatible over oils, shellac, and lacquer.

- **Nonyellowing varnishes.** For some decorative painting projects, the mellow coloring of varnish adds a softening effect. For other projects, pure, clear colors and brilliant whites may be important. Varnishes that contain polyvinyl acetate are nonyellowing.

- **Either furniture or floor varnish** can be used confidently on your decorative painting projects.

- **While a larger quantity may seem more economical, it's best to purchase a smaller size.** When you finally use the last half of a gallon, it may have begun to thicken, form a skin, or get full of little "ickies" and dust. Always work with fresh varnish.

- **Avoid using different types of finishes on the same project.** Avoid using, for example, a spray varnish and a brush-on varnish, or a varnish and a lacquer. Chemical incompatibilities exist between different products. Some product combinations can cause a finish to crackle, blister, or peel. If you insist on combining products, be sure to test first for compatibility on a scrap of wood.

- **Lacquers** contain such powerful solvents that their use over enamels, varnishes, oil paints, oil stains, and products containing linseed oil or tung oil is risky. Such undercoats are easily softened or damaged by the solvents in lacquer, and may cause a lacquer topcoat to craze or crack.
- **Shellac** is not only a time-honored sealer, it's also enjoyed the same reputation as a finish coat. It dries quickly, can be safely applied over oils and acrylics, and is unaffected by varnish solvents and so can be used as an isolating coat. It does not, however, stand up to heat, alcohol, or moisture, and so would not be a good finish for trays, tabletops, and other similar surfaces.
- **The choice of brush-on or spray finish is entirely yours.** A thicker protective layer can be built up more quickly with brush-on. I prefer brush-on varnish for everything except intricate tinware pieces, particularly those with cutout (lace) edges. Be sure to read the directions on your spray finish carefully. Some sprays must be recoated within a specified number of minutes. If this period of time is allowed to elapse, recoating must be delayed 24 to 48 hours to prevent the finish from crazing. Use special caution when working with sprays. Adequate ventilation is essential; working outdoors is best. A breathing mask is invaluable to your good health.

The foregoing barely "scratches the surface" of the complex subject of finishes. To learn more, read *Coloring, Finishing, and Painting Wood* by Adnah Newell (Peoria, Illinois: C. A. Bennett Co., 1961).

Tips for Successful Finishing
The following tips will help you obtain a fine, professional finish.

- **Let your painting cure** for a couple of days for acrylics; for weeks (or even months) for oils, depending upon the thickness of the application of paint.
- **Varnish is a fair-weather friend.** Avoid using it in damp or humid weather, as any moisture trapped under the drying varnish can result in a disagreeable whitish bloom. This is particularly the case for the slower-drying oil- and spirit-based varnishes. If you've had the misfortune of trapping a bloom in a coat of your oil- or spirit-based varnish, wait for a warm, sunny day, then varnish again, right over the bloom. Sometimes a follow-up coat will soften the previous one enough to release the trapped moisture.
- **Varnish prefers to avoid the cold,** so be sure that your project, the varnish, and the surrounding air is about 72°F; otherwise, you may see your brush-on varnish creeping away from the surface. Spray varnish applied in the cold will appear as goosebumps on your project.
- CAUTION! **Varnish is volatile. NEVER WARM IT ON THE STOVE.** If you find it necessary to warm the varnish, do so by standing it in a bowl of hot water.
- **Work in a dust-free room,** or at least try not to stir up the dust wherever you're working. Turn off the fans and send the kids next door to practice their gymnastics. Also, remember to take off your shaggy wool sweater or anything else that might shed fuzz or lint on your work.
- **Use only fresh varnish, never old, thick stuff.** Also, don't try to thin old, gummy varnish—it will only give you a disappointing finish. If the varnish seems good except for a few "ickies," strain it through a piece of clean nylon stocking.
- **Never try to use malfunctioning spray cans.** Test the spray on a scrap to ensure that the nozzle is clear and functioning properly. If the spray sputters, spewing blobs instead of a fine mist, remove the nozzle and try to clear it with a fine pin or wire. Never poke anything into the valve opening of the can.
- **Remove all dust from your project before you begin to varnish.** Wipe it lightly with a tack cloth (a sticky cloth designed to trap minute particles of dust, available at paint and hardware stores). If you can't find one, dip an old cotton handkerchief or a piece of rinsed cheesecloth into warm water and wring it out. Place it in a gallon-sized plastic bag, then sprinkle in a mixture of 2 teaspoons of paint thinner, turpentine, or mineral spirits plus 3 teaspoons of oil-based varnish. Close the plastic bag and knead the mixture into the damp cloth until it's thoroughly dispersed. Keep the cloth in a small, tightly sealed jar when not in use.
- **Begin the varnishing process with a clear gloss varnish,** which doesn't contain the matting or dulling agents found in satin,

matte, or antique finishes. You can use the gloss to build up many coats without compromising the clarity of your painting. Use the satin or matte finish (of the same brand) for the final two or three coats.

- **Most brush-on varnishes should be thoroughly stirred, not shaken.** Some water-based varnishes are formulated for fast dispersion of bubbles and may, therefore, be shaken without adverse effect. Read the label to be sure.
- **Apply several thin coats of varnish instead of one or two thick ones.** Thin oil- or spirit-based varnish with mineral spirits or paint thinner (*never* with gum turpentine, which can impede the drying process). Thin water-based varnish with water.
- **Pour the amount of varnish you think you'll need into a small dish or large jar lid.** Immediately reseal the varnish can to prevent evaporation, thickening, and dust contamination. Never work out of the original varnish container; the dust that alights on your brush while you're working will end up swimming in the varnish container to contaminate your next project. You'd be surprised at the amount of unwanted stuff that will accumulate in an open can of varnish if you work out of the can repeatedly. Discard any varnish not used from the small dish or jar lid. If you try to save it for reuse and pour it back into the varnish can, you will contaminate the entire container of varnish.
- **Use a good-quality brush to flow on the varnish.** Dip the brush into the varnish and let the excess drip back into the can. Do not wipe the brush on the lip of the can to remove excess varnish. Doing so causes bubbles that will pockmark your finish. Also avoid overbrushing, which causes streaking and bubbles.

Good quality brushes are a considerable initial expense; however, if properly cared for, they will last for years. The long-term savings over using countless disposable foam brushes, plus the better quality of the results, justifies the expense. For most projects, I use a 1½-inch synthetic taklon brush by Loew-Cornell, Series 7550. For larger projects, I use the 2-inch brush; for smaller projects, the 1-inch brush of the same series. (See also "Cleaning Your Varnish Brushes," below.)

- **Remove all projects from your work area,** except the one you're working on, to avoid splattering or dripping on them.

- **Place the dish of varnish close to the hand you'll be brushing with** so that you won't have to reach across your project to load your brush. This prevents dragging sleeves through wet varnish, dripping varnish onto the piece unknowingly, and excessively disturbing the air and dust above the piece.
- **Face into the light while varnishing.** Hold your project at different levels and angles to check for drips, sags, and missed spots. Run your finger under the bottom to wipe away any drips that, if left, would dry into unsightly bumps.
- **Set the varnished piece aside in a dust- and draft-free area to dry.** This is particularly important when using the slower-drying oil- or spirit-based varnishes. If the piece is large and/or flat, stand it on its edge instead of laying it flat on the table with its exposed side up. That way, most of the falling dust will fall *beside* it, not *on* the design area. If the piece is small enough, set it under a box raised slightly to allow for some ventilation. If you prefer painting to housekeeping, do not for a moment consider placing your varnished pieces under a bed—with the dust bunnies—to dry.

Cleaning Your Varnish Brushes

It is imperative that brushes used for varnishing be clean and dust-free. Brushes left standing in the open will accumulate dust that will eventually be deposited into the varnish. To clean a brush after varnishing, wipe as much varnish from the brush as possible onto newspaper or paper towels. For oil- and spirit-based varnishes, rinse the brush vigorously in three separate containers of paint thinner or mineral spirits, saving the thinner for repeated reuse as described below:

1. Pour some thinner into three jars. Label the jars 1, 2, and 3, and use them in that order. Store the solvent in the jars for future brush cleaning, being sure to rinse them in jar 1 first, and so on. Thus, the solvent in jar 3 will be the cleanest, and should always be used last.
2. Next, wash the brushes thoroughly and repeatedly with soap and warm water. Work the soap up into the ferrule area, removing all traces of varnish. Rinse the brush repeatedly to remove every bit of soap. Any soap left in the brush

Applying Brush-on Varnish

SUPPLIES

Cloths (to remove chalk and water-soluble transfer paper lines, to wipe down the project after sanding, and for buffing)

A kneaded eraser, soap and water, paint thinner, *or* odorless turpentine (to remove graphite)

A tack cloth

Oil- *or* water-based brush-on varnish

#600 wet-and-dry sandpaper

A bar of soap *or* liquid soap

Powdered pumice

Finishing oil

A piece of heavy felt

1. Remove all pattern lines. Use a damp cloth to remove chalk and water-soluble transfer paper such as Chacopaper. Use a kneaded eraser, soap and water, or a little paint thinner or odorless turpentine to remove graphite.
2. Remove any dust by wiping the project lightly with a tack cloth.
3. Apply two coats of varnish. If your paint application or brushstrokes are thick in places, apply a third. Let dry between coats.
4. After the second or third coat of varnish, sand very lightly before applying the next coat. Use #600 wet-and-dry sandpaper dipped into water and rubbed on a bar of soap or sprinkled with liquid soap. The soap and water help reduce friction and result in a smoother sanding.
5. After sanding, wipe repeatedly with a cloth rinsed in clean water to remove the soap. Let dry thoroughly. If you wish to antique your project, do so at this point. (See "Antiquing," page 293.) Continue with step 6 after the antiquing has dried.

6. Wipe lightly with the tack cloth.
7. Varnish again. Continue varnishing, drying, sanding, rinsing, drying, and tacking until you have applied as many coats as desired. (My cherished pieces have over twenty coats of varnish.)
8. When the final coat is dry, do not sand. Instead, sprinkle the surface with fine, powdered pumice. (Get the finest available at your hardware store, or ask your pharmacist for 4F dental-grade pumice.) Pour a little finishing oil onto a piece of heavy felt. (Baby oil, mineral oil, or lemon oil will suffice in a pinch.) Rub in a circular motion to obtain a lustrous, soft sheen. Be gentle, though; the powder is abrasive. *(Hint:* In a real pinch, you can polish with toothpaste!)
9. Finally, buff with a soft, clean, dry cloth. If you wish to apply a wax finish for extra protection (see page 292), remove all traces of the oil first by wiping the project with a 50:50 mix of vinegar and water on a cloth.

1

2

3

4

5

6

7

8

will dry flaky and leave "dandruff" in your next coat of varnish.

3. After the brush is completely dry, wrap it in plastic to protect it from dust. For water-based varnishes, skip the solvent rinses, but wash thoroughly as described above with soap and warm—not hot—water. Rinse, dry, and store.

Applying Spray Varnish

When applying spray varnish, it's essential that you work in a well-ventilated area, preferably outdoors on a calm, warm, clear day. Your project, the varnish, and the surrounding area should be at least 72°F. Wise painters also wear a protective breathing mask. Before you begin, cover the surrounding area with newspapers to protect it from any over-spray. Also, check to make sure that the spray head functions properly. Review the directions on the can for the recommended drying time and the distance from the object to be sprayed.

1. Remove all pattern lines as suggested in step 1 of "Applying Brush-on Varnish," page 291.
2. Wipe the project with a tack cloth.
3. Elevate the project to be sprayed so that it doesn't touch the newspapers you've put down to protect your work area.
4. Begin the stream of spray off one edge of the project and sweep onto and across it, going off the edge on the other side. Sweep back and forth in this manner to prevent a sagging buildup of paint on the edges.

5. Apply many thin spray coats, drying between each, instead of one or two heavy ones that will sag, drip, and run.
6. If you've applied several spray coats, you may do an oil and pumice rub (see step 8 of "Applying Brush-on Varnish," page 291). Just remember that spray coats are much thinner than brush-on ones. Polish gently so that you won't break through the varnish to mar your painting.

Applying a Wax Finish

On heavy-use items such as trays, you may want the extra protection of a wax finish. Any good, hard, floor paste wax will do. Apply one or two coats, buffing between, according to the manufacturer's directions.

For a special wax finish, try this tip from Ray Miller, a dear friend and a fine craftsman. His expertise came from years of building and repairing organs, calliopes, and carousel horses, and from crafting fine woodwork.

Ray Miller's Polishing Wax

Spoon some floor paste wax into a wide-mouth jar and place it in a bowl of very hot water until the wax liquifies. (Wax is a volatile substance, so do not attempt to melt it on the stove.) Mix cornstarch into the wax to form a thick paste. Rub the paste onto your project, then buff it to a glorious finish. The cornstarch is mildly abrasive, so it works to smooth the varnish coat while you polish the wax.

Start and stop the spray off to the side of the piece. Spray in smooth, horizontal, back-and-forth movements.

Antiquing

Antiquing can be done with oil paints, water-based gel stain, wax, and even shoe polish. Antiquing can either enhance or diminish your painted project. Some items and designs look more harmonious when we mute their colors with an antiquing glaze; others look muddy or inappropriate. Some painters antique everything they paint, misguided by the notion that the antiquing glaze will cover their mistakes. Antiquing *is* fun, and it can be very effective when properly used. Just remember: All things in moderation!

Before antiquing a project, apply two thin coats of varnish to protect your painting. The varnish will prevent the antiquing glaze from soaking directly *into* the paint, and will allow you to remove the glaze if the effect does not please you.

Oil-based Antiquing

You can purchase premixed clear and colored antiquing glazes, both water- and oil-based, from your craft and hobby shop or paint and hardware store, or you can mix your own glazes. I prefer to mix my own because it allows for more color variation and for greater experimentation, and it's more economical.

A selection of colored glazes *(from left to right):* burnt umber, black, and raw umber.

Clear Antiquing Glaze Medium

Mix the following together and store in an airtight container:

> 1 tablespoon oil- or spirit-based varnish (McCloskey's Heirloom, gloss finish)
>
> 3 tablespoons paint thinner *or* mineral spirits
>
> 1 to 2 drops linseed oil

If you plan to do a lot of antiquing, mix a larger quantity so that it's ready when you need it. Experiment first, however, to determine whether you like to work with a fast- or slow-drying medium, or a thick or thin one. Then alter the proportion of the ingredients to suit your needs. For a thinner glaze, add more thinner or mineral spirits. For a more heavily bodied glaze, use more varnish. For a slower-drying glaze, which will give you more working time, add a little more linseed oil. Eliminate the oil for faster drying. The proportions of the ingredients can vary greatly with no adverse effect. When I'm out of glaze and want to antique a single project, I simply use my palette knife to scoop small amounts of each ingredient onto my palette in the approximate proportions desired.

To make colored antiquing glazes, select a color of oil paint (refer to the list below for suggestions). Squeeze approximately an inch of the paint into a small container. (The amount you use will depend on the amount of antiquing to be done.) Gradually mix the medium into the paint until the mixture is the consistency of tomato soup.

A Selection of Antique Colors

- Burnt umber—A warm, reddish brown (a most popular antiquing color)
- Raw umber—A cool, greenish brown (also very popular)
- Burnt umber + raw umber—A pleasing combination
- Burnt sienna—An orange–reddish brown (a bit garish to use alone)
- Raw sienna—A warm, golden brown
- Burnt umber + ultramarine blue—A cool brown
- Burnt umber + Prussian blue—A deep, aged green
- Raw umber + ivory black—A pewter gray
- Ivory black—A cold gray
- Ivory black + asphaltum—A mellow pewter tone

Oil-based Antiquing

SUPPLIES

Clear Antiquing Glaze Medium (or make your own with varnish, thinner, and linseed oil; see recipe on page 293)

Oil paints

Palette knife

Palette

Plastic or rubber gloves or baggies (to protect your hands)

A poly foam brush

Cheesecloth

Mop brush

3M Home 'n Hobby Pad (fine grade) or #0000 steel wool

Vinegar

There are two basic methods of oil-based antiquing. If you want to try a quick and easy method, do just the first two steps below. If you prefer your project to have a little more pizzazz, do all four steps. Antiquing can be a little messy, so slip your hands into protective gloves or plastic baggies before you start. Mix the Clear Antiquing Glaze Medium with the oil color of your choice, then . . .

1. Take a deep breath and be brave. Use a foam brush to apply a heavy coat of the muddy glaze "soup" to your project, being sure to work it into all the crannies and crevices. It's scary the first time you do this, as you watch your beautiful handwork disappearing beneath the goop. Set it aside to rest for a couple of minutes while you regain your composure.

2. Use a piece of cheesecloth to wipe away the excess glaze. If you're planning to do all four steps, leave the antiquing a little heavier than you want the final result to be. If you're doing the two-step method, remove the glaze until you're pleased with the results. Rub harder where you want more of the original color to show through. If you want to work back to fresh, unglazed color, barely moisten a corner of the cloth with thinner and use it to wipe out any remaining glaze.

If you're doing the four-step method, proceed to the next step. If you're doing the two-step method, set the project aside to dry for at least 24 hours before varnishing.

3. While the glaze is still wet, use a soft, large mop brush to smooth the glaze and eradicate distinct and abrupt changes in coloring caused by rubbing or wiping with the cloth. Whisk the brush gently over the surface and into corners to disperse the paint. Set aside for three to five days before proceeding.

4. Don't rush into this step. Allow ample drying time. No damage will be done by waiting longer, but you can ruin your efforts by not waiting long enough. With a fine-grade 3M Home 'n Hobby Pad or #0000 steel wool well lubricated with finishing oil or lemon oil, gently rub in a circular motion to remove the antiquing glaze from the raised surfaces of the paint. Textured brushstroke work creates hills and valleys, letting the antiquing remain in the valleys. Light rubbing will remove the glaze from the hills. The result will be clear, sparkling color enhanced by the surrounding antiquing. Wipe up the residue frequently with a clean cloth, and carefully check your work. It's very easy to rub through the antiquing, the varnish, the painted design, and even the basecoat paint if you're not careful. To remove the antiquing should require a bit of rubbing. If the antiquing glaze lifts up rapidly and almost completely, the glaze has not cured enough. Set it aside and wait another day.

Remove the oil residue by wiping with a 50:50 mix of vinegar and water on a soft cloth. Let dry. Apply two or more varnish coats to protect the antiquing. (Note: Since I use an oil-based antiquing glaze, I prefer to use a spirit- or oil-based varnish instead of a water-based one over my antiqued pieces. I always use the same varnish for finishing antiqued pieces that I used in making the Clear Antiquing Glaze Medium.)

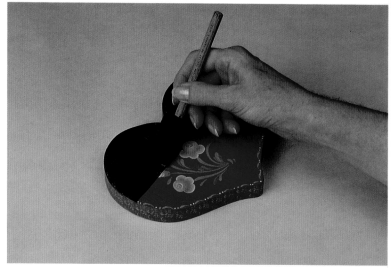

Step 1. Brush on the glaze.

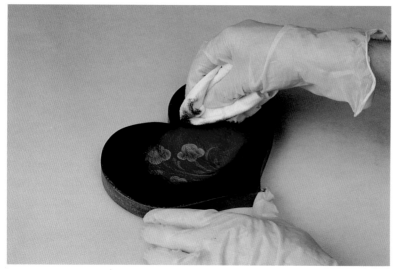

Step 2. Wipe off excess glaze.

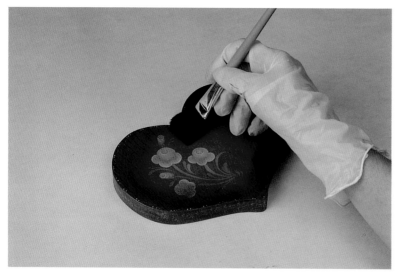

Step 3. Smoothly blend the glaze with a mop brush.

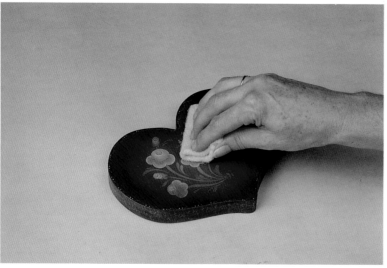

Step 4. Rub gently with fine abrasive to create highlights.

Different colors will have strikingly different effects on your painted designs. While the list above suggests each color's hue, you should experiment with the glazes over swatches of the colors with which you like to paint. This will enable you to see which combination gives the most pleasing effect.

(Hint: You can also glaze with greens, reds, yellows, and other colors. Such glazes won't actually antique a project, but they do provide an interesting treatment of color.)

Shoe Polish Antiquing
Antiquing with wax shoe polish is quick, easy, and involves very little mess. The selection of colors however, is limited, and the stains used in the wax polish grab tenaciously to the paints. There is little opportunity to soften them, even when protective water-based varnish coats have been applied. Be sure to test the polish beforehand on a painted sample.

After your painting has thoroughly dried, apply wax shoe polish with a soft cloth, buffing as you go. You can adjust the color slightly by mixing oil paint into the wax polish.

Paste Wax Antiquing
If you would like the soft mellow look of age without the effort and heavier coloring of oil antiquing, try paste wax antiquing.

After you've applied as many coats of varnish as desired, mix a little oil paint into paste wax. (See the color suggestions on page 293.) Apply one or two coats of the colored wax, buffing after each coat.

Water-based Gel Stain Antiquing
Antiquing can also be done with water-based products. The Wood 'n Resin Gel Stains by DecoArt dry a little more slowly than acrylic paints, allowing a bit of time to work the antiquing. Brush on a thin film of the gel stain. While the project is still wet, rub it with a cloth to remove any excess and to force color down into the valleys, cracks, and crevices. To wipe out more color, wait an hour, then use a slightly damp cloth in the areas you wish to lighten. Let the antiquing cure a couple of days. Spray on a protective coat of clear acrylic sealer, let dry, then varnish as desired.

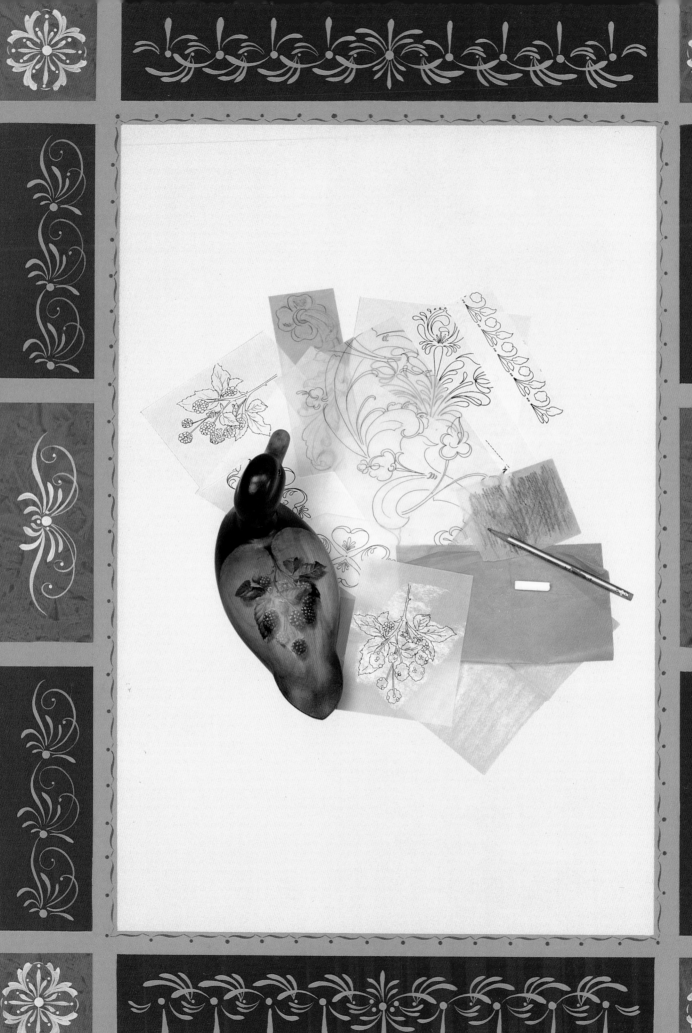

Chapter 15

Working with the Patterns

This section contains the patterns for all the painting project lessons in this book. It also includes some hints for transferring patterns onto the painting surface and ways to enlarge and reduce patterns. Note that the patterns have been reduced to fit comfortably on one page, so you'll certainly get your share of practice enlarging them if you use them as shown in each project. If you have access to a photocopier that enlarges images, you can take advantage of the percentage for enlargement that accompanies each pattern so that you can use it at the "right" size for its particular project without having to rely on a pantograph or make a proportional grid.

Hint: To get triple-duty use from the patterns, select the pattern you like (regardless of skill level) and use the directions from one of the other skill levels (Quick and Easy, Intermediate, Advanced) for painting it. For example, if you are an advanced painter, you could paint the Quick and Easy Vegetable pattern using the process described for the Advanced Vegetables. Conversely, a beginner could paint the Advanced Vegetables pattern using the Quick and Easy techniques.

Be daring in your use of the patterns. Rearrange their elements, adding or subtracting as needed to recreate a design to suit your tastes and your project. Let the pattern be your guide when you feel you need it, but be bold enough not to let it become your master. Maintaining the conviction of your own innate creativity will allow you the freedom to experiment and grow as a decorative artist.

With just a few simple tools, you can learn to use the patterns at the end of this chapter with practically any project.

Transferring Patterns

Copy the pattern from the book onto tracing paper. If it's a pattern you expect to use repeatedly, trace it onto a heavier paper (such as Vidalon vellum) for greater durability. Once you've copied the pattern onto tracing paper, you are ready to transfer the design onto the basecoated project. There are four ways you can do this:

Method 1. *Retrace Pattern Lines with Chalk.* Turn the pattern face down. On the back side of the pattern, carefully retrace the pattern lines using a chalk pencil. Then lay the pattern, chalked side down, onto the project. Retrace the pattern lines with a stylus or "dead" ballpoint pen. Use as little pressure as possible so you won't put grooves in your project.

Method 1. Retracing pattern lines with a chalk pencil.

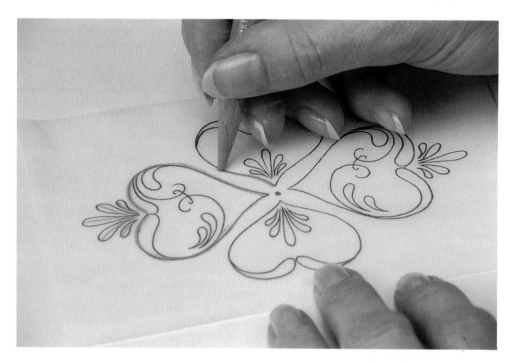

Method 2. Rubbing the back of the pattern with chalk or pencil.

Method 3. Using transfer paper.

Method 4. Making your own transfer paper.

When making multiple transfers, check the raised ridges on the underside of the vellum.

Method 2. *Rubbing the Back of the Pattern with Chalk or Pencil.* With the pattern face down, rub the back with chalk or a No. 2 pencil. Shake off any excess chalk or graphite dust, then lay the pattern, chalk or graphite side down, onto the project. Trace over the lines as described in Method 1.

Method 3. *Using Commercial Transfer Paper.* Use special artists' transfer paper, such as water-soluble Chacopaper. The transfer paper acts like carbon paper. (Under no circumstances, however, should you ever use carbon paper; over time, it will bleed through your paints.) Slide the artists' transfer paper, treated side down, between the pattern and the project. Trace over the pattern lines.

Method 4. *Making Your Own Transfer Paper.* Make your own sheets of light-and-dark transfer paper. Cover one side of a piece of tracing paper thoroughly with white chalk. (Cheap, soft chalk works best. Do not use artists' pastels; their wax base can mar your painting.) Rub the chalk into the paper with your fingers. Shake off any excess chalk dust. Cover another piece of tracing paper with colored chalk (for use on white or cream-colored basecoats), or use a No. 2 pencil, held nearly horizontal to the paper, to cover the paper with graphite. Shake off any excess. Fold the coated papers in half, treated side facing in, when not in use.

Multiple Transfers

If you plan to paint many copies of a design, or if you're teaching a design to a class, the following is an easy way to make multiple transfers quickly and easily. Trace the pattern onto heavy Vidalon vellum, then place the traced pattern on an old phone book or several magazines for cushioning. Use a dead ballpoint pen to retrace the pattern lines into the vellum, applying very firm pressure. On top of the vellum the pattern lines will appear as grooves. Upon completing the tracing, turn the vellum over. The pattern should be visible on the back as raised ridges.

Gently rub the side of a piece of soft chalk over the back (the ridged side) of the pattern, then shake off any excess. Lay the pattern on the basecoated project (ridgy, chalked side down), and gently rub the palm or edge of your hand across the paper. Do not apply heavy pressure in rubbing, and do not rub with your fingernails; such pressure

Transfer only the "bare bones" of the pattern *(see the bold lines at right)* onto your project.

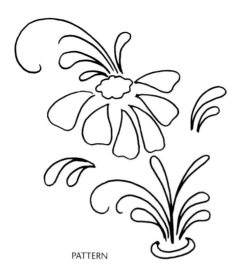

PATTERN

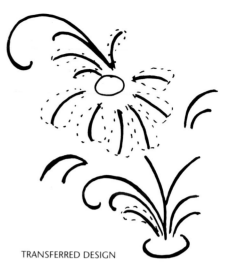

TRANSFERRED DESIGN

would flatten the raised design. When you lift the vellum, you'll see the pattern neatly transferred onto the project. You should be able to transfer the pattern two or three more times before rubbing on more chalk. The ridged pattern should last for several dozen uses before having to retrace over the lines to restore the ridges.

Hints for Successful Transfers

- **Use a stylus.** Use a stylus or dead ballpoint pen to retrace over the pattern lines when transferring a design onto a project. This keeps your pattern clean and uncluttered with lines from multiple tracings.
- **Transfer a minimum of the design.** Transfer onto your project as little of the design as possible. This will force you to be more creative and will allow you greater freedom in executing such aspects as stroke work.
- **Use wax paper to find your place.** If you're transferring a very elaborate pattern and are worried that you won't be able to tell what parts you've traced or missed, fasten a piece of wax paper on top of the pattern. The stylus or dead ballpoint pen will etch the wax paper as you work, showing clearly where you have traced. This hint is especially useful if you get called away from your task while you're right in the middle of completing it.
- **Check to make sure that you're transferring the pattern correctly.** If, before the days of word processors, you ever typed a letter, form, or report with the carbon paper in backward, you know the frustration of having to repeat the job. Be aware that the same thing can happen when transferring patterns.

Make a habit of checking, soon after you begin, to be sure that the pattern is transferring onto the project instead of onto the back of the pattern.
- **Remember to transfer patterns gently.** Use very little pressure when transferring the pattern. You don't want to groove the surface of the project with irremovable pattern indentations.
- **Position the pattern properly.** To ensure you transfer the pattern onto the project in the desired position, try this: Before copying the pattern from the book, lay a piece of tracing paper on top of the project, extending it over the edges. Holding a pencil at an angle, rub the edge of the lead on the paper along the edge of the project. (This traces the outline of the project onto the paper.) Arrange the paper on the pattern in the book until you are satisfied with the position of the design in relation to the sketched outline of the project. Then trace the pattern onto the tracing paper. Finally, reposition the traced pattern on the project, aligning the edge of the project with the outlines rubbed earlier onto the tracing paper.
- **Removing pattern lines.** To remove pattern lines after painting:
 1. For chalk and Chacopaper transfer sheets, use a soft cloth, paper towel, or cotton swab dampened with clean water.
 2. For some artists' transfer papers and graphite, use a kneaded eraser, soap and water, or mineral spirits.
 My personal choice for transferring patterns is chalk. It is easily and thoroughly removable, and it allows for creativity and alterations without ever leaving behind a "ghost" of a pattern.

Enlarging and Reducing Patterns

There will be times when the pattern you want to use does not fit the project you have available. Instead of using a pattern whose proportions or scale do not match the project, take the time to make adjustments. Your work will appear more professional for the effort. Here are some ways to enlarge and reduce patterns.

Making Photocopies

If you have access to a photocopier that enlarges and reduces, this is the simplest method for changing the size of the pattern. Instead of making many haphazard attempts trying to get the right size, use a calculator to figure exactly what percentage to reduce or enlarge by dividing the *desired* pattern size by its *current* size. For example:

- If your pattern measures 4 inches wide and it needs to be $5^1/_2$ inches wide, you need to enlarge it 1.38 times its original size (5.5 inches ÷ 4 inches = 1.38). This means that you would photocopy the original pattern at a 138-percent enlargement.
- If your pattern measures 4 inches wide and it needs to be 3 inches wide, you need to reduce it 0.75 times its original size (3 inches ÷ 4 inches = 0.75). This means that you would photocopy the original pattern at a 75-percent reduction.

Be sure to also check the height of the proposed reduction or enlargement to ascertain that it, too, will properly fit the project.

A word of caution: It is generally permissible to make photocopies of patterns from decorative painting books for your personal use. Under no conditions, however, should you make copies to give or sell to others without first securing permission from the author(s) of the book. It is against the law and is punishable as a copyright violation. When seeking any author's permission for such use, extend the courtesy of including a self-addressed stamped envelope with your request.

Using a Pantograph

This device consists of a lead drawing point, a metal tracing point, a pair of connecting nuts and bolts, a balance pin, and four arms containing holes at certain intervals. A range of enlargements and reductions is possible, depending on where the arms are attached to one another with the nuts and bolts, and where the tracing and drawing points are placed. While the tracing point follows the original pattern lines, the drawing point will make either an enlarged or a reduced version. Pantographs are available in art and drafting supply stores and through some mail-order art catalogs. Inexpensive versions also can be found in some toy stores.

Using a pantograph.

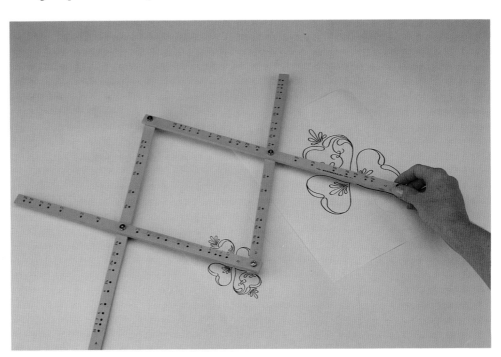

Step 1. Draw a rectangle (to the nearest ¹/₂ inch) around the pattern.

Step 2. Mark every ¹/₂ inch along the edges of the rectangle, then connect the marks to form a grid.

Step 3. Draw your second rectangle *(right),* which corresponds roughly to the desired pattern size, with bold left and lower lines.

Step 4. With one rectangle on top of the other, draw a diagonal line from the lower left corner of the smaller rectangle through its upper right one.

Step 5. Use a pencil to mark the other two edges of the enlarged version of the gridded pattern.

Step 6. Divide the enlarged version of the gridded pattern into the same number of squares as appear on the original.

Step 7. Using its grid lines as your guide, draw the pattern on the enlarged grid.

Using a Proportional Grid

This is an age-old, do-it-yourself method, but it's cheap, and it works.

1. Draw a rectangle around your pattern, rounding its dimensions to the nearest ¹/₂ inch. Be sure the corners are square.

2. Use a ruler to mark every ¹/₂ inch along the length and width of the rectangle. Connect the marks to form a grid on your pattern.

3. Prepare a second rectangle that corresponds roughly to the size you want the pattern to be. Draw the bottom and left line of the rectangle, firmly, with each line extending a little beyond your rough outline.

4. To enlarge or reduce a pattern proportionally, you must make sure that the second rectangle is in proper proportion (width and height) to the one drawn around the original pattern. To do this, place the smaller rectangle on top of the large one, aligning the lower left corners. Then, draw a diagonal line from the lower left corner through the upper right corner of the gridded rectangle and beyond.

5. For the two rectangles to be proportional, the upper right corner of the second rectangle must be positioned along the diagonal line. Mark the spot along the diagonal line that comes closest to the rough sketch you drew in step 3. With a straight edge, extend a line from the mark to the left edge, and another line from the mark down to the bottom edge.

6. Divide the second rectangle into the *same number of squares* as there are on the gridded pattern. Since the size of the second rectangle is either larger or smaller than your original, the grid on that rectangle will not be in ¹/₂-inch increments. To determine the placement of the grid lines, either divide the length of the line by the number of blocks needed, or skip the math and follow the instructions on page 303 for making evenly spaced lines.

7. Draw the pattern onto the new grid, one section at a time. Observe where the original pattern lines intersect the grid lines (midway, low, high, or at an intersection).

Hint: For very complex patterns, a grid with increments of less than a ¹/₂ inch will make it easier to copy details accurately. Sections of the original grid may be divided into smaller units later if the complexity of the pattern warrants it. Just be sure to make the same divisions on both rectangles. For simple patterns, 1-inch grid lines may be sufficient.

Dividing Spaces Evenly—Without Math!

At some point in your decorative painting career, you may need to divide an area into equally spaced sections—and that sounds dreadfully like an exercise in math. However, I want to keep you working on the right—that is, the creative—side of your brain, so we'll divide without the math. Besides, who wants to deal with the fractions involved in dividing $17^7/8$ inches into twenty-four equal segments when there's an easier way?

For this exercise, you'll need a pencil, a ruler, and a blank (unlined) 3×5 inch index card (or you can draw a 3×5 inch rectangle on a piece of paper).

Divide the card into eleven evenly spaced rows. The key is to fit an appropriate number of evenly sized spaces on the card. This is where the ruler comes in—not because it's marked in inches and parts of inches, but because it has conveniently marked equal

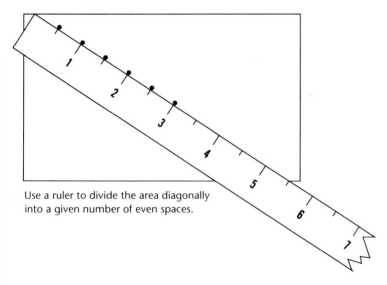

Use a ruler to divide the area diagonally into a given number of even spaces.

spaces. If we start at the zero end and count eleven $^1/2$-inch segments, we end up at the $5^1/2$-inch mark on the ruler.

1. Place the ruler diagonally on the blank side of the index card with the zero end of the ruler on the top edge. The rest of the ruler will extend toward the lower right edge. Pivot the ruler until the $5^1/2$-inch mark intersects the lower right edge of the index card. Count them: There are eleven segments. They are not, however, going to be $^1/2$ inch wide each. (Remember: You're not to think of them as parts of inches.)
2. Mark the index card at each $^1/2$-inch point along the ruler. You should make ten marks.
3. Remove the ruler and use a T-square or right angle (another index card will do) to draw the lines where indicated by the marks, parallel to the long axis of the card. If you do not have a T-square, you can make two register marks for each column. Do this by aligning the zero end of the ruler first at the upper left, extending down to the right; mark the segments. Then align the ruler from the lower left extending up toward the right; mark the segments. The marks will form an X, giving you two dots along which to align your ruler or straight edge to draw each line.

Repeat the exercise to be sure you understand it. This time, divide a card into fourteen columns.

Use this technique for making grids for enlarging or reducing patterns. Also use it on projects for making grids to aid with even placement of repetitive patterns.

Mark the area into equal divisions.

Mark the segments on the other diagonal to form an X. Then connect the marks to draw lines that are parallel to the length of the area.

REPEAT THE BORDER MOTIF AROUND THE CIRCLE

CORNER MOTIFS FOR
THE BOTTOM STEP

BORDER DESIGN FOR THE TOP STEP
NOTE: IF YOU WISH TO OMIT THE LETTERED QUOTATION, CENTER THIS DESIGN WITHIN THE PAINTED STRIP ON BOTH STEPS

ENLARGE ALL THREE PATTERNS 157%

INTERMEDIATE STROKE DESIGN
REPEAT THE PATTERN AT THE DASHED LINE

ADDITIONAL INTERMEDIATE STROKE DESIGN
FLIP THE PATTERN AT THE DASHED LINE TO COMPLETE THE OTHER HALF

ENLARGE BOTH PATTERNS 157%

ADDITIONAL INTERMEDIATE STROKE DESIGN
PLACE AN INITIAL OR MONOGRAM IN THE CENTER, IF DESIRED

ENLARGE 157%

SIDE OF BUCKET
LEFT THIRD OF THE PATTERN

ENLARGE 165%

SIDE OF BUCKET, CONTINUED
MIDDLE THIRD OF THE PATTERN
JOIN THE PATTERN PIECES BY OVERLAPPING THE DASHED LINES

ENLARGE 165%

SIDE OF BUCKET, CONTINUED
RIGHT THIRD OF THE PATTERN

ENLARGE 165%

ADVANCED STROKE DESIGN
PATTERN FOR LID
REPEAT THE PATTERN FOR THE OTHER HALF OF THE LID

ENLARGE 157%

INTERMEDIATE APPLES
USE THIS PATTERN TO HELP DETERMINE THE SIZE OF THE CIRCLE STROKE

ENLARGE 121%

Advanced Apples

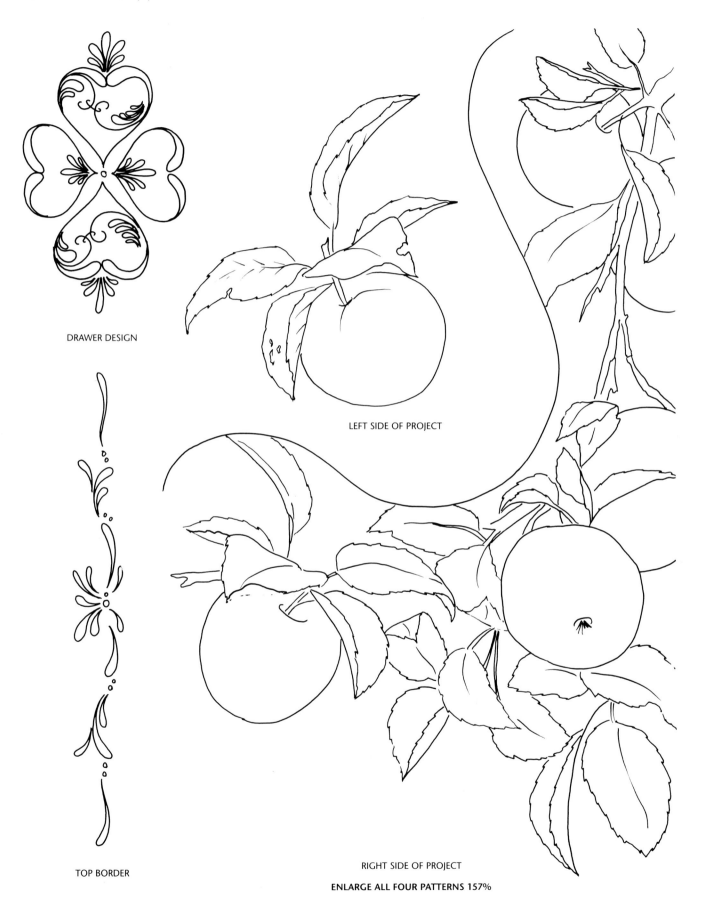

DRAWER DESIGN

LEFT SIDE OF PROJECT

TOP BORDER

RIGHT SIDE OF PROJECT

ENLARGE ALL FOUR PATTERNS 157%

QUICK AND EASY BLACKBERRIES
REPEAT THE BORDER AROUND THE PROJECT

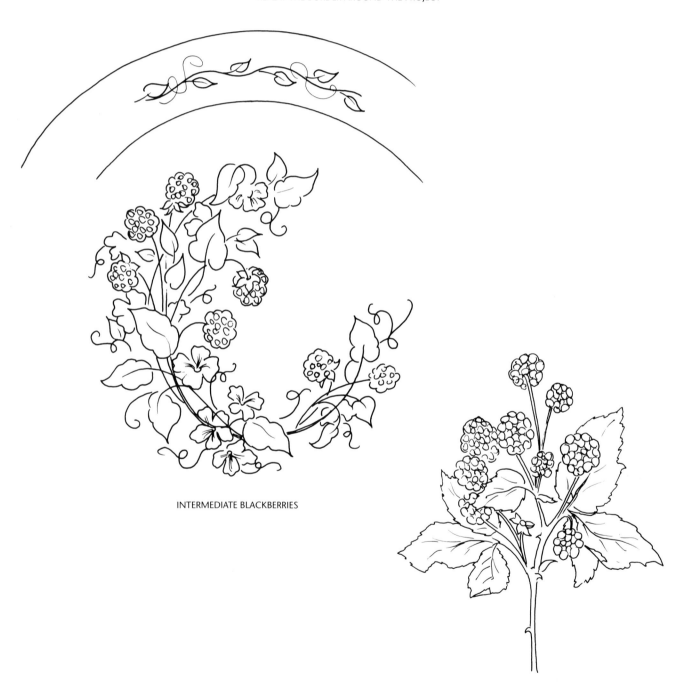

INTERMEDIATE BLACKBERRIES

ENLARGE ALL THREE PATTERNS 157%

ADVANCED BLACKBERRIES

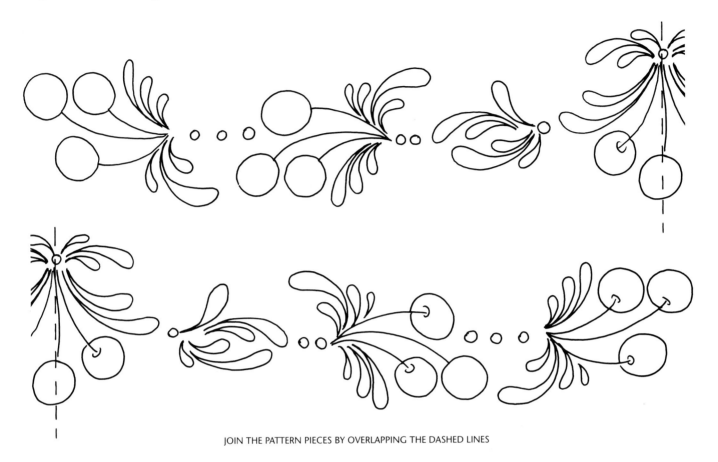

JOIN THE PATTERN PIECES BY OVERLAPPING THE DASHED LINES

HANDLE DESIGN

ENLARGE BOTH PATTERNS 121%

INTERMEDIATE CHERRIES

ADVANCED CHERRIES
(SCROLL WORK FOR SIDES)
USE THE PATTERN ON ONE SIDE,
THEN REVERSE IT FOR THE OTHER

BEGIN WITH THE LOWER HALF OF THE DESIGN
(IT HAS FEWER STROKES AND IS EASIER).
THE NUMBERED SEQUENCE IS ONLY A
SUGGESTION, AND CAN BE VARIED TO SUIT
YOUR PREFERENCE. IF YOU'RE UNSURE OF YOUR
SCROLL PAINTING, FOLLOW THE NUMBERS.
THEIR PROGRESSION WILL HELP YOU BUILD
THE SCROLL GRADUALLY.

ENLARGE BOTH PATTERNS 157%

Advanced Cherries

CORNER DESIGN FOR DOORS

ENLARGE BOTH PATTERNS 157%

TOP OF CABINET

SIDE OF CABINET

LEFT DOOR
FLIP THIS PATTERN FOR THE DOOR ON THE RIGHT

ENLARGE ALL THREE PATTERNS 157%

Advanced Pears

TOP OF BOX

LID OF BOX

ENLARGE ALL FOUR PATTERNS 157%

Quick and Easy Vegetables

ALIGN PATTERN PIECES ALONG DASHED LINES

BORDER DESIGN

ENLARGE ALL FIVE PATTERNS 183%

END DESIGN

Intermediate Vegetables

ALIGN THE ADVANCED VEGETABLE PATTERN WITH THE DOTTED LINES ABOVE RIGHT TO COMPLETE THE PATTERN FOR THE INTERMEDIATE VEGETABLE
PROJECT (REFER TO THE INSTRUCTIONS FOR THE ADVANCED PATTERN FOR ADJUSTING IT TO FIT THE SMALLER PROJECT)

ENLARGE 200%

ALIGN THE DASHED LINES WITH THE
RADISHES ON THE RIGHT SIDE OF
THE PATTERN AT LEFT TO COMPLETE THE
ADVANCED VEGETABLES PATTERN

BORDER DESIGN

TO ADAPT THE ADVANCED VEGETABLES
PATTERN FOR USE ON A SMALLER
PROJECT (SUCH AS THE INTERMEDIATE
VEGETABLES LAP DESK), USE THE LEAF
PATTERNS ABOVE TO REPLACE THE
ONIONS ON THE LEFT AND RIGHT SIDES.
TO INCLUDE AN ONION IN THE
PAINTING, REPLACE THE CENTER
MUSHROOM WITH THE ONION ABOVE.

**ENLARGE ALL SIX
PATTERNS 200%**

ENLARGE 157%

ENLARGE 183%

ENLARGE 183%

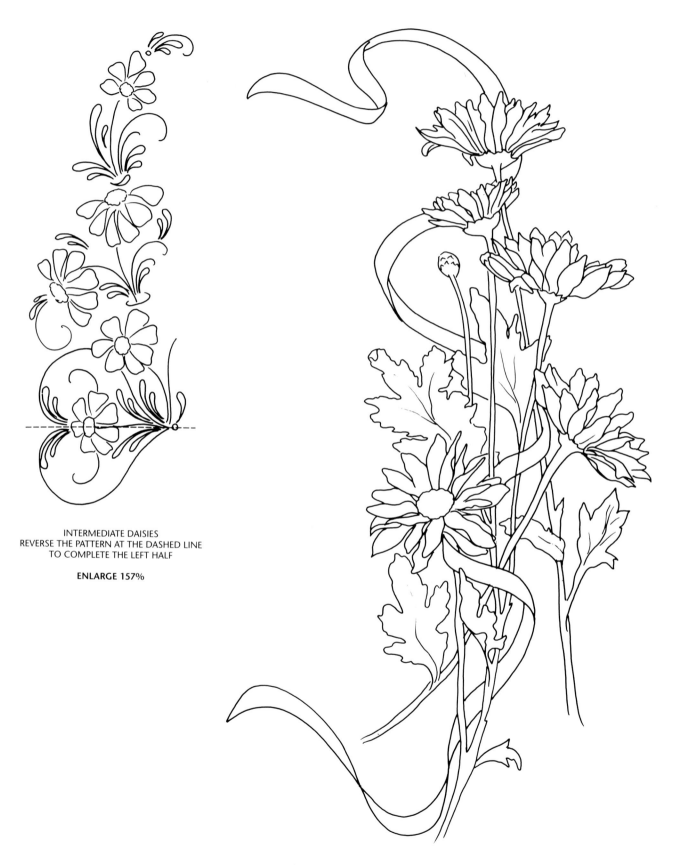

INTERMEDIATE DAISIES
REVERSE THE PATTERN AT THE DASHED LINE
TO COMPLETE THE LEFT HALF

ENLARGE 157%

ADVANCED DAISIES

ENLARGE 183%

Quick and Easy and Intermediate Dogwood

QUICK AND EASY DOGWOOD
REPEAT THIS PATTERN TO MAKE THE BORDER

INTERMEDIATE DOGWOOD

ENLARGE BOTH PATTERNS 157%

CORNER SCROLL DESIGN

ENLARGE BOTH PATTERNS 183%

INTERMEDIATE FORGET-ME-NOTS

ADVANCED FORGET-ME-NOTS

ADVANCED FORGET-ME-NOTS
BORDER DESIGN

ENLARGE ALL THREE PATTERNS 157%

QUICK AND EASY ROSES
PLACE THIS DESIGN IN THE CENTER OF THE PROJECT. REPEAT THE STEMMED ROSES UNTIL THEY MEET ON THE OTHER SIDE.

ENLARGE 157%

INTERMEDIATE ROSES

ENLARGE 157%

ADVANCED ROSES (BORDER DESIGN)
JOIN THE PATTERN PIECES BY OVERLAPPING THE DASHED LINES.
THREE REPETITIONS WILL FIT AROUND THE LARGE MUSEUM BOX.

ENLARGE 200%

ENLARGE 200%

QUICK AND EASY TULIPS

INTERMEDIATE TULIPS

ENLARGE BOTH PATTERNS 157%

RIBBON FOR THE BACK OF THE BOX

ENLARGE BOTH PATTERNS 157%

Source Directory

The following is a list of sources for the materials and projects used in this book. Your very best source for supplies, however, is your friendly neighborhood craft store owner or manager, who can assist you with product selection and offer advice when you need help. Most of the sources listed below sell their products primarily through retail shops, so ask your favorite shopowner to order any items he or she might not currently stock for you. By doing so, you'll save on shipping charges and help support the shopowner's business. When writing directly to any of the companies, be sure to include with your order or request a large, self-addressed stamped envelope for a reply.

As with clothing, fashions in wood and tin items go in and out of style. Items that were available when this book was first published may not be if you're reading this even a short time later. Just keep looking. You're sure to find equally pleasing substitutes.

Supplies

Brushes
Loew-Cornell
563 Chestnut Avenue
Teaneck, New Jersey 07666-2490
(800) 922-0186

Paints
DecoArt
Box 360
Stanford, Kentucky 40484
(800) 367-3047

Practice Paper and Instructional Videos
Jackie Shaw Studio, Inc.
13306 Edgemont Road
Smithsburg, Maryland 21783
(301) 824-7592

Spray Finishes and Primers
Loctite Corporation
705 North Mountain Road
Newington, Connecticut 06111
(203) 280-3558

Stencil Pencils
Lehman Manufacturing Company, Inc.
Box 46
Kentland, Indiana 47951
(219) 474-6011

Wire Hanger Hooks
Oliver Trahan
P.O. Box 616
Sulphur, Lousiana 70664-0616
(318) 527-3857

Project Suppliers

Basketville
P.O. Box 710
Putney, Vermont 05346
(800) 258-4553

40-pound bucket with lid, page 119
Granny's bucket, page 184
Round basket with hinged cover (#A-265), page 215
Half bucket (#U-323.5), page 260

Cabin Craft Midwest
1225 West 1st Street
Nevada, Iowa 50201
(800) 669-3920

Cut-corner beverage tray (#30-383), page 114
Recipe card/bookshelf (#36-005), page 149
Collector's cabinet (#31-585), page 172
Clipboard box (#30-646), page 224
Children's and adult wooden coat hangers, page 231
Pencil/candle box (#34-064), page 263

Crafts Manufacturing Company
72 Massachusetts Avenue
Lunenburg, Massachusetts 01462
(508) 342-1717

Molly Pitcher lamp, page 163
Tin candle sconce (#108), page 246

Crew's Country Pleasures
HRC 64, Box 53
Thayer, Missouri 65791
(417) 264-7246

Folding step stool, page 111
Narrow cabinet with shelves, page 188

Designs by Bentwood
P.O. Box 1676
170 Big Star Drive
Thomasville, Georgia 31792
(912) 226-1223

9³/₄-inch casserole carrier (#72D), page 150
Small piggin (#31S), page 160
Tray (#26), page 212
Casserole carrier (#72B), page 222
Large scoop (#30-L), page 238
Oval carrier (#3), page 242
Extra-large museum box (#50), page 252

Greenfield Basket Company, Inc.
11423 Wilson Road
North East, Pennsylvania 16428
(800) Basket-5

Pie basket/small lap desk (#22), page 146
Large lap desk (#24), page 191

Herr's, Inc.
70 Eastgate Drive
Danville, Illinois 61832
(800) 637-2647
In Illinois: (800) 252-5091

Cut-out apples, page 142

Norwegian Wood
P.O. Box 471
Battle Lake, Minnesota 56515
(218) 864-8673

Salt box (#205), page 176

Paintin' Cottage
4813 Moffett Road
Mobile, Alabama 36618
(800) 874-4064

Lathe-turned apples (#20-0008), page 142
Lathe-turned pears, page 168
Calendar (#53-0193), page 218
Candlesticks (#16-001), round box (#22-0010),
 and wooden eggs (#21-0105), page 235

Peco's Pine
242 East Main Street
Suite 8
Ashland, Oregon 97520
(503) 535-6006

Christmas tree, page 270
Pig puzzle, page 275
Horse puzzle, page 280

Stoney Point
U.S. Route 13
Oak Hill, Virginia 23416
(800) 446-4082

Carved wooden decoy, page 158

Sunshine Industries Unlimited
P.O. Box 178
3714 Long Street
Sweet Home, Oregon 97386-3025
(503) 367-2765

Watermelon sign (#93-JS-2), page 179
18³/₄ × 8 inch mushroom board
 (#93-JS-1), pages 205, 208,
 and 210
Mushroom cutout (#93-JS-1A), page 205
Tulip cutouts (#93-JS-3), page 254

Walnut Hollow Farm
Route 2
Dodgeville, Wisconsin 53533
(800) 346-2414

Bread tote (#3250), page 107
9¹/₂-inch double-beaded plate,
 page 154
Ashford curio cabinet, page 167
Wickhambrook cabinet (#17021),
 page 230

Weston Bowl Mill
Main Street
Weston, Vermont 05161
(802) 824-6219

11¹/₂-inch bowl, page 183

Mail Order Companies

The Artist's Club
5750 N.E. Hassalo
Building C
Portland, Oregon 97213
(800) 845-6507

Cabin Craft Midwest
1225 West 1st Street
Nevada, Iowa 50201
(800) 669-3920

Char-Lee Originals
P.O. Box 606
Somonauk, Illinois 60552
(800) 242-7533

Suggested Reading

Battersby, Martin. *Trompe L'Oeil: The Eye Deceived.* New York: St. Martin's Press, 1974.

Black, Mary C., and Jean Lipman. *American Folk Painting.* New York: Clarkson N. Potter, Inc., 1966.

Blanchard, Roberta Ray. *How To Restore and Decorate Chairs.* New York: M. Barrows and Company, Inc., 1952.

Brazer, Esther Stevens. *Early American Decoration.* Springfield, Massachusetts: Pond Ekberg Co., 1940.

Christensen, Erwin O. *The Index of American Design.* New York: The Macmillan Company, 1959.

Coffin, Margaret. *History and Folklore of American Country Tinware (1700–1900).* Camden, New Jersey: Thomas Nelson & Sons, 1968.

Cramer, Edith. *Handbook of Early American Decoration.* Boston: Charles T. Branford Company, 1951.

De Dampierre, Florence. *The Best of Painted Furniture.* New York: Rizzoli International Publications, Inc., 1987.

DeVoc, Shirley Spaulding. *The Tinsmiths of Connecticut.* Middletown, Connecticut: Wesleyan University Press, 1968.

Ebert, John and Katherine. *American Folk Painting.* New York: Charles Scribner's Sons, 1975.

Fales, Dean, Jr. *American Painted Furniture: 1660–1880.* New York: E. P. Dutton Company, 1972.

Gibbia, S. W. *Wood Finishing and Refinishing.* New York: Van Nostrand Reinhold Co., 1981.

Gould, Mary Earle. *Antique Tin and Tole Ware.* Rutland, Vermont: Charles E. Tuttle Company, 1947.

Graves, Maitland. *The Art of Color and Design.* New York: McGraw-Hill Book Company, 1951.

Grotz, George. *Instant Furniture Refinishing and Other Crafty Practices.* New York: Doubleday and Co., 1966.

Hayward, Charles H. *Staining and Polishing.* Philadelphia: J. B. Lippincott Co., 1960.

Hoke, Elizabeth S. *Home Craft Course: Pennsylvania German Painted Tin (Tole Ware).* Plymouth Meeting, Pennsylvania: Mrs. C. Naaman Keyser, 1943.

———. *Home Craft Course: The Painted Tray and Free Hand Bronzing.* Plymouth Meeting, Pennsylvania: Mrs. C. Naaman Keyser, 1949.

Hornung, Clarence P. *Treasury of American Design and Antiques.* New York: Harry N. Abrams, Inc., n.d.

Hunt, Peter. *Peter Hunt's Workbook.* Chicago, Illinois: Ziff-Davis Publishing Company, 1945.

Innes, Jocasta. *Scandinavian Painted Decor.* New York: Rizzoli International Publications, Inc., 1990.

Jabolonski, Romana. *The Paper Cut-Out Design Book.* Owings Mills, Maryland: Stemmer House Publishers, Inc., 1976.

Johnson, Edwin. *Restoring Antique Furniture.* New York: Sterling Publishing Co., Inc., 1982.

Johnstone, James B., and Sunset Editorial Staff. *Furniture Finishing and Refinishing.* Menlo Park, California: Lane Magazine and Book Co., 1969.

Kauffman, Henry J. *Pennsylvania Dutch American Folk Art.* New York: Dover Publications, Inc., 1964.

Lea, Zilla Rider. *The Ornamented Tray.* Rutland, Vermont: Charles E. Tuttle Company, 1971.

Lichten, Frances. *Folk Art of Rural Pennsylvania.* New York: Bonanza Books, 1956.

Lipman, Jean. *American Primitive Painting.* New York: Oxford Press, 1942.

———. *American Folk Art in Wood, Metal, and Stone.* New York: Dover Publications, Inc., 1948.

McCann, Michael. *Artist Beware.* New York: Watson-Guptill Publications, 1979.

Mayer, Ralph. *American Artist Technical Page.* New York: American Artist Magazine, Billboard Publications, Inc., 1962.

———. *The Artist's Handbook of Materials and Techniques.* New York: Viking Press, 1970.

Miller, Margaret M., and Sigmund Aarseth. *Norwegian Rosemaling.* New York: Charles Scribner's Sons, 1974.

Miller, Rex, and Glenn E. Baker. *Painting and Decorating.* Indianapolis, Indiana: Theodore Audel and Co., 1984.

Murray, Maria D. *The Art of Tray Painting.* New York: Thomas Y. Crowell (Studio Publication), 1954.

Newell, Adnah. *Coloring, Finishing, and Painting Wood.* Peoria, Illinois: C. A. Bennett Co., 1961.

Ormsbee, Thomas. *Care and Repair of Antiques.* New York: Gramercy Publishing Company, 1949.

Palekh Miniature Painting. Leningrad: Progress Publishers, 1978.

Palekh: Village of Artists. Moscow: Progress Publishers, 1977.

Pennsylvania Farm Museum of Landis Valley. *Pennsylvania German Fraktur and Color Drawings.* Lancaster, Pennsylvania: Landis Valley Associates, 1969.

Plath, Iona. *The Decorative Arts of Sweden.* New York: Dover Publications, Inc., 1969.

Polley, Robert L., ed. *America's Folk Art.* Waukesha, Wisconsin: Country Beautiful Corporation, 1971.

Powers, Beatrice Farnsworth and Olive Floyd. *Early American Decorated Tinware.* New York: Hastings House, 1957.

Pronin, Alexander and Barbara. *Russian Folk Arts.* South Brunswick, New Jersey, and New York: A. S. Barnes and Company, Inc., 1975.

Rainwater, Clarence. *Light and Color.* New York: Golden Press, 1971.

Richardson, Nancy. *How To Stencil and Decorate Furniture and Tinware.* New York: The Ronald Press Company, 1956.

Ritz, Gislind M. *Alte Bemalte Bauernmobel Europa.* Munich: Verlag Callwey, 1980.

Ritz, Josef M. and Gislind M. *Alte Bemalte Bauernmobel.* Munich: Verlag Callwey, 1975.

Rumford, Beatrix T., gen. ed. *American Folk Paintings.* Boston: Little, Brown and Company, 1988.

Sabine, Ellen S. *American Antique Decoration.* New York: Bonanza Books, 1956.

———. *Early American Decorative Patterns and How to Paint Them.* New York: Bonanza Books, 1971.

Sargent, Walter. *The Enjoyment and Use of Color.* New York: Dover Publications, Inc., 1964.

Scharff, Robert. *Complete Book of Wood Finishing.* New York: McGraw-Hill Book Company, Inc., 1956.

Slayton, Mariette Paine. *Early American Decorating Techniques.* New York: The Macmillan Company, 1972.

Smith, Elmer L. *The Folk Art of Pennsylvania Dutchland.* Lebanon, Pennsylvania: Applied Arts Publishers, 1966.

———, ed. *Tinware Yesterday and Today.* Lebanon, Pennsylvania: Applied Arts Publishers, 1974.

Stern, Arthur. *How to See Color and Paint It.* New York: Watson-Guptill Publications, 1984.

Yemelyanova, Tatyana. *Khokhloma Folk Painting.* Leningrad, Russia: Aurora Art Publishers, 1980.

Zhostovo Painted Trays. Moscow: Progress Publishers, 1987.

Index